TIME
LIFE

GREAT PHOTOGRAPHS OF

THE CIVIL WAR

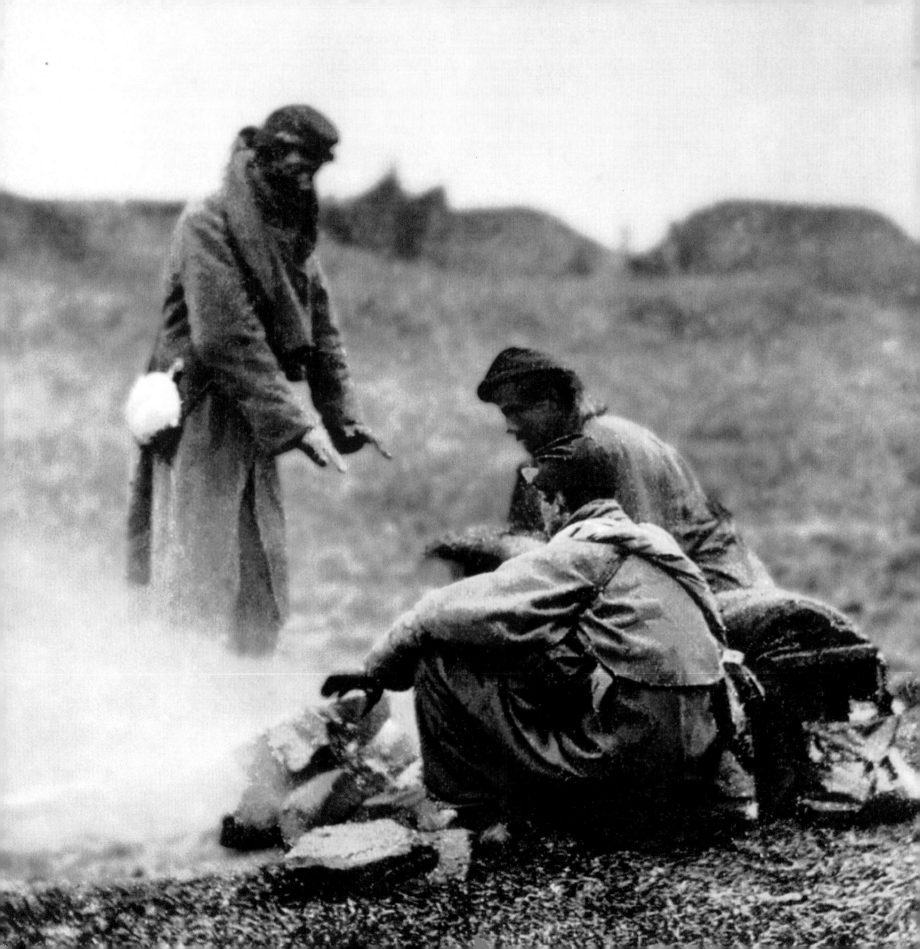

TIME
LIFE

GREAT PHOTOGRAPHS OF
THE CIVIL WAR

Edited by Neil Kagan

Introduction by Brian C. Pohanka

OXMOOR HOUSE — BIRMINGHAM, ALABAMA

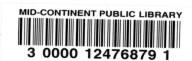
Oxmoor House®

© 2003 by Oxmoor House, Inc.
Book Division of Southern
Progress Corporation
P.O. Box 2463, Birmingham, Alabama 35201

TIME-LIFE is a registered trademark of Time Warner Inc. and affiliated companies. Used under license.

This book is a compilation of material previously published by Time Life Inc. © 1977, 1983, 1984, 1985, 1986, 1987, 1990, 1991, 1995, 1996, 1997, 1998, 2000, 2002, Time Life Inc.

FIRST EDITION

Library of Congress Control Number:
2003108543
ISBN 0-8487-2817-3

PRINTED IN THE UNITED STATES OF AMERICA

Great Photographs of the Civil War
was prepared by:

Kagan & Associates, Inc.
Falls Church, Virginia

President/Editor-in-Chief: Neil Kagan
Vice President/Director of Administration:
 Sharyn Kagan
Writers/Editors: Harris J. Andrews, Lisa Kagan,
 Brian C. Pohanka
Designers: Antonio Alcalá, Mary Dunnington,
 Mike Dyer
 Studio A, Alexandria, Virginia
Associate Editor/Copyeditor:
 Mary Beth Oelkers-Keegan
Indexer: Susan Nedrow
Special Contributor: Susan Finken
 (rights and permissions)
Prepress Services: DigiLink, Inc.,
 Alexandria, Virginia

Front Cover: Shortly after the battle of Antietam, President Lincoln meets with General McClellan (*second from left*) and his staff at V Corps headquarters near Sharpsburg, Maryland. With more than 22,000 casualties, the Battle of Antietam proved to be the bloodiest single day of combat in American history.

Page 2: Waging the soldier's never-ending struggle for comfort, three Union men capture what warmth they can from a small fire in a bivouac somewhere in Northern Virginia.

Neil Kagan is the former Publisher/Managing Editor and Director of New Product Development for Time-Life Books. Over his 26-year career, he created a wide range of Time-Life Books series, including the award-winning *Voices of the Civil War, What Life Was Like, Our American Century,* and *The Time-Life Student Library.* As an accomplished photographer and creative director, Kagan brings a strong vision to selecting images and combining them into photographic essays that tell compelling stories.

Harris J. Andrews has done extensive research and writing on the Civil War over the past 20 years. A native Virginian and descendant of several Confederate soldiers, he had toured every battlefield on the East Coast by the age of 12. Andrews was a major contributor to all of Time-Life Books Civil War projects, and he developed and edited the definitive Civil War volumes on arms and equipment—*Echoes of Glory.* He also played a major role assembling the comprehensive collection of Civil War letters, diary entries, and first-person accounts that appeared in Time-Life Books' *Voices of the Civil War.*

Brian C. Pohanka is a military historian and author who has written several books and dozens of articles on the Civil War. He was a major contributor to all of the Time-Life Books Civil War projects and was Series Consultant for the television documentary *Civil War Journal.* He has served as a historical adviser for a number of films, including *Glory* and *Gettysburg.* Pohanka is active in the cause of Civil War battlefield preservation and participates in Civil War battlefield reenactments as the Captain of Company A, 5th New York Volunteer Infantry, Duryee's Zouaves.

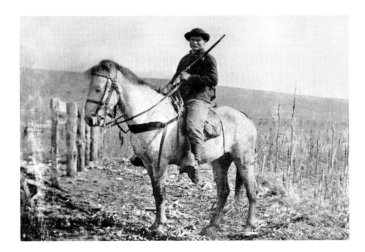

Contents

Images of War

CLOSE YOUR EYES AND IMAGINE WHAT LIFE WAS LIKE 140 YEARS AGO during the Civil War. Haunting images come to mind—the glow of infantry on parade with fixed bayonets and polished muskets; the scarred back of a former slave forever altered by the lash; the harvest of death at Gettysburg; the grim confines of Andersonville, where neglected prisoners of war died in droves; or the cracked portrait of Lincoln days before his assassination.

These images are real, etched forever in our minds because they were captured on coated glass by pioneering photographers who used heavy equipment and portable darkrooms mounted on wagon beds to record this fateful struggle. Through their eyes, we witness the determined faces of soldiers before they entered battle *(right)*—and the mangled bodies of the dead strewn across the field afterward.

After poring over thousands of Civil War photographs from museums and private collections around the country, I realized that the greatest of these images take us back in time and transform us from observers into participants. They engage our curiosity, drawing us ever deeper into the war and its riddles. A woman washing laundry in a Federal camp—how did she care for her children during the war? Three brothers brandishing bowie knives and revolvers—did they make it home from battle? General Grant puffing on a cigar in the Massaponax churchyard—what was going through his mind?

In *Great Photographs of the Civil War* we have assembled 300 of these gripping images into 20 chronological photo essays. When viewed together, they offer you the opportunity to experience the emotional history of that tragic era and relive the epic battles that redefined our nation.

Neil Kagan

Neil Kagan
Editor

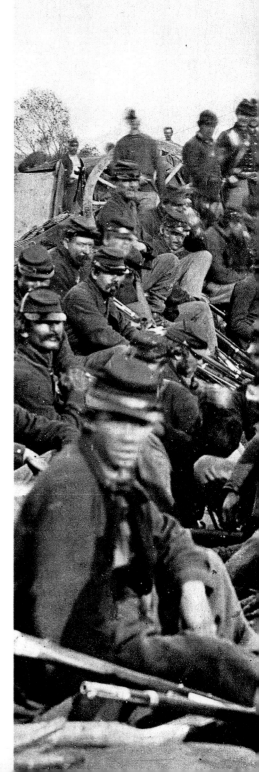

QUIET MOMENT BEFORE BATTLE
Two Federal officers standing just beyond enemy rifle range survey Rebel positions southwest of Fredericksburg while infantrymen take cover in captured rifle pits. On May 3, 1863, these troops of William T. H. Brooks' division would capture Fredericksburg and advance toward Chancellorsville, only to suffer a bloody repulse at Salem Church.

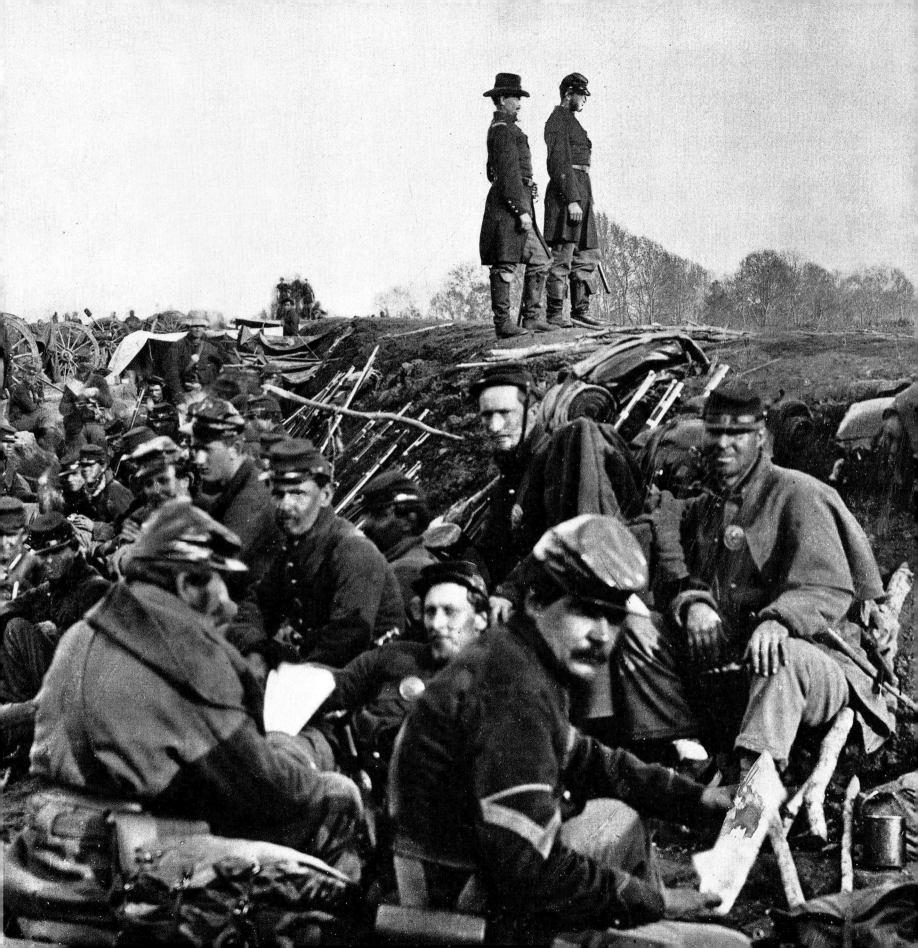

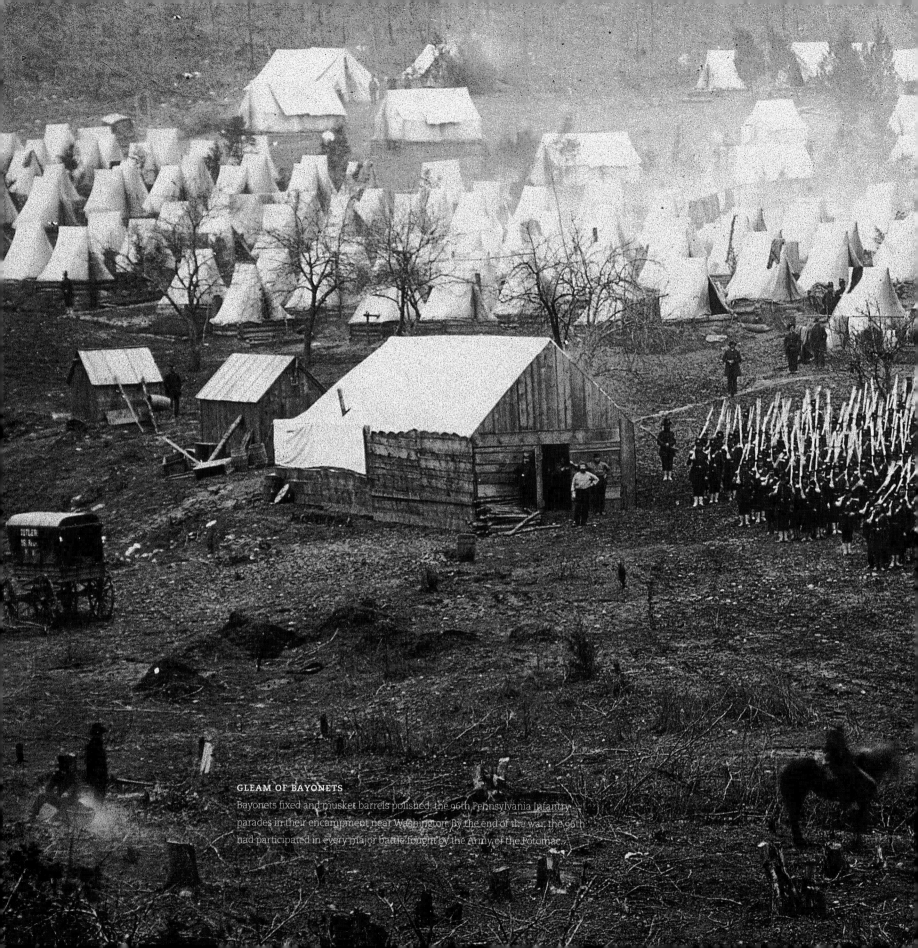

GLEAM OF BAYONETS
Bayonets fixed and musket barrels polished, the 96th Pennsylvania Infantry parades in their encampment near Washington. By the end of the war, the 96th had participated in every major battle fought by the Army of the Potomac.

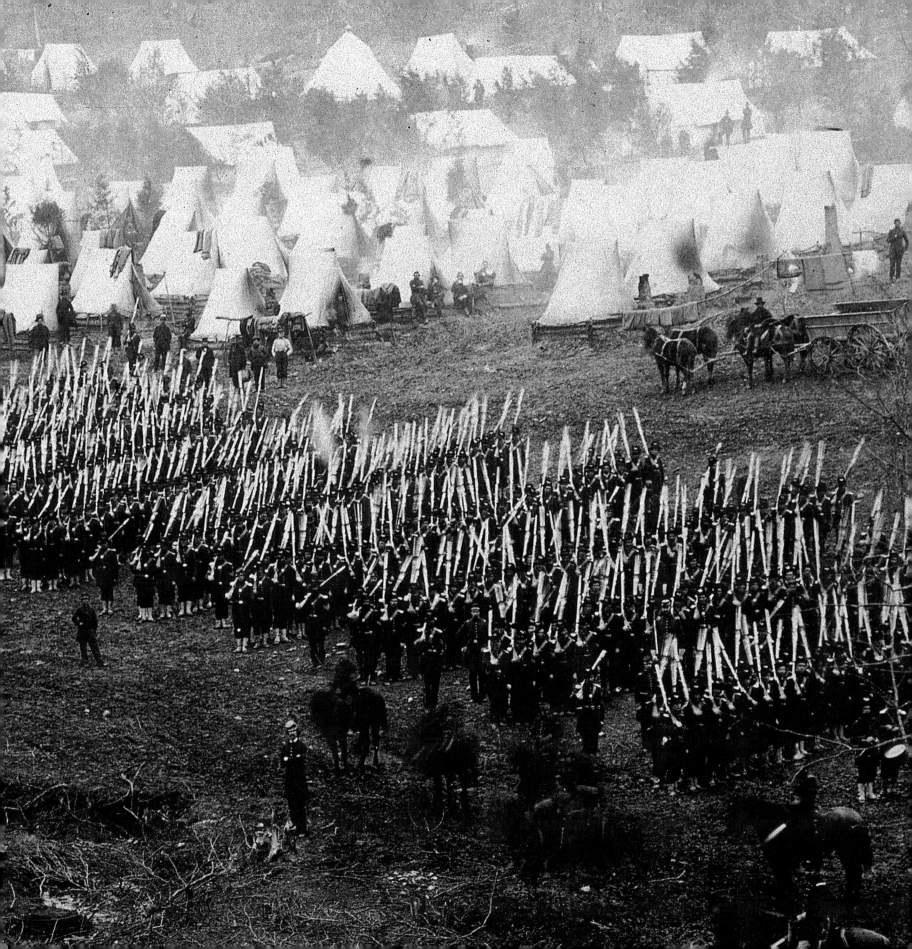

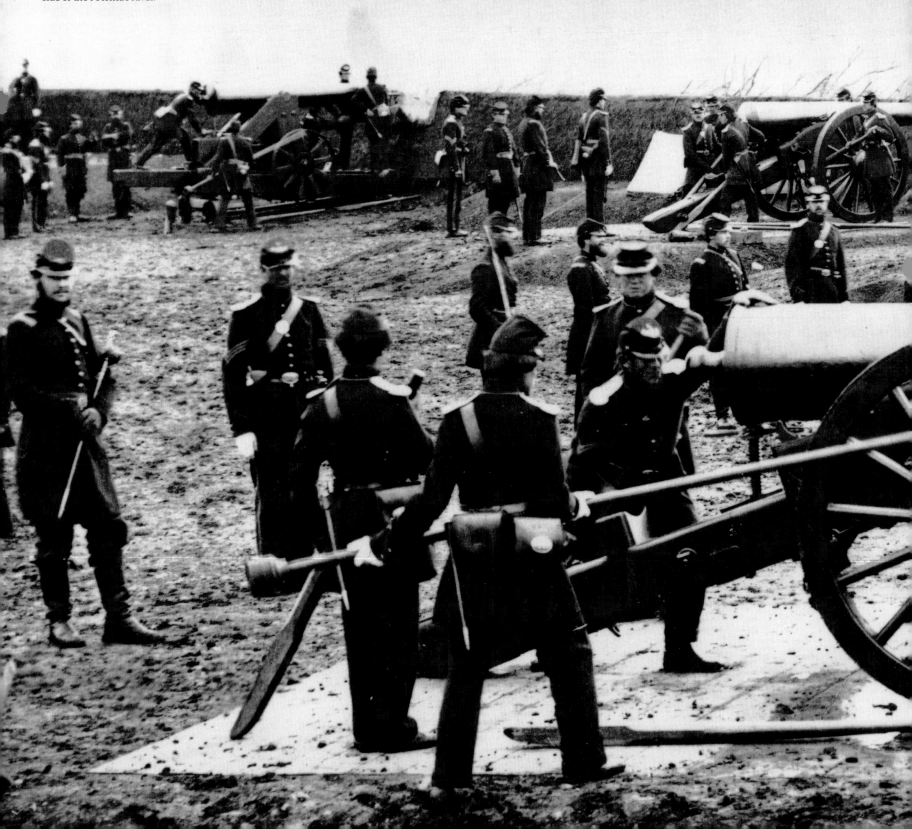

GUARDIANS OF WASHINGTON

The 1st Connecticut Heavy Artillery Regiment drills at a fort on the Arlington Heights, which command Washington from the Virginia side of the Potomac River.

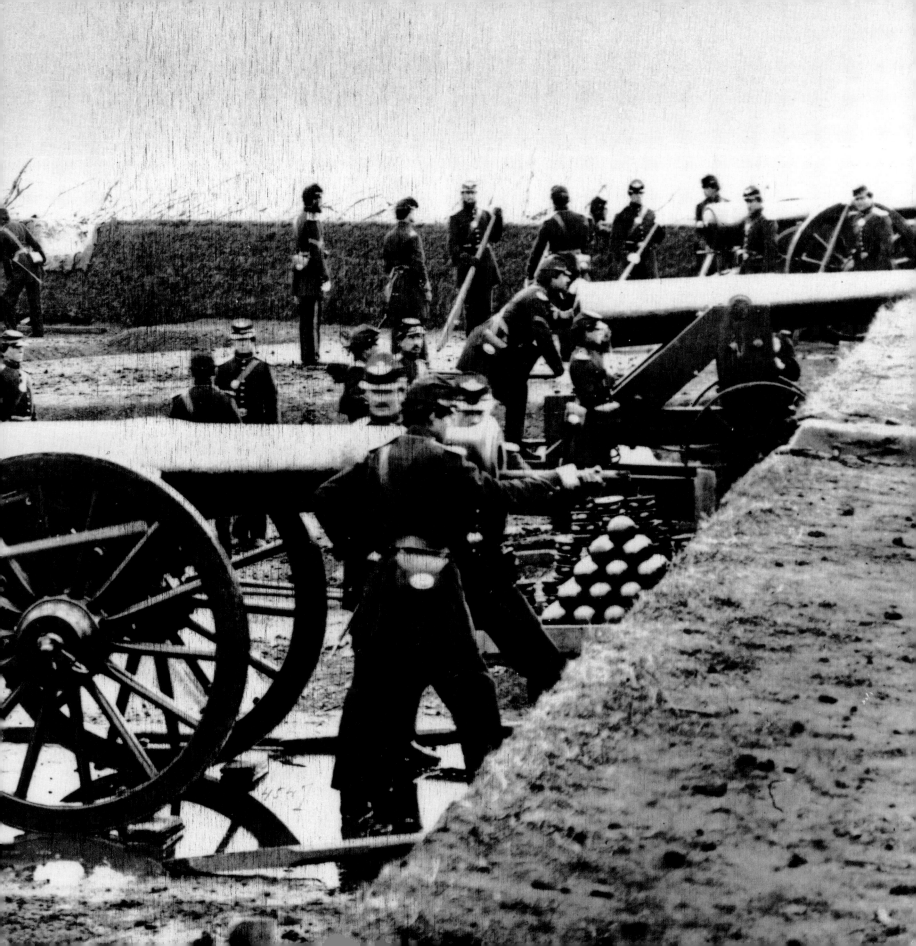

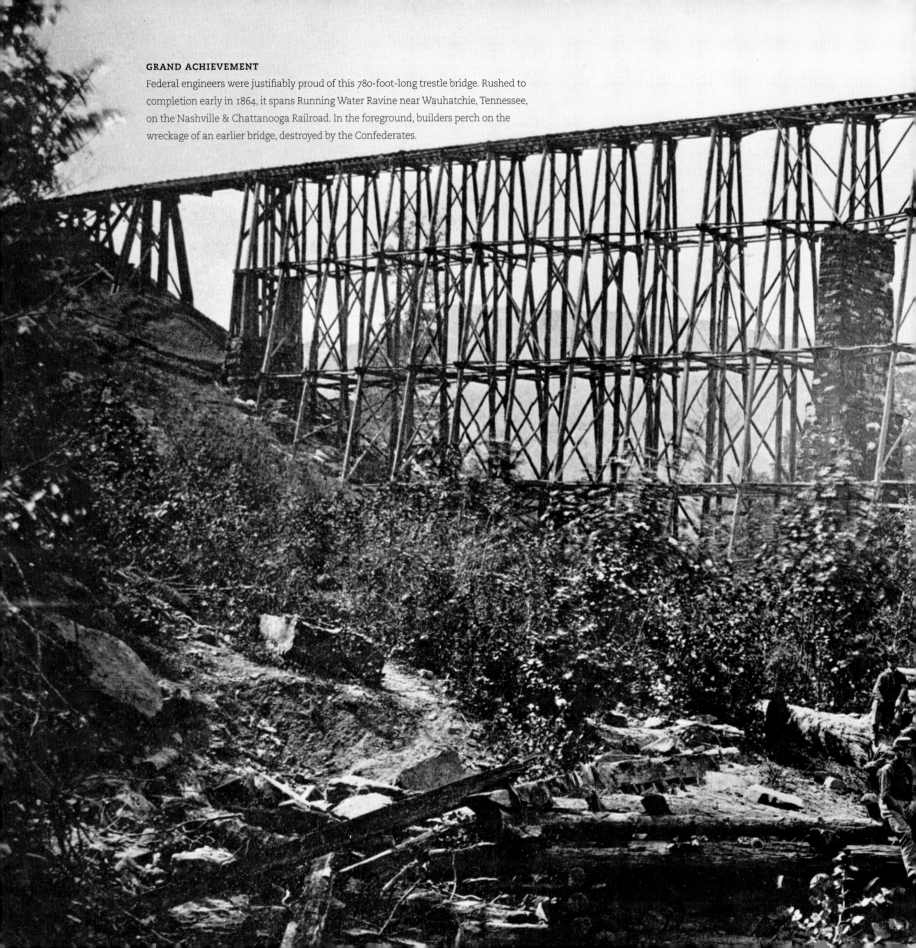

GRAND ACHIEVEMENT
Federal engineers were justifiably proud of this 780-foot-long trestle bridge. Rushed to completion early in 1864, it spans Running Water Ravine near Wauhatchie, Tennessee, on the Nashville & Chattanooga Railroad. In the foreground, builders perch on the wreckage of an earlier bridge, destroyed by the Confederates.

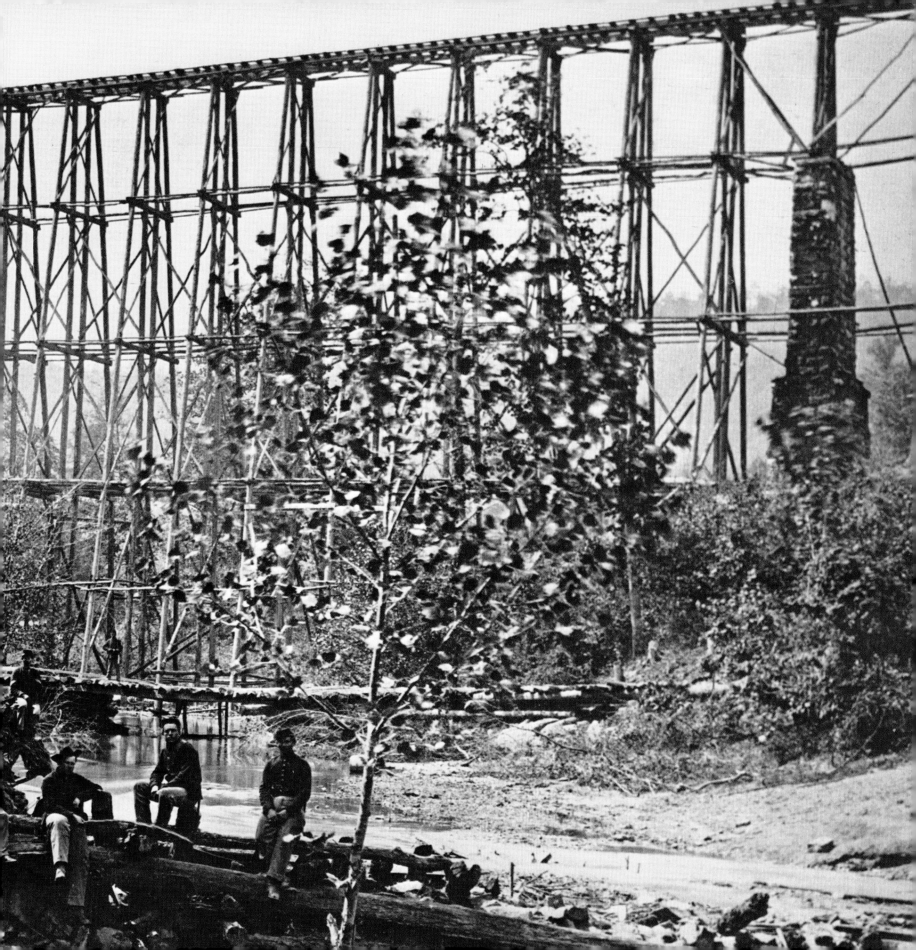

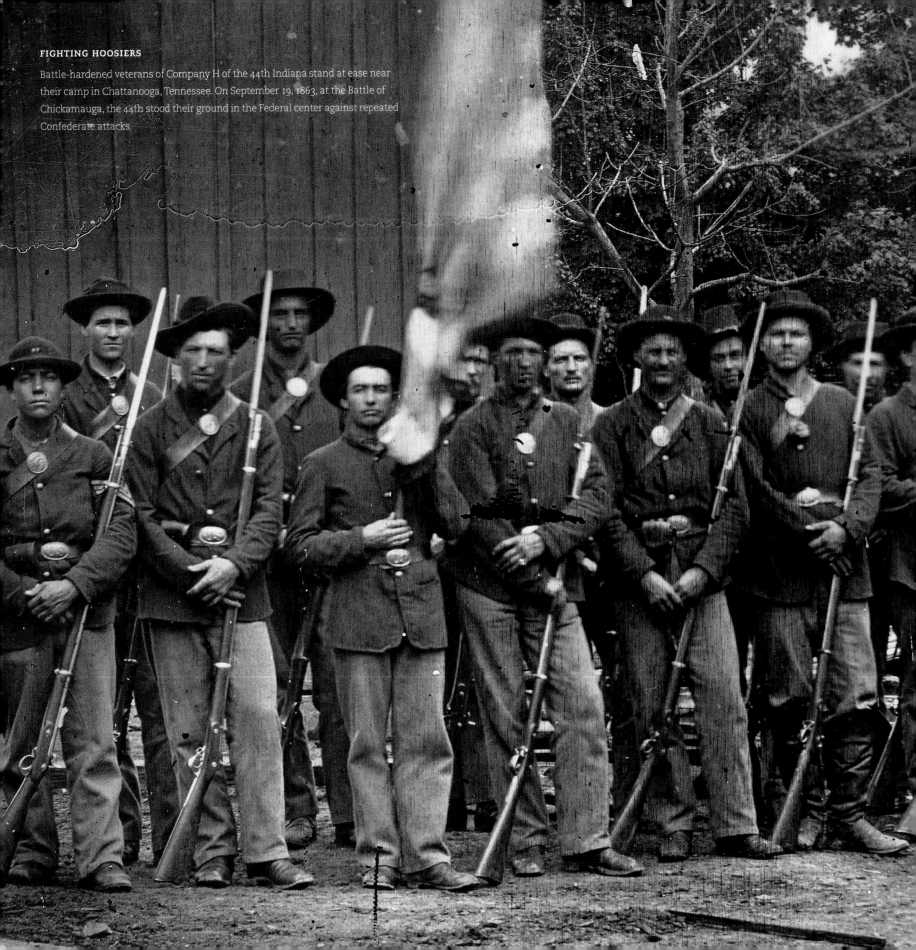

FIGHTING HOOSIERS

Battle-hardened veterans of Company H of the 44th Indiana stand at ease near their camp in Chattanooga, Tennessee. On September 19, 1863, at the Battle of Chickamauga, the 44th stood their ground in the Federal center against repeated Confederate attacks.

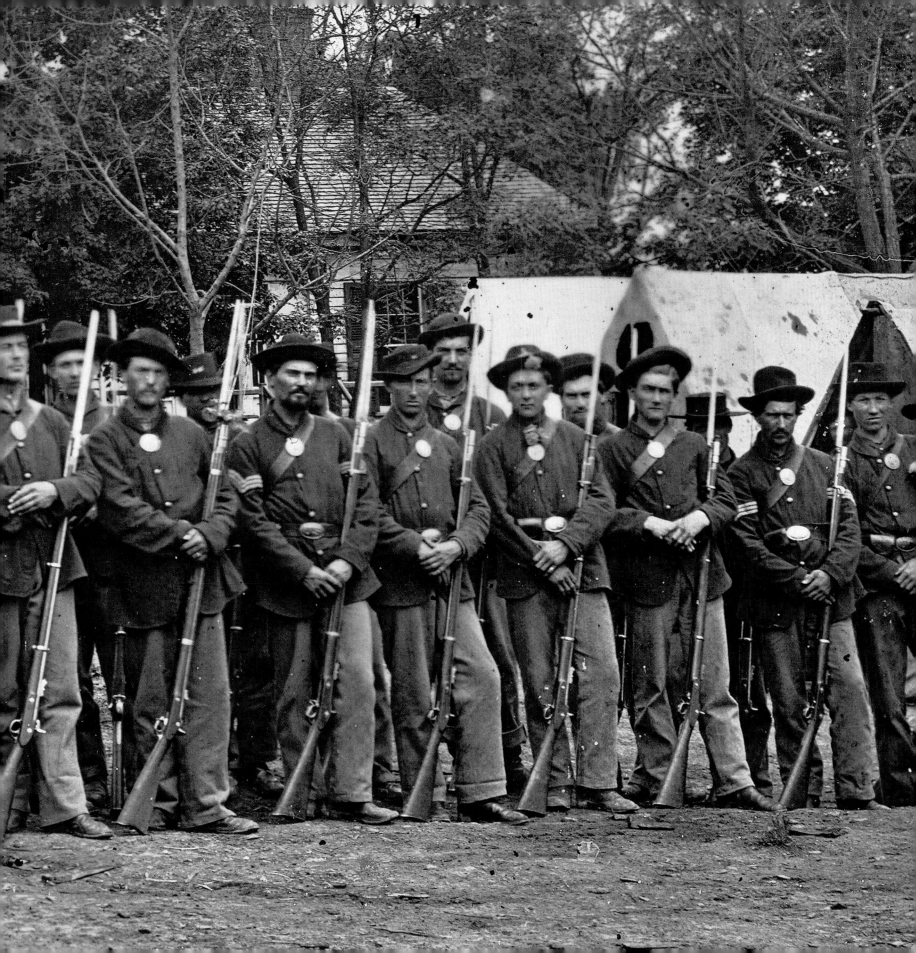

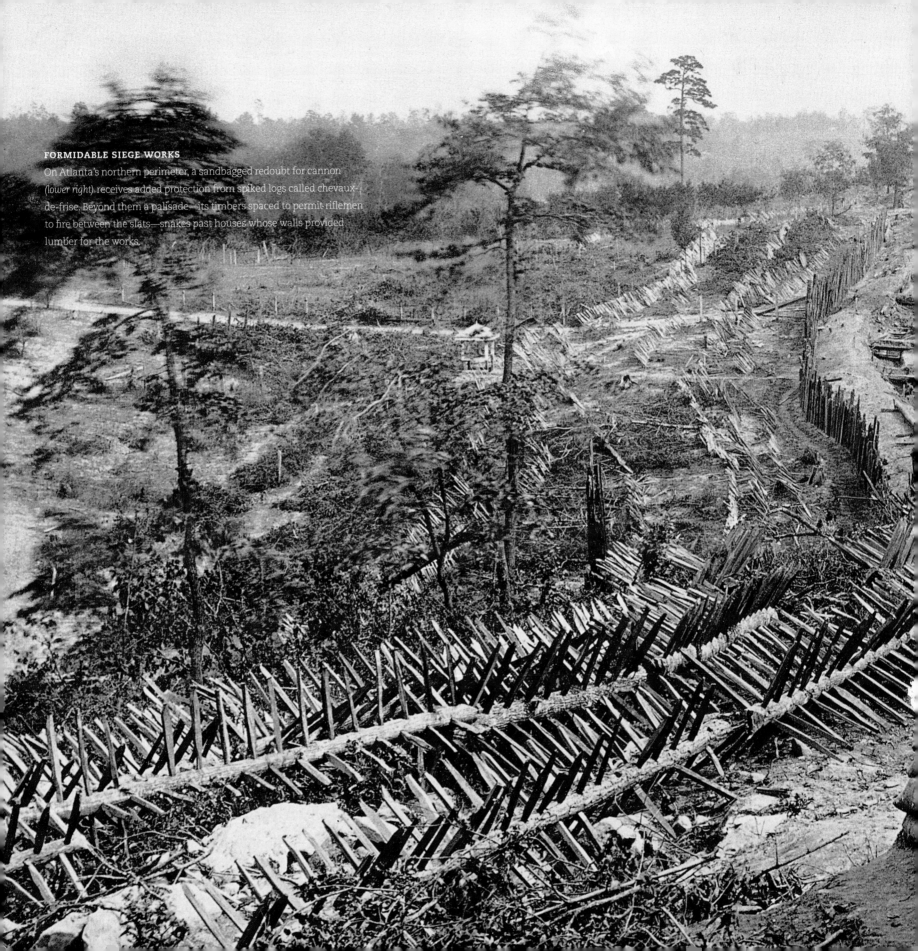

FORMIDABLE SIEGE WORKS
On Atlanta's northern perimeter, a sandbagged redoubt for cannon
(lower right) receives added protection from spiked logs called chevaux-
de-frise. Beyond them a palisade—its timbers spaced to permit riflemen
to fire between the slats—snakes past houses whose walls provided
lumber for the works.

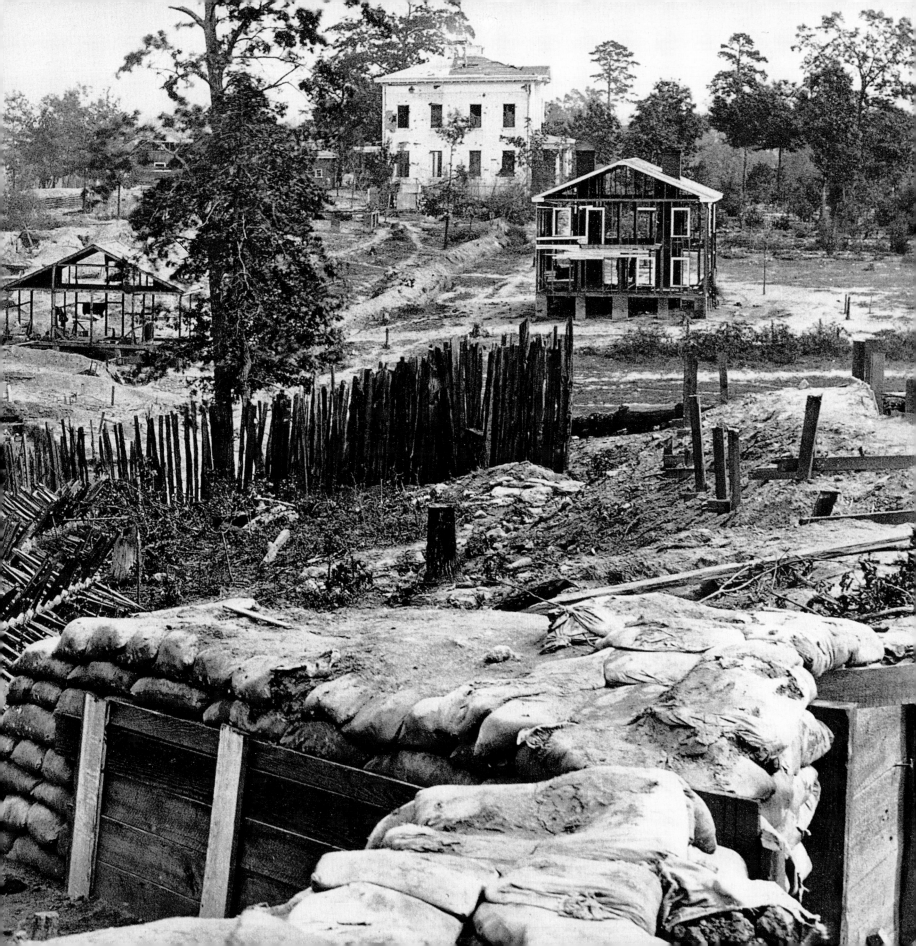

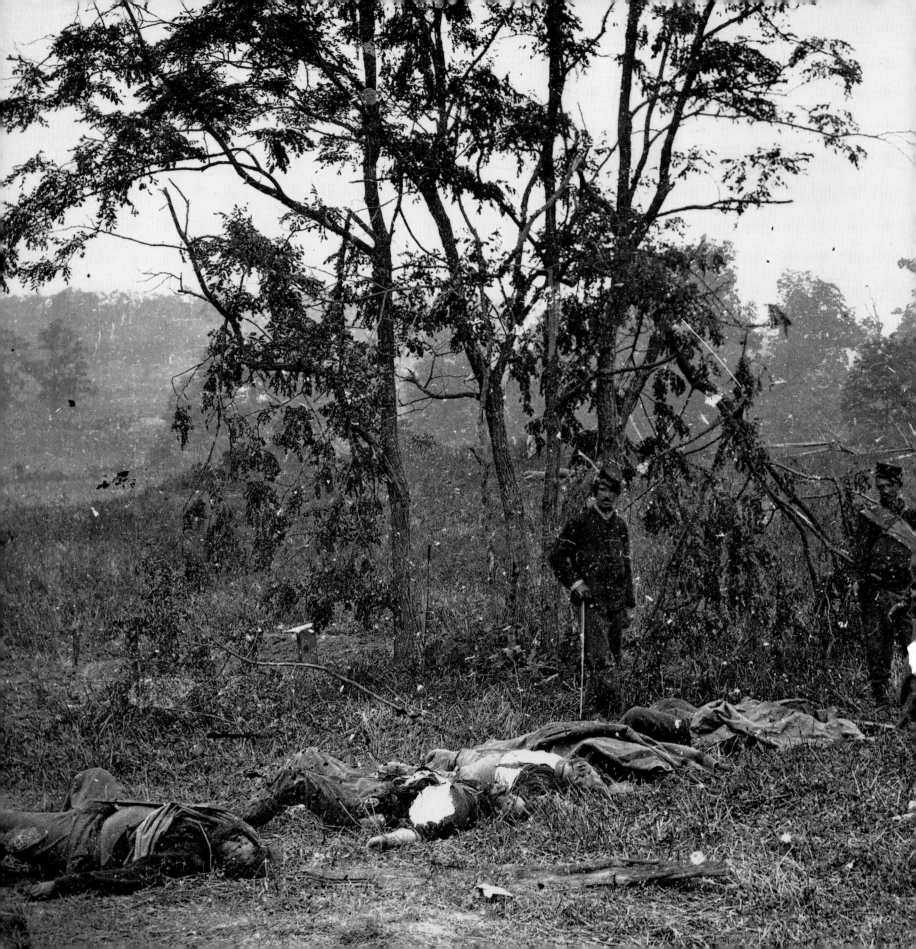

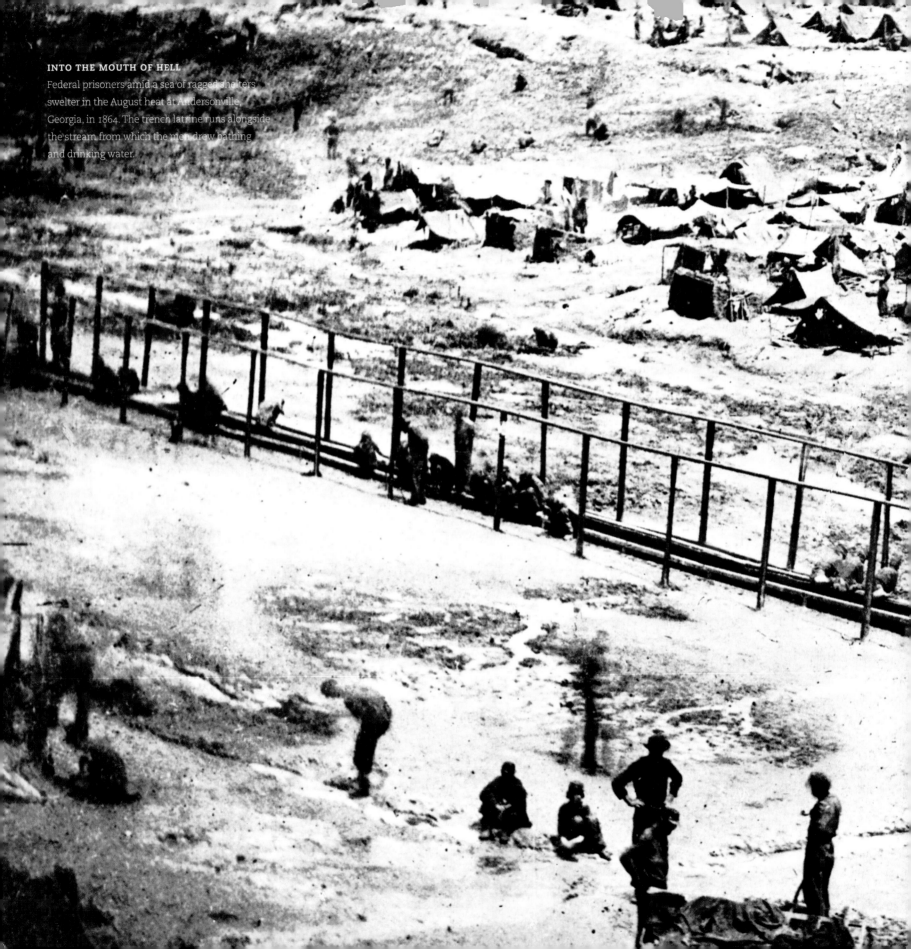

INTO THE MOUTH OF HELL
Federal prisoners amid a sea of ragged shelters
swelter in the August heat at Andersonville,
Georgia, in 1864. The trench latrine runs alongside
the stream from which the men drew bathing
and drinking water.

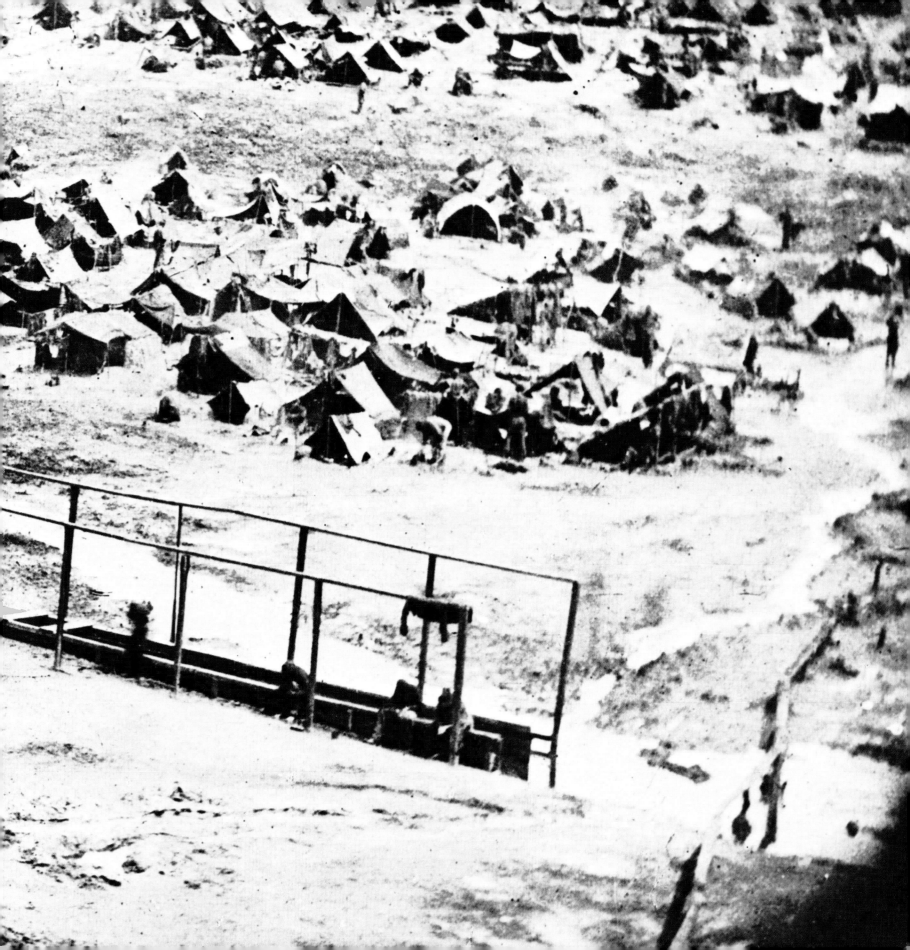

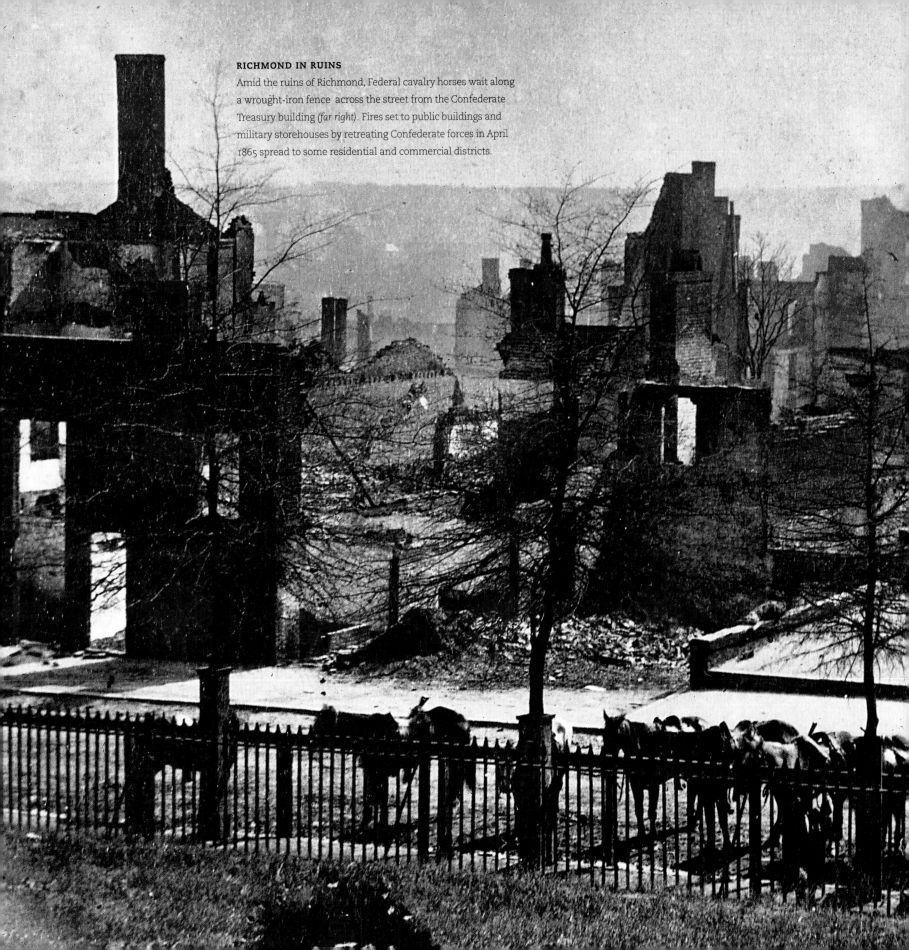

RICHMOND IN RUINS
Amid the ruins of Richmond, Federal cavalry horses wait along a wrought-iron fence across the street from the Confederate Treasury building *(far right)*. Fires set to public buildings and military storehouses by retreating Confederate forces in April 1865 spread to some residential and commercial districts.

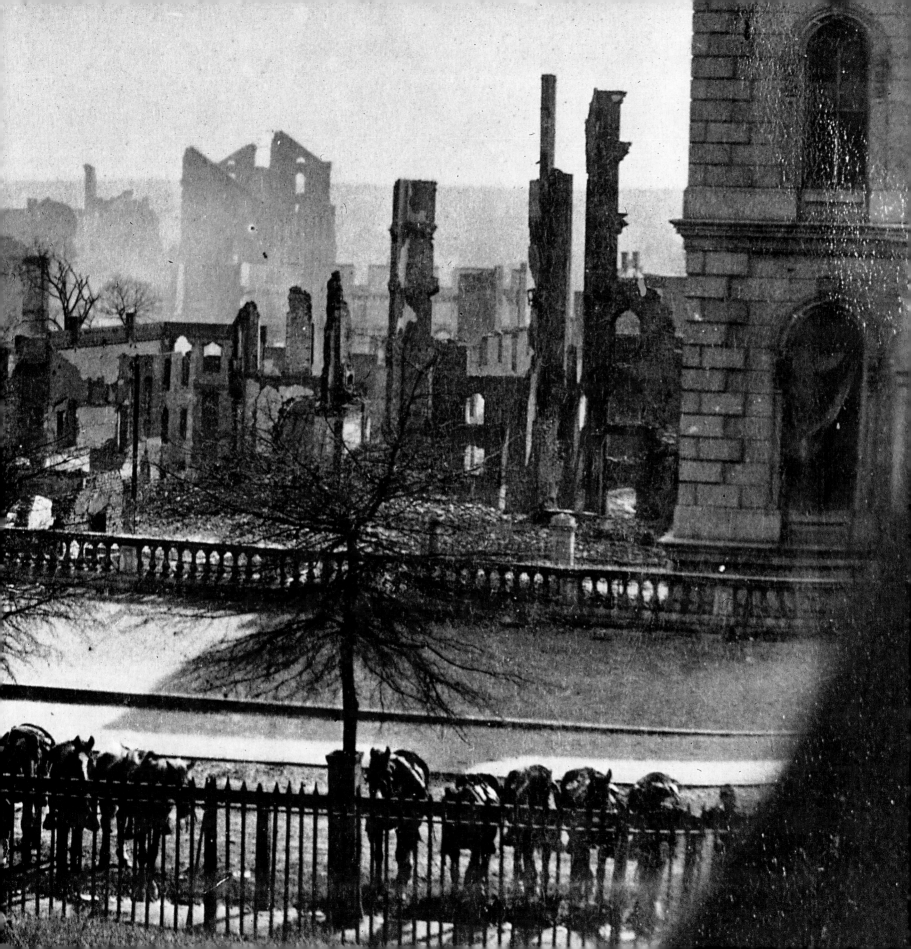

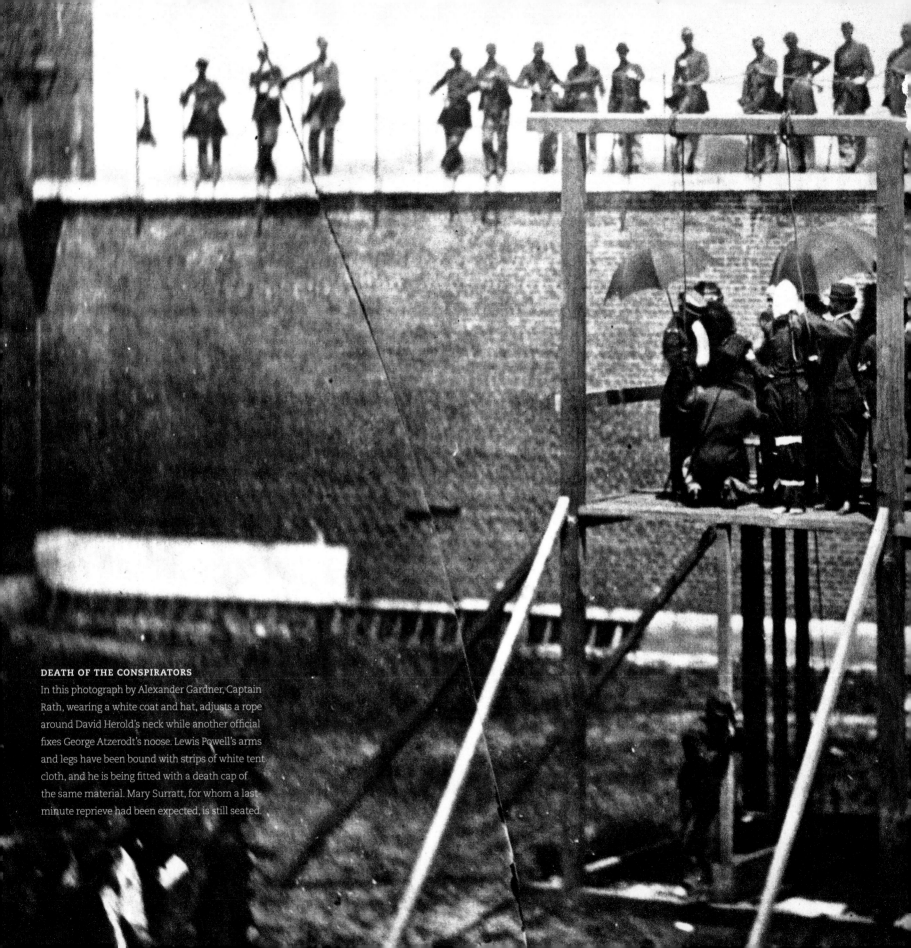

DEATH OF THE CONSPIRATORS

In this photograph by Alexander Gardner, Captain Rath, wearing a white coat and hat, adjusts a rope around David Herold's neck while another official fixes George Atzerodt's noose. Lewis Powell's arms and legs have been bound with strips of white tent cloth, and he is being fitted with a death cap of the same material. Mary Surratt, for whom a last-minute reprieve had been expected, is still seated.

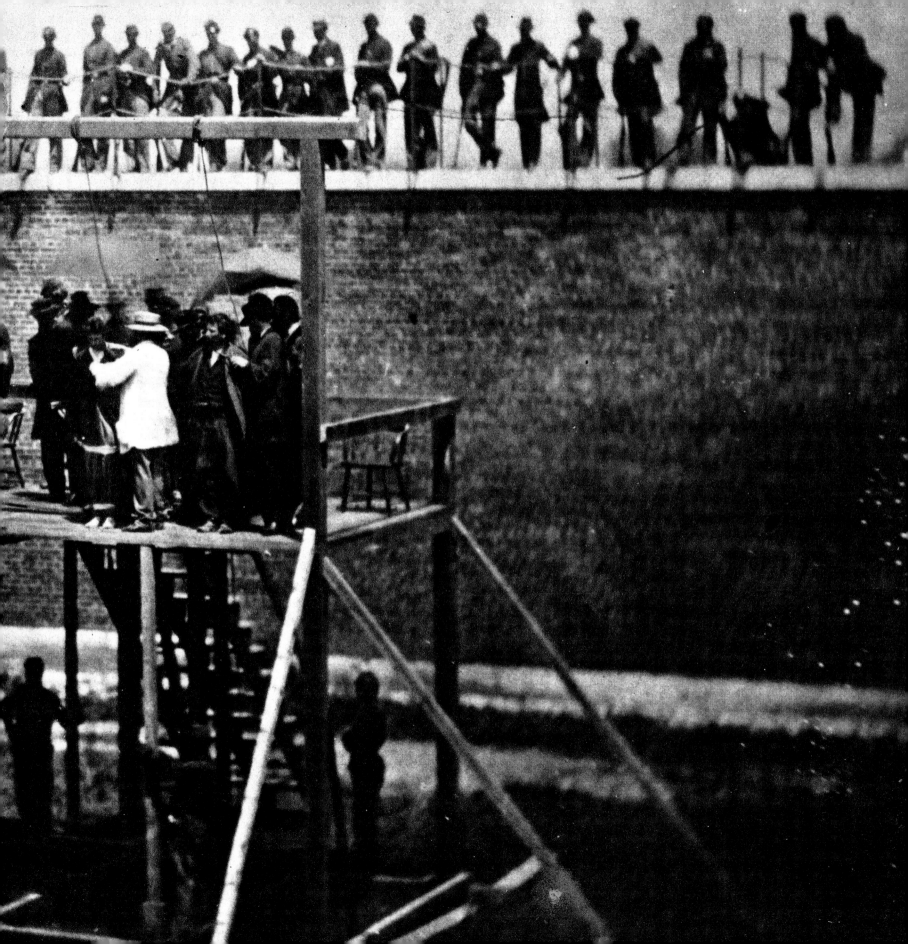

America's First Photojournalists

SHORTLY AFTER 11 O'CLOCK on the morning of May 21, 1864, Massaponax Baptist Church in Virginia's Spotsylvania County briefly became the nerve center of a mighty army. For more than three years, the soldiers of the Federal Union and Southern Confederacy had been locked in a bloody conflict that would determine the future of the Republic, and Massaponax Church itself bore the scars of earlier campaigns. Now the tide of war was again passing by, and the humble brick building was commandeered as headquarters for the senior Federal military leader, General Ulysses S. Grant, and his principal lieutenant, Army of the Potomac commander General George Meade.

On May 4, Grant had embarked on a relentless campaign aimed at the destruction of his Southern foe, General Robert E. Lee's vaunted Army of Northern Virginia. But although Grant was fighting his way ever southward, toward the Confederate capital at Richmond, victory had proven elusive. Savage combat in the tangled thickets of the Wilderness and along the bullet-swept earthworks at Spotsylvania had cost the Union nearly 40,000 men—killed, wounded, or missing. And the end was nowhere in sight.

As supply wagons of the Fifth Army Corps rumbled past, staff officers carried pews into the front yard of the little church for an improvised council of war. Grant sat cross-legged, puffing on a cigar, deep in thought as he pondered his next move. Meade was nearby, poring over a map with some officers, while others enjoyed a brief rest from their tiring exertions, or read the latest newspapers from the North. Curious to see what was transpiring in the churchyard, enlisted men wandered over from the nearby road, standing at a respectful distance from their commanders. But many eyes were directed not at Grant, or Meade, or the other high-ranking officers. They gazed upward, to a second story window of the church, where a 24-year-old photographer named Timothy H. O'Sullivan maneuvered his bulky wooden camera to record the historic scene below.

Photography had been a flourishing presence in American life for more than two decades when in April 1861 long-simmering tensions between the northern and southern states erupted in fratricidal conflict. The earliest permanent photographic image had been made in 1826 by Frenchman Joseph Nicephore Niepce—a murky view of rooftops and chimneys that required an eight-hour exposure time. Three years later Niepce joined forces with Louis Jacques Mandé Daguerre, an enterprising artist and technical innovator who went on to develop the first reliable

VIEW OF MASSAPONAX CHURCH

Timothy O'Sullivan photographed Federal troops gathered in front of Massaponax Baptist Church on the day that the church served as Grant and Meade's temporary headquarters. The men in Zouave jackets and sashes are members of the 114th Pennsylvania, on duty as headquarters guards.

COUNCIL OF WAR

In the first of three photographs O'Sullivan took of the council of war held in the yard of Massaponax Church on May 21, 1864, General Grant sits cross-legged, smoking a cigar, in the pew directly beneath the trees. At his left are Assistant Secretary of War Charles Dana and Brigadier General John Rawlins, Grant's chief of staff. General Meade, wearing a hat with downturned brim, sits at the far end of the pew at left, studying a map.

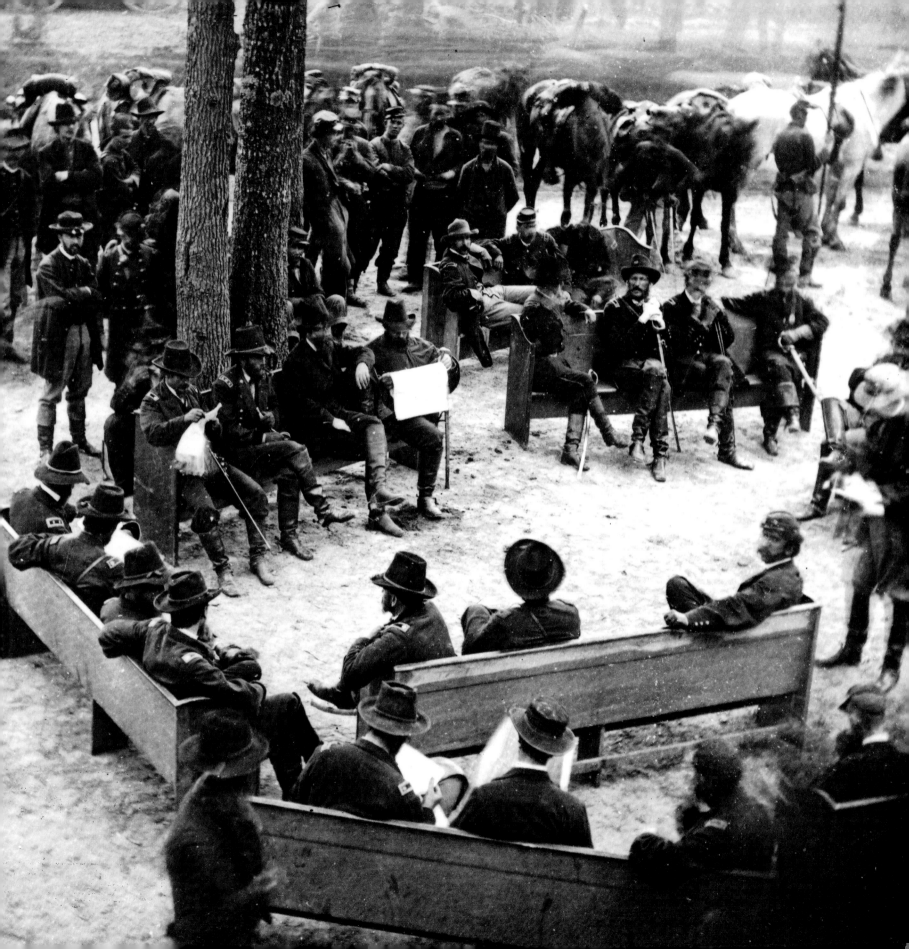

AMBROTYPE OF YOUNG GIRL

A poignant reminder of the human cost of war, this ambrotype of a young girl was found between two bodies—one a Union soldier and the other a Confederate—on the battlefield of Port Republic, Virginia. Her identity has never been determined.

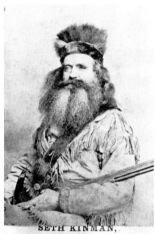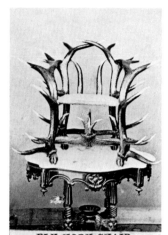

photographic technique. Officially announced in 1839, the daguerreotype process recorded remarkably sharp images on sheets of copper plated with polished silver. By the mid-1840s, with exposures reduced to 30 seconds or less, daguerreotype artists turned their attention primarily to portraiture. Hundreds of daguerreotypists were in business in the United States, among them a young entrepreneur named Mathew B. Brady. Brady's Manhattan studio recorded the images of numerous celebrities, whose portraits were displayed in an elegant gallery that became a focal point for the burgeoning new art form.

Photographic science took a dramatic step forward in 1851 with the discovery of a process that enabled images to be fixed on plates of glass coated with light-sensitized collodion—a syrupy solution of guncotton, alcohol, and ether. The advent of collodion led to the introduction of the ambrotype—a glass plate negative backed with black paper, varnish or metal transforming it into a positive image. In bright sunlight, typically reflected through a series of rooftop skylights in the photographer's studio, ambrotypes required as little as three seconds exposure time. Another variation—the tintype, or ferrotype—recorded images on thin sheets of varnished iron coated with collodion. Like the daguerreotype, which they soon supplanted in popularity, ambrotypes and tintypes were reversed, or mirror images of the subject. Sometimes tinted with color, these one-of-a-kind photographs were usually enclosed in decorative, velvet-lined cases made of leather or gutta-percha (a type of hard rubber).

The wet collodion process inspired another technique, which by the late 1850s had supplanted all others in the public's love affair with the camera. Contact prints could now be made from glass negatives, some as large as 18 by 22 inches, on albumen paper, a printing paper coated with egg whites, salt, and ammonium chloride. Albumen prints were neither reversed nor one of a kind; indeed, a potentially limitless number of prints could be made from a single negative. Their

marketability proved an economic bonanza for photographic galleries, particularly the two-by-four-inch *carte de visite* (calling card) format, which enabled common citizens to augment their family albums with images of royalty, actors, politicians, and military commanders. The trading and collecting of cartes de visite inspired Oliver Wendell Holmes, one of photography's most zealous proponents, to characterize them as "the social currency, the sentimental 'greenbacks' of civilization." Another popular form of albumen printing was the stereograph. Using a double-lensed stereoscopic camera, photographers simultaneously recorded two images of a scene, which when mounted side by side and viewed through a hand-held stereoscope, gave a remarkable illusion of three-dimensional reality.

CARTES DE VISITE

A pair of cartes de visite made at Mathew Brady's Washington studio shows California mountain man Seth Kinman and a unique gift he presented to Abraham Lincoln to demonstrate his state's fealty to the Union. Kinman had become so indignant when Eastern newspapers questioned California's loyalty that he traveled 3,000 miles from San Francisco to give the President a chair made entirely of California elk horns.

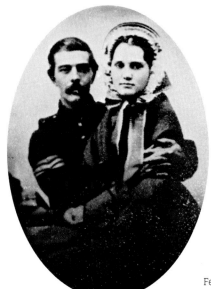

Federal sergeant and wife

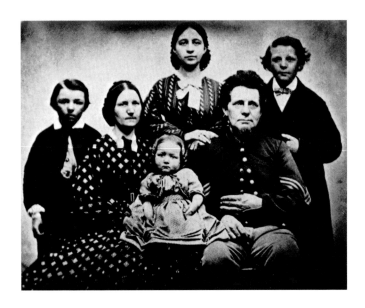

Sergeant Joel S. Stevens, 16th Maine Infantry, and family

With as many as 10,000 American photographers plying their trade at the outbreak of war in April 1861, it became an almost ritual procedure for enthusiastic Union and Confederate volunteers to record their warlike mien for family and friends. Heads clamped firmly in the inevitable supporting rod that prevented movement and blurring during the exposure, they did their best to appear heroic, if sometimes a little stiff and self-consciously postured. "My uniform being made," recalled Confederate lieutenant McHenry Howard, "in the pride of my heart I had my picture taken to be sent home." The mother of Ohio soldier Oscar Ladley wrote her son, "When you go to Washington if you get your Photograph taken I wish you would get a dozen or more if they don't cost too much; the Girls can hardly wait till they get here." For their part, the folks at home often presented their own photographs to fathers, sons, and husbands, who carried those treasured images of loved ones as they marched off to an uncertain future.

Scores of itinerant photographers flocked to the armies in search of business during periods of military inactivity, particularly during the long winter months when the opposing forces passed the time in cramped huts constructed of logs and mud. Setting up shop in canvas tents or wooden shacks, the photographers enjoyed a virtually limitless military clientele. In January of 1862, Union colonel Robert McAllister noted that one cameraman was "making two or three hundred dollars a day" in the camp of the New Jersey Brigade alone. Although most images were made of individual soldiers posed in front of a canvas backdrop,

GENERAL GRANT IN PHOTOGRAPHER'S STUDIO
In this revealing image of the photographic process, General U. S. Grant stands beneath studio skylights, his head held in a clamp intended to prevent movement during the exposure. Despite his unostentatious demeanor, Grant acknowledged his immense popularity in the North by posing for dozens of portraits, many of them made by the leading photographers of the day.

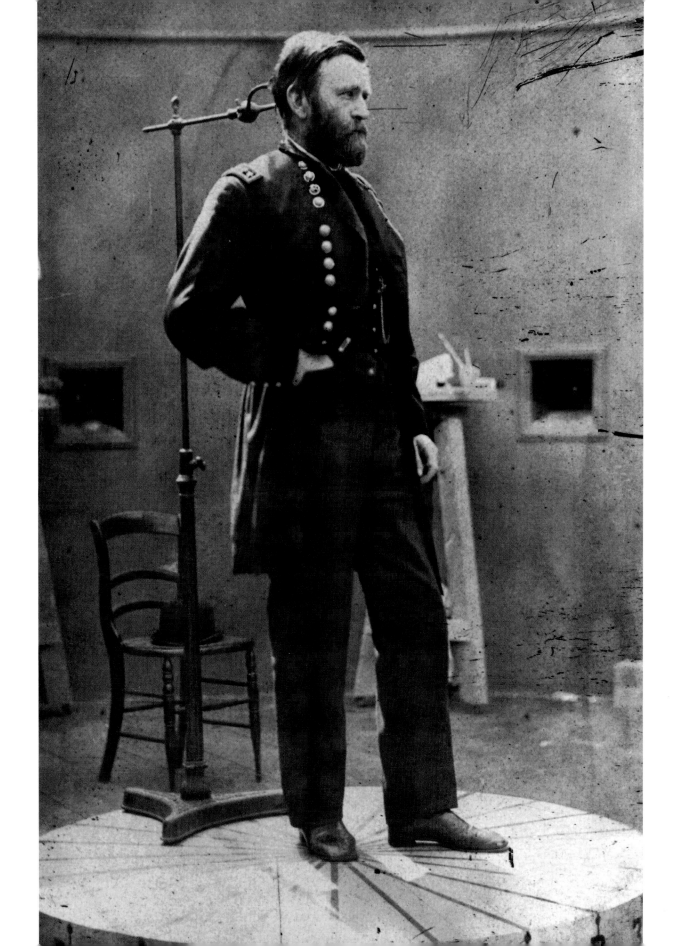

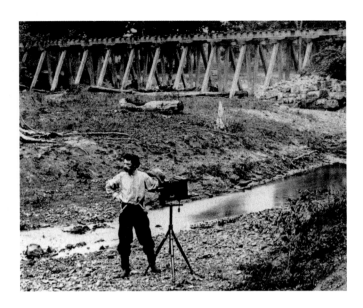

PHOTOGRAPHER IN THE FIELD
Stripped to his shirtsleeves and ready for work, a photographic field operative assesses the potential of a scene near a military railroad trestle.

CIVIL WAR CAMERA
The typical Civil War-era camera consisted of a set of bulky wooden boxes and a lens. The inner box, loaded with an 8-by-10-inch glass negative, slid forward and back to sharpen the image; the knob on the front moved the lens for finer focus.

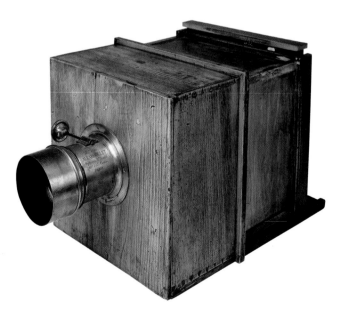

sometimes entire regiments would assemble for the camera. "When we had formed in line a daguerrian artist came on the ground to take our 'mugs,'" Connecticut volunteer Lewis Bissell wrote from his unit's camp near Alexandria, Virginia. "He took us standing in line of battle, in four ranks, in a hollow square and in four ranks at bayonet charge."

While most Civil War photographers were content to pursue their profitable vocation in towns or military encampments, a handful of intrepid cameramen chose to follow the soldiers when they set forth to battle. Along with other masters of the medium, Mathew Brady's talented crew of "field operatives"—Alexander Gardner, Timothy O'Sullivan, George N. Barnard, and James F. Gibson—inspired and financed by their ambitious and visionary employer, set out to record a compelling and highly marketable visual record of men at war. Brady supplied them with cameras, chemicals, and covered wagons that doubled as mobile darkrooms. Though failing eyesight and business obligations at his New York and Washington studios prevented Brady from personally taking few if any photographs, his contacts with senior officers and zeal to document the conflict were vital to the success of his gifted staff. Several of them, including O'Sullivan, went on to work with Alexander Gardner, who opened his own Washington gallery in 1863.

Photographers accompanying the armies on campaign faced a multitude of challenges. Blankets, tentage, and rations had to be obtained in advance, since as civilians they would not be supplied by the military. As the field operatives followed the marching columns along rutted or muddy roads, the jostling of the darkroom wagon posed a constant threat to the volatile chemicals and fragile glass plates that were the mainstay of their profession. Only intermittently able to communicate with their employers in Washington or New York, and generally unaware of the strategic dispositions and movements of the contending forces, the views they chose to photograph were encountered more often by chance than by design. And no matter how powerful or

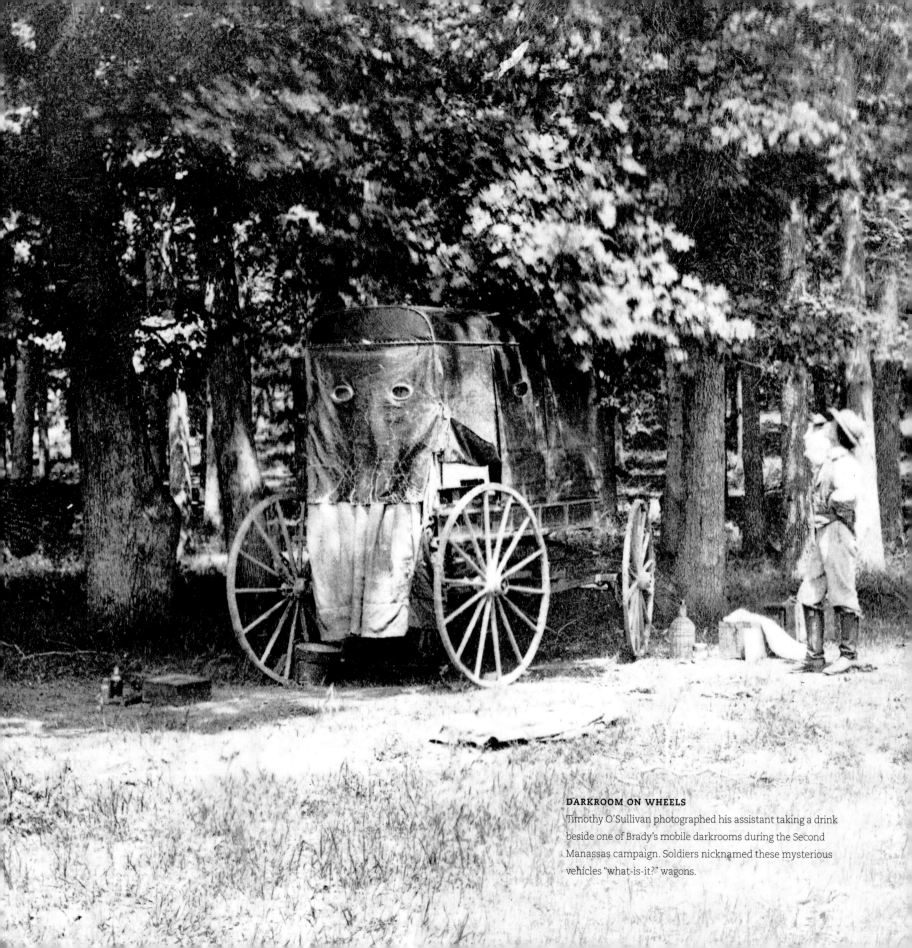

DARKROOM ON WHEELS
Timothy O'Sullivan photographed his assistant taking a drink beside one of Brady's mobile darkrooms during the Second Manassas campaign. Soldiers nicknamed these mysterious vehicles "what-is-it?" wagons.

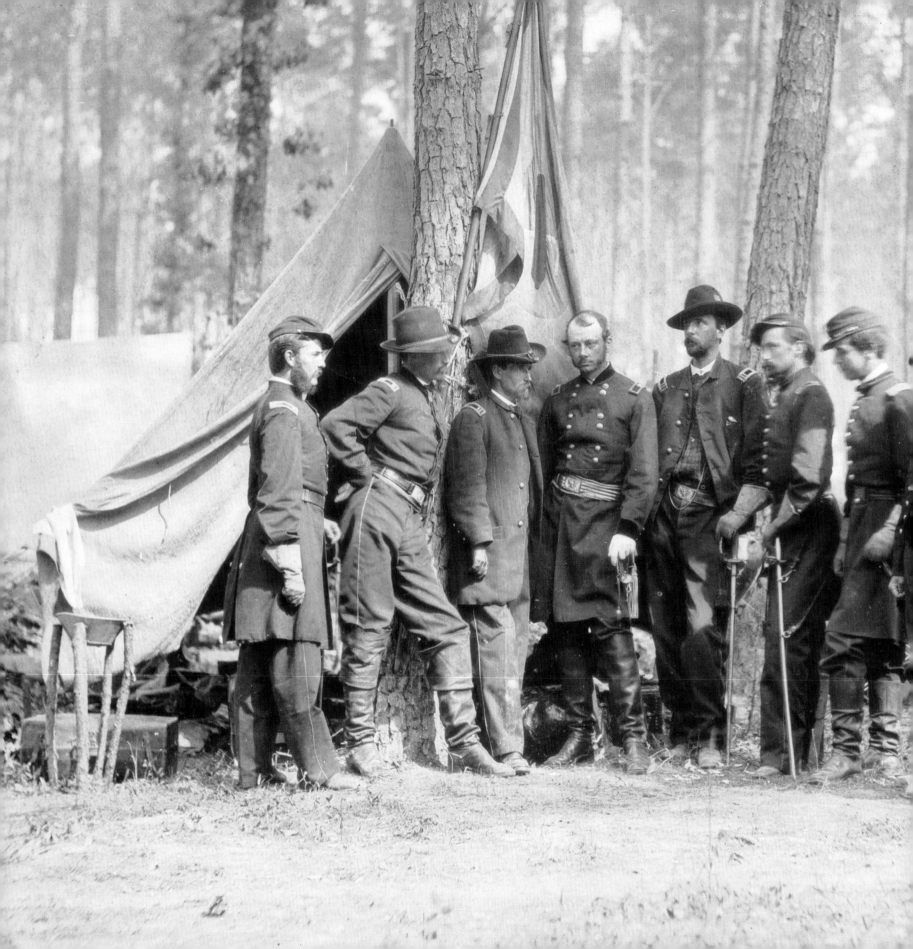

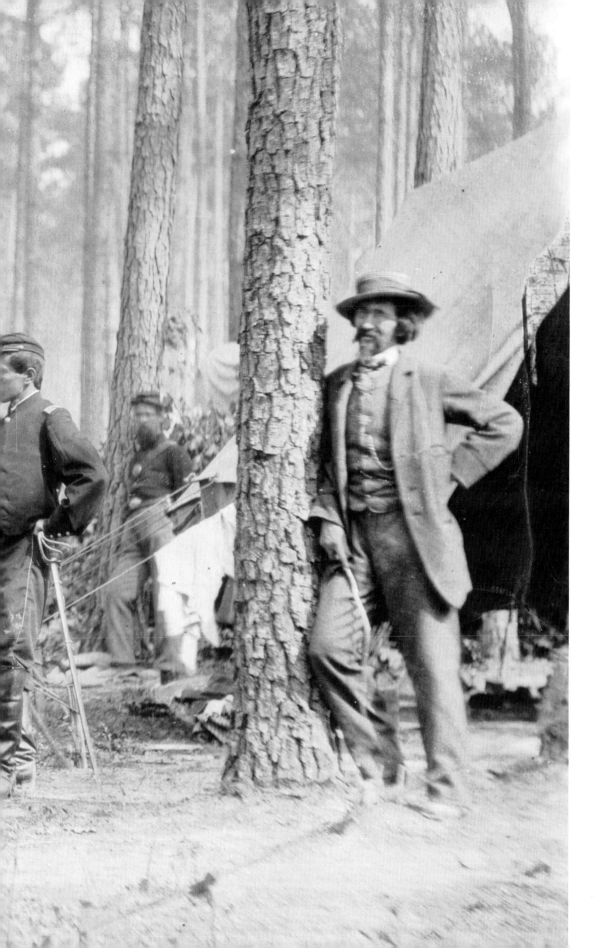

*"The camera is
the eye of History."*

MATHEW B. BRADY

BRADY AT THE FRONT

Mathew Brady leans against the tree at right in a
June 1864 image of Brigadier General Robert B. Potter
and his staff taken during the siege of Petersburg.
Handicapped by failing eyesight, Brady rarely
operated a camera, but his fame as a photographic
entrepreneur and his connections with senior
officers gained his operatives virtually unlimited
access to the Federal armies in the field.

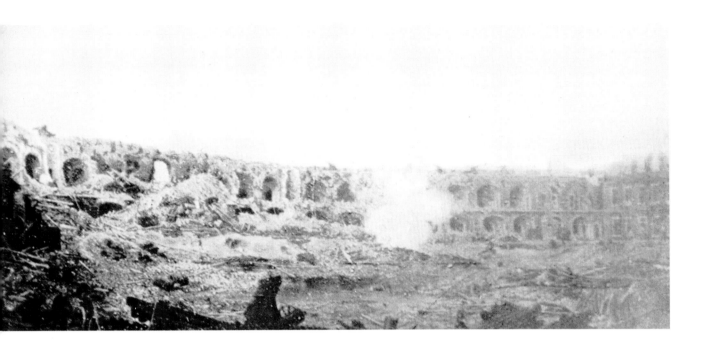

PHOTOGRAPHER UNDER FIRE

Charleston photographer George S. Cook took this picture from inside Fort Sumter on September 8, 1863, just as a shell fired by a Federal iron-clad exploded on the rubble-strewn parade ground. At left, some of the defenders can be seen sitting and standing amid the ruins.

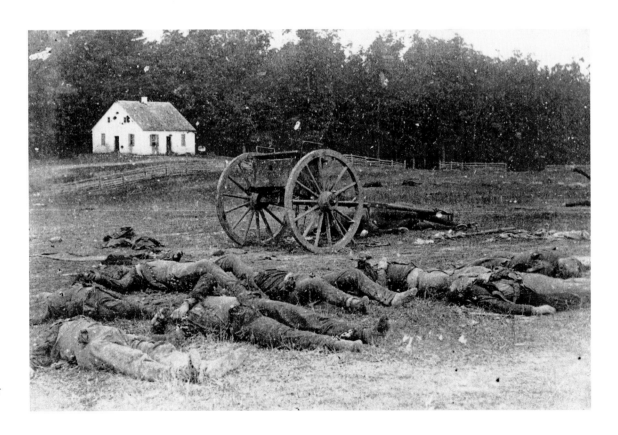

ANTIETAM DEAD

In one of a series of images made on the battlefield of Antietam in September 1862, Alexander Gardner photographed Confederate dead—most likely from Captain W. W. Parker's Virginia battery—sprawled beside a wrecked artillery limber near the battle-scarred Dunker Church.

dramatic the scene, without sufficient sunlight it was impossible to record an image.

The technical difficulties involved in creating a wet-plate photograph, daunting enough in a studio, were more difficult to surmount in the field. But the complex process was essentially the same. In the portable darkroom, the photographer or one of his assistants poured collodion over a clean glass plate, being careful to evenly coat the entire negative. Once the coating attained a tacky consistency, the plate was bathed in a solution containing silver nitrate, which made it light sensitive. The plate was then enclosed in a light-proof holder, taken from the darkroom and inserted in the camera. Removing the lens cap, the

"Mr. Brady has done something to bring home to us the terrible earnestness of war."

New York Times, October 20, 1862

photographer exposed the image for some 3 to 10 seconds, depending on the available light. The plate was then returned to the darkroom, where it was alternately treated with solutions of iron sulfate and potassium cyanide, rinsed in water, and then dried over a low flame. At no time prior to the final developing and fixing of the image could the negative be allowed to dry out. The entire process took from 10 to 15 minutes, and even if the results were successful, it was still necessary to safely transport the glass negative to a studio, where contact prints were made on albumen paper.

Given the logistical challenges and technical limitations of the medium—long exposure times in particular—it was extremely difficult for even the most skilled photographic operator to successfully record movement.

Some, like O'Sullivan, Gibson, and U.S. Military Railroad photographer captain Andrew J. Russell, occasionally managed to capture events in progress—candid, unposed, and remarkably akin to the newsreel footage of a later era. O'Sullivan's views of the council of war at Massaponax Church are a striking example. Although it proved impossible to document the fluid chaos of combat, several of Russell's images reveal the distant smoke of musketry, and in April 1863 Confederate photographer George S. Cook achieved the unique accomplishment of photographing the explosion of an artillery shell on the battered ramparts of Fort Sumter.

Perhaps the most powerful of the many thousands of images recorded during the Civil War are those of the human wreckage left in the wake of battle. For the first time in American history, photographers sought out and preserved the gruesome reality that stood in such horrifying contrast to the colorful trappings of 19th century armies. And their shocking vision of the corpse-strewn battlefields of Antietam, Gettysburg, and Petersburg were displayed in the picture galleries of Manhattan and Washington.

"Let him who wishes to know what war is look at this series of illustrations," Oliver Wendell Holmes wrote of Alexander Gardner's Antietam views. "The sight of these pictures is a commentary on civilization such as the savage might well triumph to show its missionaries." One New York reporter observed, "We recognized the battlefield as a reality, but a remote one, like a funeral next door. Mr. Brady has done something to bring home to us the terrible earnestness of war. If he has not brought bodies and laid them in our dooryards and along streets, he has done something very like it."

The enterprise, skill, and devotion of those visual chroniclers whose work appears in this volume was a watershed in the history of photography, and a turning point in humankind's perception of war.

The Two Americas

"NO POWER ON EARTH DARES TO MAKE WAR ON COTTON. COTTON IS KING," thundered one southern senator shortly before the Civil War. Indeed, during the 1850s, more and more land in the Deep South was planted in cotton to meet the increasing demands of British and New England textile mills and more and more slaves were put to work, cultivating those fields. By 1860, the South produced seven-eighths of the world's cotton.

At the same time the northern states were undergoing their own revolution, reaping the benefits of increasing industrialization, as evidenced by the clattering and roaring phalanxes of new machines in northern mills. The northern states contained four-fifths of America's factories and two-thirds of the nation's railroad mileage.

Despite economic growth and a seemingly stable union, political tensions intensified over the question of slavery. Born into bondage, a slave could expect little more than a lifetime of unremitting labor. Slaves enjoyed no civil rights and were coerced into obedience by the threat of brutal beatings. In the North a determined abolition movement kept the question of slavery before the public with constant political agitation. In 1859, amid increasing tension between North and South, Kansas radical John Brown lead a bold but unsuccessful raid on the Federal arsenal at Harpers Ferry, Virginia, hoping to trigger a massive slave rebellion. After a Virginia court had sentenced him to death for treason, Brown proclaimed, "The crimes of this guilty land will never be purged away but with blood."

The election of Republican candidate Abraham Lincoln in 1860 served as the final catalyst for the secession of the southern states and the formation of the Confederacy. On April 12, 1861, South Carolina gunners opened fire on Fort Sumter in Charleston Harbor after the Federal garrison had refused to evacuate. After 33 hours and 4,000 rounds, the Federals surrendered—the Civil War had officially begun.

STARK EVIDENCE OF A BRUTAL SYSTEM

The gruesome network of scars that crisscross this former slave's back bear witness to a series of severe beatings. The man escaped from his owners during the war and fought as a soldier in the Union Army.

THE NORTH'S MAIN STREET

Horse-drawn wagons and carriages stream up and down Broadway, a bustling commercial artery four miles long flanked by buildings up to six stories tall.

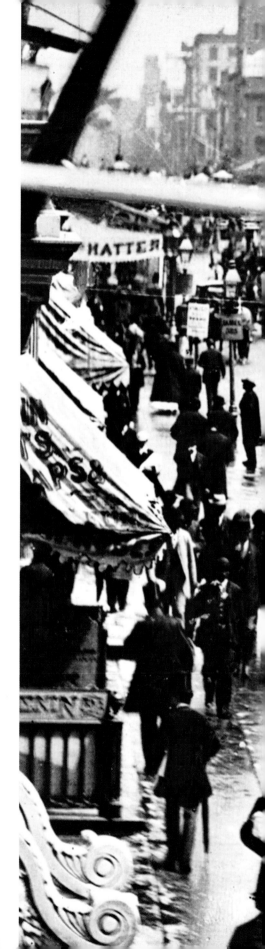

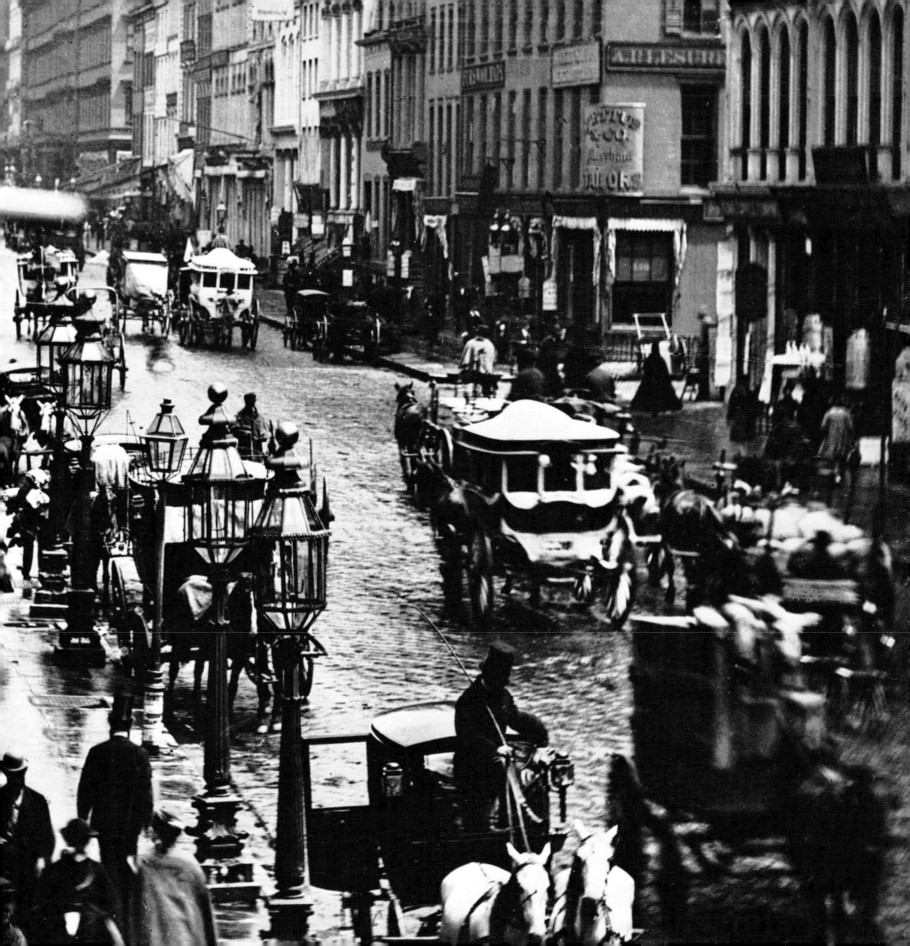

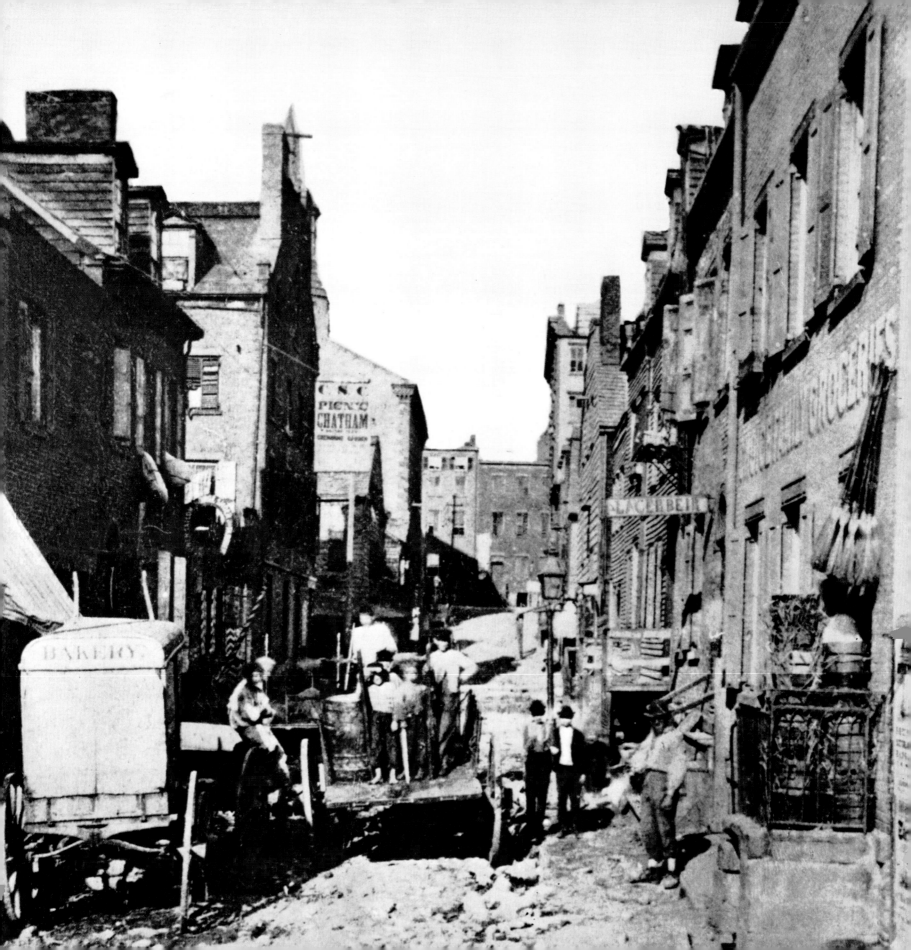

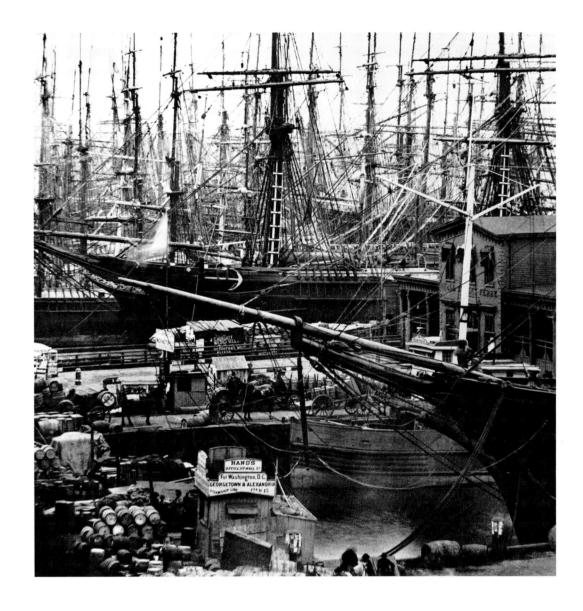

THE DARK SIDE OF NORTHERN PROSPERITY

Ragged children pose for a photograph in a lane that served as both roadway and sewer in the New York tenement neighborhood of Five Points. Contemporary observers claimed that at least one murder occurred there every night.

GATEWAY TO THE WORLD

Merchant ships from around the globe crowd the docks of New York City's waterfront. Cargo in the foreground awaits shipment to Washington.

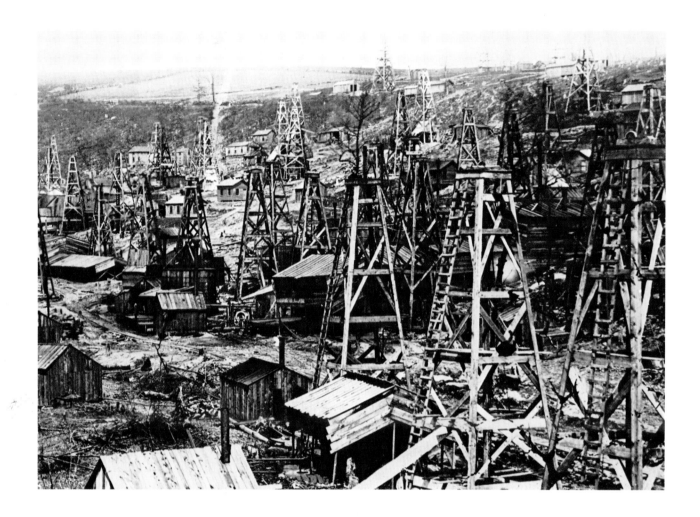

WOODEN SPIRES OF INDUSTRY

Oil derricks stand timber to timber on a field developed near Oil Creek, Pennsylvania, in the mid-1860s. The shacks housed steam engines, boilers, and drilling tools. The farmer who owned the land made $6,000 a day by leasing it to drillers.

RAW MATERIAL FOR NORTHERN FOUNDRIES

Workmen at the Jackson Mine in northern Michigan load iron ore into rail cars. With the opening of the Sault Sainte Marie Canal, which linked Lake Superior with the other Great Lakes, this remote region doubled its ore shipments.

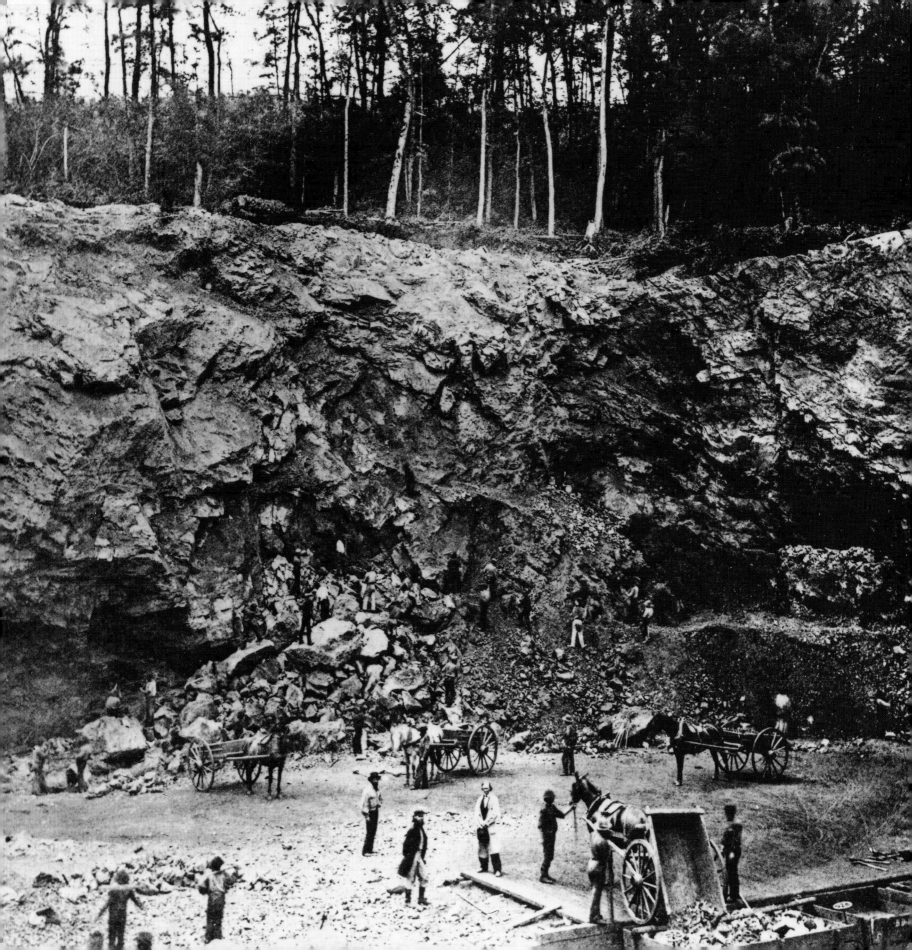

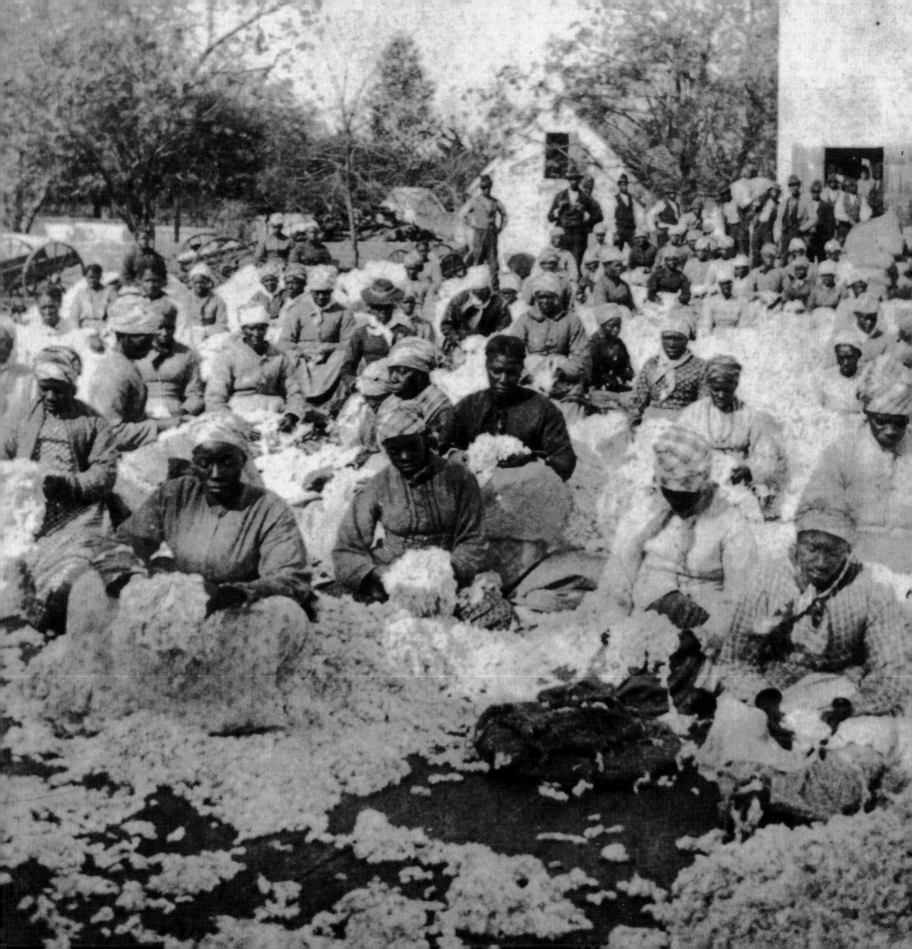

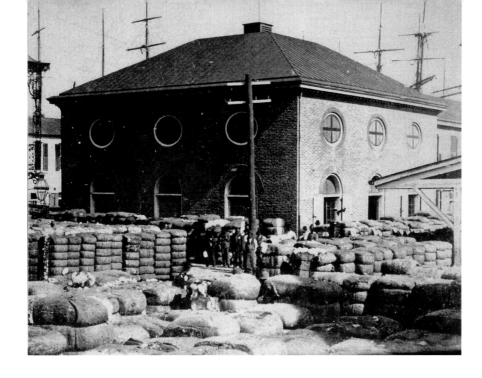

COTTON WAREHOUSE

Bales of cotton cover the docks at Charleston. Acknowledging the wealth that could be gained by planting cotton, one Southerner observed that Southerners were "unquestionably the most prosperous people on earth, realizing ten to twenty percent on their capital with every prospect of doing as well for a long time to come."

A LUCRATIVE TRADE IN HUMAN CHATTEL

From 1858 to 1861, the firm of Price, Birch, and Company—self-proclaimed "Dealers in Slaves"—operated this slave-trading house in Alexandria, Virginia. Captives were held in the large, heavily guarded room—men in one section, women and infants in another, and older children and teenagers in another—while whites wandered through to look the slaves over. Prices ranged from a high of $2,500 to $2,800 for a healthy, strong young man to about $250 for a small child.

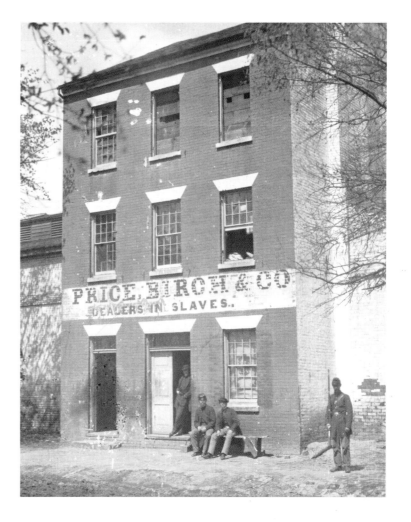

SLAVES PICKING COTTON

Former slaves sort cotton on a plantation occupied by Federal soldiers in the South Carolina coastal islands. Before the war, slaves on the larger plantations lived in communities organized around work gangs under the direction of a hired overseer.

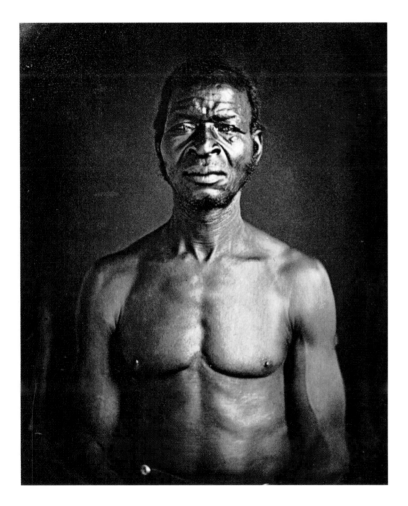

Jack, a slave driver

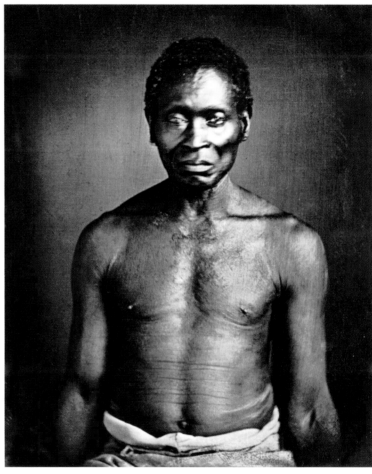

Fassena, a carpenter

TO BE A SLAVE

Four African-born slaves gaze impassively from daguerreotypes taken in South
Carolina in 1850. The pictures, among the earliest known photographs of slaves,
were part of a study on racial characteristics conducted by scientist Louis Agassiz.

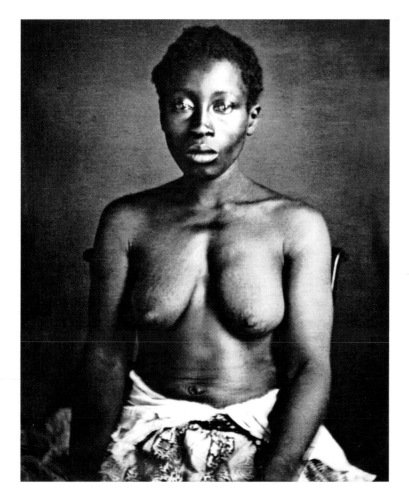

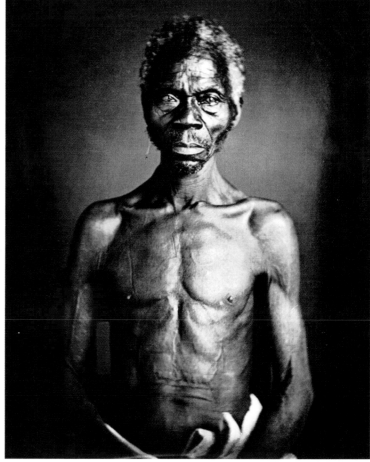

Delia, occupation unknown

Renty, a field slave

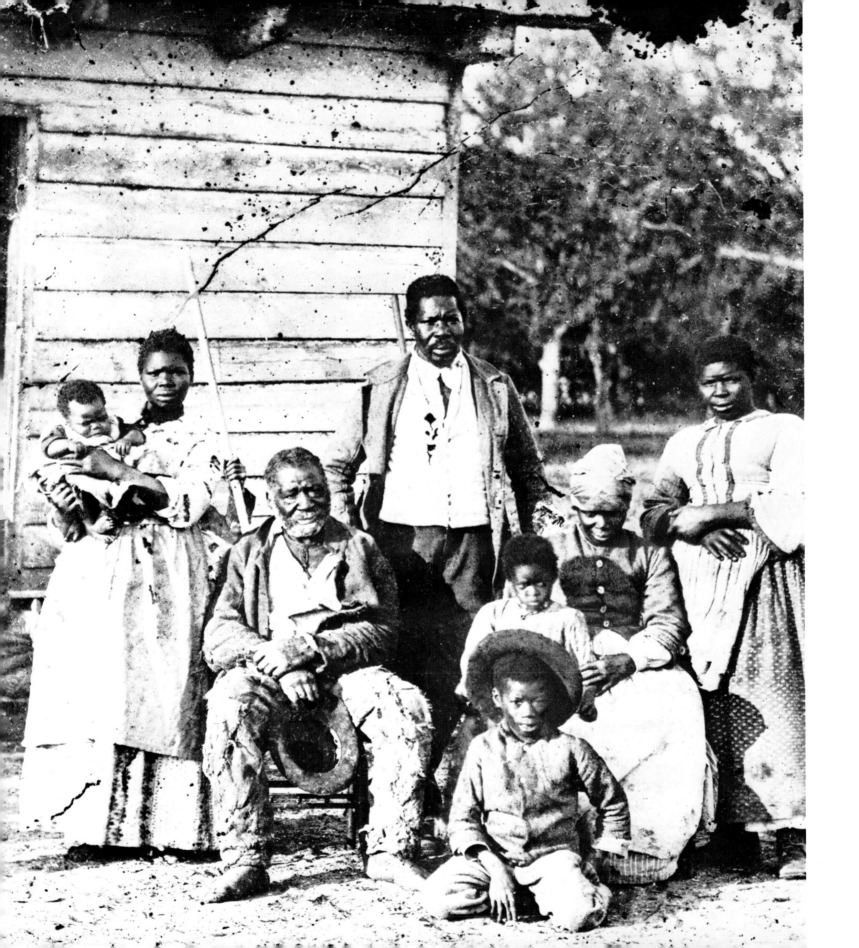

GENERATIONS IN BONDAGE

Five generations of a slave family, all born on the same plantation near Beaufort, South Carolina, assemble for a portrait. They were among 10,000 slaves abandoned by their masters when Federal troops occupied the area in November 1861.

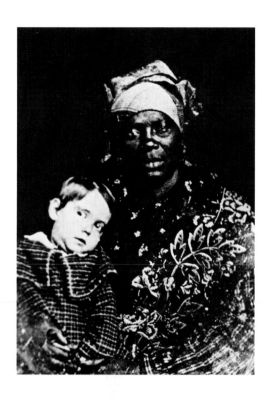

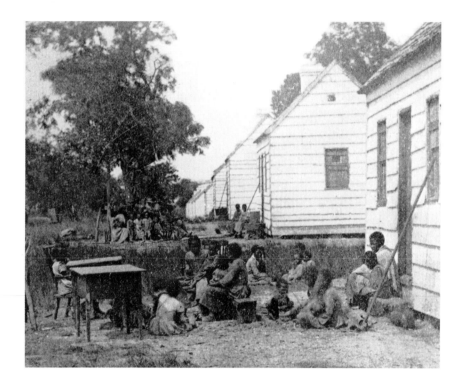

**PERSONAL RELATIONSHIPS
IN A DIVIDED SOCIETY**

In an 1840s daguerreotype from Louisiana, a nurse holds her master's child. Raised by black servants, planters' children became close to their slave "mammy" and might defer to her even as adults.

BEHIND THE BIG HOUSE

Slave children pass time by their cabins on a South Carolina plantation. Many grew up on black folktales such as the Br'er Rabbit stories, in which the weak use cunning to overcome the strong.

LEADERS IN THE
WAR AGAINST SLAVERY

Created by the unification of several
regional abolition societies in 1833,
the American Anti-Slavery Society, led
by William Lloyd Garrison, agitated
for the immediate emancipation of
slaves held in the United States.
Garrison's group of New Englanders,
joined by former southern slaves like
Frederick Douglass and Sojourner
Truth, became a powerful voice in
American politics and was able to
influence the creation of the Liberty
and Free Soil political parties.

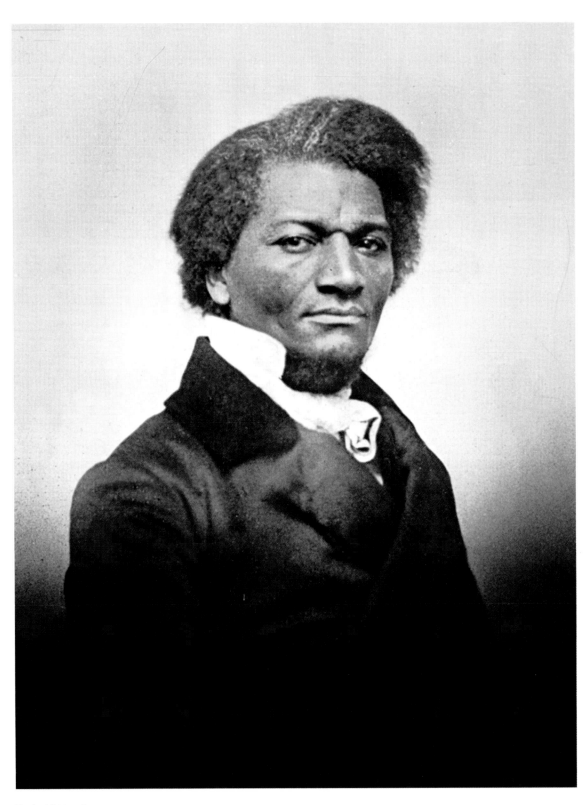

Frederick Douglass

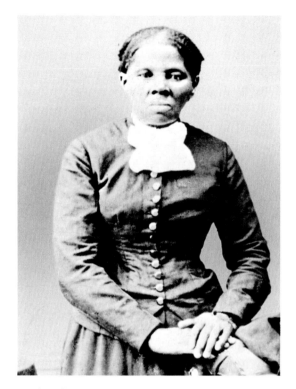

Harriet Tubman

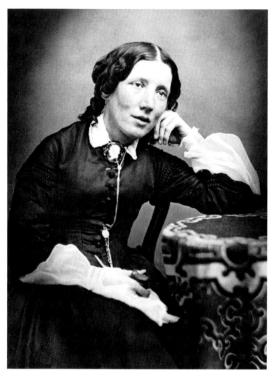

Harriet Beecher Stowe

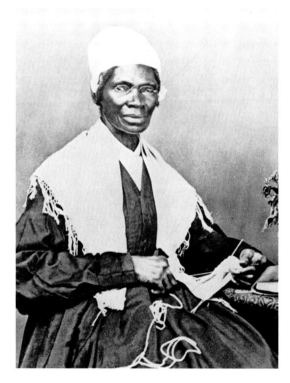

Sojourner Truth

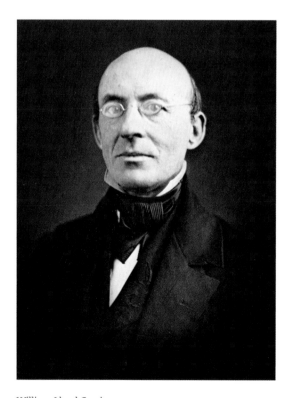

William Lloyd Garrison

RAIDER'S LAST STAND AT HARPERS FERRY

The federal armory at Harpers Ferry contained the guns and ammunition that John Brown and his men needed to arm a slave uprising. Less than 36 hours after the raiders seized the town, however, U.S. Marines commanded by Lieutenant Colonel Robert E. Lee stormed Brown's stronghold in the armory fire-engine house, taking Brown prisoner.

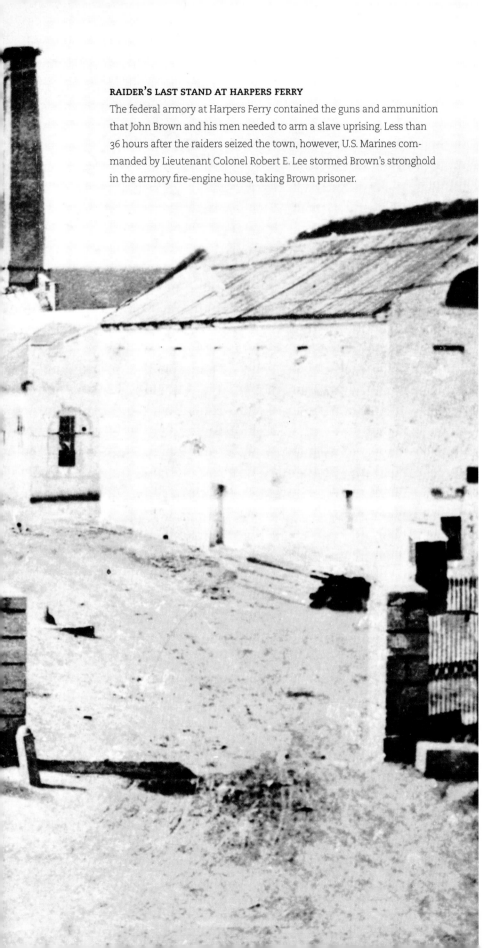

"Let Virginia make him a martyr!... His soul was noble; his work miserable. But a cord and a gibbet would redeem all that, and round up Brown's failure with a heroic success."

HENRY WARD BEECHER

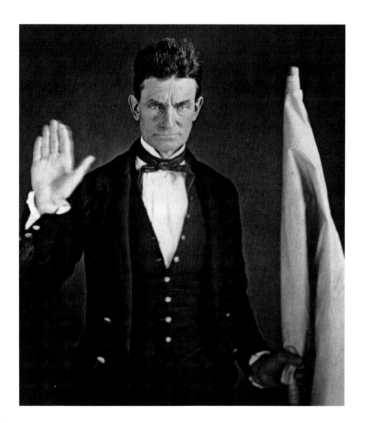

FIREBRAND OF ABOLITION

Youthful and beardless, John Brown pledges allegiance to an unidentified flag—possibly an abolitionist banner. The photograph, the earliest known picture of Brown, was most likely taken in 1846 in Springfield, Massachusetts. At the time, Brown made a living grading wool for New England textile manufacturers. On the side, he aided runaway slaves, attended abolitionist meetings, and formulated grandiose plans for freeing the South's slave population.

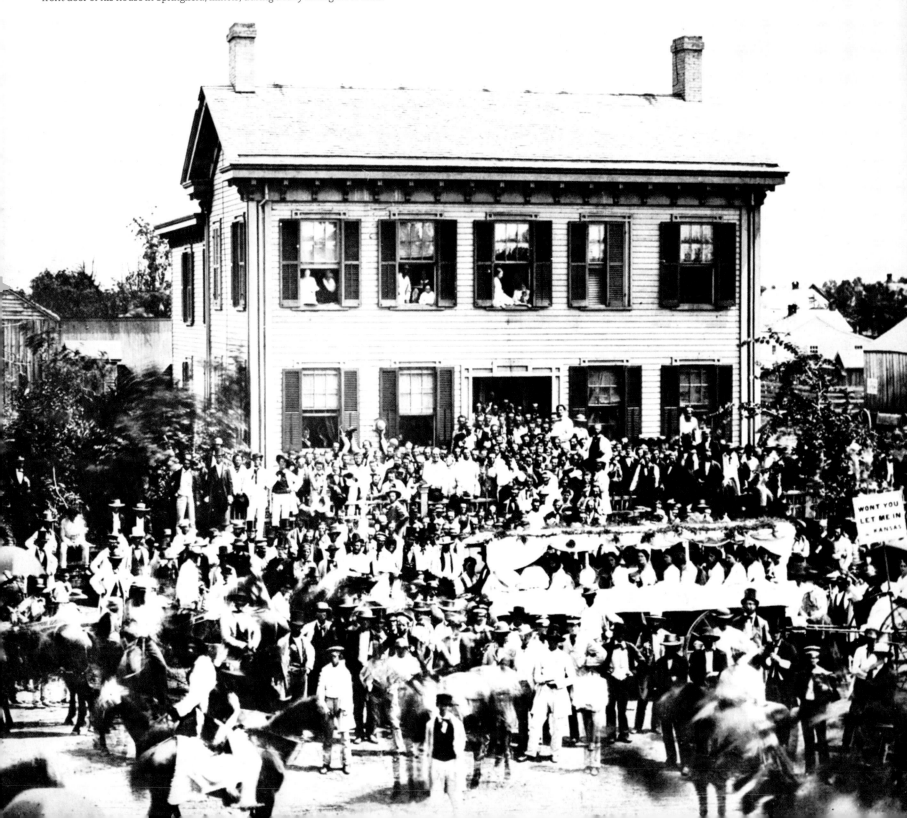

RALLYING FOR THE "RAIL SPLITTER"

Greeting local Republicans, Abraham Lincoln towers above supporters at the front door of his house in Springfield, Illinois, during a rally in August of 1860.

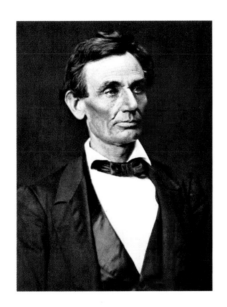

FROZEN IN TIME

Photographers adequately recorded Abraham Lincoln's image, but their cameras couldn't catch his rapidly changing facial expressions. When Lincoln spoke, recalled a *Chicago Tribune* editor, "the dull, listless features dropped like a mask. The whole countenance was wreathed in animation."

PARADING FOR REPUBLICAN VICTORY

A group of Wide Awakes, uniformed Republican Party activists, assembles for a demonstration in Mohawk, New York. Their marching song was "Ain't You Glad You Joined the Republicans?"

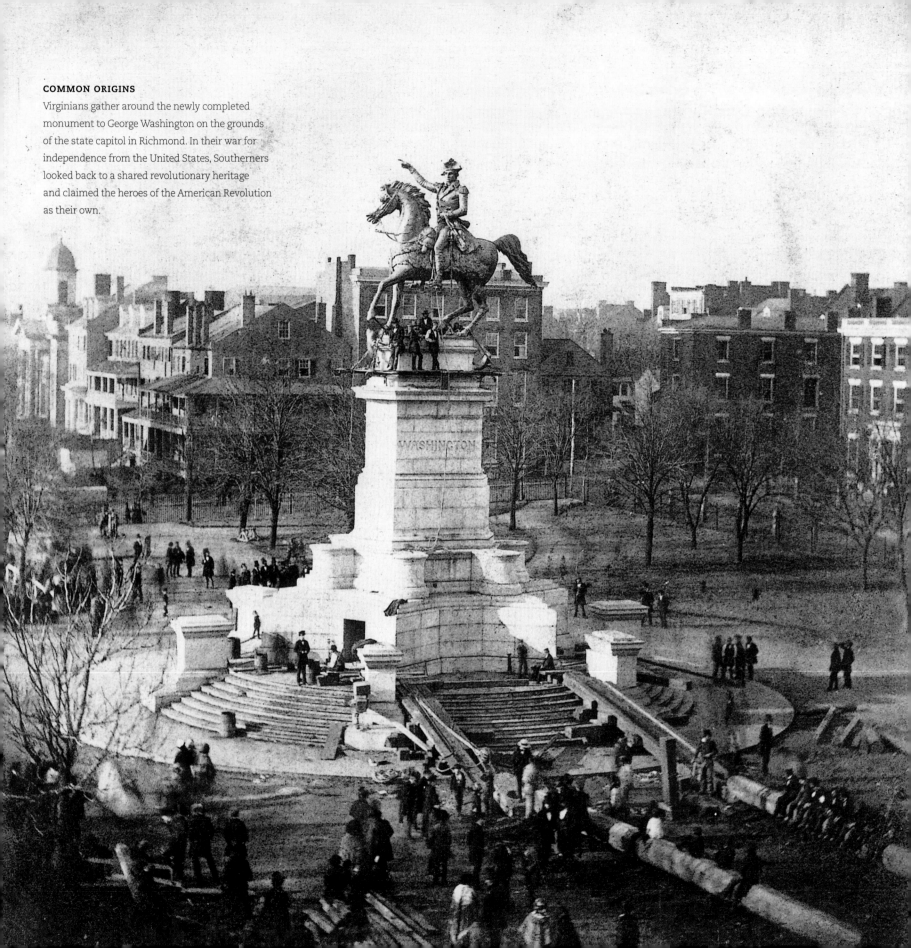

COMMON ORIGINS

Virginians gather around the newly completed monument to George Washington on the grounds of the state capitol in Richmond. In their war for independence from the United States, Southerners looked back to a shared revolutionary heritage and claimed the heroes of the American Revolution as their own.

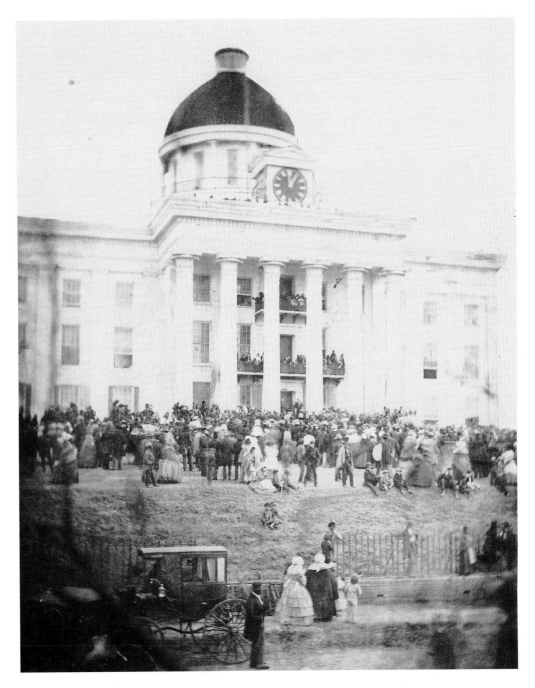

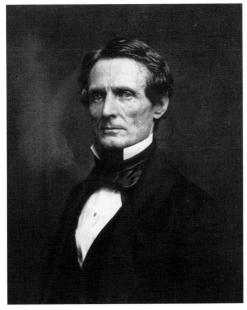

THE FIRST SOUTHERN PRESIDENT

A crowd gathers in front of the Alabama State House in Montgomery to witness the inauguration of Jefferson Davis of Mississippi as the Confederacy's first president. About the ceremony Davis later wrote, "Upon my weary heart were showered smiles, plaudits and flowers, but beyond them I saw troubles and thorns innumerable."

PRESIDENT JEFFERSON DAVIS

The South's new president brought considerable political skill to the Confederate office. Davis had served the United States as a congressman, senator, and secretary of war.

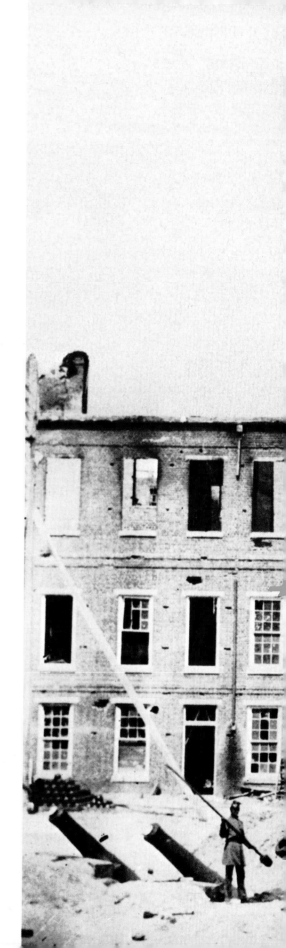

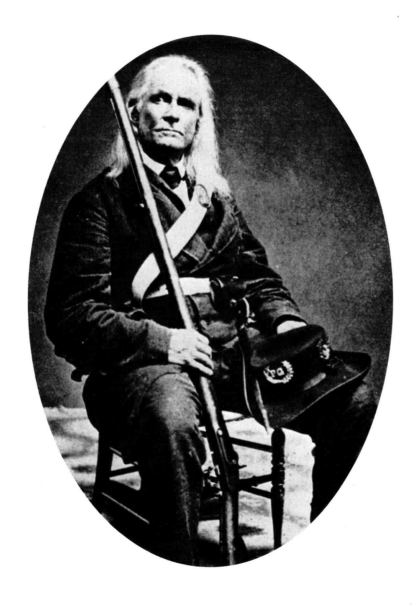

SOUTHERN FIRE-EATER

Edmund Ruffin, the ardent Virginia secessionist who took part in the bombardment of Fort Sumter at the age of 67, sits for a victory photograph as a member of the Palmetto Guard—a South Carolina militia unit—six days after Sumter's surrender. A fervent rebel to the end, Ruffin committed suicide when the Confederacy fell.

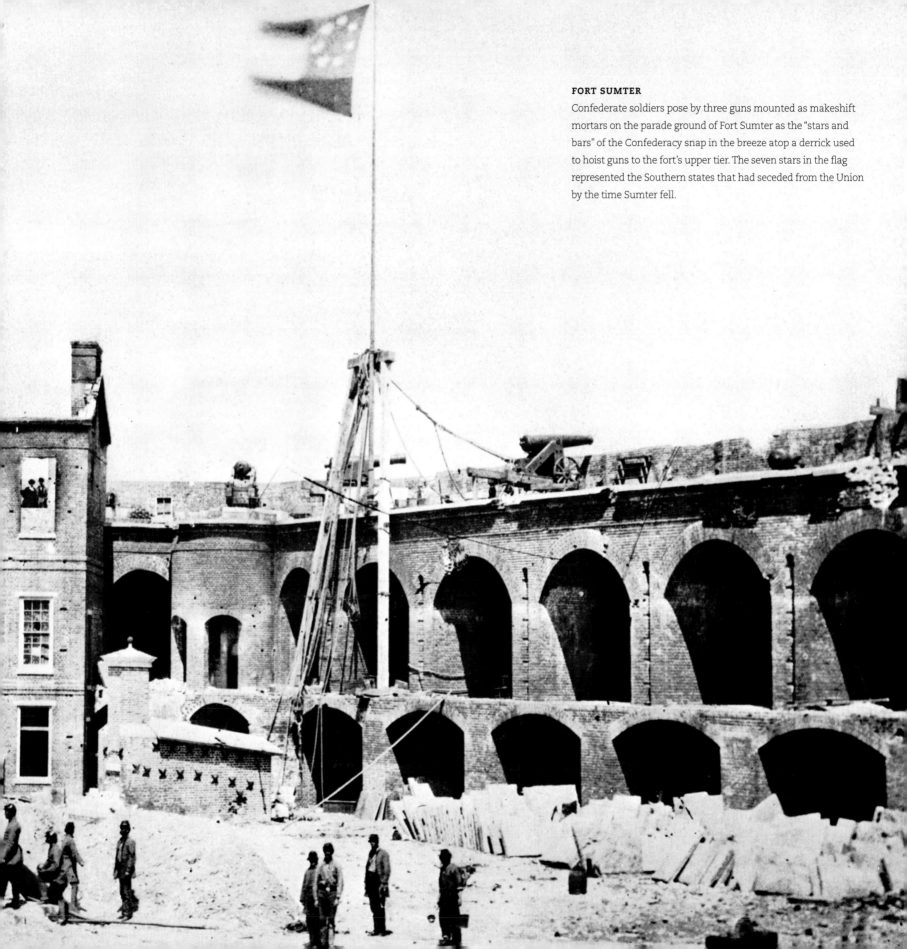

FORT SUMTER
Confederate soldiers pose by three guns mounted as makeshift mortars on the parade ground of Fort Sumter as the "stars and bars" of the Confederacy snap in the breeze atop a derrick used to hoist guns to the fort's upper tier. The seven stars in the flag represented the Southern states that had seceded from the Union by the time Sumter fell.

First Blood

"OH! JOYFUL AND EVER TO BE REMEMBERED DAY," wrote a Richmond, Virginia, girl on April 17, 1861, the day Virginia joined the southern Confederacy. Excited citizens poured into the capitol square to see the new flag of the Confederacy hoisted over the state capitol.

Patriotism was no less in evidence in the North. In Manhattan 100,000 people rallied in support of the Union in what the *New York Times* described as "the largest meeting ever held on the continent." Eager volunteers flocked to join recently organized state regiments—many enlisting for a three-month term in the optimistic assumption of a quick and decisive victory.

The enthusiastic volunteers were instructed in rigidly choreographed, close-order drill and tactics that had changed little since Napoleon's time. With a limited number of trained professional officers, Yankee and Rebel soldiers alike received hasty training in small unit drills under the tutelage of volunteer officers whose military knowledge was limited to what they might glean from drill manuals. Their first real test came in early June, when Lincoln ordered General Irwin McDowell to lead his army into Northern Virginia against the Confederate forces of P. T. G. Beauregard, who held a line behind Bull Run near Manassas Junction.

A day of confused fighting on July 21, 1861, ended with a resounding Confederate victory that sent Federal soldiers streaming off the battlefield in full retreat. Despite their success, the Confederates were too disorganized and exhausted to pursue the beaten Federals and reap the rewards of their victory.

The Southern victory shocked the North—and the world—as the romanticism of the war began to fade. A South Carolinian solider wrote, "For ten long hours it literally rained balls, shells and other missiles of mass destruction . . . the dead, the dying and the wounded, all mixed up together, friend and foe embraced in death . . . Mine eyes are damp with tears."

FIRST BLOOD IN BALTIMORE'S STREETS
Seventeen-year-old private Luther Ladd of the 6th Massachusetts Volunteers was one of the three Massachusetts soldiers killed in a melee with secessionist rioters in Baltimore on April 19, 1861. Fighting erupted when northern troops attempted to march through the city on their way to reinforce Washington.

BELEAGUERED CAPITOL
Top-hatted members of the so-called Frontier Guard, a group of civilian volunteers assigned to protect the president, form ranks on the White House lawn in April 1861. Washington's garrison was so small at the war's outset that several such temporary units were organized to protect the city.

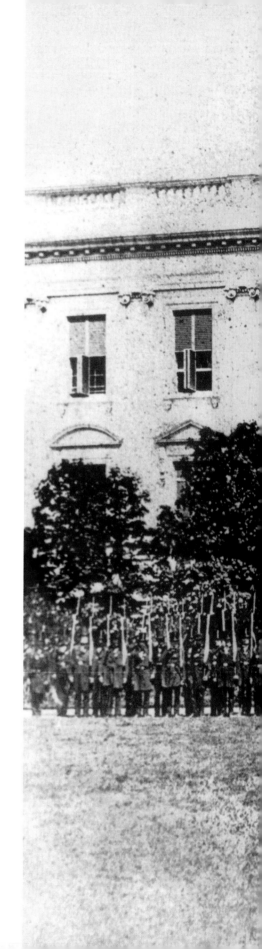

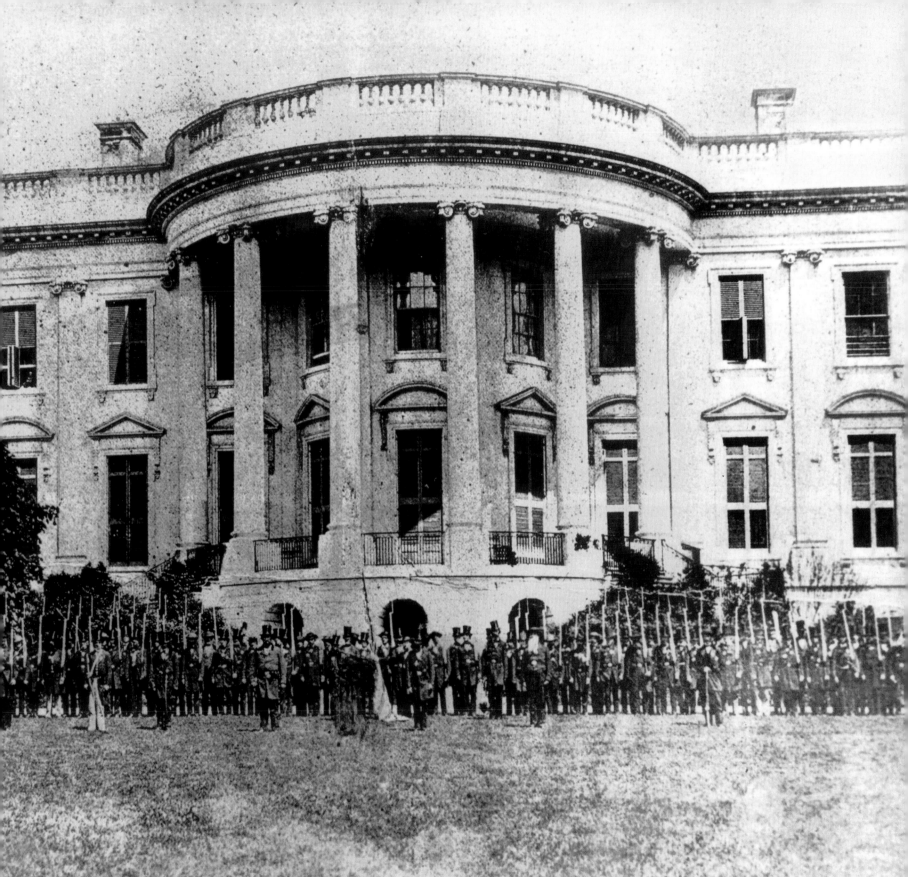

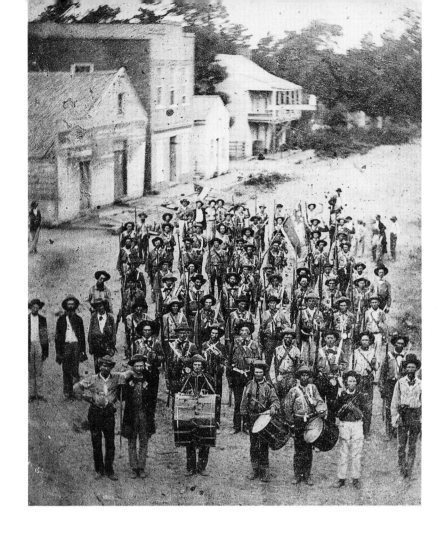

FARMERS IN ARMS

Clad in a mix of civilian attire and hastily manufactured battle shirts, the men of Company H, 3rd Arkansas Infantry, muster in the streets of Arkadelphia in June 1861. Two months later the regiment suffered 110 casualties in the Battle of Wilson's Creek in Missouri—the heaviest Confederate loss in that engagement. Afterward, the survivors were assigned to other southern units.

GUARDING THE GULF COAST

Soldiers of the 9th Mississippi Infantry gather round a campfire near Pensacola, Florida. Their unsoldierly appearance prompted a British journalist to call them "great long-bearded fellows in flannel shirts and slouched hats, uniformless in all save brightly burnished arms and resolute purpose."

VOLUNTEERS FOR DIXIE

Exuberant volunteers of the 1st Virginia Infantry pose for a Richmond photographer in the spring of 1861. A foreign observer noted the confidence of the new recruits: "Every private," he reported, "feels a determination, not only to carry his regiment through the fight, but to see his country through the war."

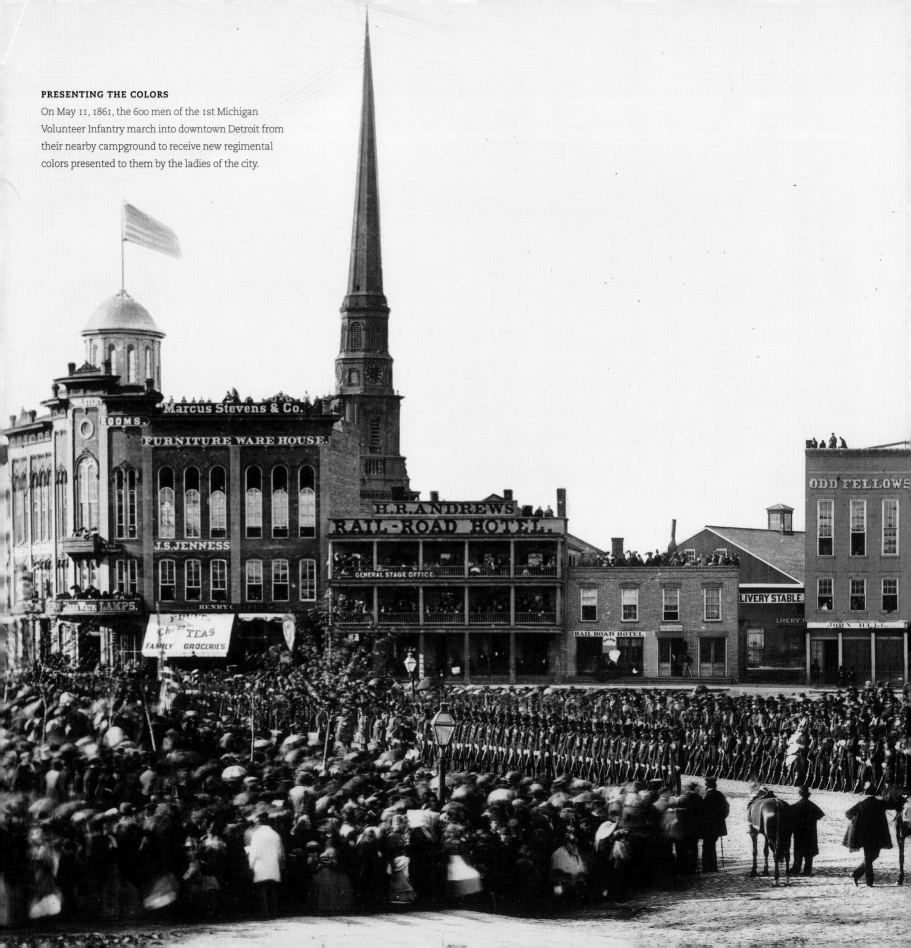

PRESENTING THE COLORS

On May 11, 1861, the 600 men of the 1st Michigan Volunteer Infantry march into downtown Detroit from their nearby campground to receive new regimental colors presented to them by the ladies of the city.

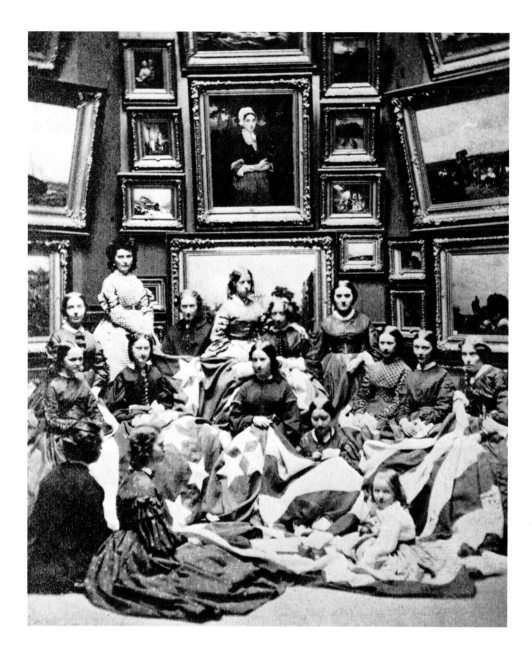

PATRIOTIC SEWING CIRCLES
Students of the Pennsylvania Academy of Fine Arts gather for a portrait with an enormous American flag
that they stitched together in the spring of 1862 as a symbolic contribution to the Federal cause. Measuring
14 by 22 feet, the flag was displayed on the academy grounds.

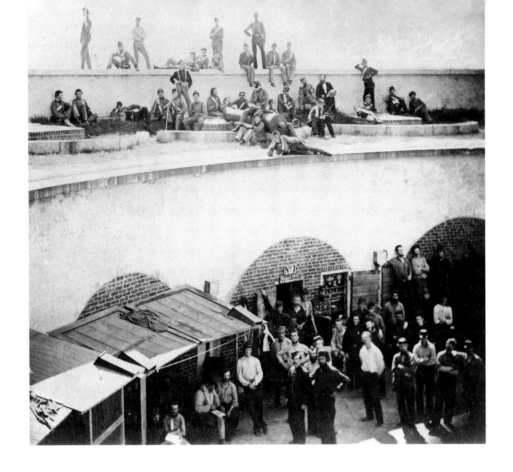

HARD-CASE YANKEES IN A SOUTHERN PRISON

Union soldiers captured at Bull Run mark time in the casements of Castle Pinckney in Charleston Harbor while their youthful guards sprawl on the parapet above. The prisoners, 156 members of New York and Michigan regiments, had been dispatched to the island fortress after proving themselves too troublesome to be held in a Richmond prison.

SCOUTS AT SUDLEY CHURCH

A group of local children curiously observe a party of Federal cavalrymen at Sudley Ford on Bull Run in the spring of 1862. A year earlier, the ford was a critical crossing point for Federal troops during the battle of First Manassas.

LONELY GRAVES

Planks in a swampy area of the Bull Run battlefield mark the graves of Union soldiers killed there in July 1861. This photograph was taken eight months later, after Confederate forces had abandoned the Bull Run line. When Union troops reoccupied the area they found that most of their fallen comrades had been hastily interred in shallow graves.

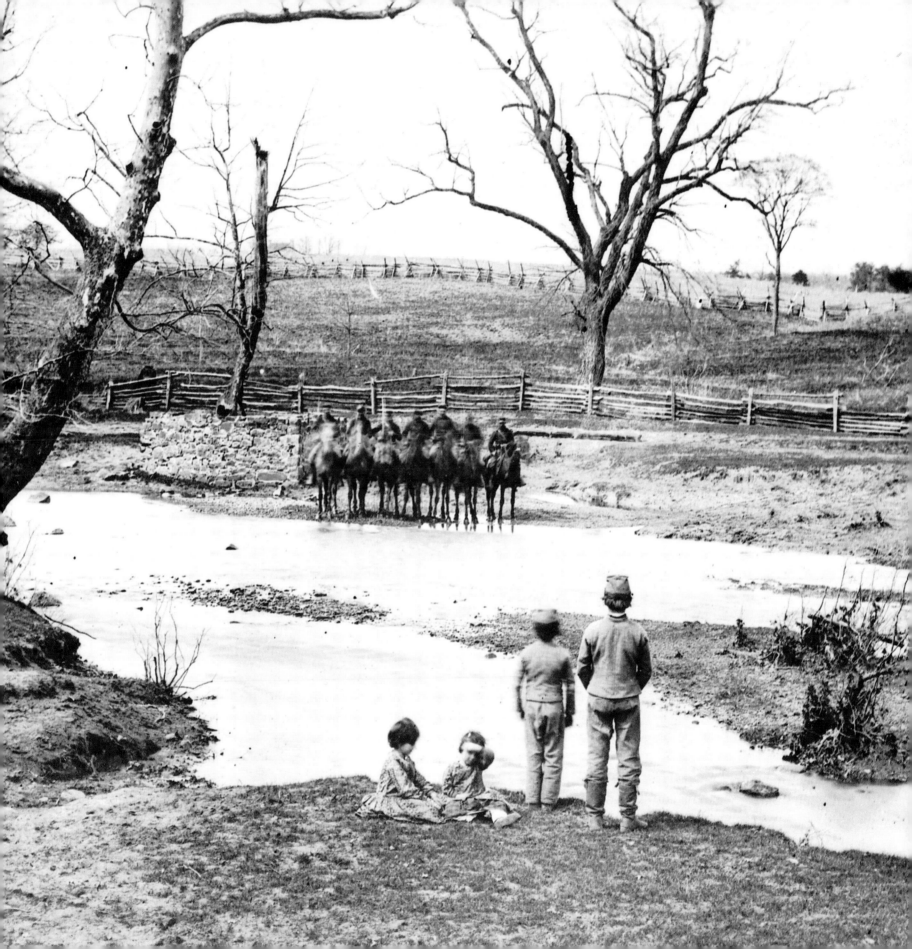

The Blockade

RUNNING A CARGO PAST THE SHIPS BLOCKADING A SOUTHERN PORT called for iron nerve and a fast vessel. "Instantly out of the gloom emerges the somber phantom form of the blockading fleet," recalled a Confederate blockade-runner. "The moment of trial is at hand; firmness and decision are essential for the emergency. Dashing between the two at anchor, we pass so near as to excite astonishment at our nondiscovery." By eluding the Federals, blockade-runners carried their valuable cargoes of cotton to neutral ports in the Caribbean and Europe, returning with war materiel and hard-to-find luxury goods. This evasive commerce challenged the Union blockade proclaimed by President Lincoln on April 19, 1861, subjecting all vessels entering or leaving southern ports to seizure by the U.S. Navy.

As the war progressed, however, control of the waterways would require superior warships. Naval technology underwent profound changes during the war, as sail gave way to steam and ironclad vessels rendered wooden ones obsolete. No vessels better illustrated the revolution in power, propulsion, armor, and armament than the ironclads USS *Monitor* and CSS *Virginia*.

On March 9, 1862, the two ships engaged in battle at Hampton Roads, Virginia—the first clash between ironclad warships. "We were enclosed in what we supposed to be an impenetrable armor," recalled Paymaster William Keeler aboard the *Monitor*. "We knew that a powerful foe was about to meet us. Ours was an untried experiment." The battle ended in a draw, but it marked the dawn of a new era in naval warfare.

Despite the efforts of the blockade-runners and a handful of Confederate ironclads, the Federal cordon drew tighter with the capture of strategic Southern ports and the introduction of powerful new warships. As the war progressed, Confederate soldiers and civilians alike would suffer from the effects of the slow strangulation of their overseas commerce.

WINFIELD SCOTT'S ANACONDA
America's grand old military hero, General Winfield Scott, recognized that the Confederacy would have to be not only defeated on the battlefield but starved economically as well. Scott's plan for the blockade was dubbed the "Anaconda Plan" after the giant South American snake that crushed its victims to death in its massive coils.

GULF COAST BLOCKADER
Six officers and some of the 95-man crew of the USS *Pocohontas* stand proudly on the deck of their ship—a 700-ton steam sloop that saw its share of blockade action around the Gulf Coast. Armed with six guns and the boat howitzer visible at center, the *Pocahontas* was credited with capturing two enemy blockade-runners.

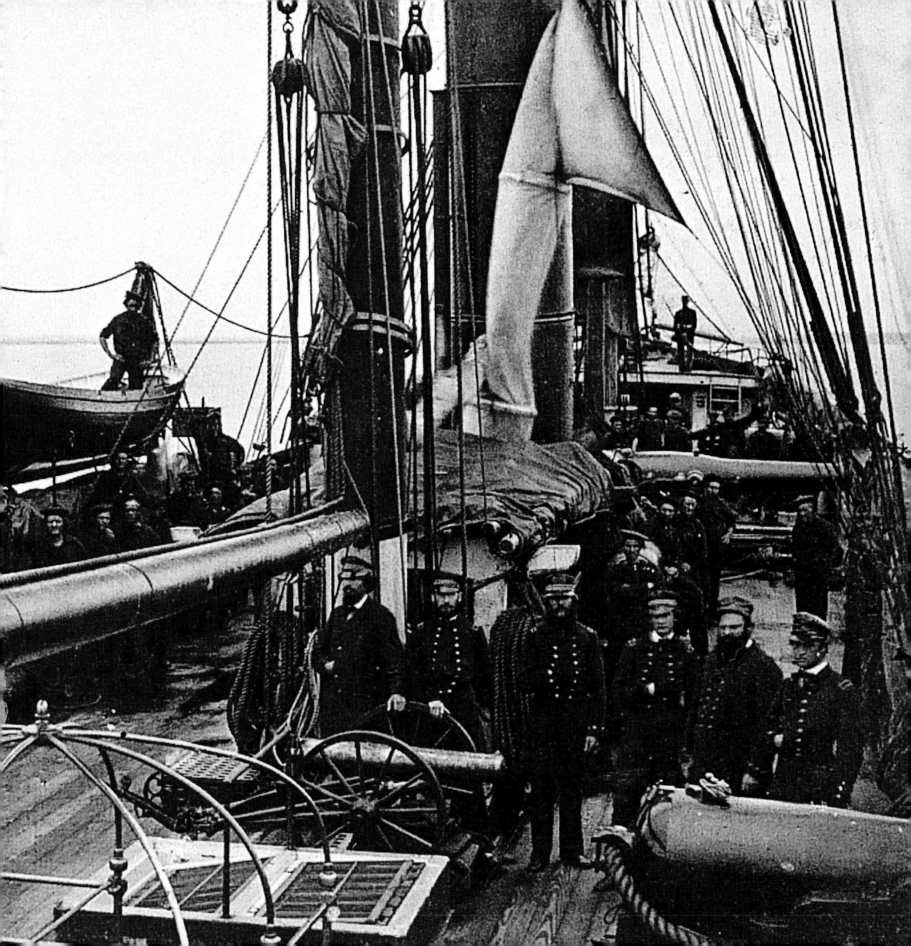

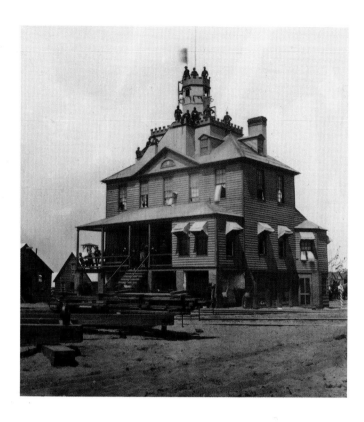

PLANTATION HOUSE TO SIGNAL STATION

The main signal station at Hilton Head was a former plantation house with a rooftop tower added to extend its signaling range. Through this station, uncounted messages passed between the warships at sea and nearby Federal army headquarters.

CAPTURED REBEL BASTION

Federal soldiers guard the waterfront earthworks of South Carolina's Fort Walker, which was later renamed Fort Welles, after Lincoln's secretary of the navy. The guns, abandoned by the Confederates, remain trained on Port Royal Sound, where U.S. Navy warships and transport vessels ride peacefully at anchor.

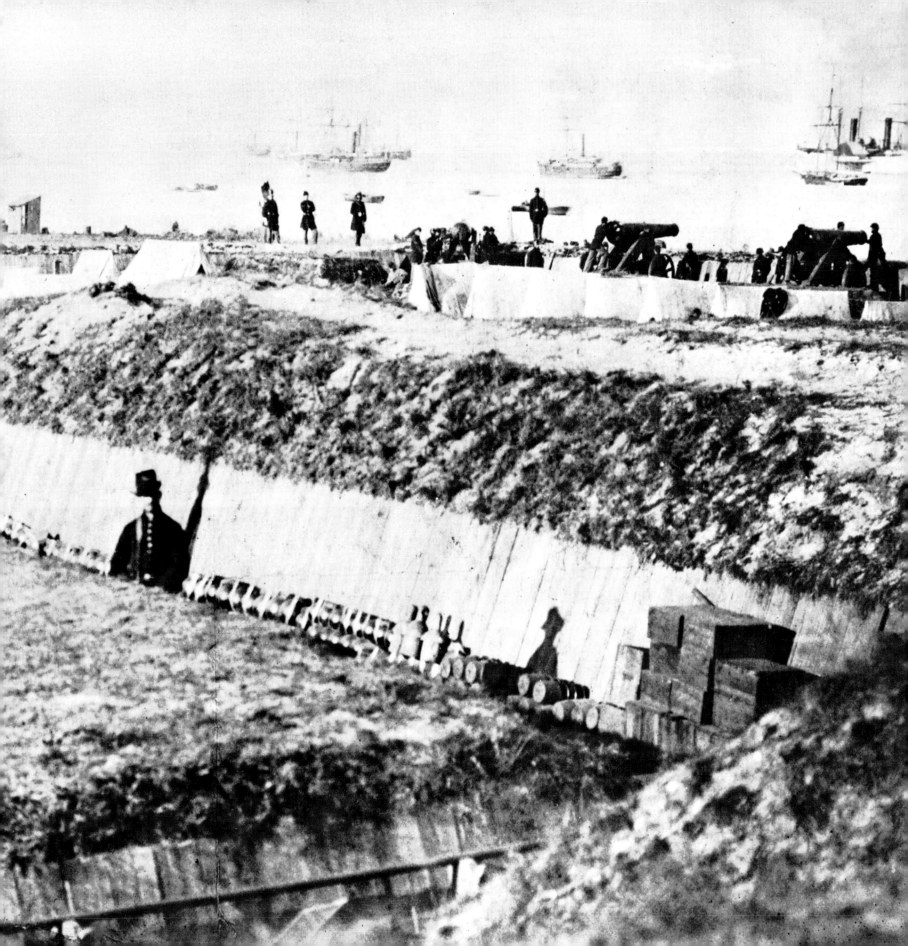

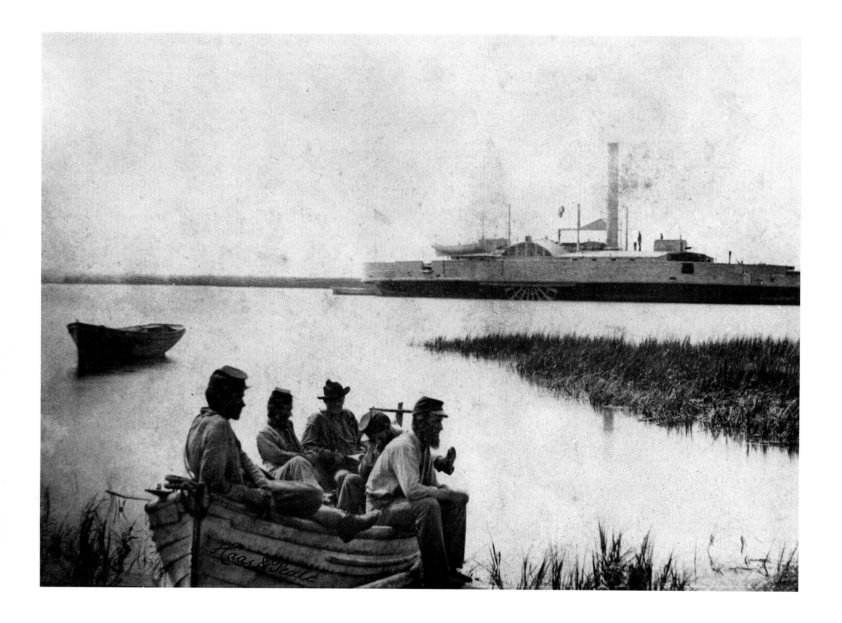

PRESSED INTO SERVICE

A lethargic group of Federal infantrymen lounge in a rowboat near Morris Island on a hot summer afternoon during the seige of Charleston. The ship in the background is the USS *Commodore McDonough*, a former New York ferryboat that had been converted into a blockade gunboat.

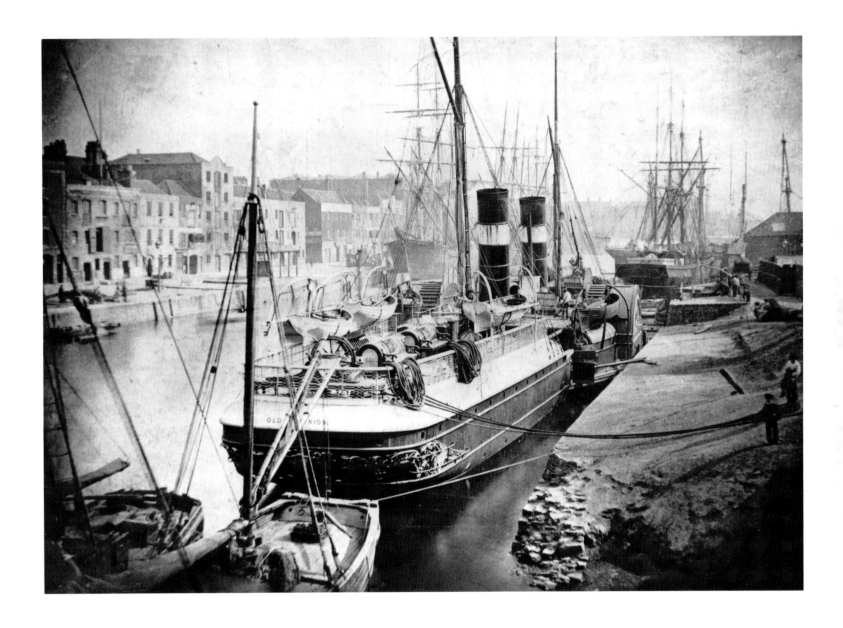

FAST STEAMERS FROM ENGLISH YARDS

In Bristol, England, the speedy packet *Old Dominion* is refitted as a blockade-runner for the Confederacy. The local U.S. consul had this picture taken to aid in intercepting the ship once she left port.

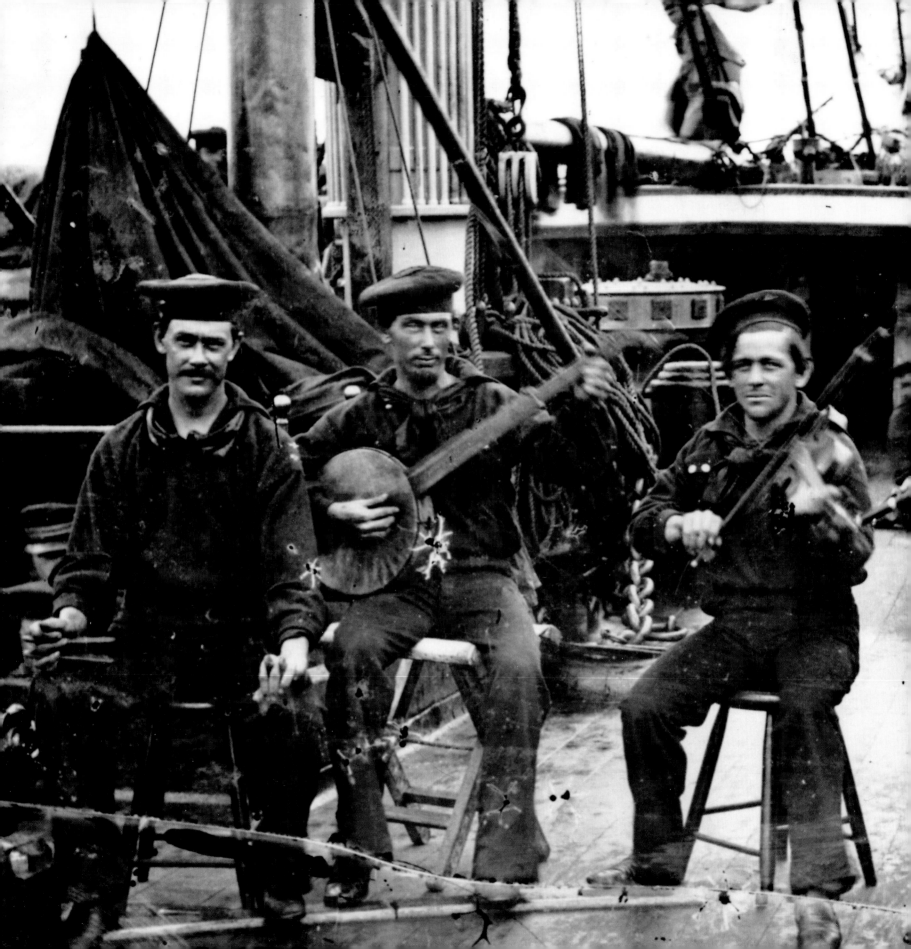

"... go to the roof on a hot summer day, talk to a half-dozen degenerates, descend to the basement, drink tepid water full of iron rust, climb to the roof again, and repeat the process at intervals until fagged out, then go to bed with everything shut tight."

FEDERAL NAVAL OFFICER,
describing life blockading a Southern port to his family

WHILING AWAY THE HOURS
Musician sailors take a break with their instruments on board Admiral Du Pont's flagship, the *Wabash*. Weeks of patrolling the entrance of a Southern harbor made for tedious duty, and any diversion was a welcome escape.

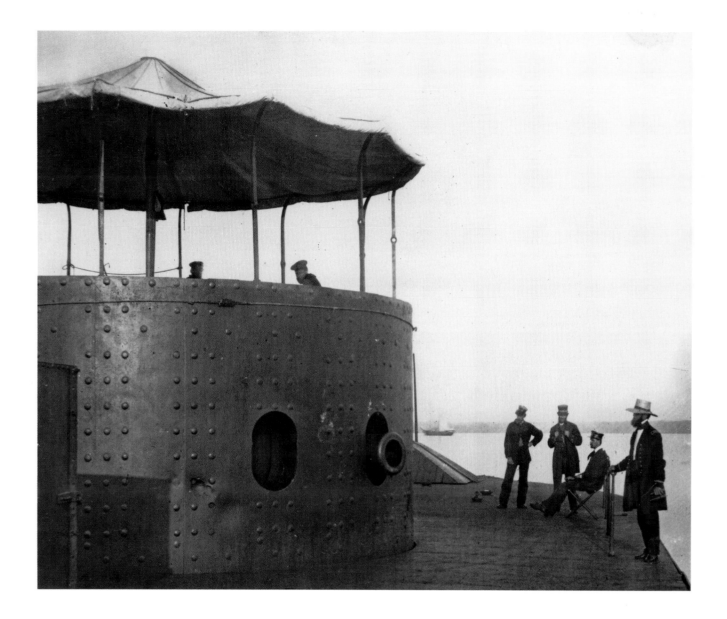

YANKEE CHEESE BOX ON A RAFT

Appraising the battle damage, officers of the *Monitor* examine dents in the turret made by the *Merrimac's* shot and shells. Partially visible in the background is a new, slope-sided pilot house, built after the original square one was wrecked in the fight.

GIANT FEDERAL IRONCLAD

Officials await the launching of the *Dictator*, prototype of the war's largest class of monitors, at the Delameter Iron Works in New York on the 26th of December 1863. The *Dictator's* 312-foot hull was protected by six inches of armor.

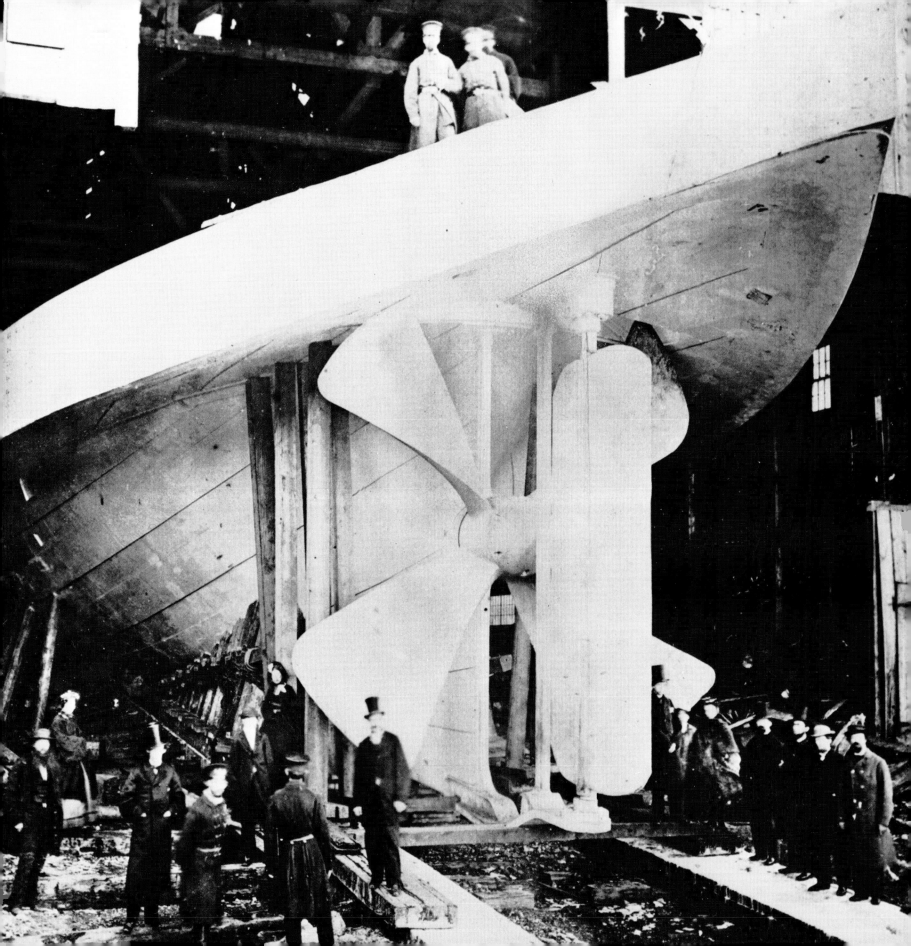

CLOSING THE JAMES RIVER

The *Onondaga*, one of five double-turret monitors built during the war, lies at anchor in Virginia's James River in 1864. The ship was 226 feet long and was armed with two 15-inch and two 8-inch cannon. The tarpaulins covering the deck were rigged to provide some shade from the blistering Southern sun.

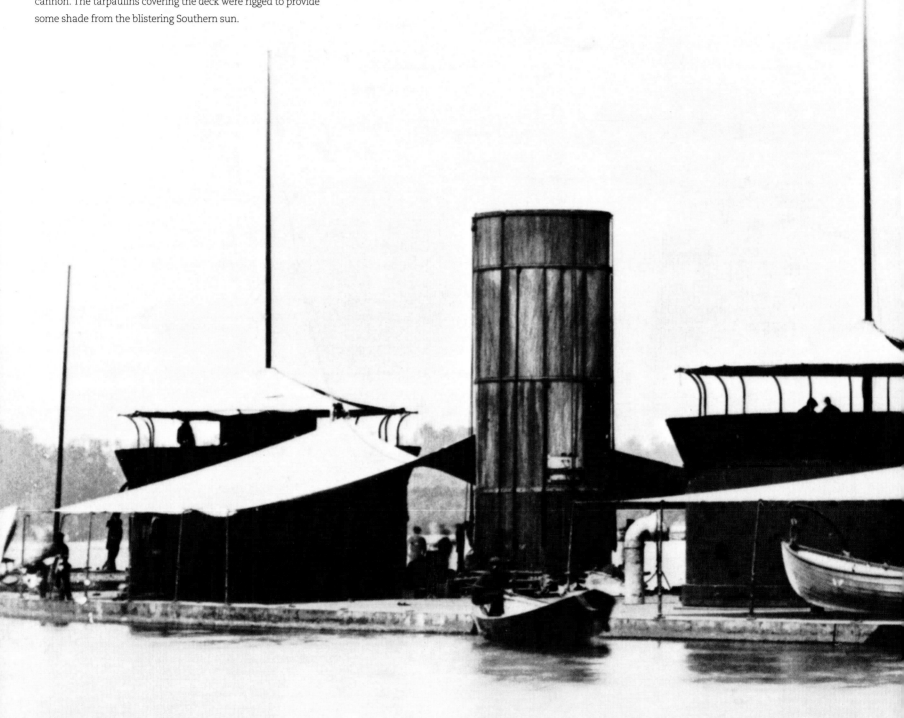

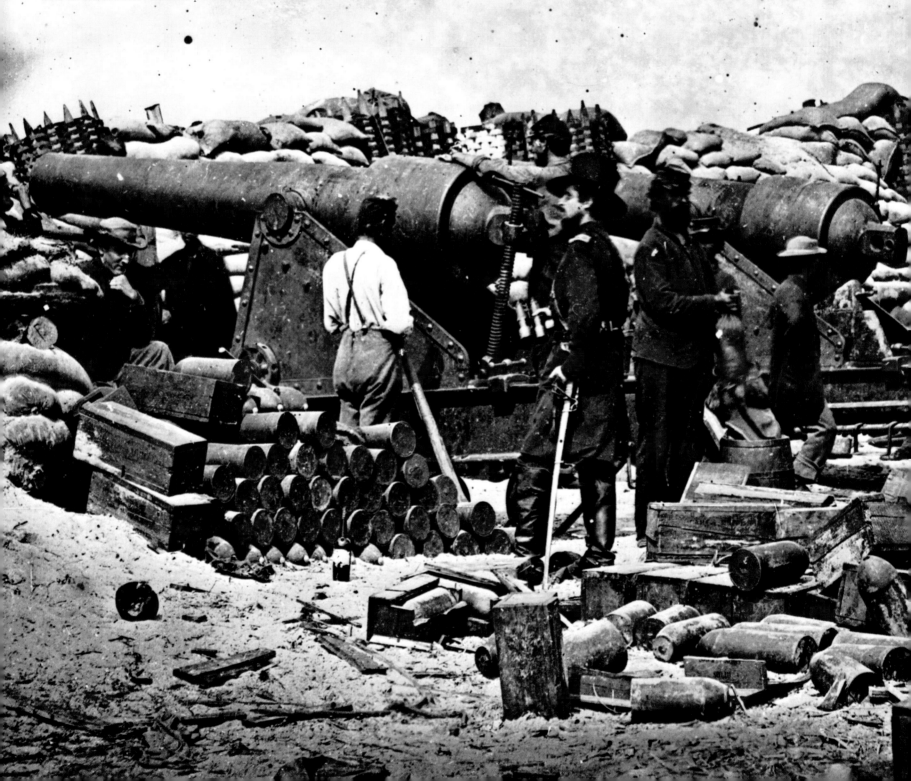

FIRING ON FORT SUMTER
Men of Company M, 3rd Rhode Island Artillery, put two 100-pounder Parrott
Rifles into action, firing on Fort Sumter from Battery Rosecrans on Morris Island
in the autumn of 1863. An empty gun carriage at right in this photograph by
Haas & Peale had held a third 100-pounder until it burst.

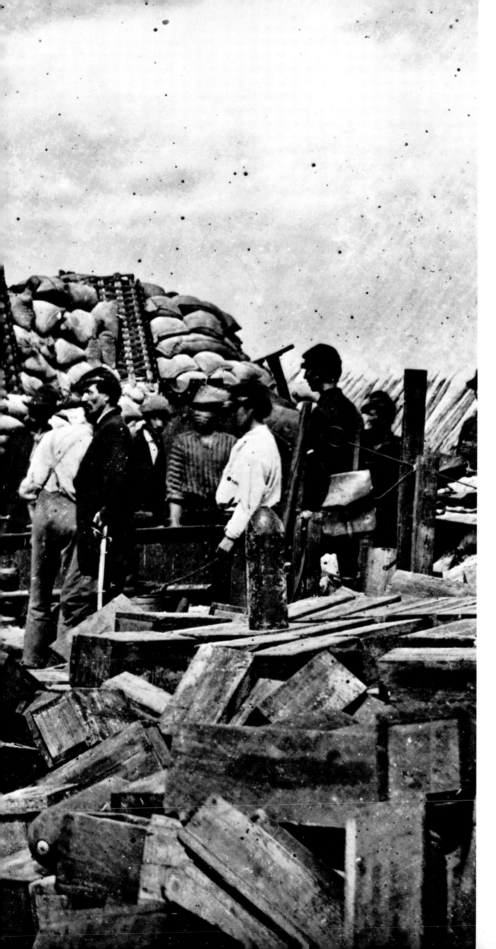

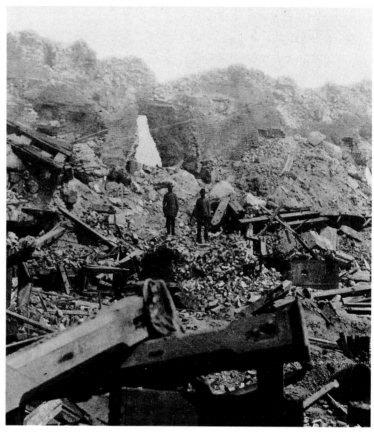

INSIDE A BATTERED REBEL STRONGHOLD

Photographer George Cook returned to Fort Sumter and took this view of the eastern barracks and casemates in a state of total ruin. During the early hours of October 31, a shell struck the already weakened structure and the roof collapsed, killing 13 men who were sleeping inside. The two men posing for Cook stand on a pile of bricks, all that remains of the hot shot furnace.

The Road to Shiloh

ON FEBRUARY 2, 1862, FORT HENRY, a Confederate bastion guarding the Tennessee River, fell to U. S. Grant's army of 15,000 men and a flotilla of river ironclads. To one Federal observer, the fort had "seemed a blaze of fire, whilst the boom of the cannon's roar was almost deafening." Grant immediately hit nearby Fort Donelson, a massive fortification guarding the Cumberland River, forcing its surrender. These stunning victories opened the Tennessee and Cumberland Rivers and led Confederate general Albert Sidney Johnston to abandon Kentucky. With one blow the Confederate line defending Tennessee collapsed, and the northern press assigned a new meaning to Grant's initials—the *U. S.* now stood for "Unconditional Surrender."

Grant pressed south to Pittsburg Landing on the Tennessee in preparation for an advance on the strategic rail junction at Corinth, Mississippi, establishing camps in the fields and woodlands surrounding a small chapel called Shiloh. At first light on April 6 the Confederates under Johnston and Beauregard struck the Union camps with a force of 45,000 men, sending stunned Union troops reeling toward the river. "Fill your canteens, boys!" shouted Colonel Pugh of the 41st Illinois. "Some of you will be in hell before the night and you'll need water!"

The beleaguered Federals made a stand in a cluster of thickets dubbed the Hornet's Nest, preventing the Confederates from driving through to the river before nightfall. Johnston was mortally wounded and the Confederate advance ground to a halt. Reinforced, Grant counterattacked at dawn on April 7, and the Confederates fell back on Corinth.

The bloodletting at Shiloh cost both sides more than 23,741 casualties. This sacrifice of more American lives than had been lost in all of the country's previous wars destroyed any notion of a negotiated peace. After Shiloh, wrote a captain from Illinois, "All sentimental talk of easy conquest ceased upon both sides."

PRISONERS FROM THE RIVER FORTS
Confederate soldiers captured at Forts Henry and Donelson in Tennessee stand before a prison barracks at Camp Douglas in Illinois shortly after their incarceration in February 1862. They wear paper prisoner-of-war identification tags on their ill-fitting overcoats.

A YOUNG TENNESSEE REBEL
Private W. J. Coker of the 3rd Tennessee was captured at Fort Donelson in February 1862. He spent several grueling months as a prisoner before being exchanged after the Shiloh campaign.

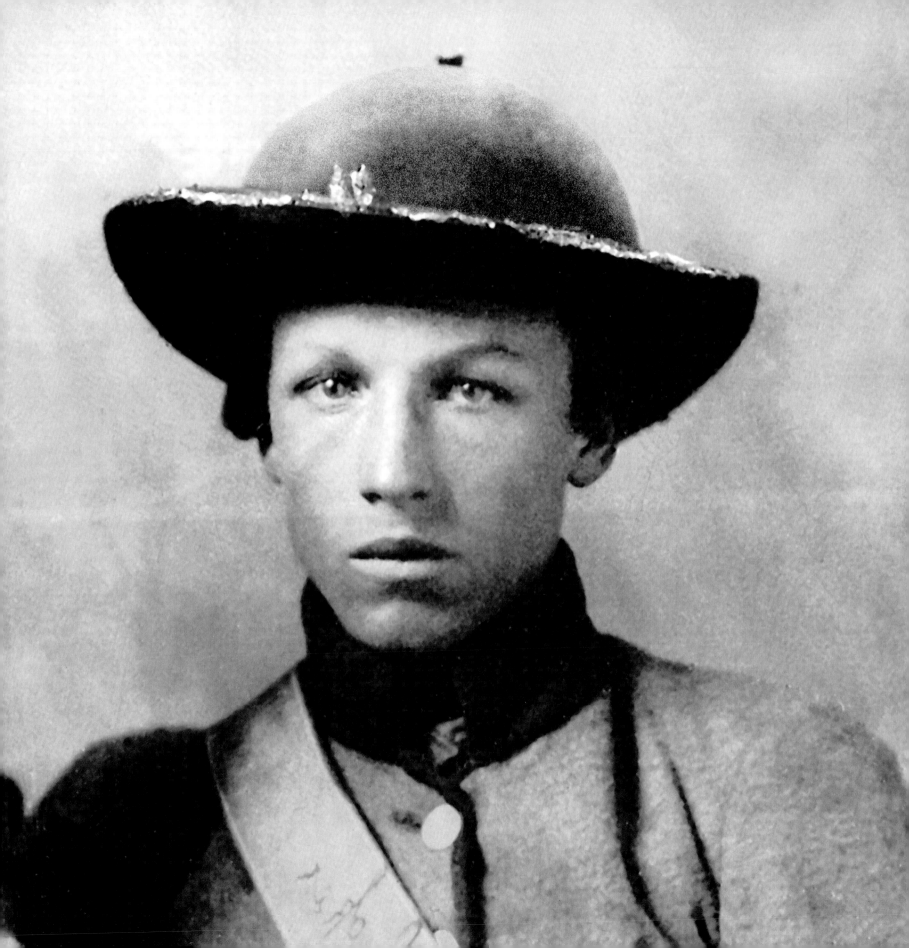

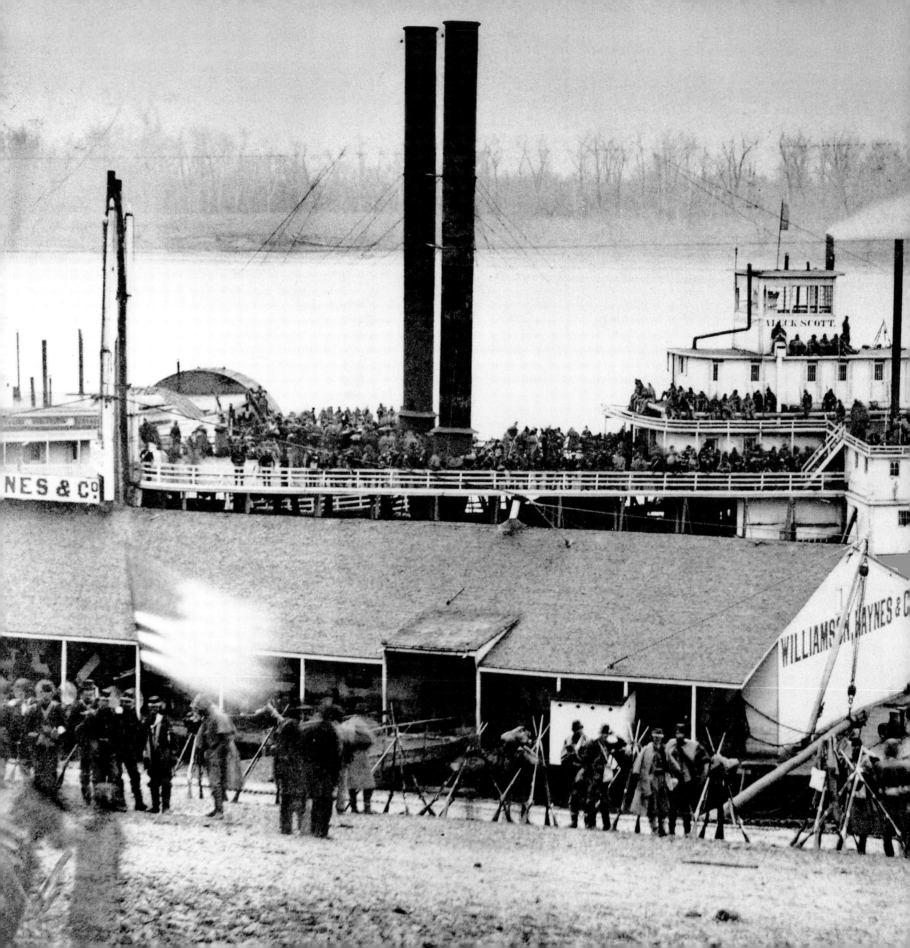

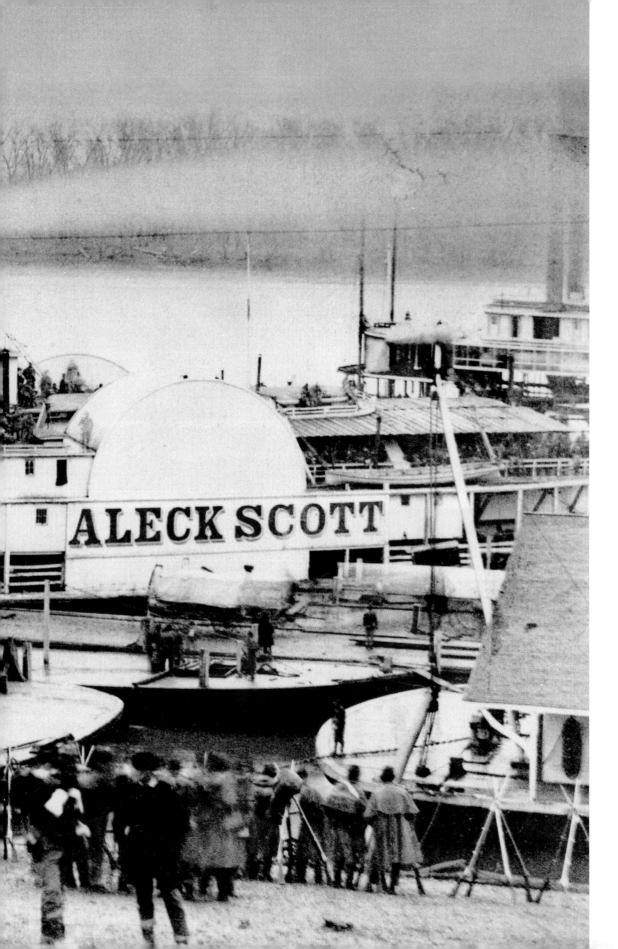

"Never was a grander sight presented to human eyes than the old Army of the Tennessee loaded on steamers, with flags floating and bands playing."

PRIVATE T. E. LEE,
41st Illinois Infantry

WORKHORSE OF THE WESTERN RIVERS
Pressed into wartime service, the 266-foot side-wheel packet *Aleck Scott* unloads newly recruited Federal soldiers at Cairo, Illinois. Built in Jeffersonville, Indiana, in 1842, the *Aleck Scott* was one of scores of riverboats that transported men of Grant's command to Pittsburg Landing and Shiloh in the Spring of 1862.

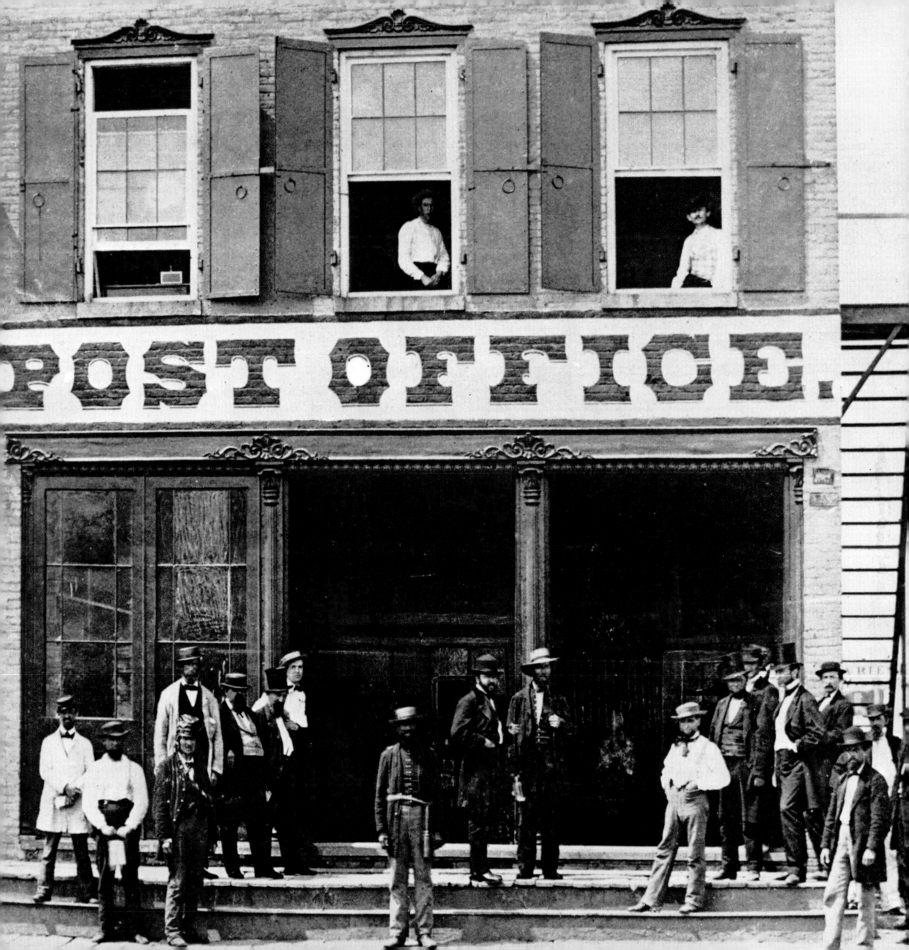

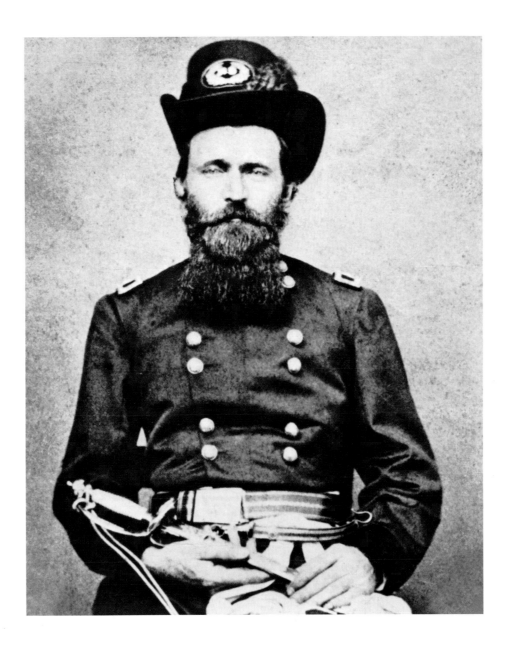

VITAL RIVER PORT
Bystanders gather at the entrance to the post office in Cairo, Illinois, in this September 1861 photograph. Cairo was vital base for federal operations on the Ohio and Tennessee Rivers.

A NEWLY MINTED BRIGADIER GENERAL
Recently commissioned Brigadier General Ulysses S. Grant wears his new dress uniform and a recently cultivated square-cut beard in this photograph taken in October 1861.

> *"The nucleus of the Mississippi flotilla . . . was completed with great skill and dispatch; they soon had full possession of the Western rivers from above Columbus, Kentucky and rendered more important service than as many regiments could have done."*

COMMANDER HENRY WALKE,
USS *Carondelet*

HUNDRED-DAY GUNBOATS

Under construction on the Missouri River, two ironclads standing stern to stern take shape at James B. Eads's shipyard in Carondelet, near St. Louis. Just below deck level in the foreground are the ship's five boilers. Constructed in less than a hundred days, Eads's first four ironclad gunboats sailed downstream to Cairo in November 1861.

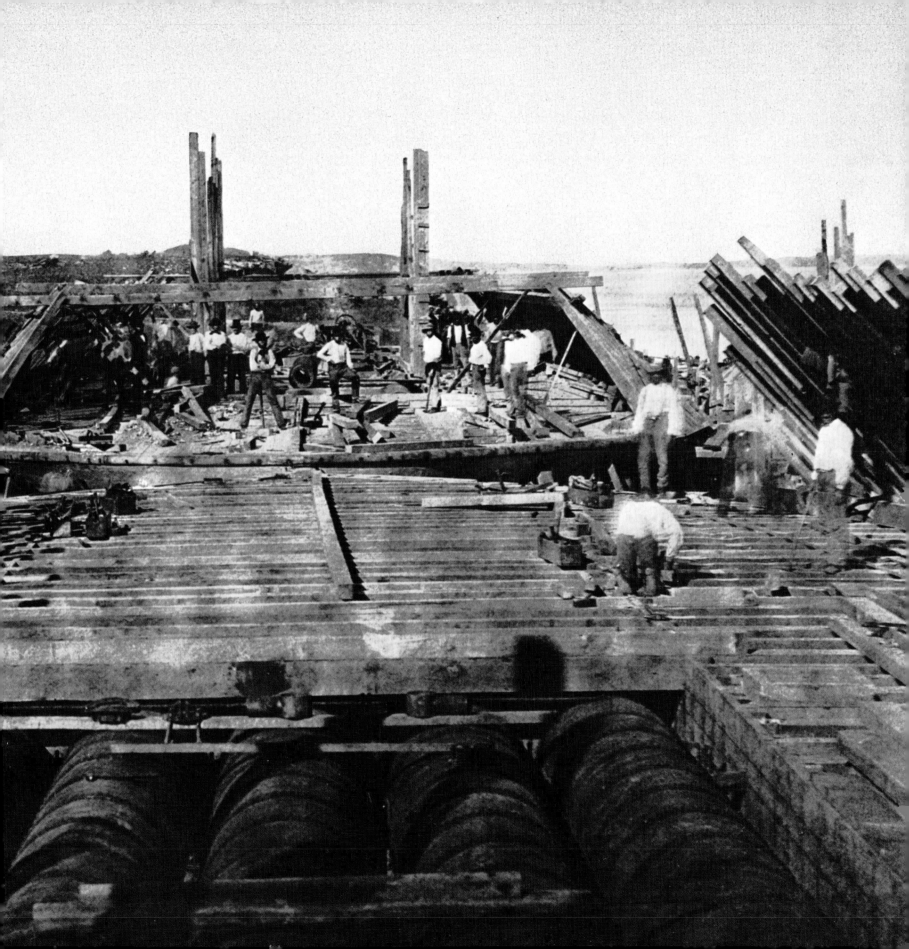

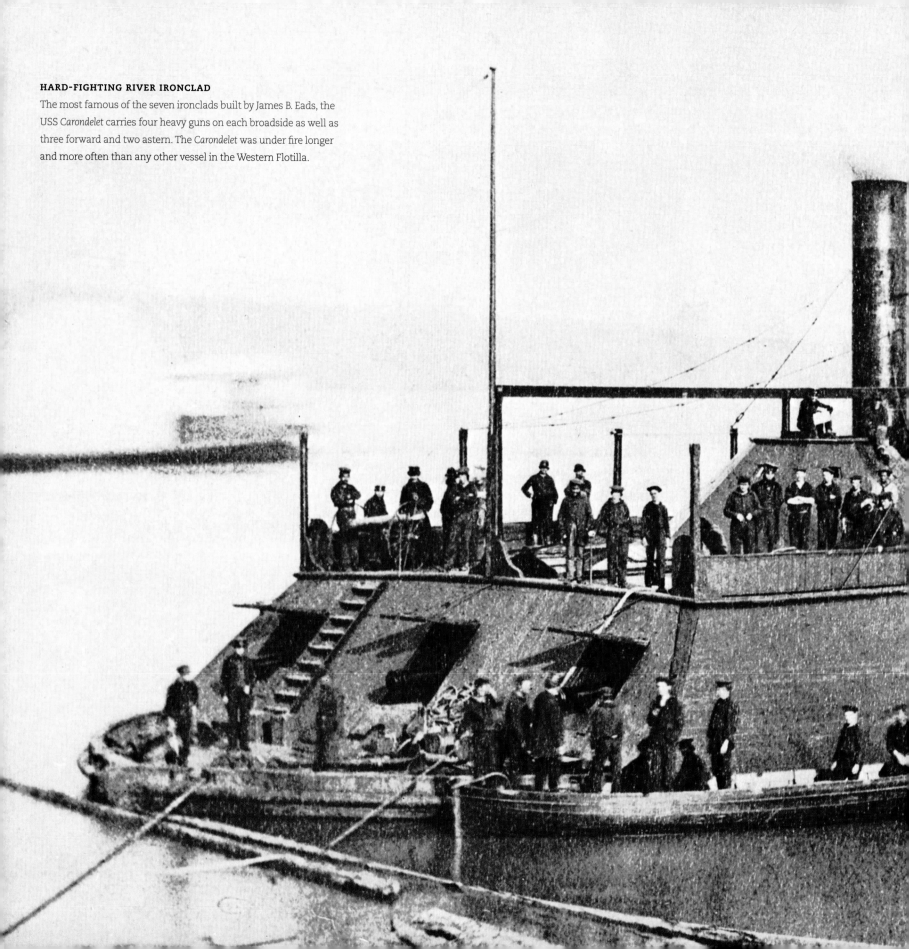

HARD-FIGHTING RIVER IRONCLAD
The most famous of the seven ironclads built by James B. Eads, the
USS *Carondelet* carries four heavy guns on each broadside as well as
three forward and two astern. The *Carondelet* was under fire longer
and more often than any other vessel in the Western Flotilla.

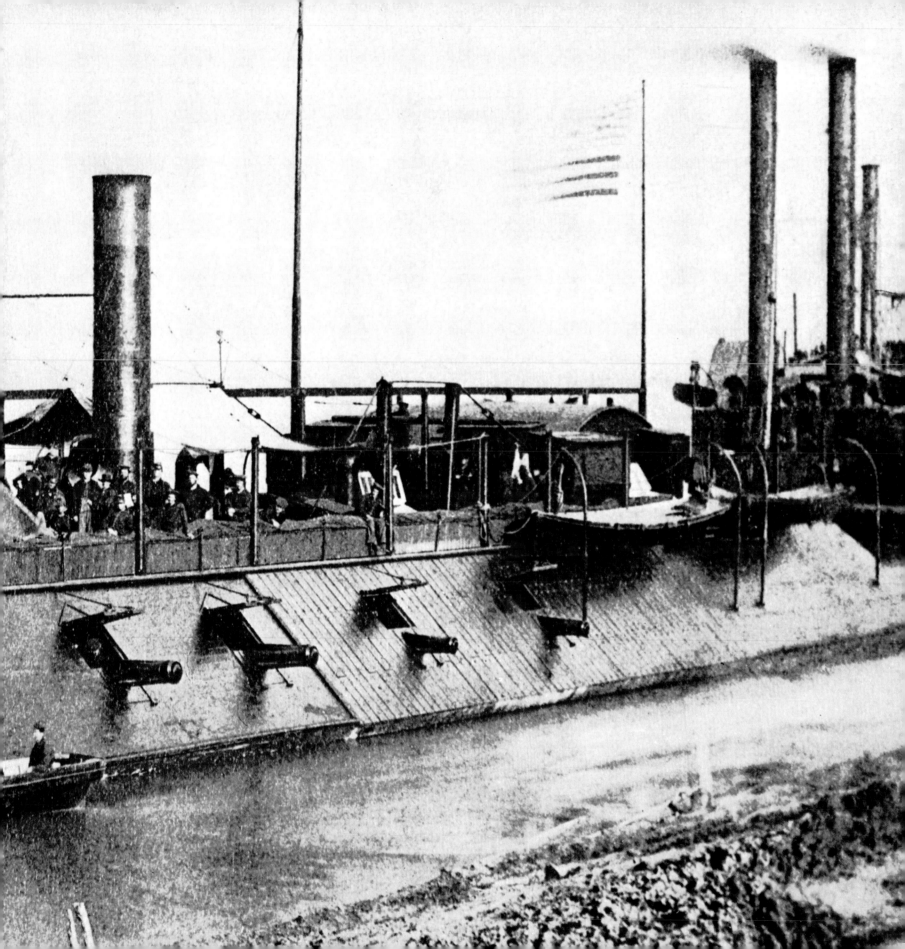

"ARMED MOB"

The British general who called America's Civil War armies "armed mobs" might have seen the men of the 21st Missouri Volunteers. Displaying a variety of uniforms and arms, the Federals were apparently as poorly disciplined as they were equipped. Grant considered them a tough bunch: While cruising upriver on a transport, the men kept up "a constant fire all the way" at objects on the riverbank. Even "the citizens on the shore were fired at."

DEFENDERS OF CORINTH

Typical of the Confederates called upon to defend Tennessee, members of the Clinch Rifles, Company A of the 5th Georgia Volunteers, lounge before a wall tent with their black servant. In April 1862 they helped guard the Cumberland Gap before participating in the siege of Corinth, Mississippi.

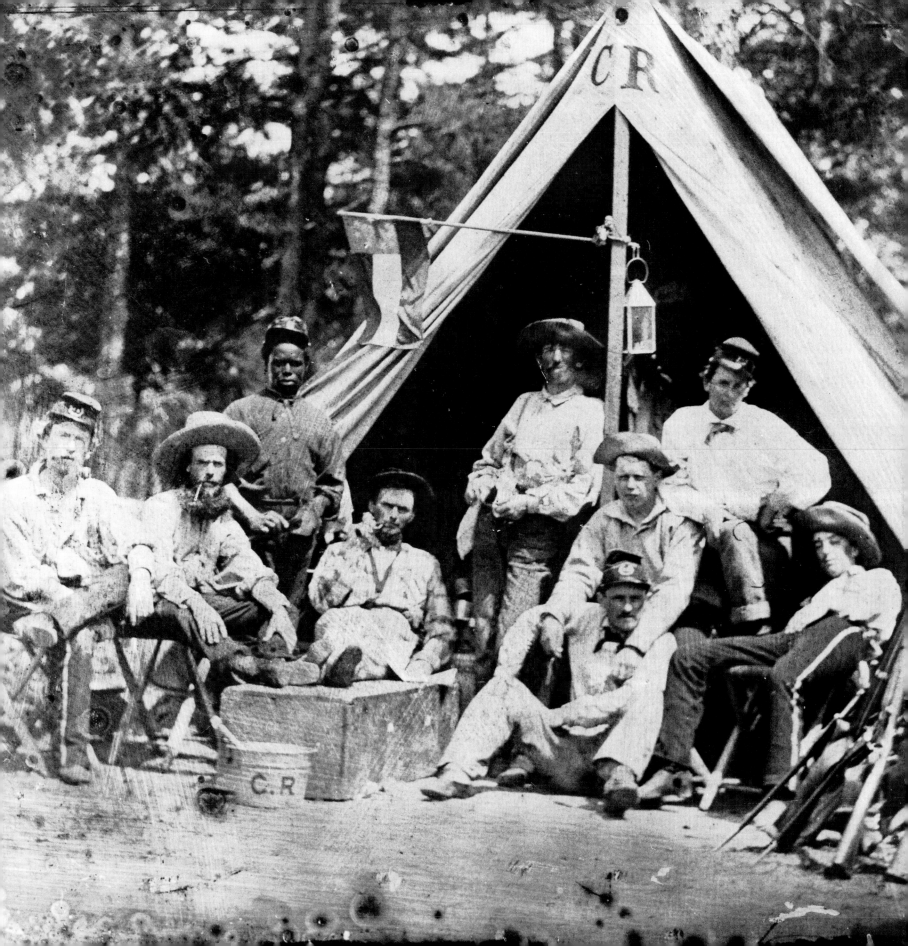

Forward to Richmond

IN LATE JULY 1861 PRESIDENT LINCOLN CALLED ON THE YOUNG and energetic General George B. McClellan to rebuild a Union army shattered by the defeat at Bull Run. A brilliant organizer, McClellan moved swiftly to restore order in the camps. He introduced new systems of drill and worked tirelessly to instill a sense of discipline and pride in the dispirited volunteers.

For eight months, with the exception of a few minor operations, McClellan made no decisive move to attack the Confederates with his reinvigorated army. The public demanded action, and the northern press urged the general they had dubbed the Young Napoleon to move "Forward to Richmond!"

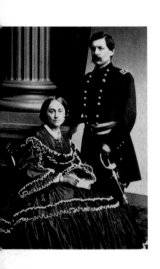

Instead of advancing overland toward the Confederate capital, McClellan planned to transport his huge army by water to Fortress Monroe, situated at the tip of the Virginia Peninsula between the York and James Rivers. McClellan's planned campaign of "rapid marches" grew excruciatingly slow, however, mired in bad roads, blocked by Confederate defenders, and hamstrung by the young general's overdeveloped sense of caution.

Back in Washington frustration with McClellan's delays were exacerbated by the operations of Confederate general "Stonewall" Jackson in the Shenandoah Valley. Jackson used rapid maneuver and superior knowledge of his home terrain to elude or defeat three Federal commands sent out to destroy him. By threatening Washington, Jackson managed to draw off thousands of Federal troops en route to join McClellan's advance on the Confederate capital.

By late May 1862, in spite of many delays, McClellan's army stood only six miles from Richmond. On May 31st Confederate general Joseph E. Johnston struck hard at Union forces near a crossroads called Seven Pines. This courageous attempt to derail the Federal advance escalated into a two-day action that left Johnston seriously wounded and his attack stalemated. Faced with disaster, Confederate president Jefferson Davis sent General Robert E. Lee to take command of the forces.

THE "YOUNG NAPOLEON"

Major General George B. McClellan stands by his wife, Ellen, in this photograph. Expectations for his command were so great that he wrote to his wife, "By some strange operation of magic I seem to have become the power of the land."

TROOPS ON PARADE

Because McClellan insisted on military pageantry as a way of instilling pride in his troops, the regiments of the Army of the Potomac formed for a dress parade each day while in camp around Washington.

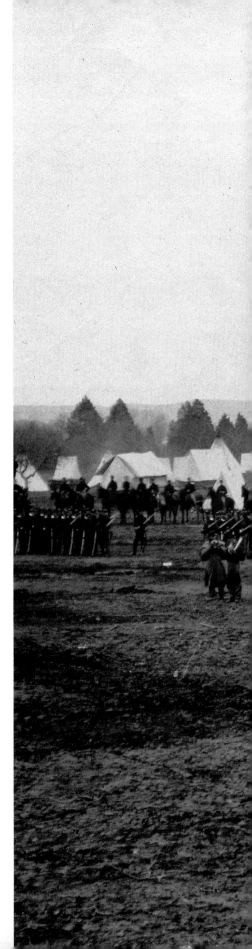

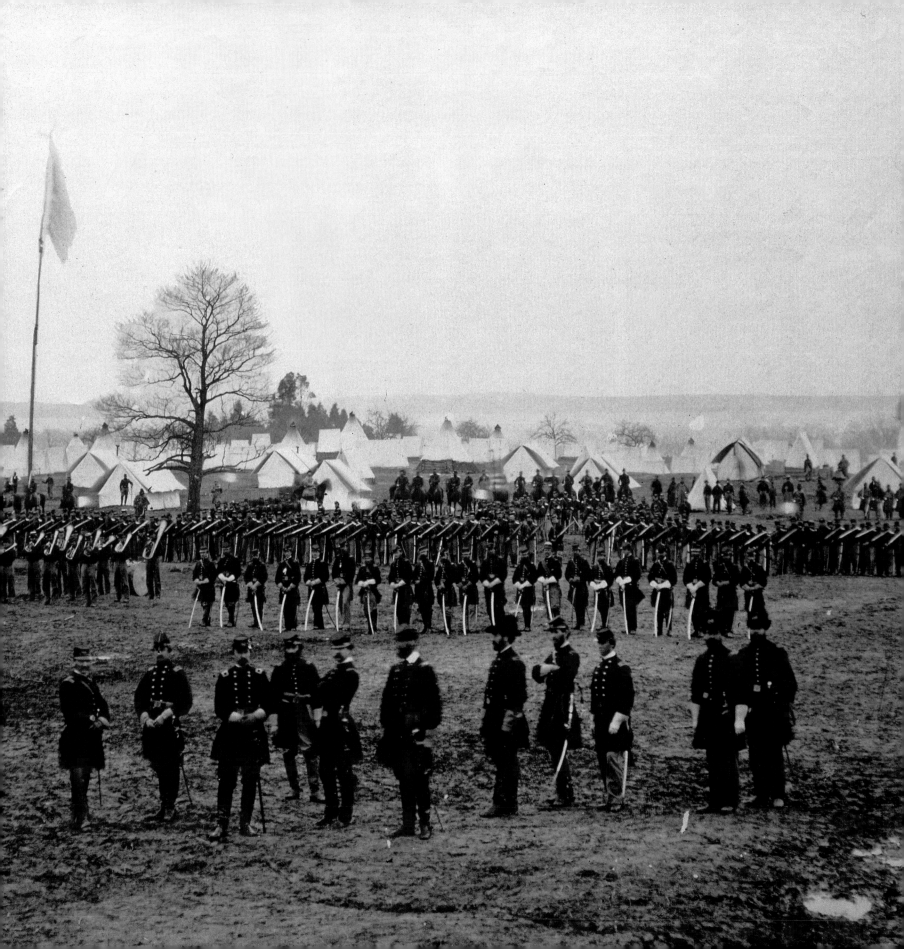

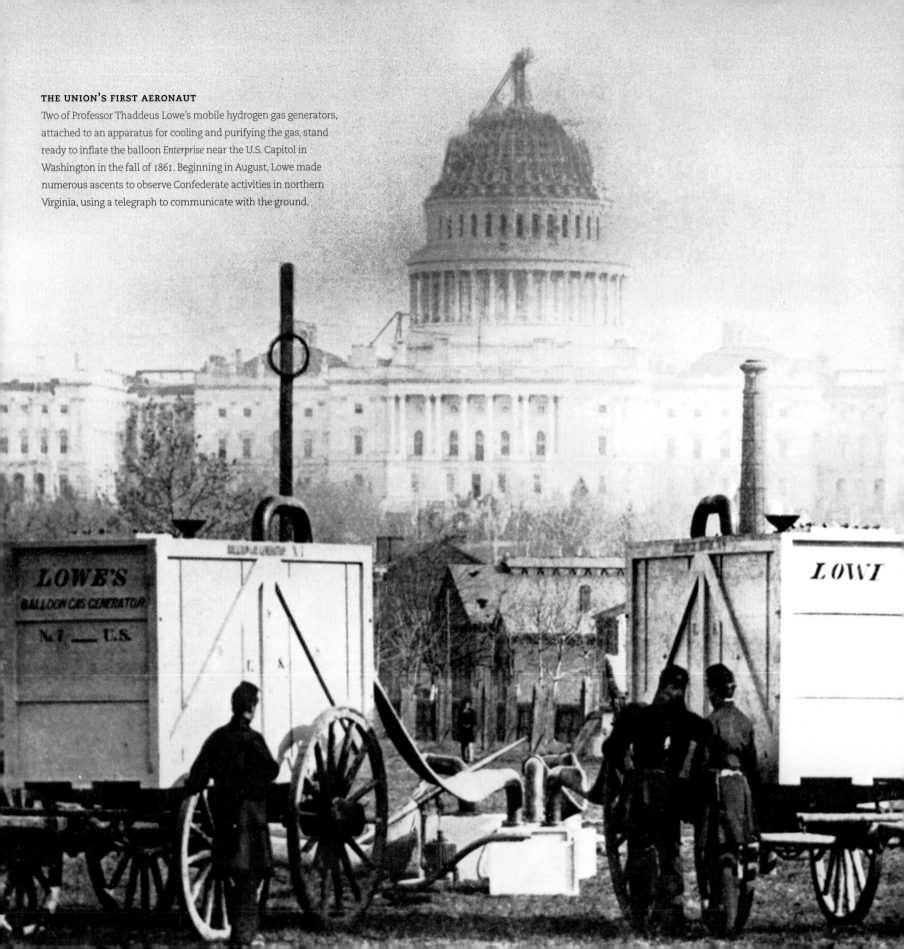

THE UNION'S FIRST AERONAUT
Two of Professor Thaddeus Lowe's mobile hydrogen gas generators, attached to an apparatus for cooling and purifying the gas, stand ready to inflate the balloon *Enterprise* near the U.S. Capitol in Washington in the fall of 1861. Beginning in August, Lowe made numerous ascents to observe Confederate activities in northern Virginia, using a telegraph to communicate with the ground.

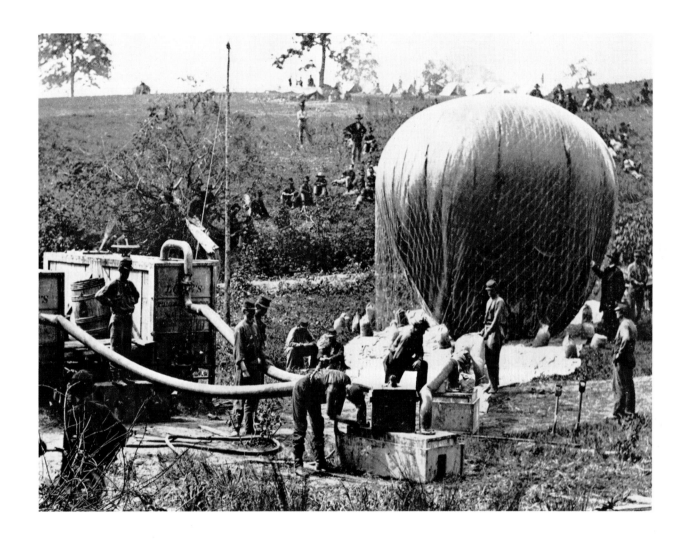

BALLOONS IN BATTLE ON THE VIRGINIA PENINSULA

Hurrying to inflate the *Intrepid*, Lowe tests its gas pressure before ascending to report on the Confederate advance near Fair Oaks, Virginia, on June 1, 1862.

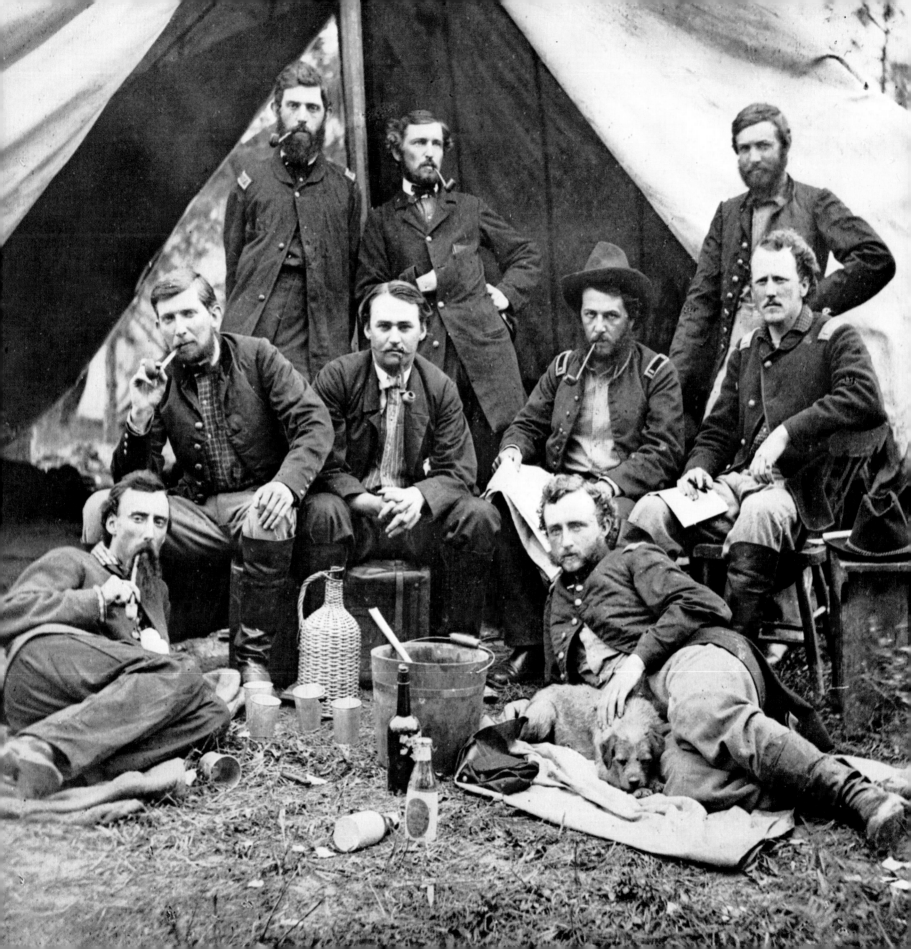

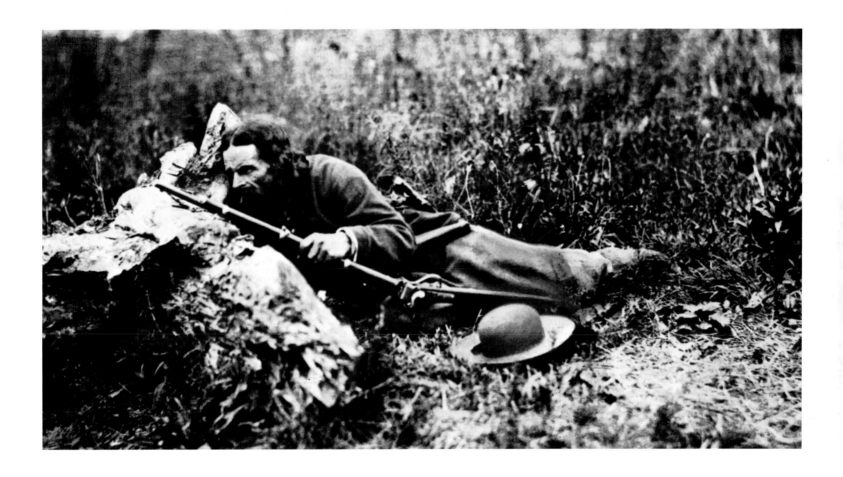

A QUIET MOMENT AT CUMBERLAND LANDING

Officers of the provost marshal's staff of the Army of the Potomac enjoy a bit of relaxation in this portrait taken at Cumberland Landing. Among them are two future generals: Captain James W. Forsyth *(seated, far left)* and First Lieutenant George Armstrong Custer *(reclining at right)*.

SHARPSHOOTER

Private Truman Head, a successful "49er" and professional hunter dubbed California Joe, lies in wait for Confederate soldiers with his Sharps rifle. Head joined Colonel Hyram Berdan's 1st U.S. Sharpshooters in 1861 and served with distinction on the Peninsula.

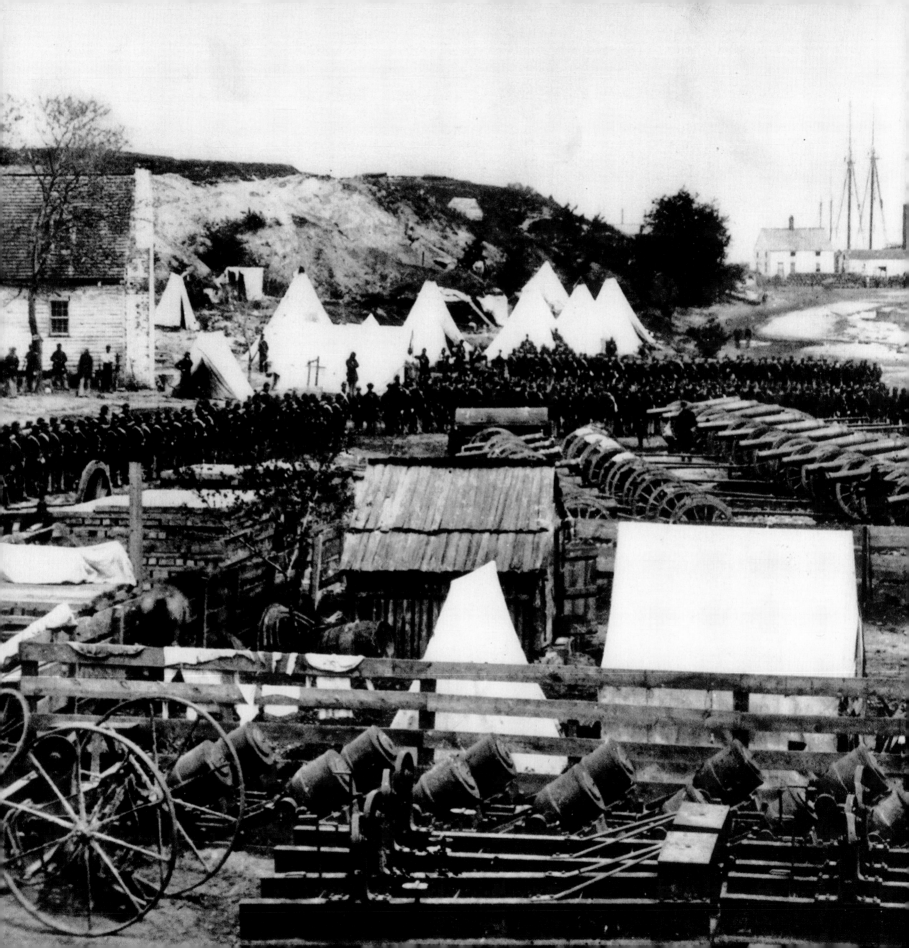

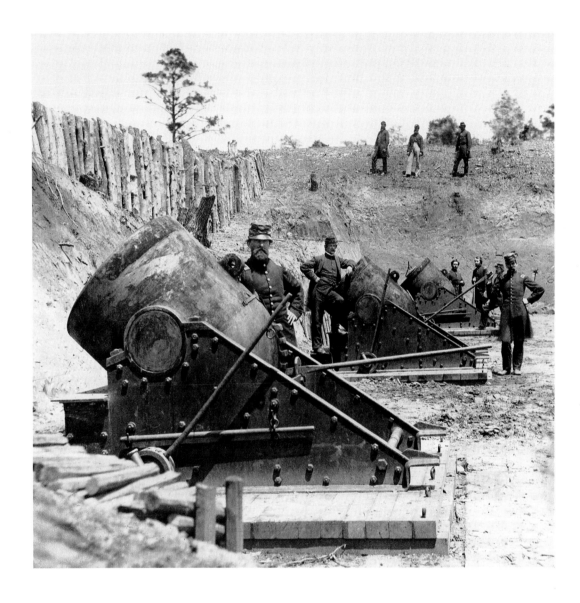

GIANT MORTARS BEFORE YORKTOWN

Behind the Yorktown lines at Wormsley's Creek, officers of the 1st Connecticut Heavy Artillery stand proudly beside their 13-inch seacoast mortars, 8-ton monsters that could throw 220-pound shells 4,300 yards. The Federals laboriously brought up 14 batteries of heavy cannon for the siege, but the Confederates evacuated their Yorktown line before any of the guns could fire a shot.

GREAT GUNS TO BOMBARD THE REBEL CAPITAL

Federal troops line up behind the Army of the Potomac's siege guns in occupied Yorktown, awaiting the ships that will carry them upriver for McClellan's anticipated siege of Richmond.

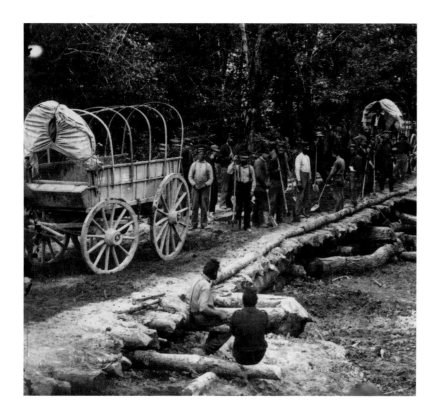

ROUGH ROADS TO SECURE FEDERAL COMMUNICATIONS
Federal engineers construct a corduroy road leading to a makeshift bridge across the
Chickahominy River. They placed logs over a bed of stones and underbrush and packed
the gaps tight with earth to form a firm surface.

THE ARMY OF THE POTOMAC'S GALLANT GUNNERS
Battery C of the 3rd U.S. Artillery, commanded by Captain Horatio Gibson (*foreground,
center*), stands ready to move into action. "Our superiority in artillery," wrote a Northern
correspondent traveling with McClellan's army, "has saved the army from annihilation."

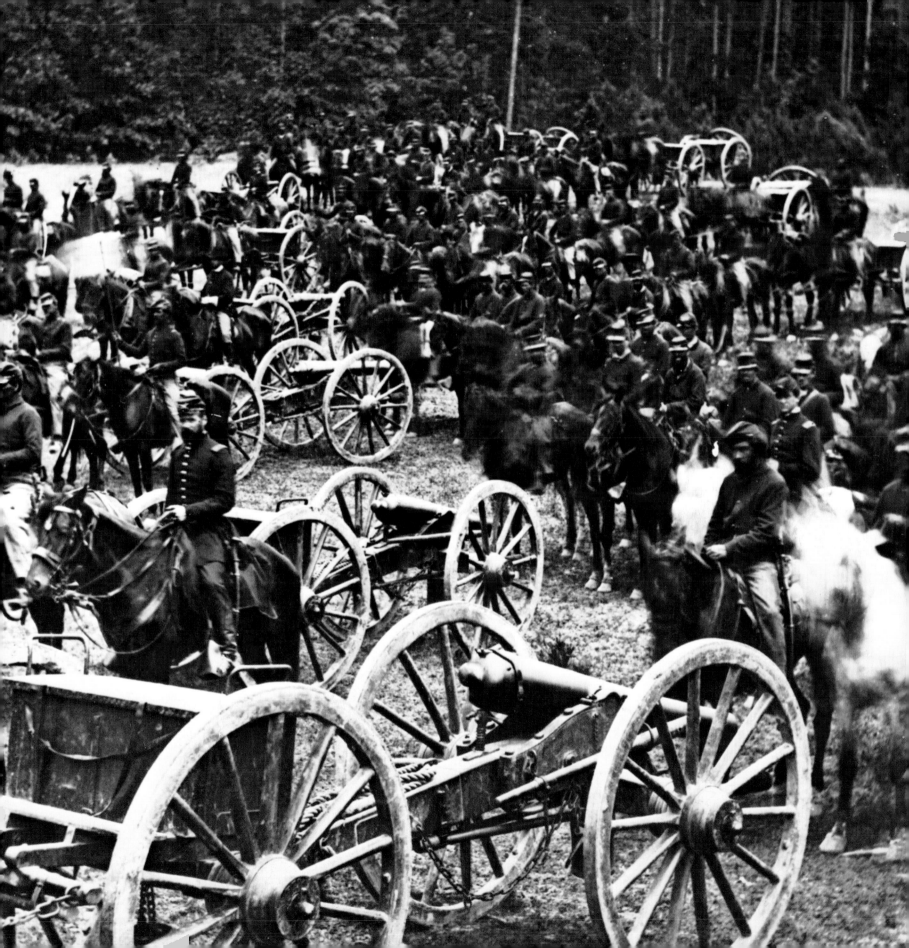

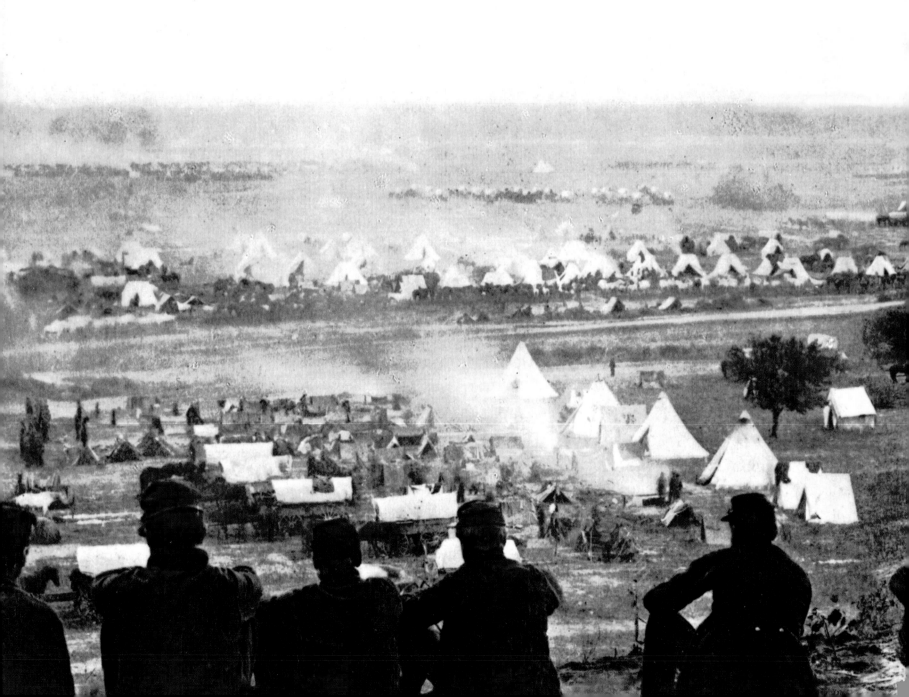

A PANORAMA OF FEDERAL MIGHT
Men of McClellan's army lounge on a hillside overlooking Cumberland Landing in this panoramic photo taken by James F. Gibson. From here, the immense Federal encampment extended two and a half miles north along the Pamunkey River to White House Landing.

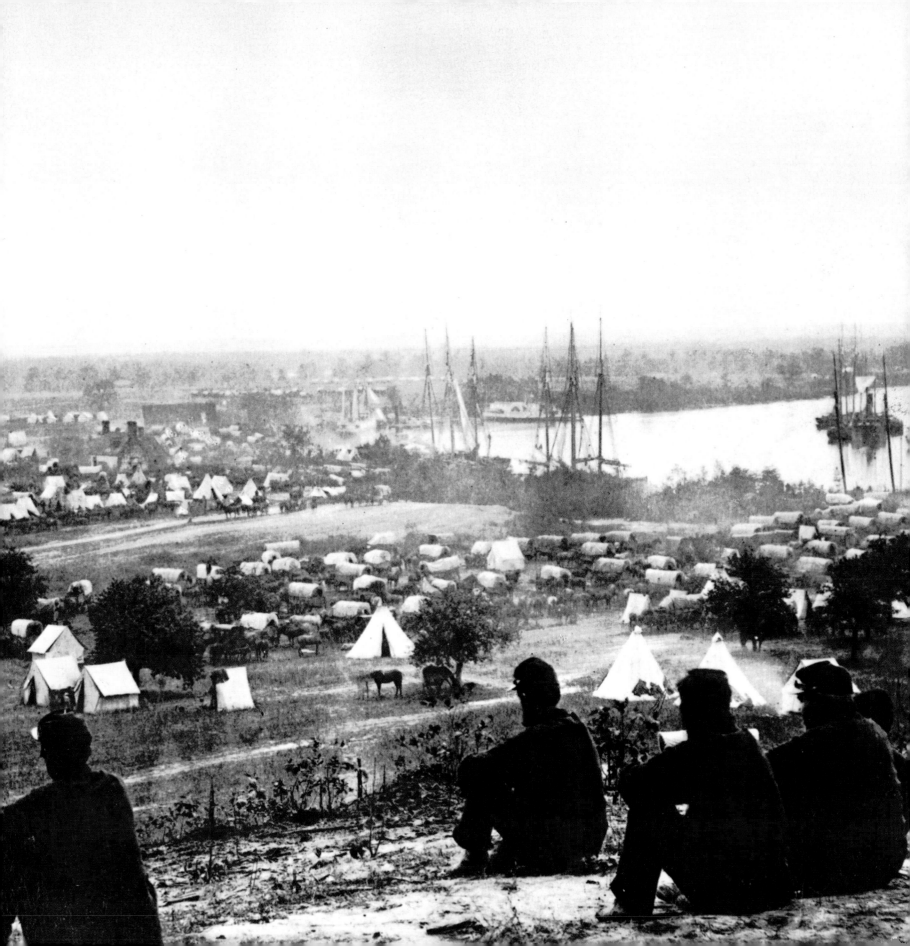

Lee Takes Command

THE BLOODY STALEMATE AT SEVEN PINES brought a momentous change in command to the Confederate forces defending Richmond. Declaring that "Richmond must not be given up!" the new commander, General Robert E. Lee, reacted with stunning speed. Quickly reorganizing his battered army into the Army of Northern Virginia, Lee prepared for an immediate counteroffensive. Badly outnumbered, he summoned Stonewall Jackson from the Shenandoah and devised a daring plan to defeat McClellan. Leaving only a thin screen of troops to hold Richmond's fortifications, he shifted the bulk of his army north of the Chickahominy River, striking at part of McClellan's forces along Beaver Dam Creek near Mechanicsville on June 26, 1862, in the first major engagement of the Seven Days' Battles.

Joined by Jackson on the following day, Lee struck at Gaines' Mill, driving the Federals from their positions in a series of frontal assaults that cost both sides over 13,000 casualties in less than six hours. Over the next four days Lee struck repeatedly at McClellan's retreating army, fighting three more battles at Garnett's Farm, Savage's Station, and White Oak Swamp. On July 1 the conflict reached a bloody climax on the slopes of Malvern Hill overlooking the James River, where McClellan's artillery smashed repeated assaults by Lee's courageous infantry.

Although his army still threatened Richmond, McClellan demanded more men. An exasperated Lincoln directed the young general to begin transporting his divisions to Northern Virginia to join Major General John Pope's newly organized Army of Virginia in an advance on Richmond from the north.

Lee, upon learning of McClellan's recall, turned north to confront Pope. Outmaneuvered by Lee and Jackson, Pope found himself under attack on the old battlefield of Bull Run, and a series of sledgehammer attacks on August 30 sent the Federals reeling back toward Washington. The devastating Union defeat at the Second Battle of Manassas left Lincoln in despair, as Lee pressed northward to invade Maryland.

A BOLD NEW COMMANDER

Robert E. Lee's reorganization of the army, his seizing of the initiative from his overcautious opponent, and his dynamic leadership during the Seven Days' Battles saved Richmond from capture by a superior force and brought ruination to George McClellan's vaunted Peninsula campaign.

ABANDONED TO THE ENEMY

Left behind after the Battle of Gaines' Mill, Federal wounded await the enemy's arrival in the yard of a home serving as a field hospital at Savage's Station. The men wearing straw hats belong to the 16th New York.

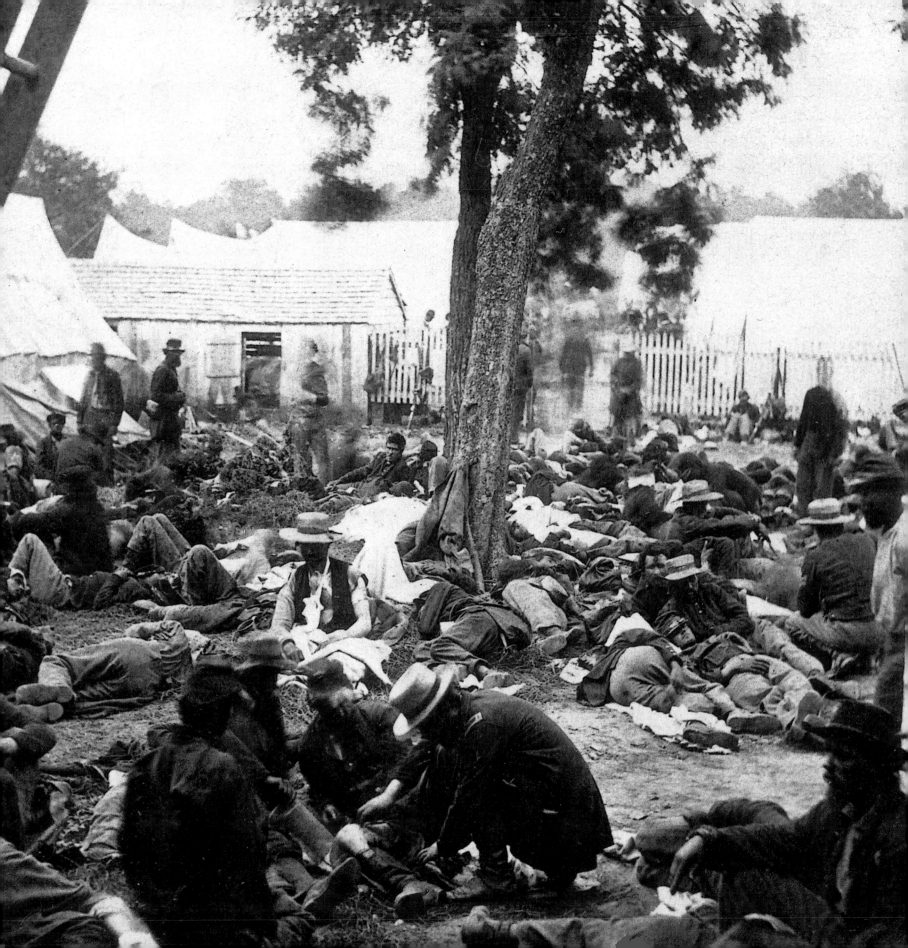

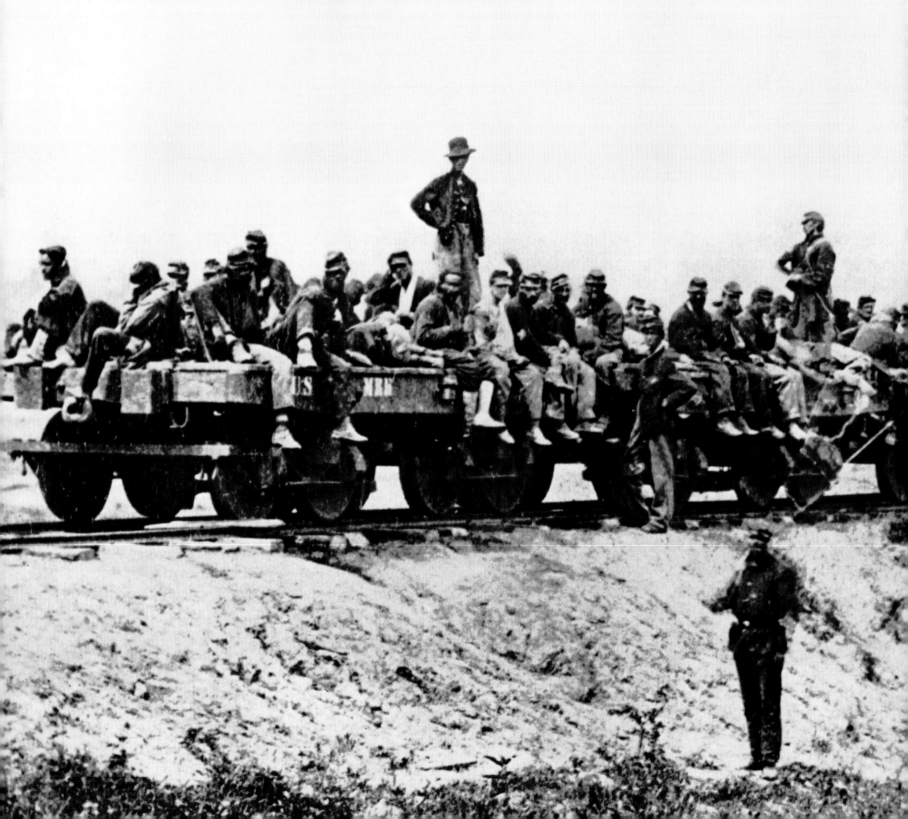

HARD-FIGHTING PENNSYLVANIANS
Zouaves of the 95th Pennsylvania, seen here deployed in skirmish formation, fought stubbornly at the Battle of Gaines' Mill, with 112 men killed or wounded.

EVACUATED BY RAIL
Federal soldiers wounded during the fighting at Fair Oaks crowd a flatcar on the Richmond & York River Railroad at Savage's Station. The rail line connected with White House Landing on the Pamunkey River, where the wounded could be evacuated by water to hospitals around Washington.

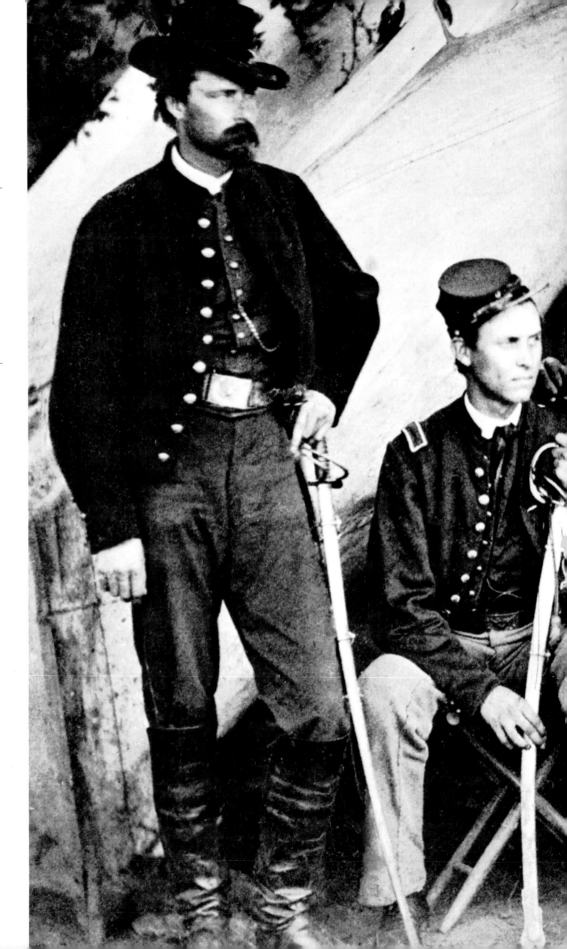

> *"To tell you the truth, no amount of money can pay a man for going through what we have had to suffer lately."*

ALFRED WAUD,
Special Correspondent, *Harper's Weekly*

BATTLE-HARDENED OFFICERS

Officers of the 3rd Pennsylvania Cavalry gather before a field tent for photographer Alexander Gardner. Their troops successfully covered the Federal retreat from Malvern Hill. Of the cavalrymen, General McClellan wrote in late July 1862: "Our men look like real veterans now—tough, brown and fearless."

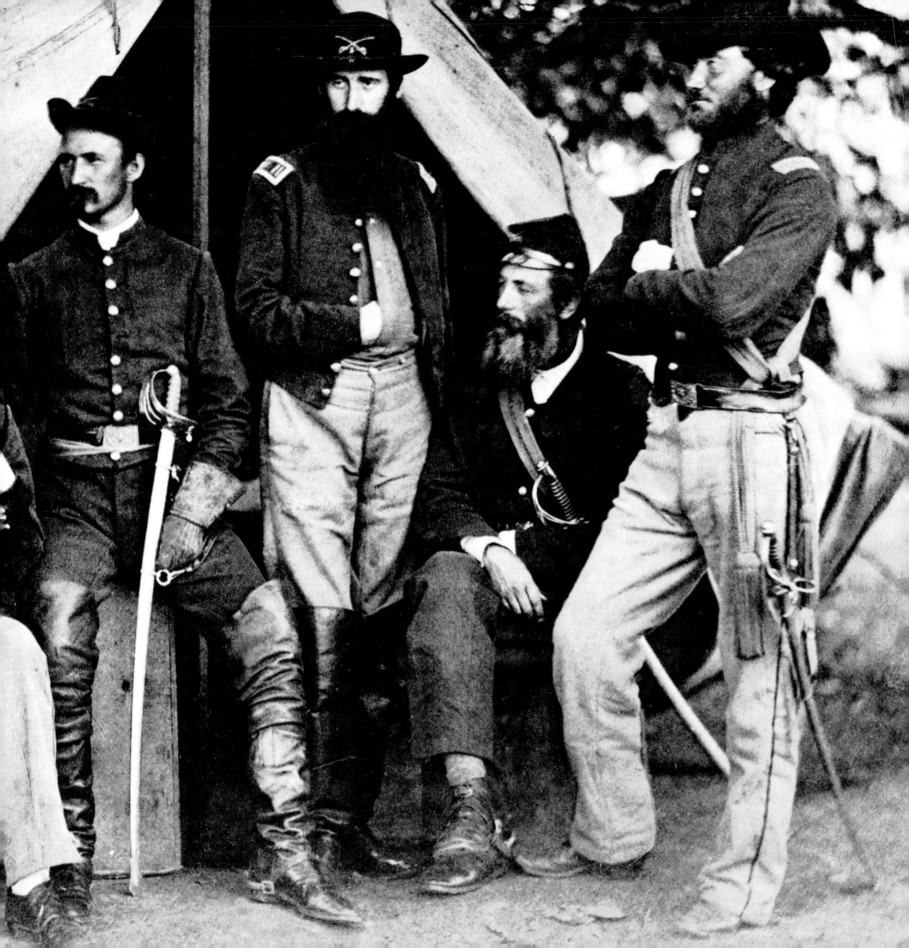

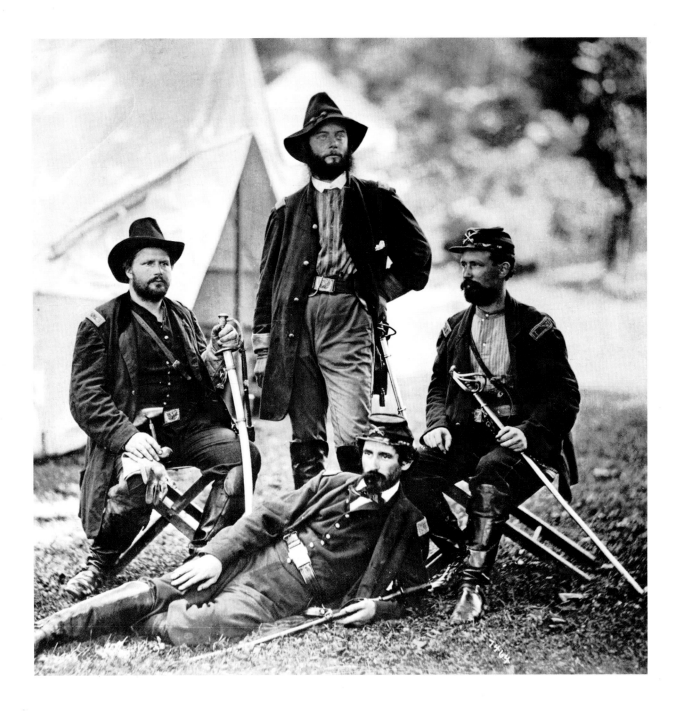

A DOOMED CAVALRYMAN

Colonel James H. Childs of the 4th Pennsylvania Cavalry *(standing)* poses with his staff officers. Childs, described by one of his men as a "commanding presence, courteous and affable," was killed at the Battle of Antietam on September 17, 1862.

EXHAUSTED VETERANS

Lieutenants Abel Wright and John Ford of the 3rd Pennsylvania Cavalry stare into Gardner's camera in front of cots draped with mosquito netting. "The ringing laugh is seldom heard," a soldier wrote. "The men go dragging along with sad and care-worn faces."

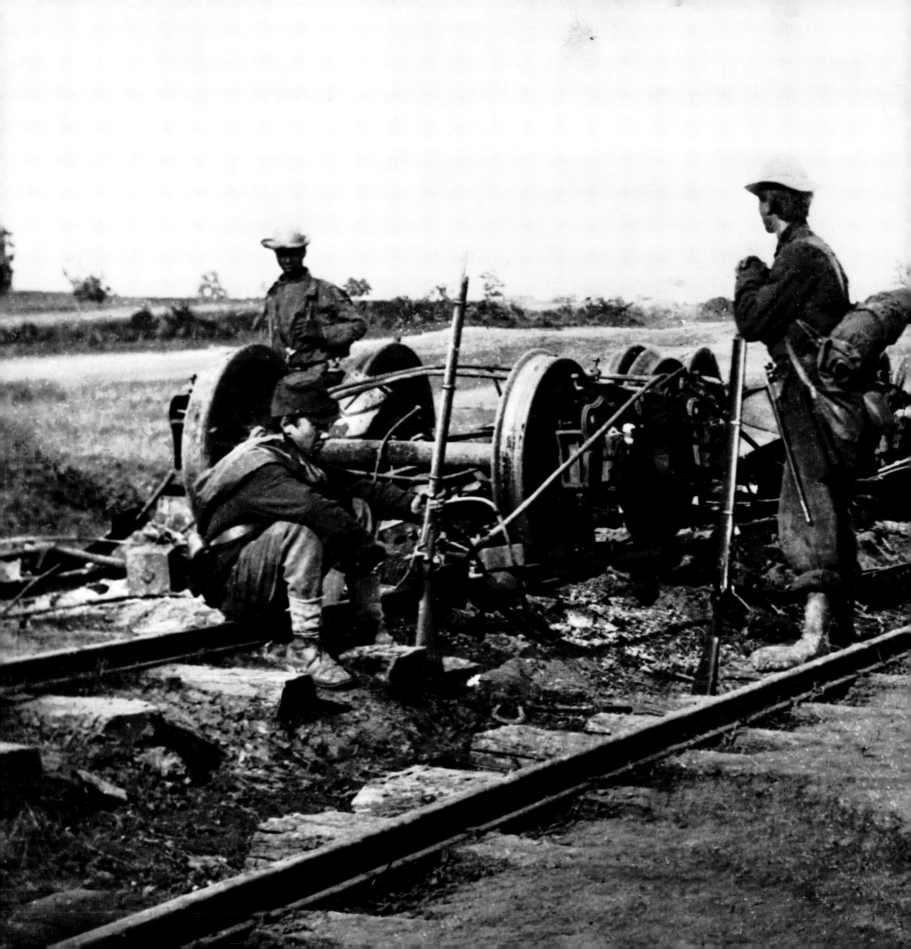

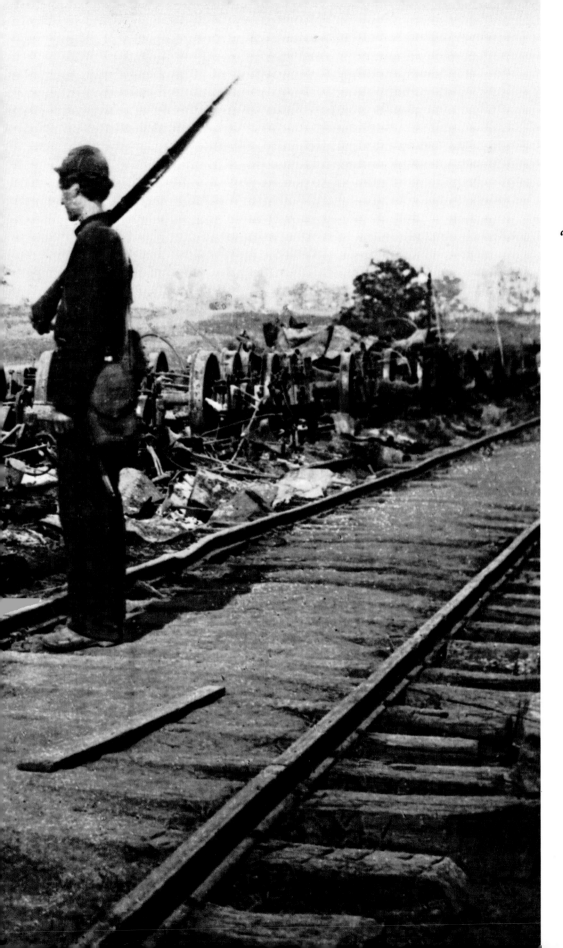

"I had often read of the sacking of cities by a victorious army but never did I hear of a railroad train being sacked. . . . I saw the whole army become what appeared to me to be an ungovernable mob, drunk, some few with liquor but the other with excitement."

CHAPLAIN JAMES B. SHEERAN,
14th Louisiana Infantry

OFF THE RAILS
Federal soldiers survey the wreckage of a train demolished by General Stonewall Jackson's troops during a surprise attack on Manassas Junction on August 26. By the following day, when this photograph was probably taken, Pope's forces realized that the raid was but the prelude to a major battle.

The Bloodiest Day

IMMEDIATELY AFTER HIS VICTORY AT SECOND MANASSAS, Lee turned his army northward to carry the war into enemy soil. "We cannot afford to be idle," Lee wrote to Jefferson Davis, "and though weaker than our opponents in men and military equipments, must endeavor to harass, if we cannot destroy them." Lee hoped to provide a respite for war-ravaged Virginia and forestall any further enemy advance on Richmond. Upon reaching Frederick, Maryland, Lee split his forces, sending Stonewall Jackson to capture Harpers Ferry while General James Longstreet continued the advance into Maryland.

Threatened by the Confederate invasion, Lincoln returned command to McClellan, who set out after Lee. At Frederick, McClellan received a lost copy of Lee's plan of operations. When Lee found out, he recalled his forces and decided to make a stand on Antietam Creek, near Sharpsburg.

On September 17th, the Federals began a massive onslaught against Lee's outnumbered forces. "I have heard of the 'dead lying in heaps,' but never saw it till this battle." recalled a Federal observer. On the brink of victory, the Union assault was halted by the arrival of Confederate reinforcements from Harpers Ferry. With more than 22,000 casualties, the Battle of Antietam proved to be the bloodiest single day of combat in American history. Though the great bloodletting failed to achieve a decisive victory for the Union, Lee's retreat the following day was perceived as a strategic success.

Lincoln was determined to take political advantage of the Confederate withdrawal. On September 22, Lincoln issued the Emancipation Proclamation, decreeing freedom for many of the Confederacy's 3.5 million slaves. Lincoln also urged the cautious McClellan to pursue Lee. On November 6, after repeated delays, the frustrated Lincoln gave command of the Army of the Potomac to General Ambrose Burnside, setting the stage for the savage battle at Fredericksburg.

TATTERED COLORS OF THE 34TH
Color bearers of the 34th New York display the regimental and national flags that they carried into battle at Antietam. In the morning fighting in the West Woods, the regiment, whose ranks had already been badly depleted during McClellan's Peninsula campaign, suffered 154 casualties, nearly half its strength.

CARNAGE ALONG THE HAGERSTOWN PIKE
Two days after the Battle of Antietam, dead Confederates, probably from General William Starke's Louisiana Brigade, remain where they fell along a fence line on the west side of the Hagerstown Pike. After rushing forward to stem a Federal advance, the Rebels were caught in a cross fire that took a heavy toll.

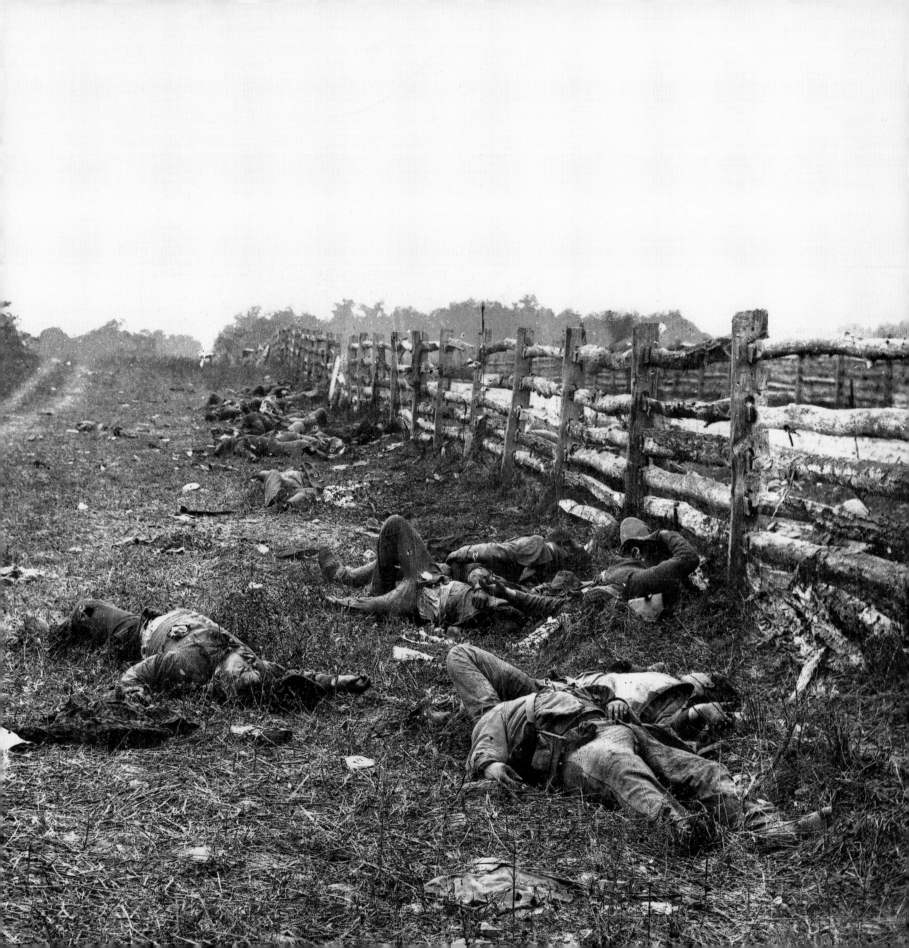

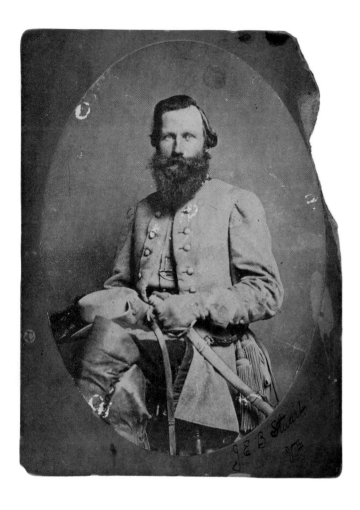

VIRGINIA'S CAVALIER

Major General James Ewell Brown "Jeb" Stuart commanded the cavalry
corps of the Army of Northern Virginia during Lee's Maryland Campaign.
In the Battle of Antietam, Stuart's cavalry guarded a ridge on the far left
of the Confederate line. From there his horse artillery harassed Federal
columns attacking from the north on the morning of September 17.

RAGGED REBELS

Confederates marching through Frederick, Maryland,
pause on Market Street in this rare photograph taken
from an upper window of J. Rosenstock's store. "They
were the dirtiest men I ever saw," a local woman noted,
"a most ragged, lean and hungry set of wolves. Yet there
was a dash about them that the northern men lacked."

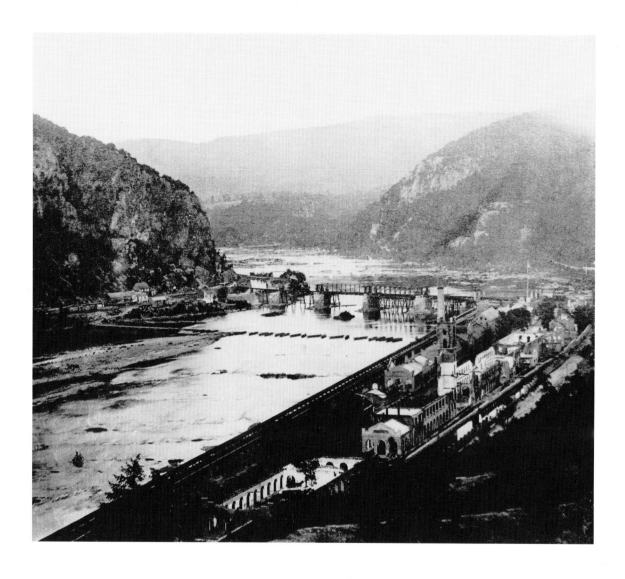

COMMANDING HEIGHTS

In this 1862 image taken before the siege, the Potomac flows past Harpers Ferry (*above, right*) to its confluence with the Shenandoah River, just beyond the town. Crossing the Potomac are the railroad bridge and a half-finished pontoon bridge that would be used by the Federals who abandoned Maryland Heights (*above, left*). The promontory to the right, Loudoun Heights, was left undefended by the Federals and during the siege became an artillery platform for Confederate gunners.

BOTTLENECK IN THE SHENANDOAH

Crowded aboard railway flatcars, soldiers pause in Harpers Ferry as a supply train chugs through town on the adjacent track. The town's strategic location and rail links with the lower Shenandoah Valley allowed occupying Federal forces to block one of Lee's key lines of communication between Virginia and Maryland.

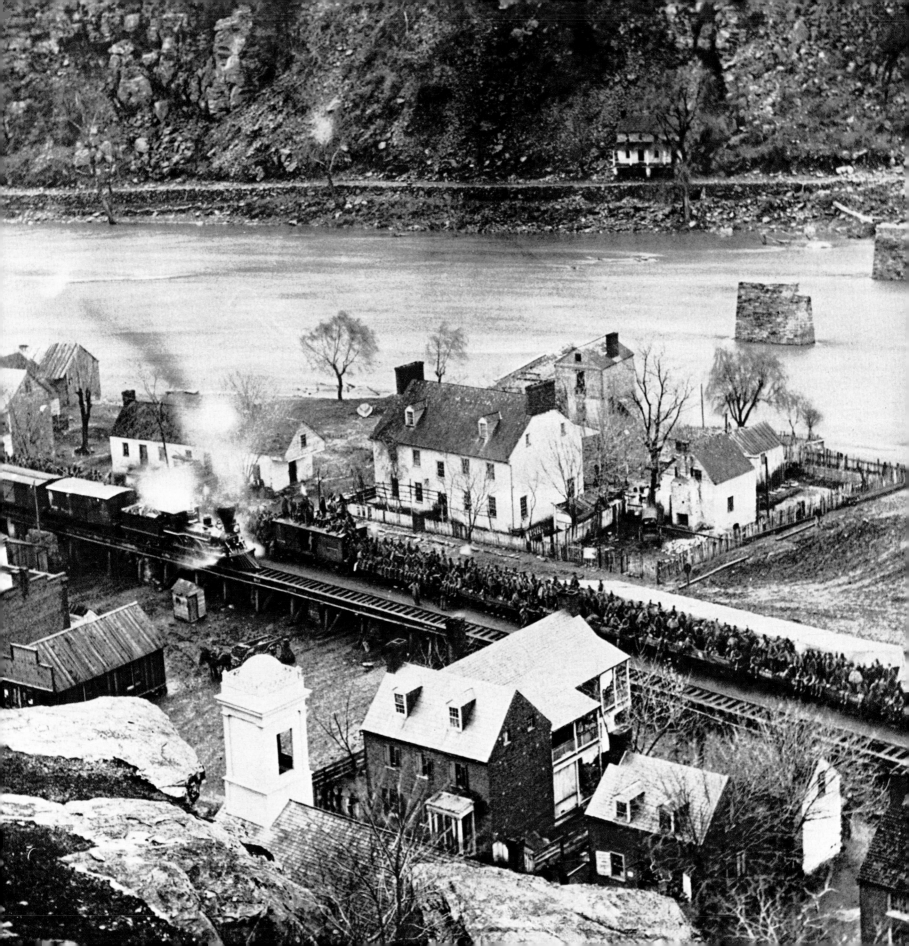

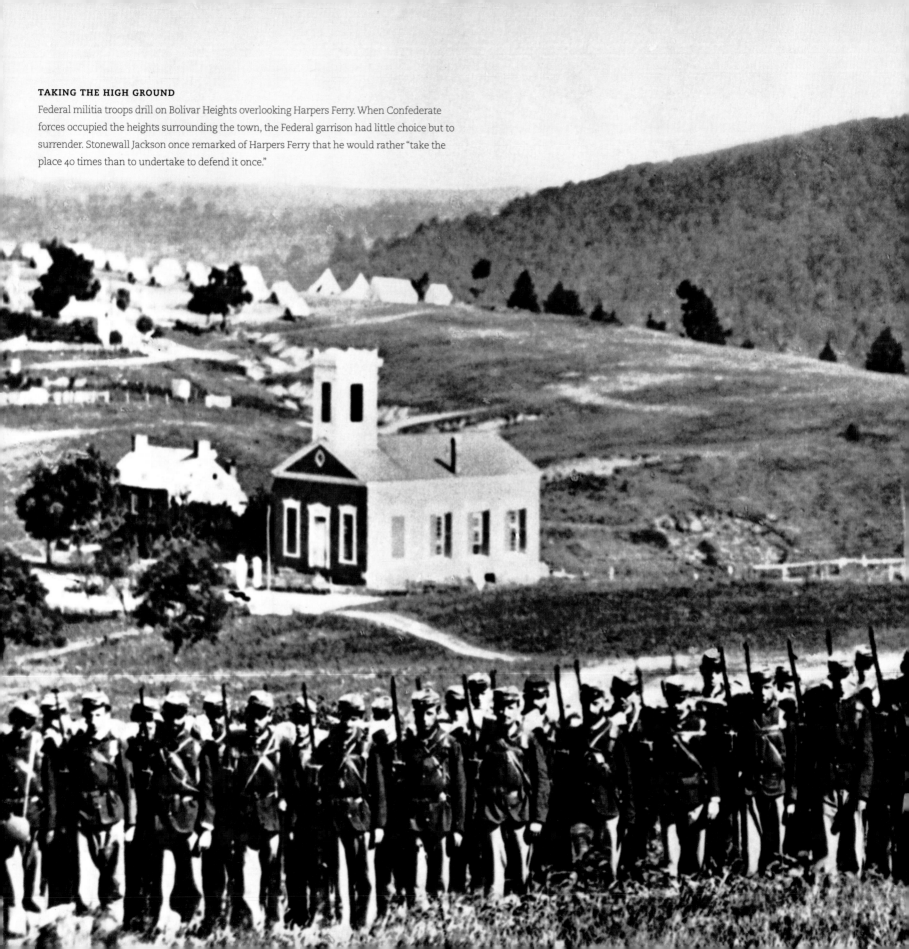

TAKING THE HIGH GROUND

Federal militia troops drill on Bolivar Heights overlooking Harpers Ferry. When Confederate forces occupied the heights surrounding the town, the Federal garrison had little choice but to surrender. Stonewall Jackson once remarked of Harpers Ferry that he would rather "take the place 40 times than to undertake to defend it once."

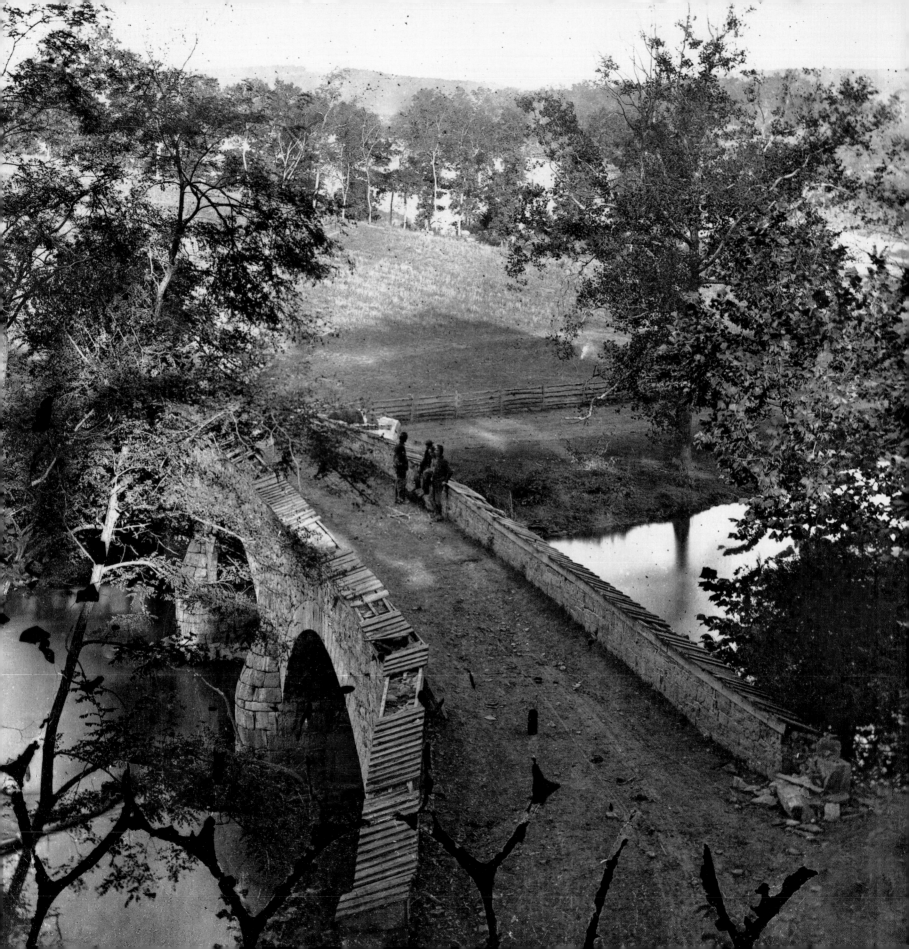

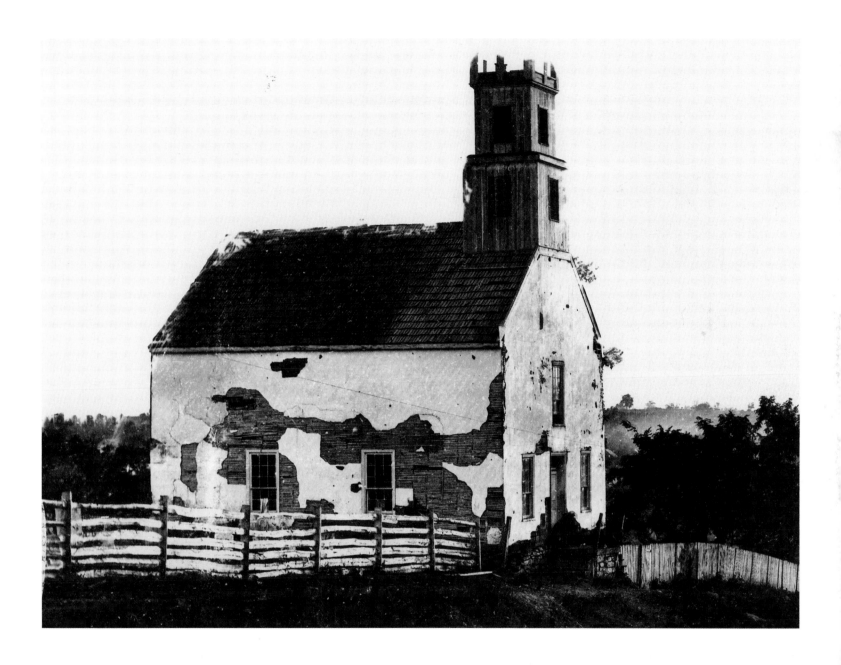

BURNSIDE BRIDGE

Federal soldiers pose on the hotly contested Burnside Bridge in this post-battle photograph taken from the wooded bluff on the west bank of Antietam Creek. From this position General Robert Toombs' Georgians held the bridge for hours, picking off Federals emerging from the tree line beyond the field on the far bank.

SCARS OF BATTLE

The Lutheran church on Main Street in Sharpsburg shows damage from Federal artillery fire. During the battle, the Confederates used the church as a signal station; by the time this photograph was taken, in late September 1862, the building housed a hospital.

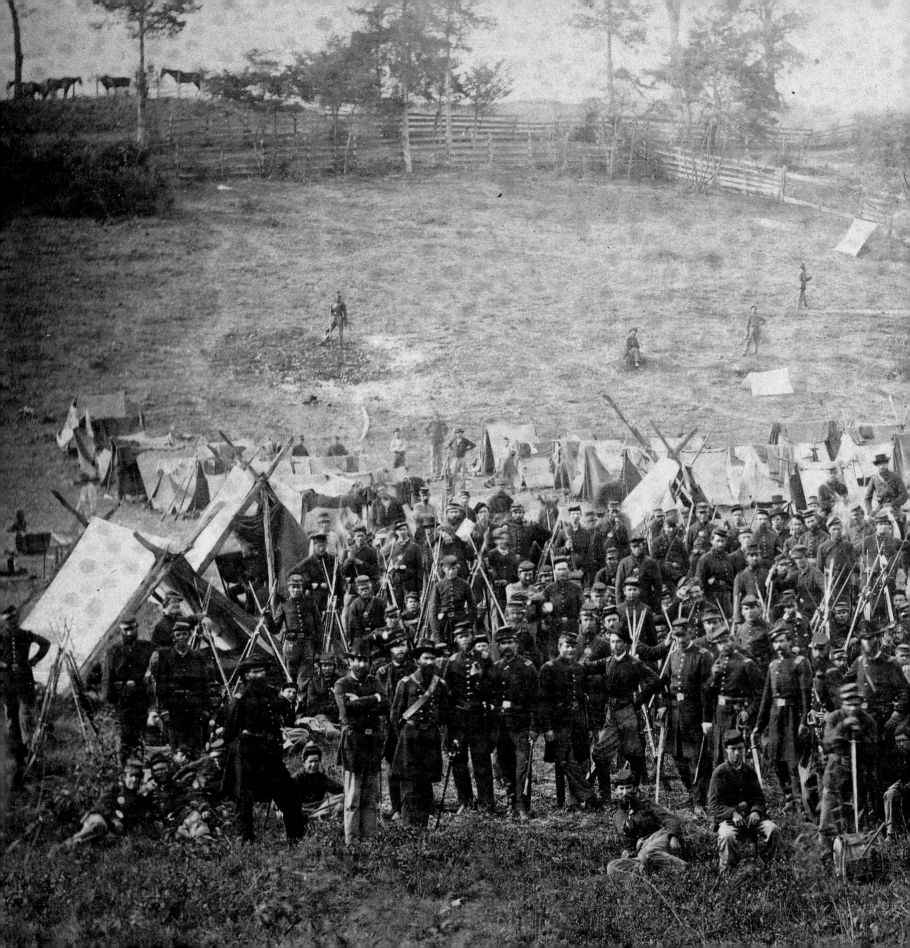

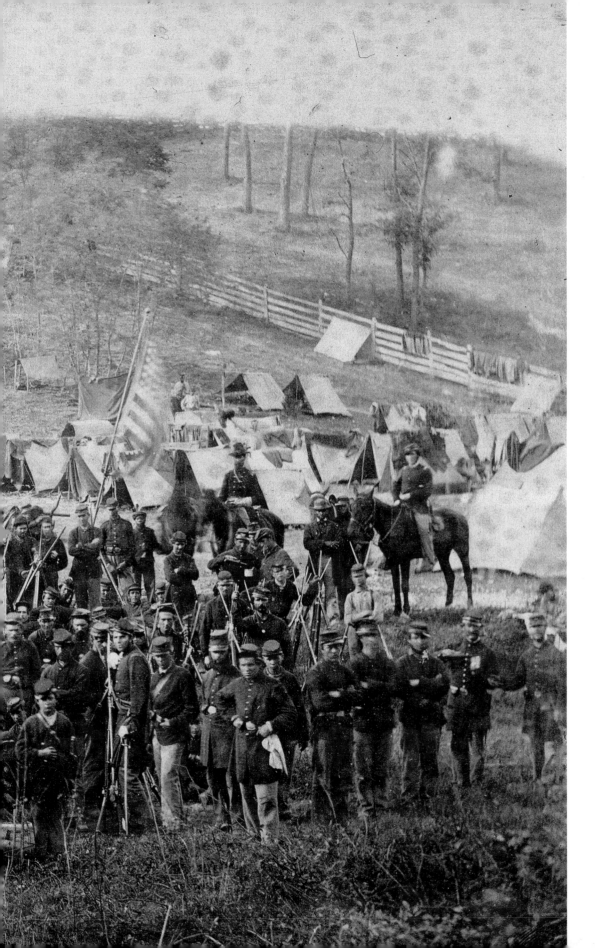

"I fear this Md trip has injured us more than done good[.] Wee lost more than wee gained in it."

CAPTAIN SHEPHARD G. PRYOR,
12th Georgia Infantry

GUARDING THE COMMANDING GENERAL
Soldiers of the 93rd New York, McClellan's headquarters guard, assemble in front of their tents near Sharpsburg after the battle. Eight months of hard campaigning had depleted their ranks from 998 officers and men to approximately 250.

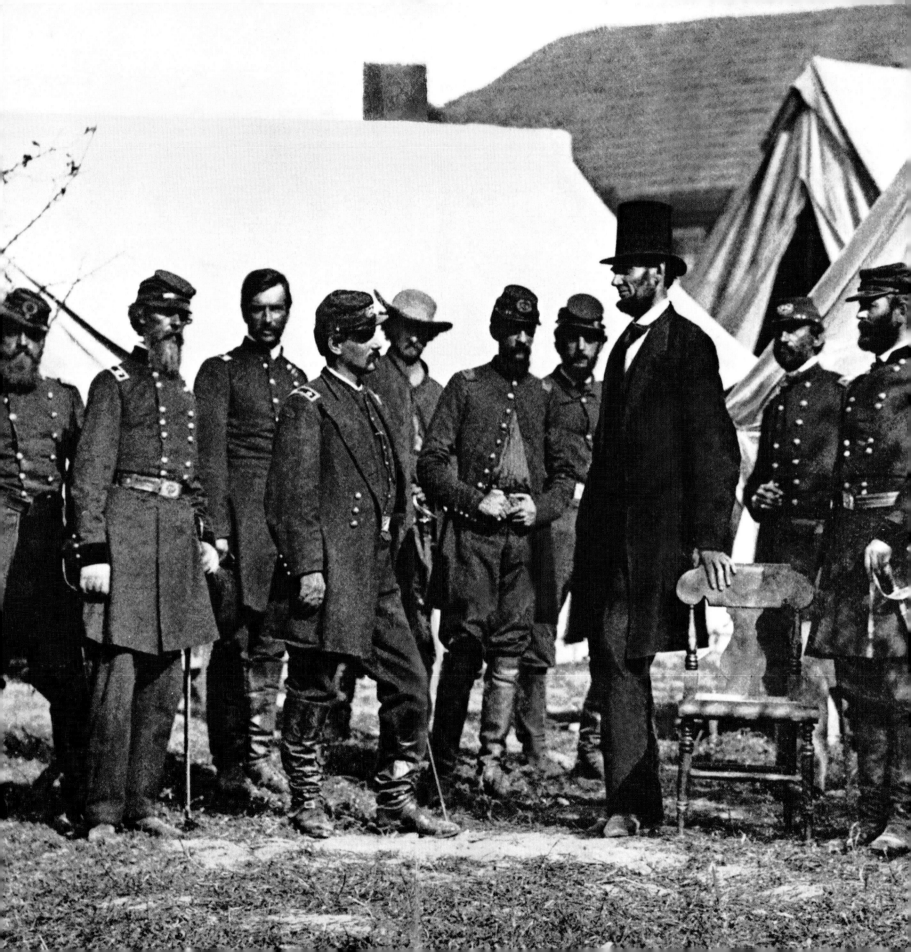

"Instead of a decided brilliant victory and the end of the war, we have a doubtful victory and the enemy left to recruit at will and prolong the contest indefinitely."

SURGEON DANIEL M. HOLT,
121st New York Infantry

PORTENTOUS MEETING

President Lincoln meets with General McClellan *(fourth from left)* and his staff at V Corps headquarters near Sharpsburg early in October 1862. Second from Lincoln's left is V Corps commander General Fitz-John Porter. At far right, wearing a slouch hat, is one of McClellan's aides-de-camp, Captain George Armstrong Custer.

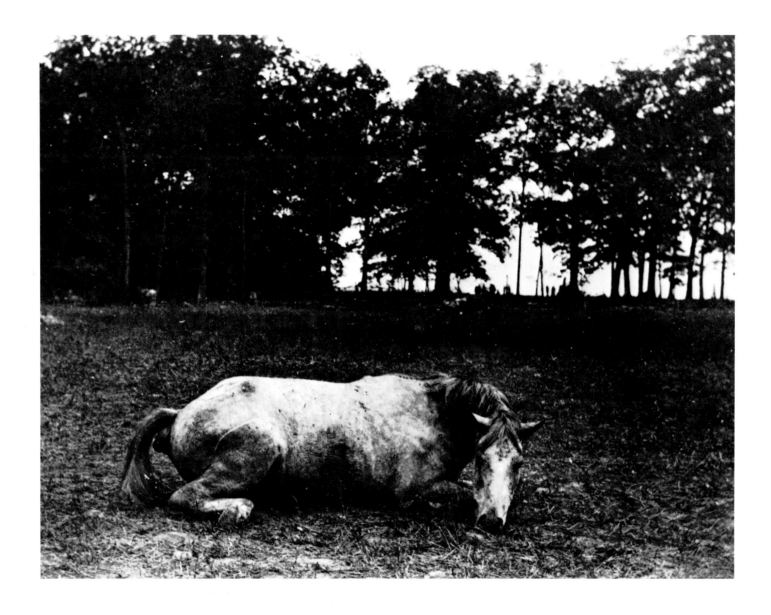

ATTRACTING THE CAMERA'S EYE

Eerily lifelike even in death, the horse of a Confederate colonel lies where it was shot from under its master in a field near the East Woods. The animal was one of many draft and riding horses killed in battle.

BURIED WHERE HE FELL

Several days after the battle, Federal soldiers relax by a dead tree on the Mumma Farm. At the foot of the tree is the new grave of Private John Marshall of the 28th Pennsylvania Infantry.

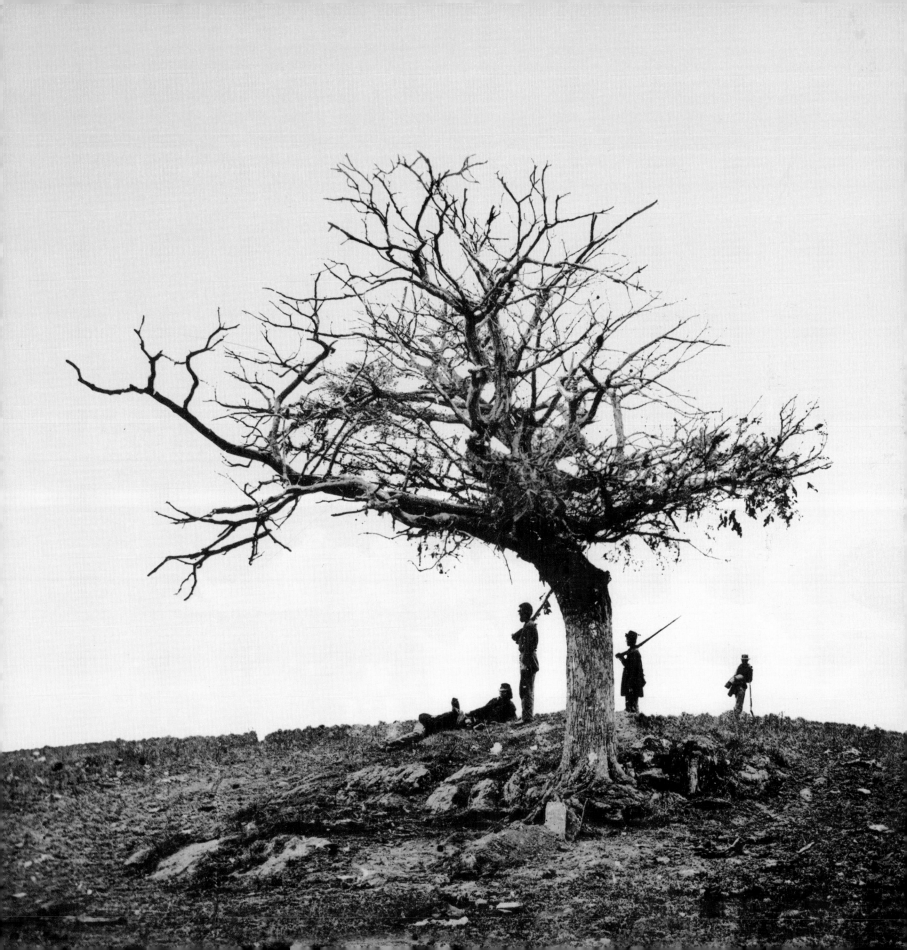

A GALLERY OF THE DEAD

In October 1862, Mathew Brady displayed a series of photographs in his New York City studio that put an end to the general public's romantic notions of the war. Taken at Antietam by Brady's colleague Alexander Gardner, the photographs were the first ever of dead Americans on a field of battle. Gardner and his assistant, James F. Gibson, reached the scene of the battle sometime between September 19 and 22, while Federal burial details still struggled with the horrific task of interring the thousands of corpses that dotted the farm fields and woodlands along Antietam Creek. Of the 55 plates exposed by Gardner and Gibson on the battlefield, the most graphic and at the same time compelling photographs were those of the contorted bodies of fallen Confederate soldiers. The Antietam photographs forever changed the perspective of an American public accustomed to landscape photography and sanitized newspaper engravings.

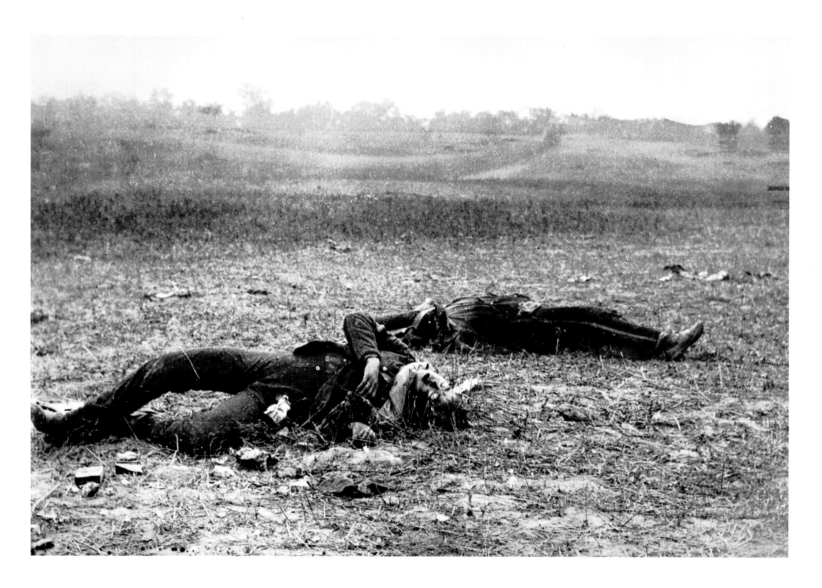

Confederate dead near Burnside Bridge

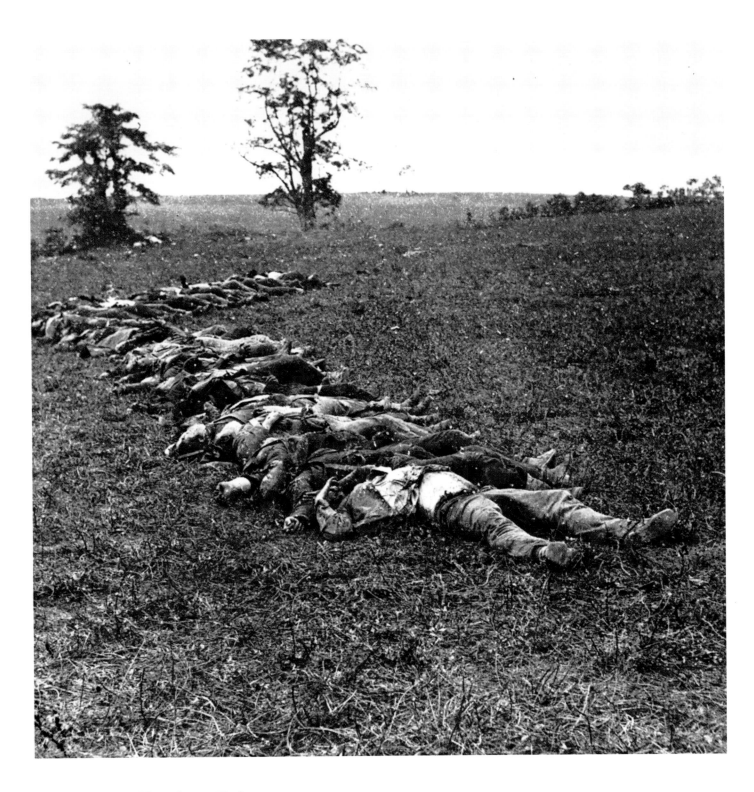

Bodies gathered for burial near the West Woods

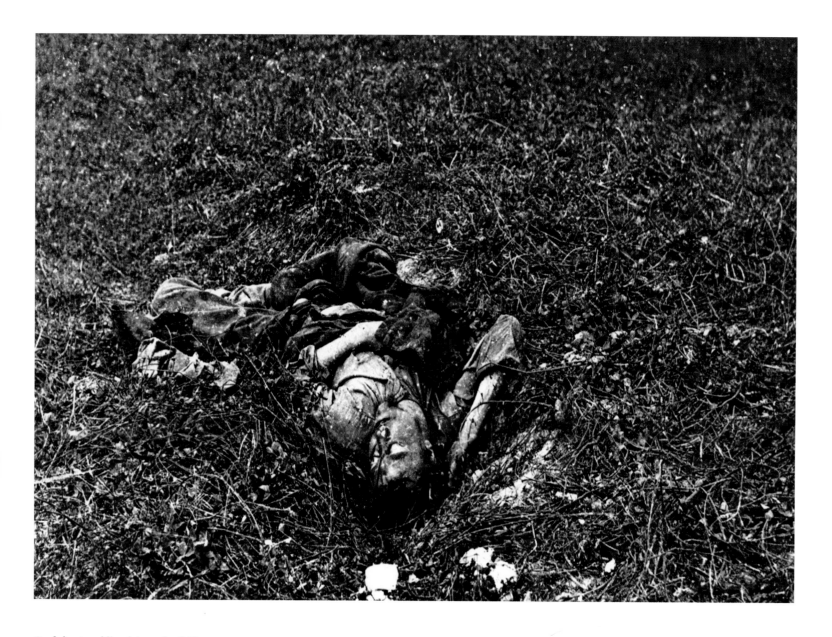

Confederate soldier slain on the field

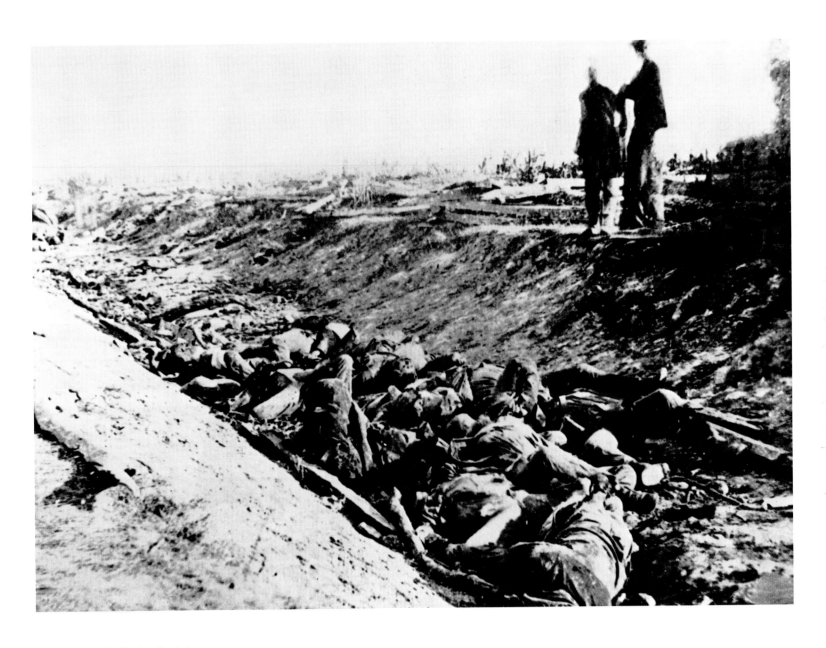

Confederates killed in the Bloody Lane

Liberation

TO CAST OFF A LIFETIME OF BONDAGE AND TAKE CONTROL OF THEIR DESTINIES as free men and women was the fervent prayer of many of the more than three million slaves living in the South when the war began. So profound was the desire for freedom that when Federal troops arrived bringing an end to bondage, many freedmen and -women likened the event to the biblical coming of the kingdom of heaven. One slave woman, amid Sunday dinner preparations, greeted each cannon blast from the nearby Manassas battlefield with a grateful, "Ride on, Massa Jesus."

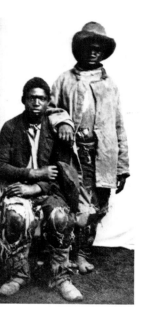

Slaves who fled to the Union lines were declared "contraband of war," and many were put to work for wages paid from the Federal treasury. These so-called contrabands were wards of the Federal government and did not gain their legal freedom until Lincoln's Emancipation Proclamation on January 1, 1863. Most slaves, however, had to await the arrival of Federal troops to experience freedom.

Northern missionaries and teachers followed the armies southward, establishing schools and churches for newly freed slaves. To a people whose memories of the lash were still vivid, the schoolhouse was a symbol of freedom and a guarantee against a return to slavery. A teacher reported that his pupils would "endure any penance rather than be deprived of this privilege."

Liberty afforded another opportunity when the War Department began recruiting former slaves for garrison duty and to man naval vessels. Ultimately, regiments of U.S. Colored Troops fought in both the eastern and western theaters. "Let the black man get upon his person the brass letters, U.S.," abolitionist Frederick Douglass declared, "let him get an eagle on his button, and a musket on his shoulder and bullets in his pocket, and there is no power on earth which can deny that he has earned the right to citizenship."

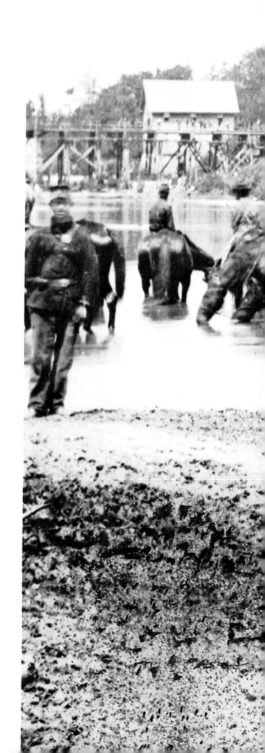

RAGGED RUNAWAYS
Two ragged young runaways from a Louisiana plantation sit for their portrait in Federally occupied Baton Rouge. During the war that city became a haven for fugitive slaves, who poured in from the surrounding countryside.

SLOW ROUTE TO FREEDOM
Traveling by oxcart, a family makes good its escape from bondage in August 1862 by reaching the Rappahannock River in Virginia, where a Federal army was camped. The war prompted thousands of slaves to desert their plantations and flee toward Federal lines.

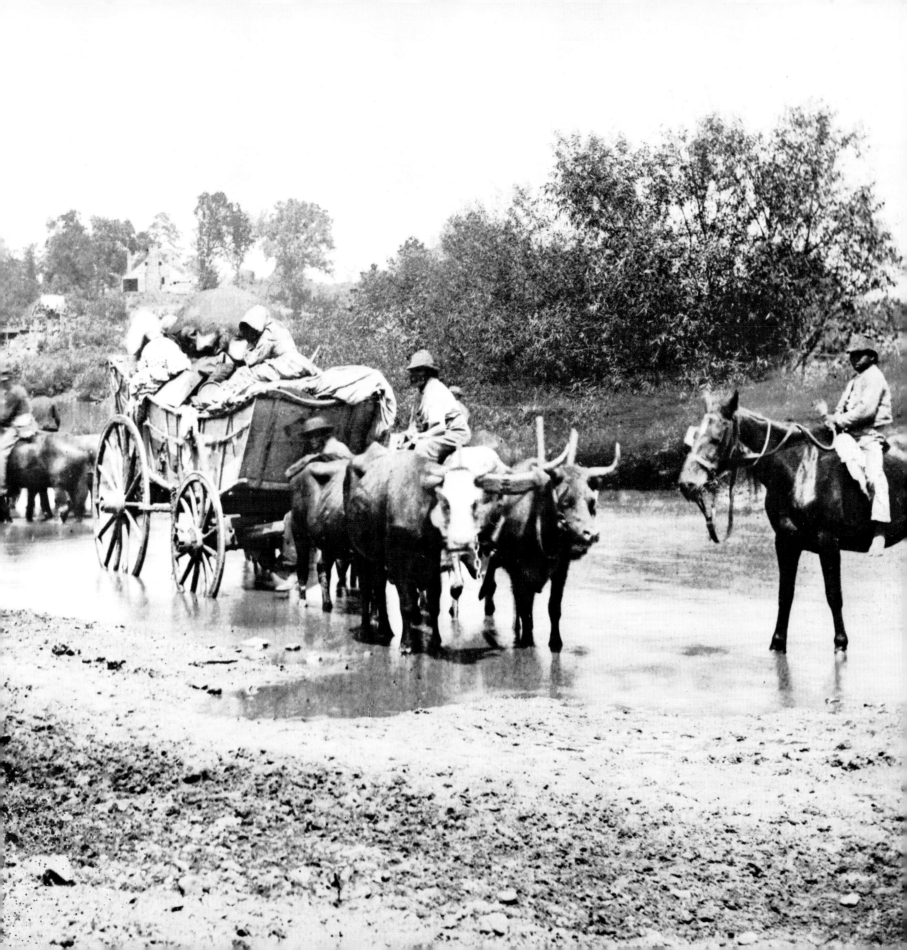

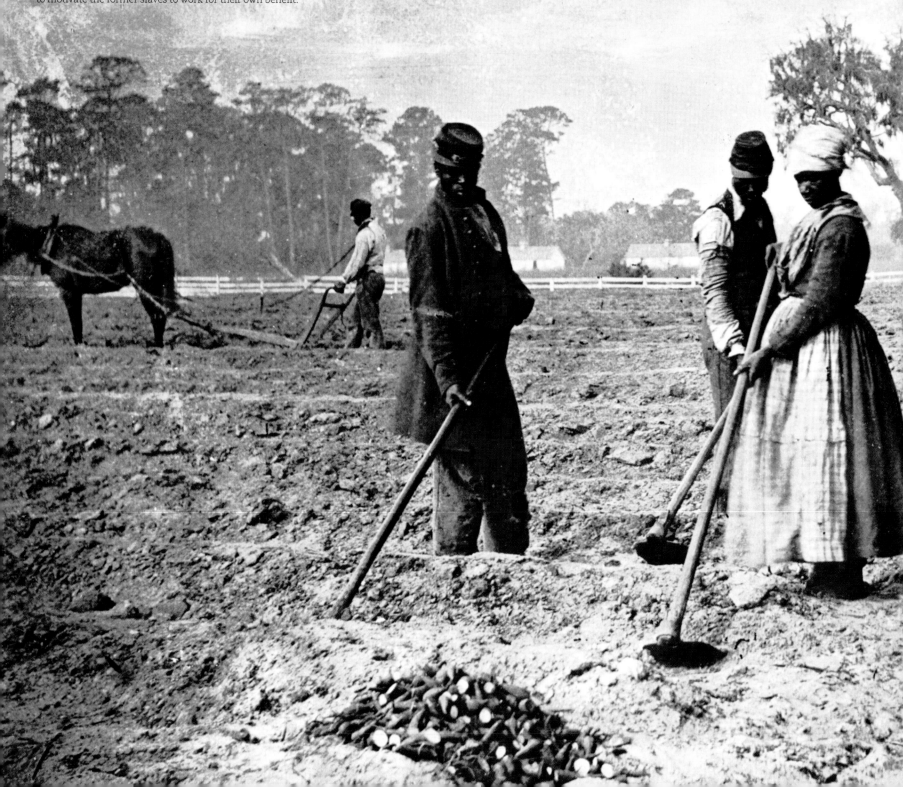

THEIR OWN PRODUCE
Newly liberated slaves, some wearing castoff Federal army uniforms, cultivate their own sweet-potato patch on a Hilton Head Island plantation. Government authorities encouraged such enterprise, both to increase food production and to motivate the former slaves to work for their own benefit.

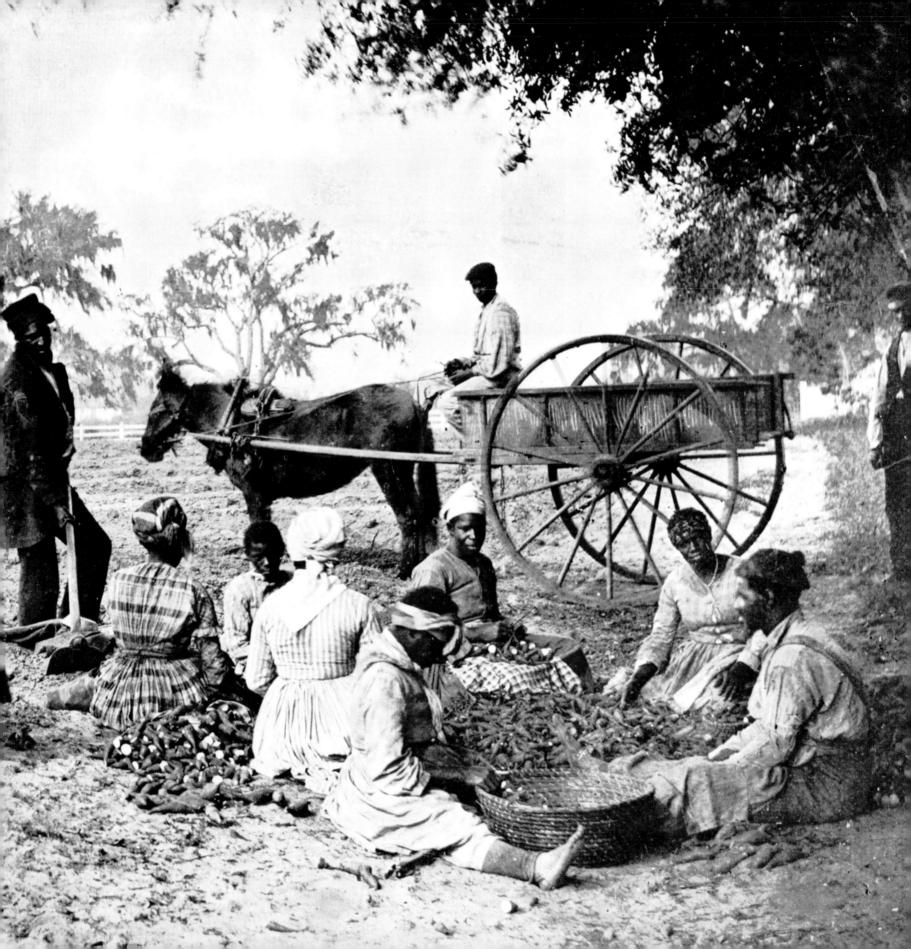

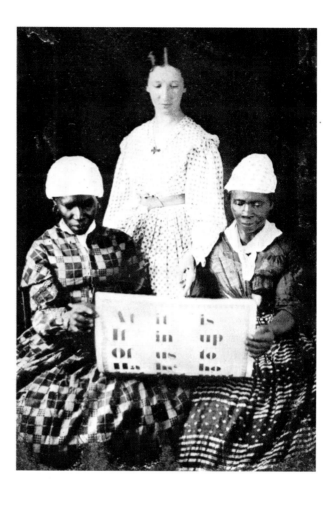

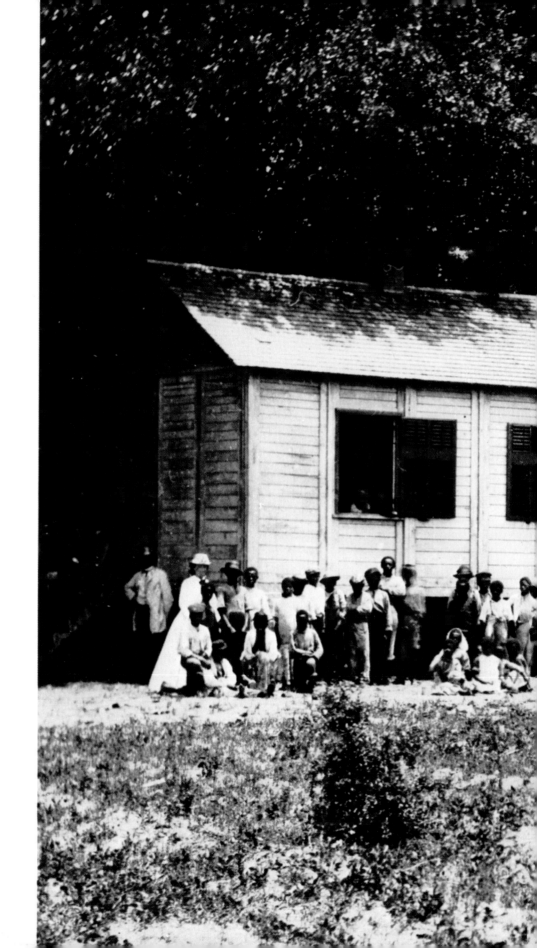

GIFT OF KNOWLEDGE
Kate Foote, a Connecticut volunteer sent to Beaufort, South
Carolina, in 1862 by the New England Freedman's Aid Society,
teaches two of her charges a grammar lesson. The slaves, one
instructor recalled, "had seen the magic of a scrap of writing
and were eager to share such power."

SEA ISLAND SCHOOLHOUSE
Newly freed slaves gather outside a school building in Beaufort,
one of 30 schools established for former slaves on the Sea Islands
by northern benevolent associations. By the end of the war, more
than 9,000 freedmen were attending classes along the South
Carolina coast.

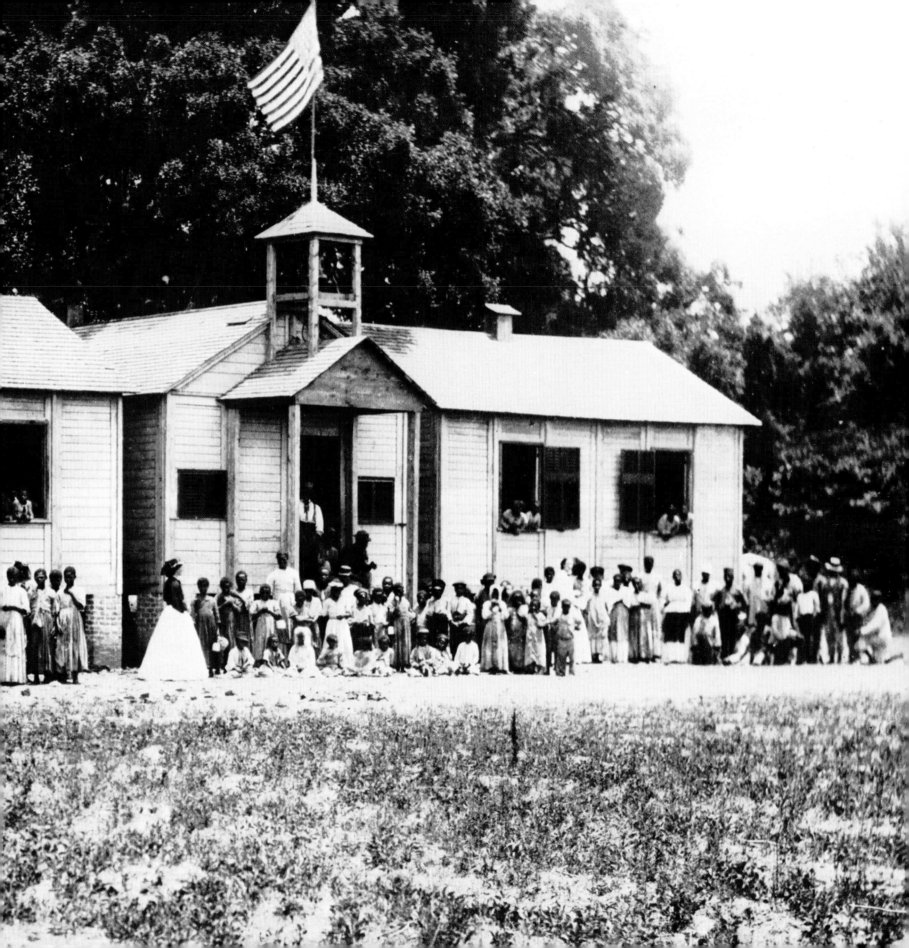

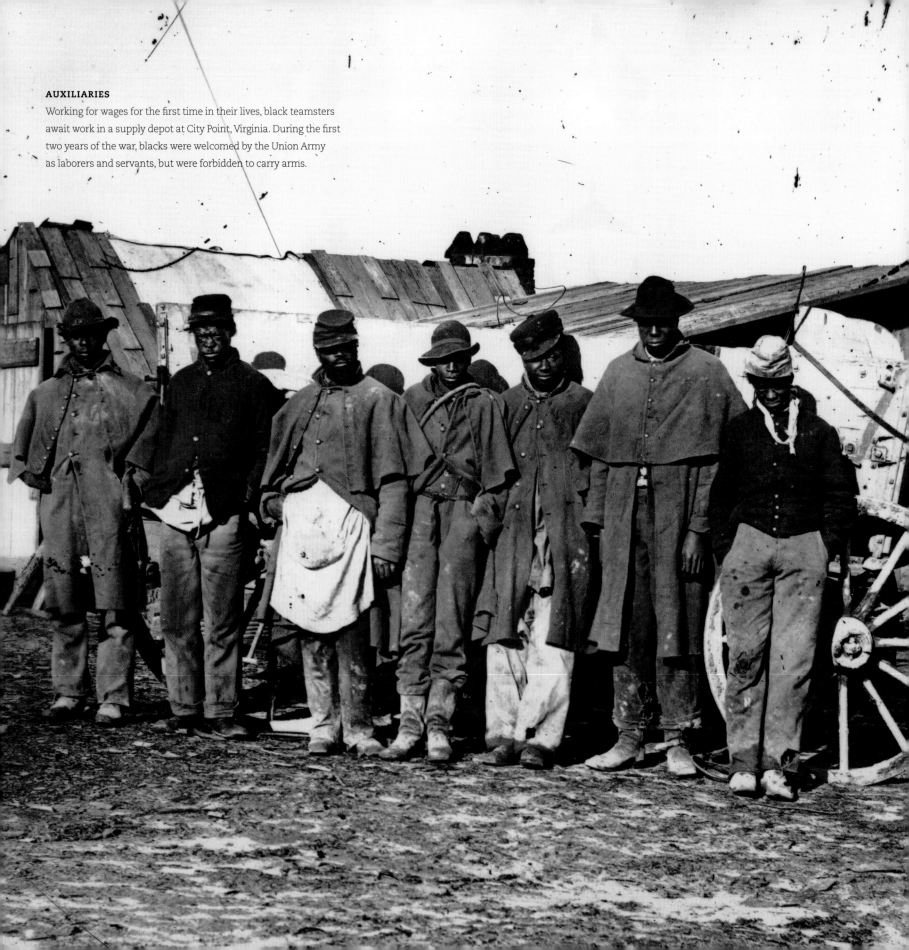

AUXILIARIES
Working for wages for the first time in their lives, black teamsters
await work in a supply depot at City Point, Virginia. During the first
two years of the war, blacks were welcomed by the Union Army
as laborers and servants, but were forbidden to carry arms.

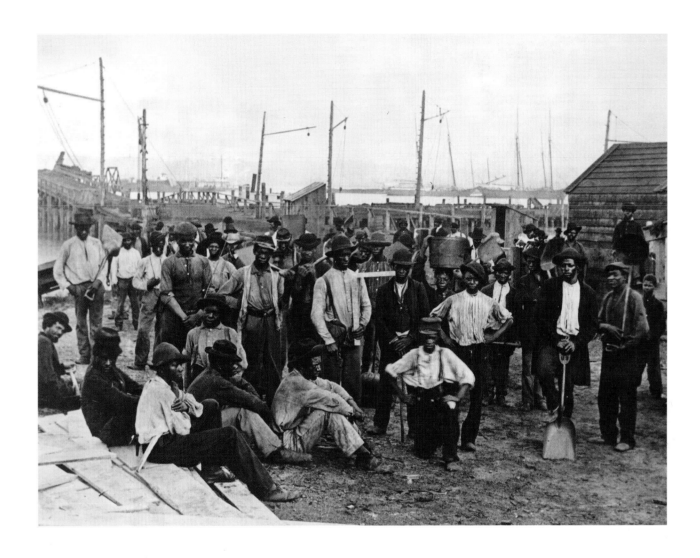

THEY ALSO SERVE

Black dockworkers assemble for work in the Federally occupied port city of Alexandria, Virginia. By mid-1862 blacks were also contributing to the Federal war effort as scouts, spies, hospital workers, blacksmiths, and mule drivers for army troops.

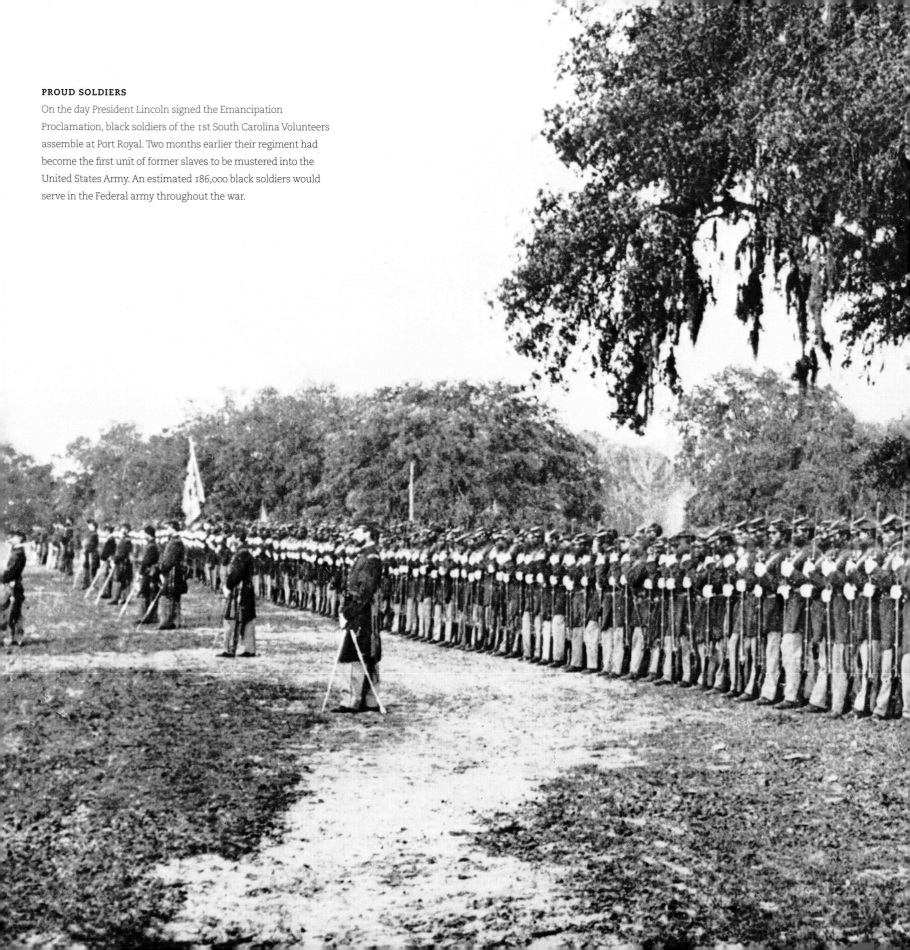

PROUD SOLDIERS

On the day President Lincoln signed the Emancipation Proclamation, black soldiers of the 1st South Carolina Volunteers assemble at Port Royal. Two months earlier their regiment had become the first unit of former slaves to be mustered into the United States Army. An estimated 186,000 black soldiers would serve in the Federal army throughout the war.

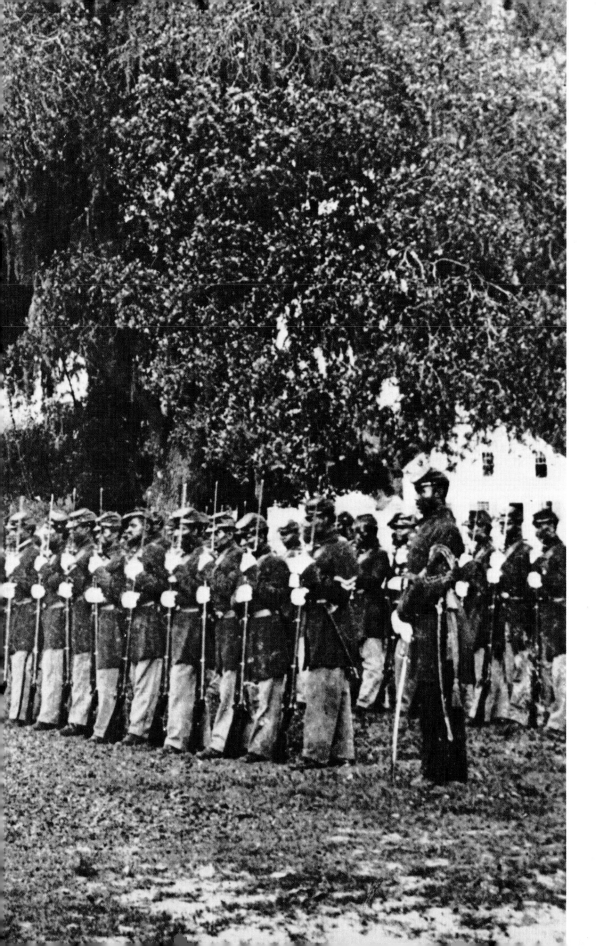

> "The arm of the slaves is the best defense against the arm of the slaveholder."
>
> FREDERICK DOUGLASS

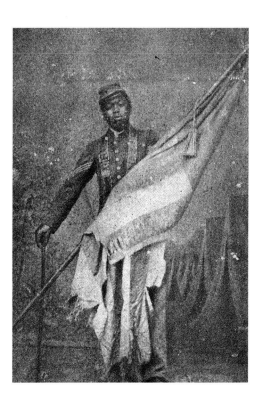

MARK OF VALOR

Sergeant William H. Carney, of Company C, 54th Massachusetts, who was born in slavery and freed upon the death of his master, later moved to the seafaring town of New Bedford, Massachusetts. During the attack on Battery Wagner near Charleston, South Carolina, Carney seized the U.S. colors from a fallen bearer and planted the flag on the ramparts. Repeatedly wounded, he managed to crawl from the battlefield, the bloodstained banner in his arms. Carney's bravery earned him the Medal of Honor.

Rebels Resurgent

IN THE FALL OF 1862, WITH WINTER RAPIDLY APPROACHING, General Ambrose Burnside reorganized his army and moved decisively to seize Fredericksburg, on the Rappahannock River. Burnside hoped to deny Lee a valuable defensive position and force the Confederates to fall back on Richmond. Costly delays, largely due to the late arrival of the Federal pontoon train, enabled Lee's troops to occupy the heights behind the city.

On December 13, Burnside ordered his men across the icy Rappahannock in an unsuccessful attack on Confederate positions south of town. In the afternoon, following a futile bombardment, the Federals occupied Fredericksburg, and Burnside launched a series of ill-conceived frontal assaults against the Rebel earthworks on Marye's Heights. Regiment after regiment attacked, marching up the corpse-strewn hill as if on parade, with fixed bayonets and flags flying. "Their devotion transcended anything I ever saw or dreamed of," General Orlando Poe wrote; "men walked right up to their death as though it were to a feast." By the day's end more than 12,000 Federals had died.

In January 1863, Major General Joseph "Fighting Joe" Hooker replaced Burnside as commander of the Army of the Potomac and immediately set about helping the dejected troops encamped above the Rappahannock on Stafford Heights. In late April, more than 70,000 Federals forded the river upstream from Fredericksburg, moving rapidly to get behind Lee's 40,000 Confederates. Despite successfully stealing a march on Lee, Hooker hesitated and fell back on the defensive around the crossroads at Chancellorsville.

Seizing the opportunity, Lee divided his army, sending Stonewall Jackson on a daring march to attack the exposed Federal right flank. The attack succeeded but was marred by the mortal wounding of Jackson by his own men. Repeated Confederate assaults over the next two days sent the Federal army back across the Rappahannock.

"FRENCH MARY"
Following French military practice, Mary Tepe—known as French Mary—served as a *vivandière*, or canteen carrier in the 114th Pennsylvania Zouaves. At Fredericksburg she was struck in the heel by a bullet as she helped succor the 114th's wounded.

WATCHING THE ENEMY
Positioned high on a slope, a Federal signal party uses telescopes and binoculars to observe Confederate positions near Fredericksburg in the spring of 1863.

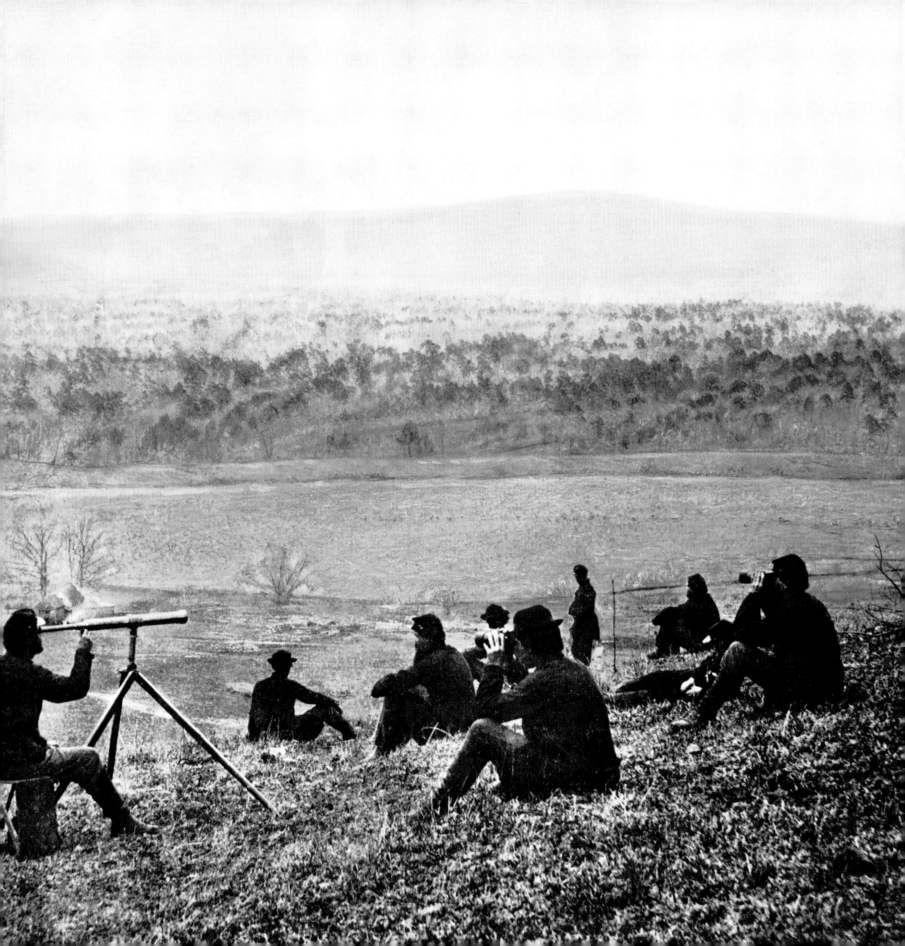

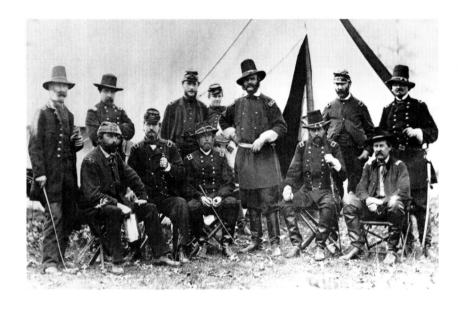

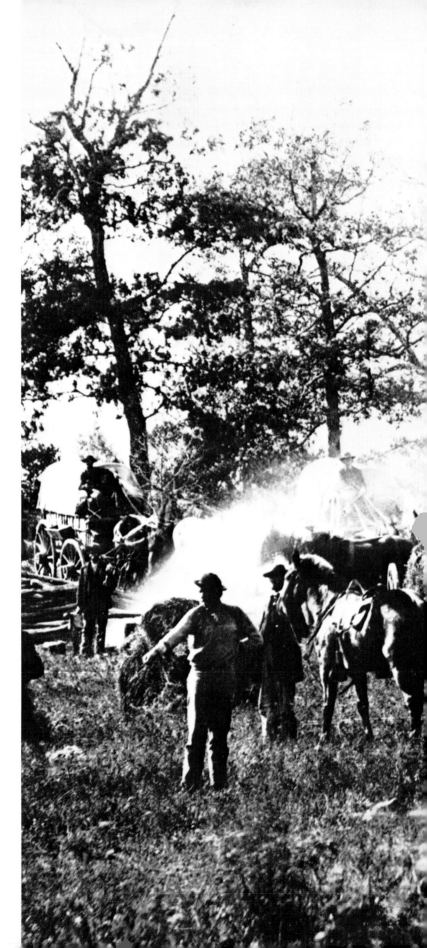

UNCERTAIN COMMAND

Ambrose Burnside and his senior generals commemorate his appointment as army commander with this photograph taken in camp at Warrenton. Several of the men pictured here bitterly opposed the removal of General McClellan, but nevertheless rallied around the affable Burnside. As Brigadier General Winfield Scott Hancock wrote, "We are serving no one man; we are serving our country."

SINGING WIRES

Perched precariously atop fresh-cut saplings, members of a telegraph construction crew string wire with the assistance of a crew on the ground. During the Chancellorsville campaign, roughly strung telegraph wires allowed Federal headquarters to communicate quickly with each other.

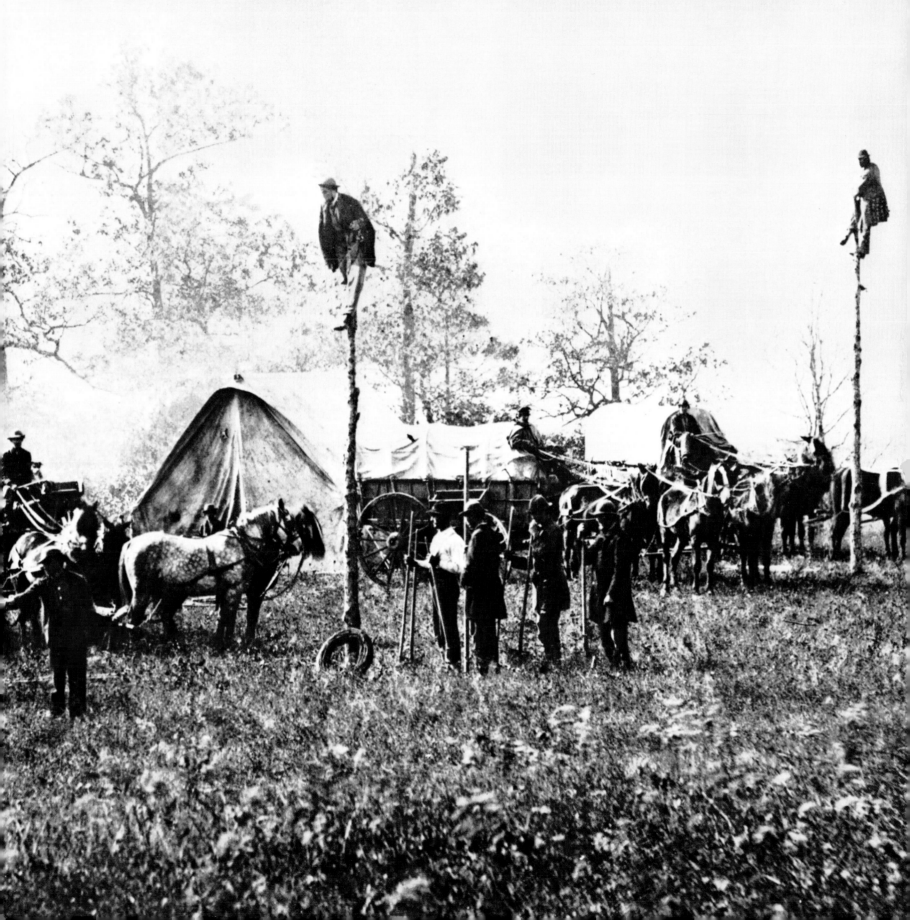

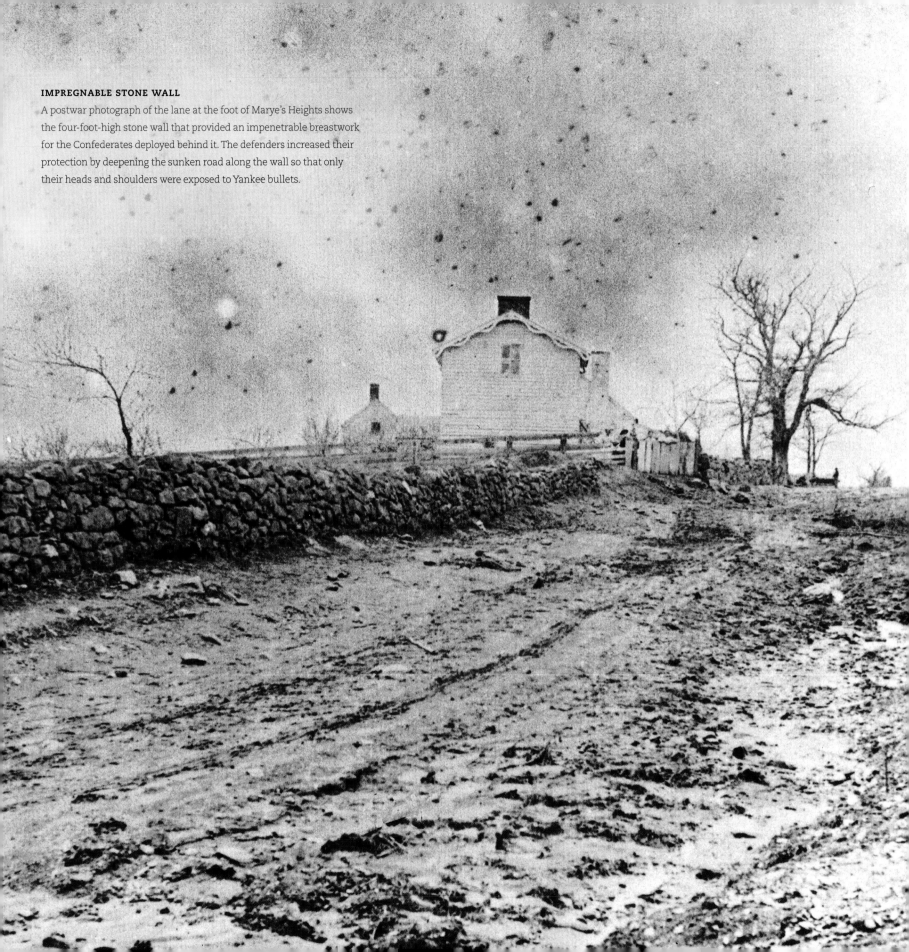

IMPREGNABLE STONE WALL

A postwar photograph of the lane at the foot of Marye's Heights shows the four-foot-high stone wall that provided an impenetrable breastwork for the Confederates deployed behind it. The defenders increased their protection by deepening the sunken road along the wall so that only their heads and shoulders were exposed to Yankee bullets.

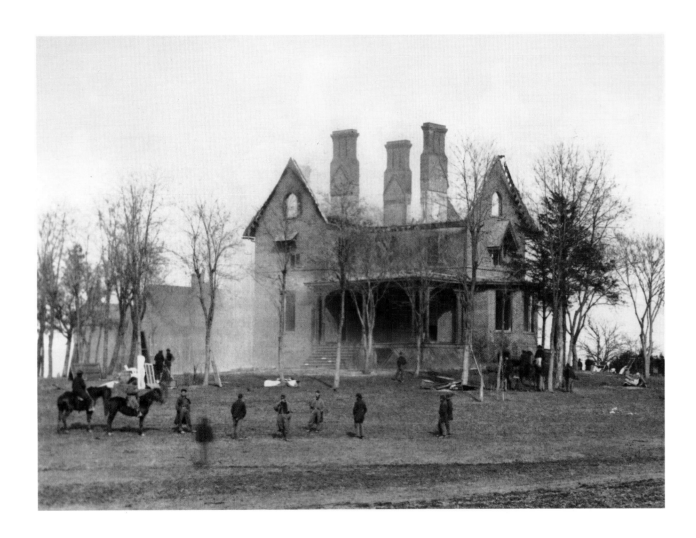

PHILLIPS HOUSE IN RUINS

The Phillips House, near Falmouth, used by Burnside as his headquarters during and after the battle, accidentally caught fire and burned to a shell in February 1863. "Not a bucket of water could be had to quench the fire," lamented Burnside's provost marshal. "Wells all dry."

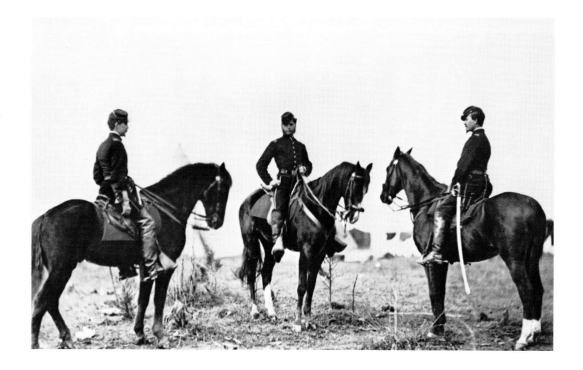

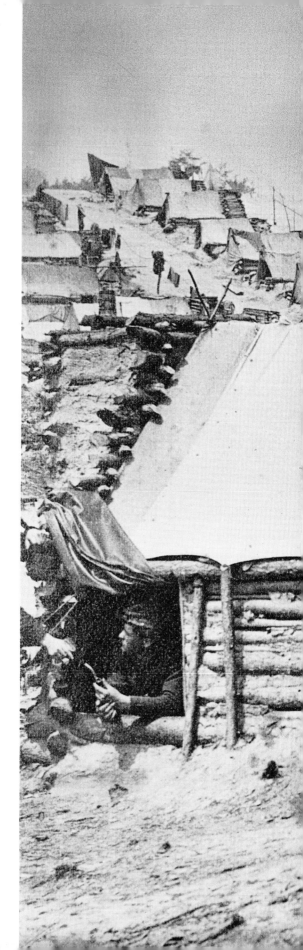

BOOTED AND SPURRED

Captains William Candler, Harry Russell, and Alexander Moore, aides de camp to General Joseph Hooker, pose atop their steeds in this photograph taken on Stafford Heights shortly before the Battle of Chancellorsville. On the battlefield, aides carried messages and served as the general's eyes and ears.

WINTER QUARTERS

The huts of a Federal winter encampment sprawl across a hillside near Stoneman's Switch, about a mile from Fredericksburg on Stafford Heights. The group gathered in the foreground includes portly Chaplain Jeremiah Shindel of the 110th Pennsylvania, whose hat bears the white diamond insignia of the III Corps.

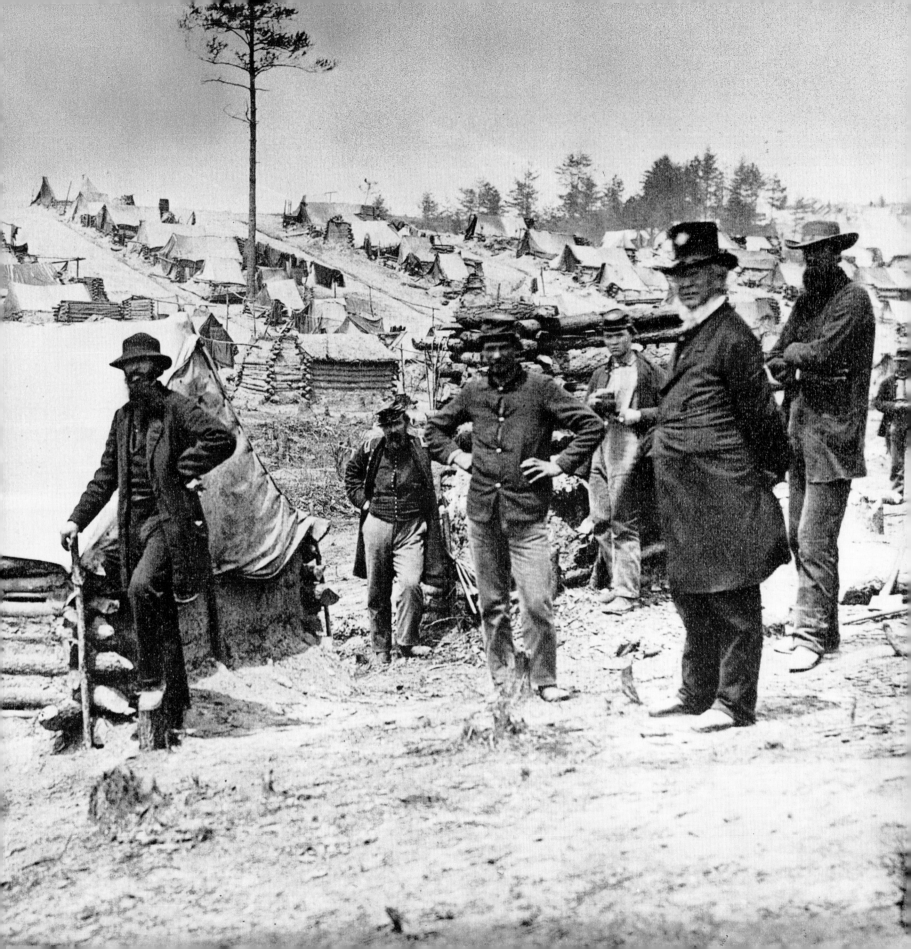

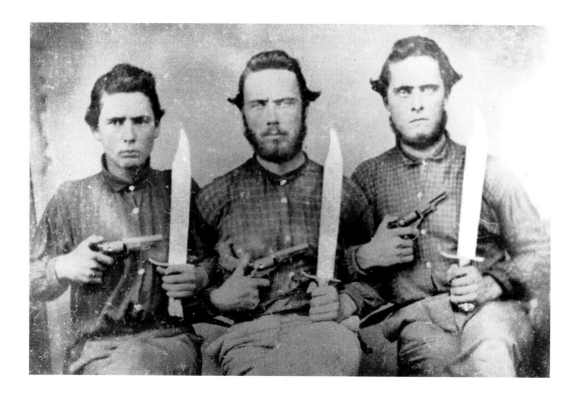

THE FIGHTING CHITWOOD BROTHERS

In 1861, siblings Daniel, John, and Pleasant Chitwood signed up with a Georgia militia company called the Bartow County Yankee Killers, which became Company A of the 23rd Georgia Infantry. In October 1862, Pleasant Chitwood succumbed to chronic diarrhea in a Richmond hospital, and on May 2, 1863, Daniel and John were captured during the fighting at Chancellorsville.

POSING FOR A YANKEE CAMERAMAN

Occupying the buttress of a wrecked railroad bridge that had spanned the Rappahannock at Fredericksburg, pickets of Brigadier General William Barksdale's Mississippi Brigade stare across the river at Union positions during the informal truce before the Battle of Chancellorsville. In this rare photograph of enemy troops, the camera lens has somewhat foreshortened the 400-foot distance between photographer Andrew J. Russell and the Confederates.

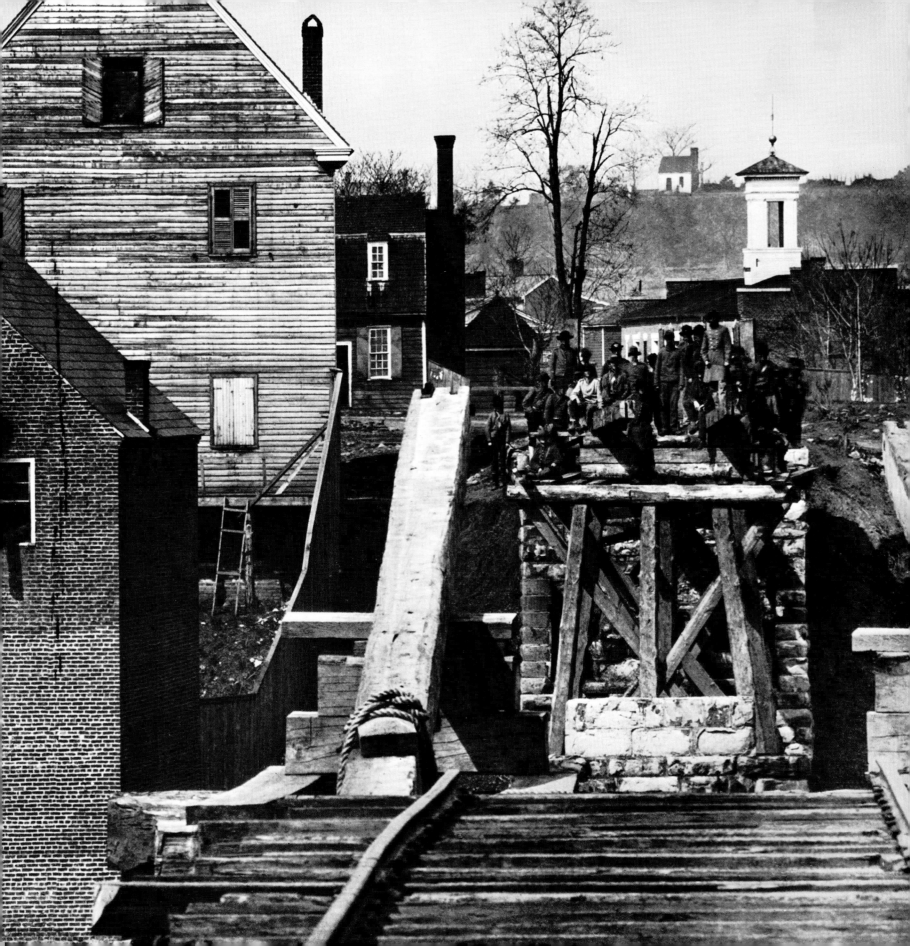

FATAL ROADSIDE

This photograph of the Plank road—with some of its wooden planking visible at right—was allegedly taken at the spot where Stonewall Jackson was mistakenly shot by his own men on the night of May 2. In fact, Jackson and his party were riding on the Mountain Road, possibly the dark track visible to the right of the two men at center, leading from the Plank road.

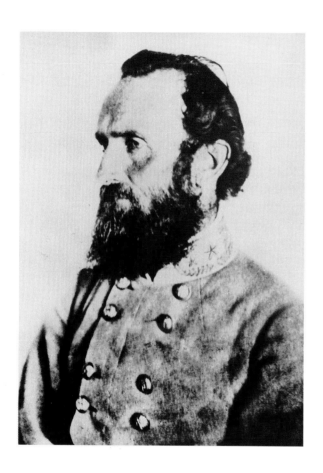

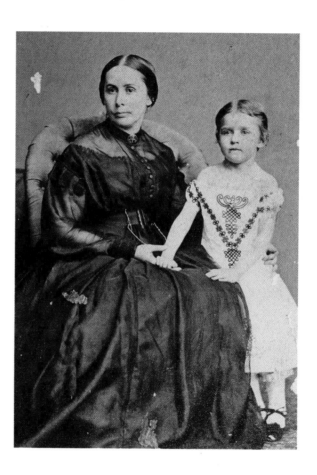

LAST PORTRAIT OF A REBEL HERO

Wearing the braid-trimmed uniform given him by the dapper Jeb Stuart, Stonewall Jackson sat in unaccustomed finery for what proved to be his final portrait. The photograph was taken at the request of his wife, Anna.

STONEWALL'S WIDOW

Dressed in mourning, Mary Anna Jackson, widow of Stonewall Jackson, poses with their daughter Julia. The campaigns of 1862 and the hard winter following the Battle of Fredericksburg had separated Jackson from his wife for a year, and he had not seen the baby daughter born to them during that time.

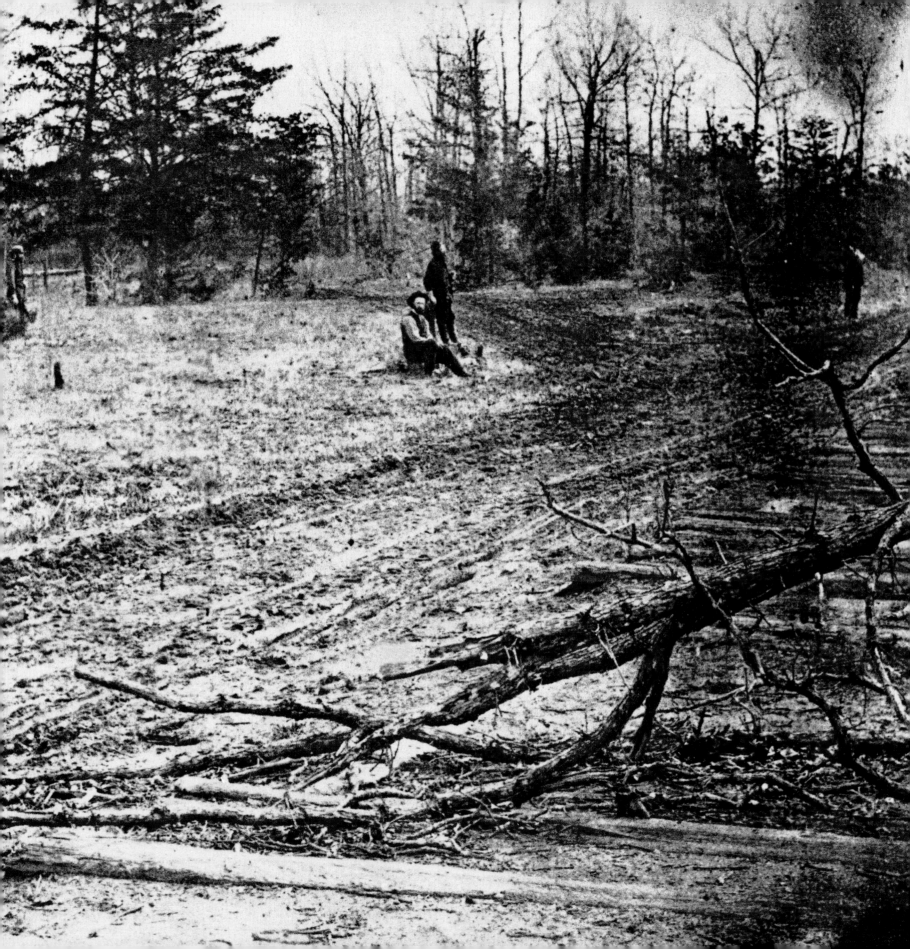

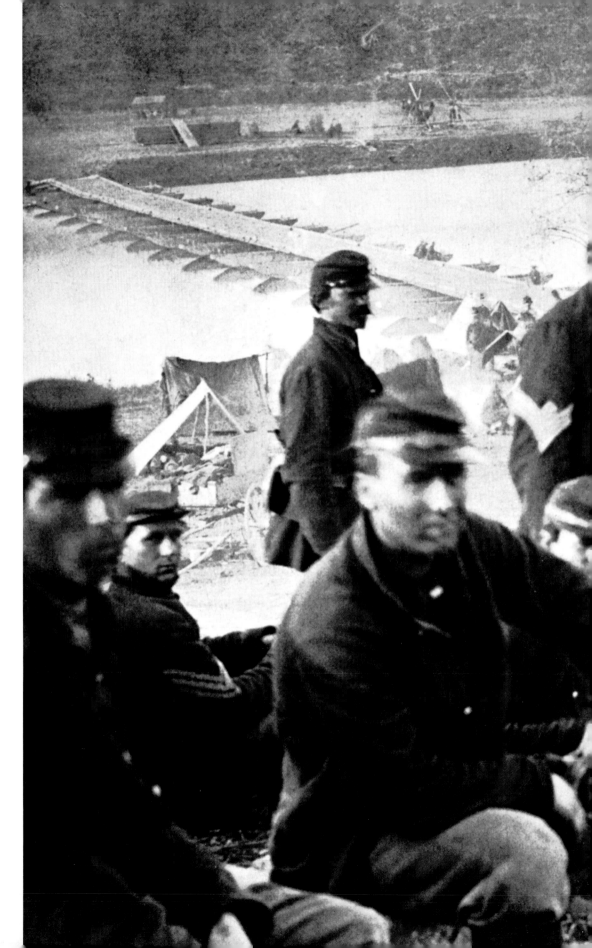

PONTOON DETAIL

In a May 1863 photograph, soldiers of the 15th New York Engineers wait on the western bank of the Rappahannock River just behind the front lines. The men had just finished building pontoon bridges for the Federal II Corps at Franklin's Crossing, just south of Fredericksburg.

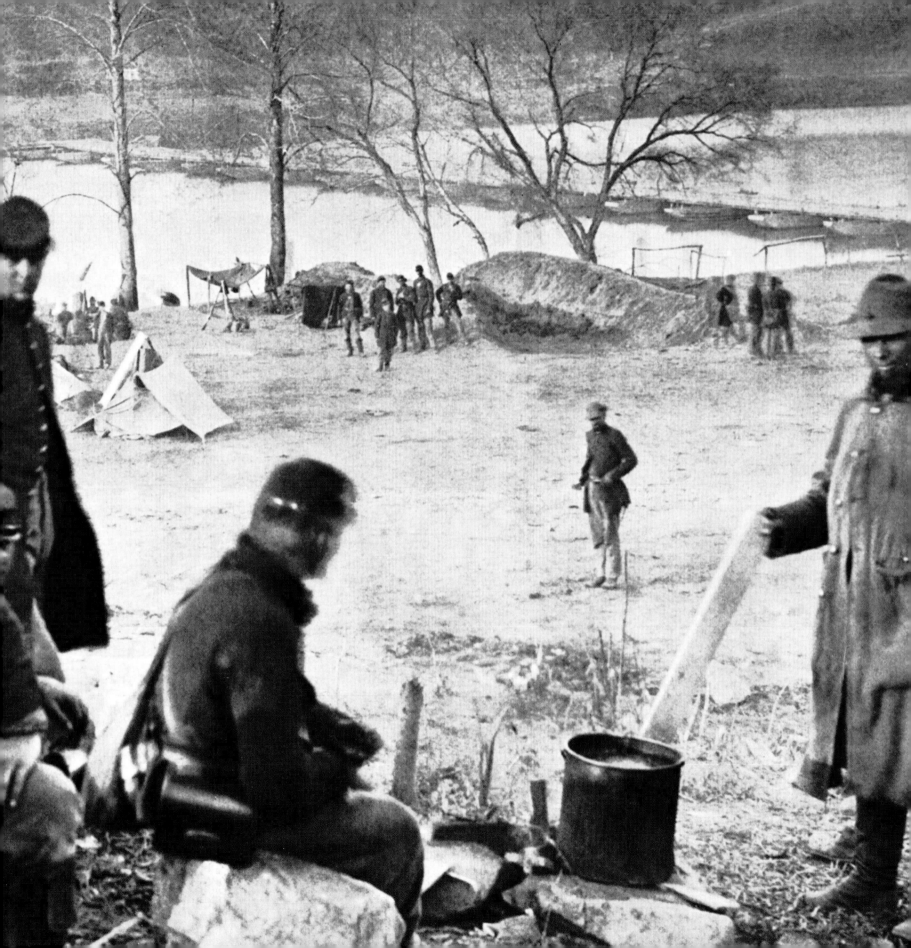

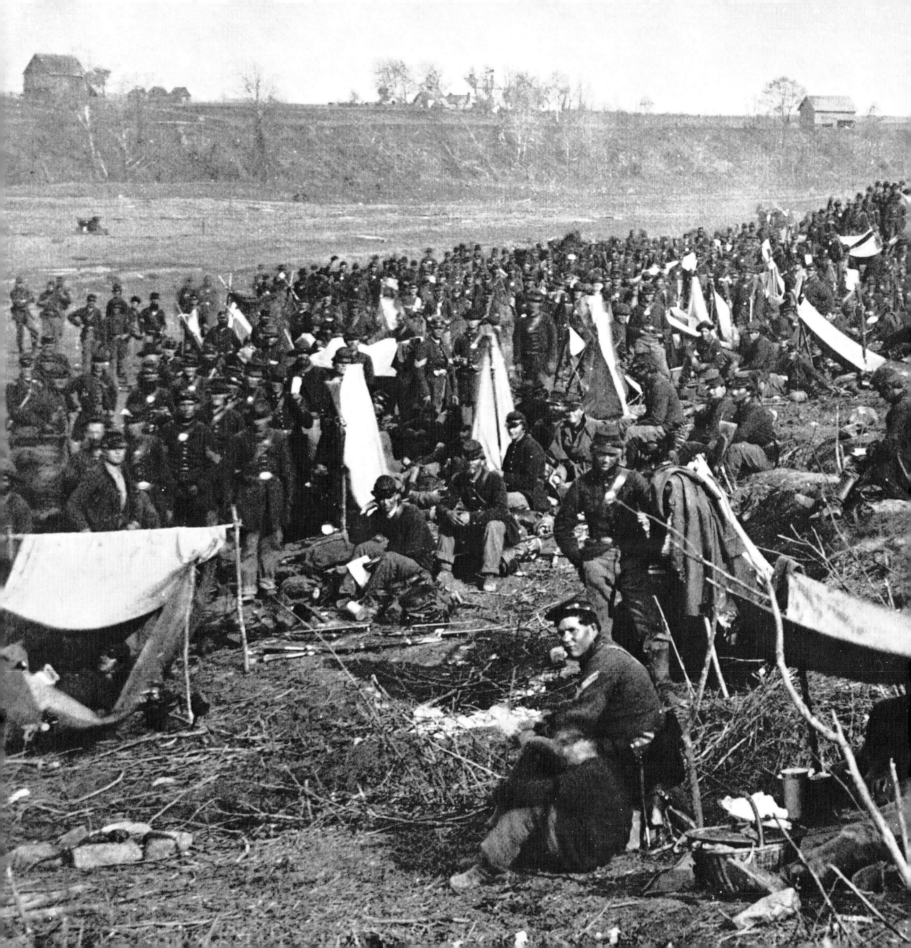

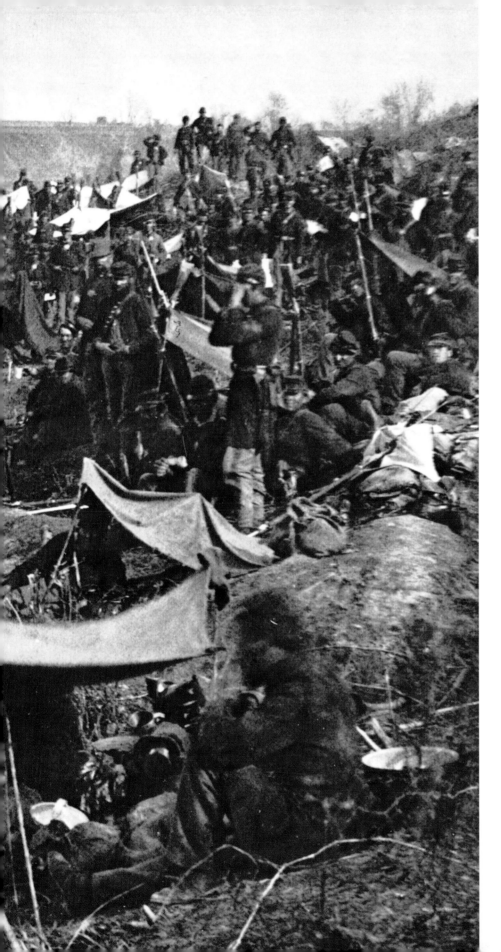

"Every man stood up . . . and for an instant silently gazed on the scene, and then, by common impulse, there broke such a yell from our line as I never heard before."

SERGEANT W. R. JOHNSON,
15th Massachusetts Infantry, Second Battle of Fredericksburg

BIVOUAC ON THE BATTLEFIELD

In this photograph, soldiers of General William Brooks' division of the Federal VI Corps bivouac in reserve on the western bank of the Rappahannock River during the Second Battle of Fredericksburg in 1863. Shortly after this photograph was taken, some of these men were killed or wounded in the fighting around Salem Church.

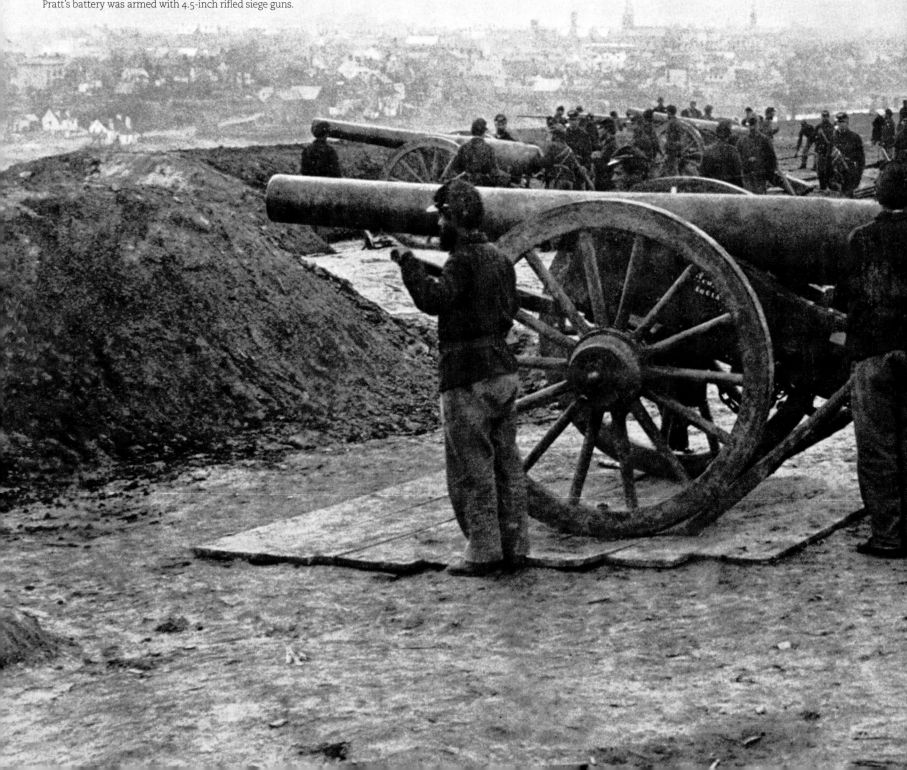

BIG GUNS ON STAFFORD HEIGHTS

This photograph taken by Federal photographer Andrew J. Russell on Stafford Heights on May 3, 1863, shows the gunners of Captain Franklin A. Pratt's Battery M, 1st Connecticut Heavy Artillery, as they await orders during the Second Battle of Fredericksburg. Pratt's battery was armed with 4.5-inch rifled siege guns.

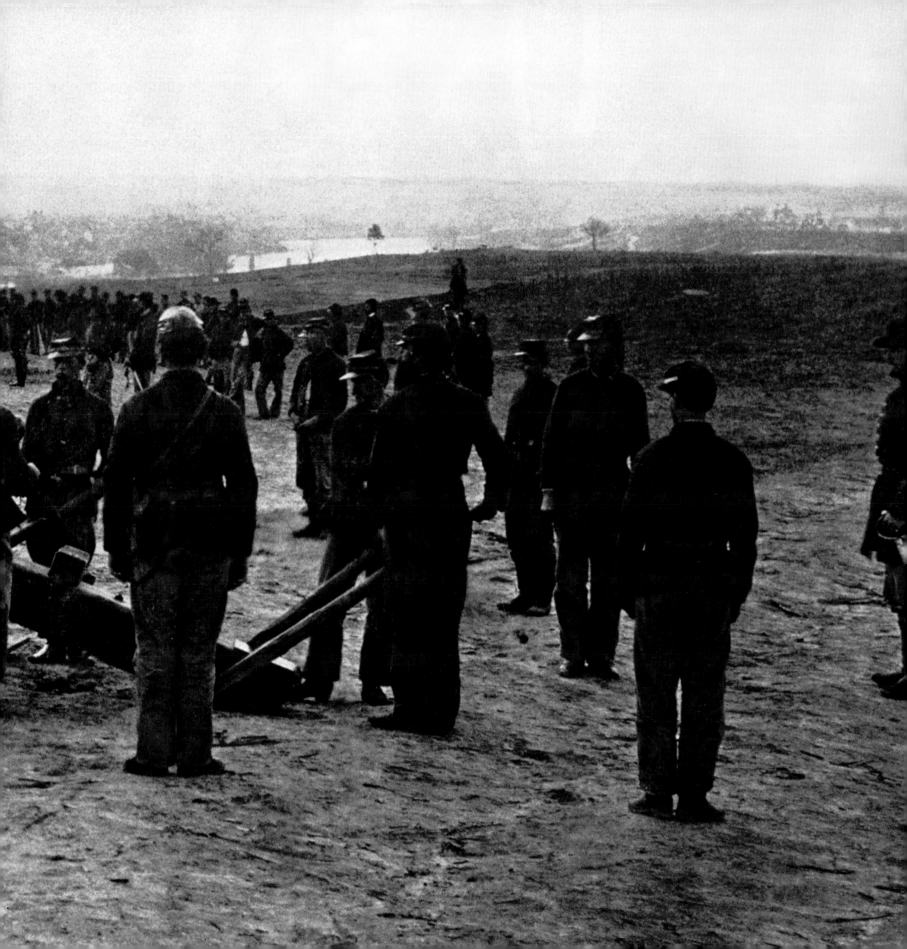

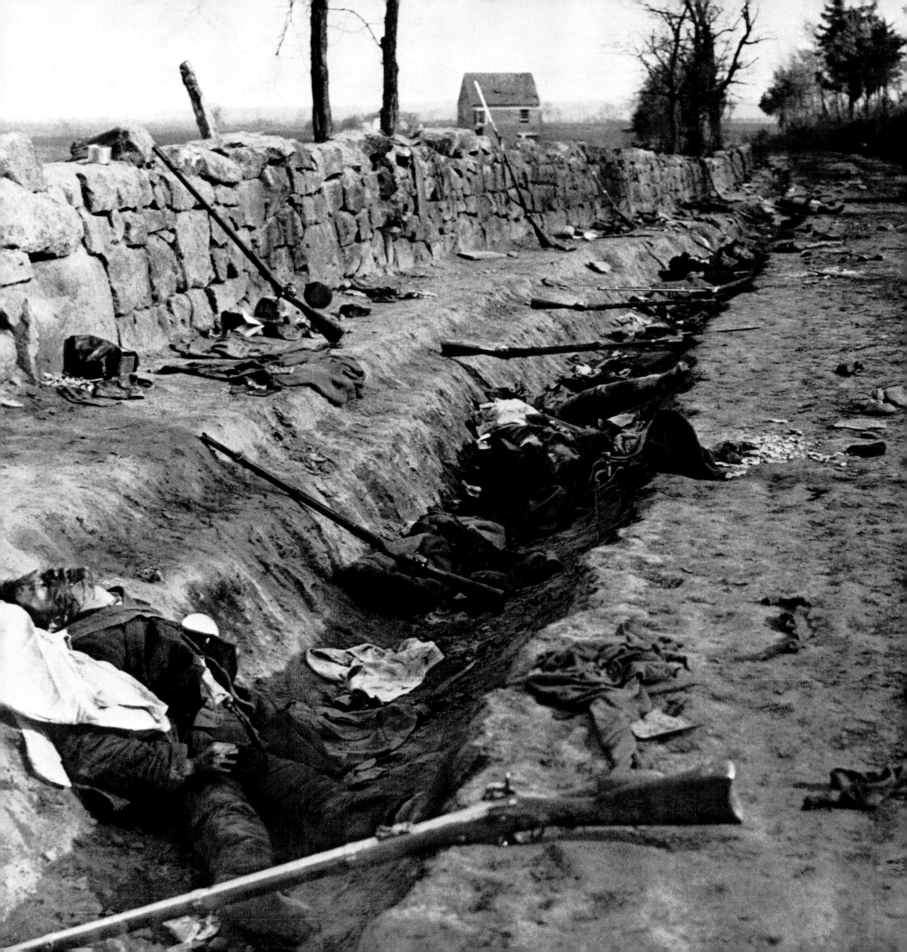

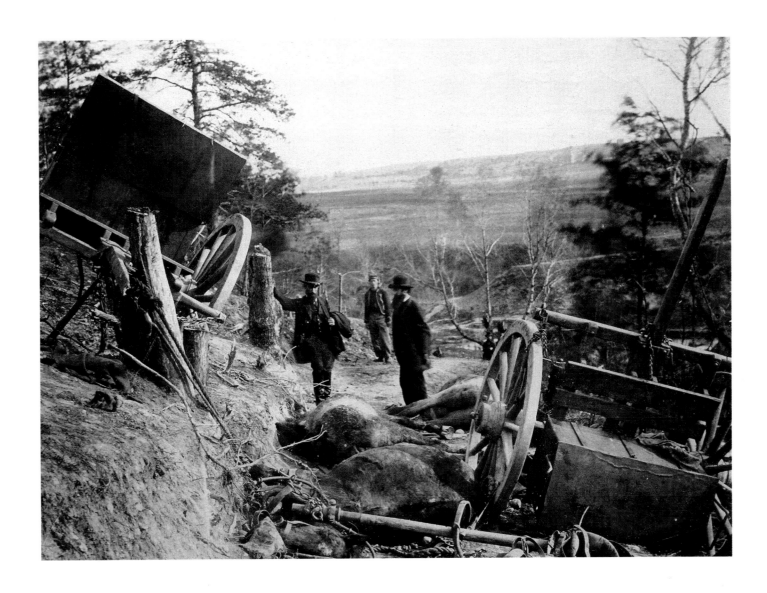

OUTCOME OF BATTLE
Confederate dead of the 18th Mississippi sprawl in the Sunken Road on Marye's Heights, where repeated Union attacks during the first battle at Fredericksburg had been stopped cold. Russell took this picture on May 4, the day after the successful Union attack.

A LUCKLESS TEAM
Standing in a narrow lane overlooking Hazel Run on the west slope of Marye's Heights, General Herman Haupt (at left) and one of his assistants, W. W. Wright, examine a wrecked caisson and dead mule team belonging to the Washington Artillery of New Orleans.

War on the Mississippi

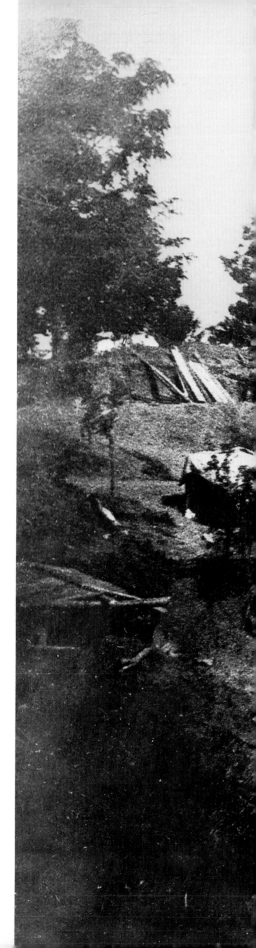

IN THE SPRING OF 1862, Union forces embarked upon one of the most difficult and important campaigns of the war—the long and arduous effort to open the Mississippi River. If successful, the campaign would sever Confederate lines of communication with the Trans-Mississippi West and open the great waterway to northern commerce between the Midwest and New Orleans.

The first operations went well for the Federals with Admiral David Farragut's capture of New Orleans on April 24, 1862. But upriver, General Grant's forces encountered a major obstacle in the fortified city of Vicksburg. The strategic Confederate stronghold, regarded by President Davis

as "the nailhead that held the south's two halves together," was fiercely defended by Rebel forces. Although Farragut's vessels successfully ran past Vicksburg's batteries to link up with Grant's forces, an attempt by the fleet to bombard the city into submission proved futile. Equally fruitless were Grant's repeated attempts throughout the fall and winter to outflank the city and take it from the rear.

Finally, in the spring of 1863, the determined Union commander shifted his army downriver, past Vicksburg's guns, to land his forces on the river's east bank. From there, he pushed northward, defeating Confederate forces at Port Gibson, Champion's Hill, and Jackson before closing in on Vicksburg itself to begin the long siege that ultimately forced the city's surrender on July 4.

When the news reached Richmond, Confederate chief of ordnance Josiah Gorgas lamented, "Absolute ruin seems our portion, the Confederacy totters to its destruction." For the North, the capture of Vicksburg, combined with the simultaneous repulse of Lee's army at Gettysburg, broke a seven-month string of humiliating disasters for Union arms. Grant was celebrated as the one Union general who could fight and win and the upswing in Federal fortunes gave Northerners renewed faith in the prospect of Union victory.

WELL-ARMED HORSEMAN

Armed with a saber and a massive Colt Dragoon revolver, a young Alabama cavalryman sits for his portrait. "War suits them," wrote Major General William T. Sherman, speaking of the western Confederate cavalrymen. "The rascals are brave, fine riders, bold to the point of rashness and dangerous in every sense."

A RABBIT WARREN OF SHELTERS

Shortly after the siege began, the beautiful grounds and gardens of Wexford Lodge—also known as the Shirley House, or White House—were destroyed by the spades of Union troops as they bombproofed the site to protect themselves from Confederate artillery fire. In this photograph, the dugouts of the 45th Illinois Infantry can be seen covering the slope beneath the battered house.

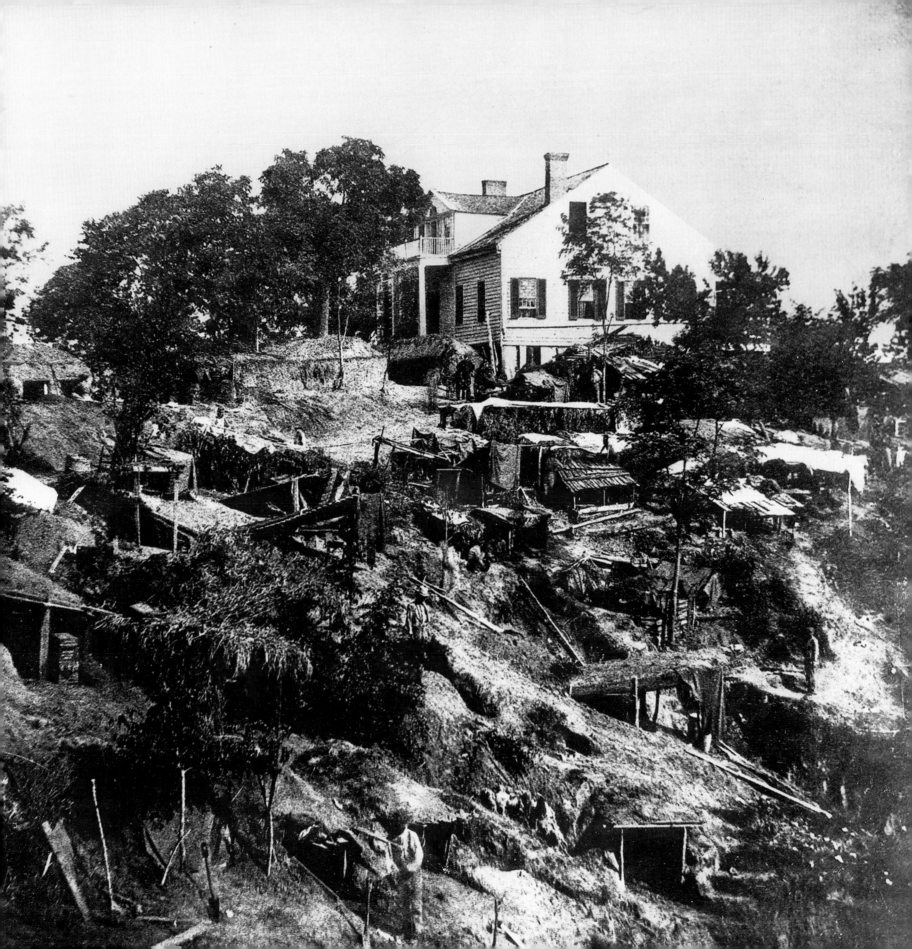

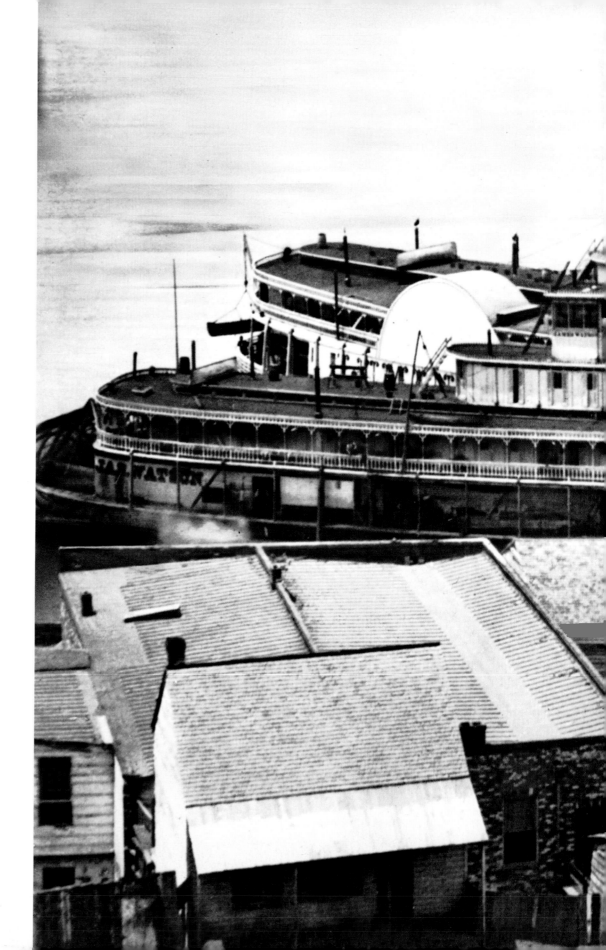

A ROUGH DISTRICT ON VICKSBURG'S WATERFRONT
Steamboats crowd the wharves along Vicksburg's waterfront, a district notorious for its saloons, gambling halls, and bawdy houses. When a prominent local doctor was shot and killed in one such establishment, a posse of vigilantes lynched five gamblers; other undesirables were tarred and feathered and set adrift on a raft in the Mississippi.

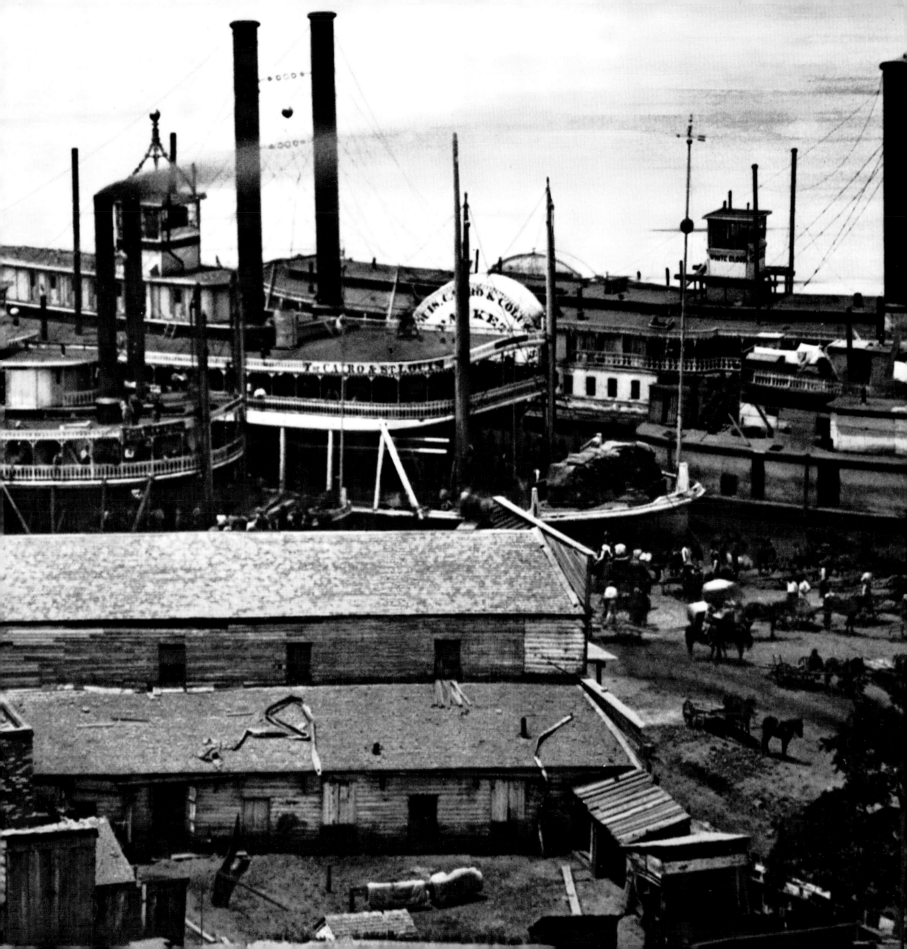

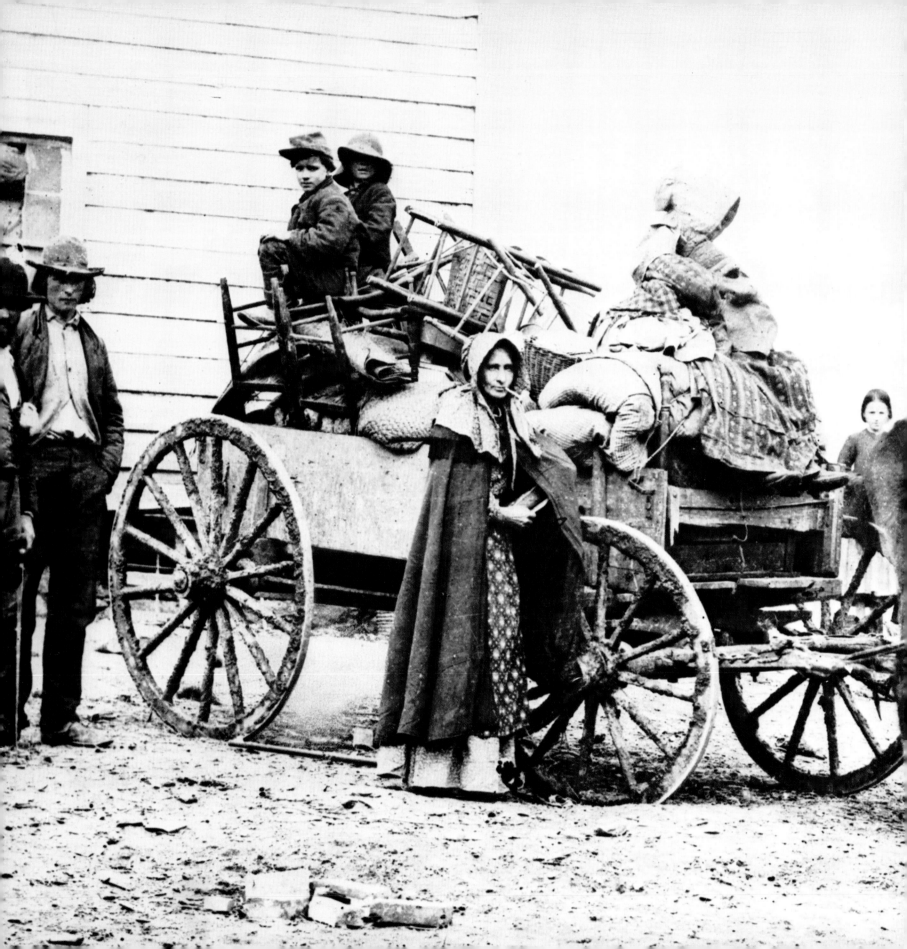

> "Bullets came thick and fast, shells hissed and screamed through the air, cannon roared, the dead and dying were brought into the old home. War, terrible war, had come to our very hearthstone."

ALICE SHIRLEY
Resident of Vicksburg

REFUGEES

Their possessions piled high on a wagon, a family prepares to leave home before the war engulfs them. To travel in war zones, civilians were required to carry official passes issued by the Confederate and Union authorities.

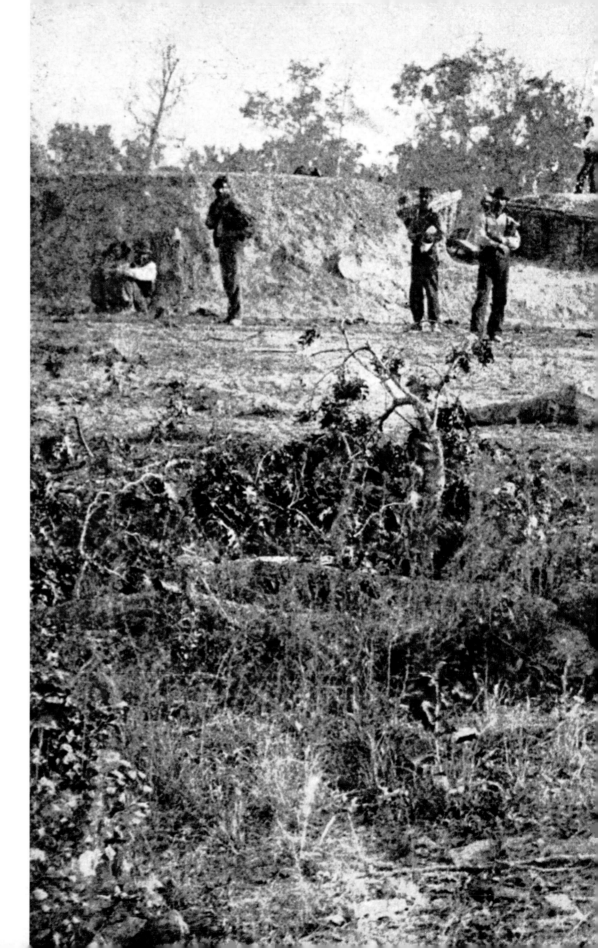

AFTERMATH OF A DESPERATE CHARGE

Federal soldiers survey the carnage in front of Battery Robinett on the day after the Battle of Corinth. The body of Colonel William P. Rogers, who led the Confederate assault, lies just left of the tree stump at center, near his dead horse.

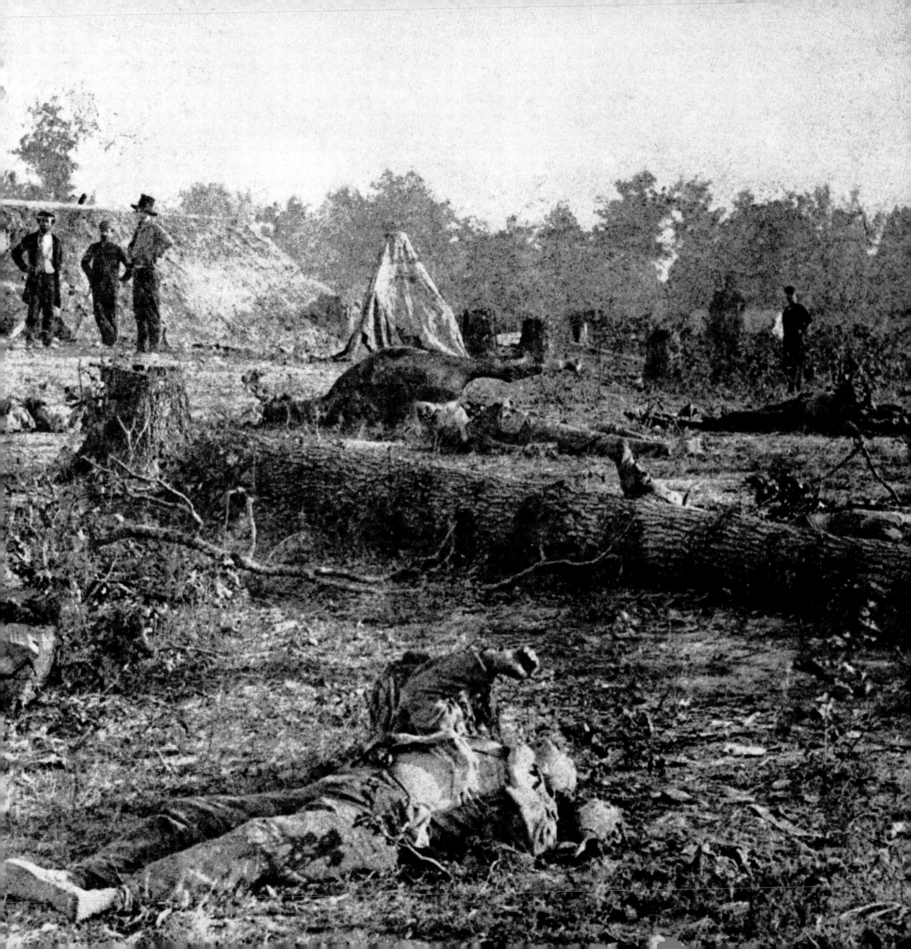

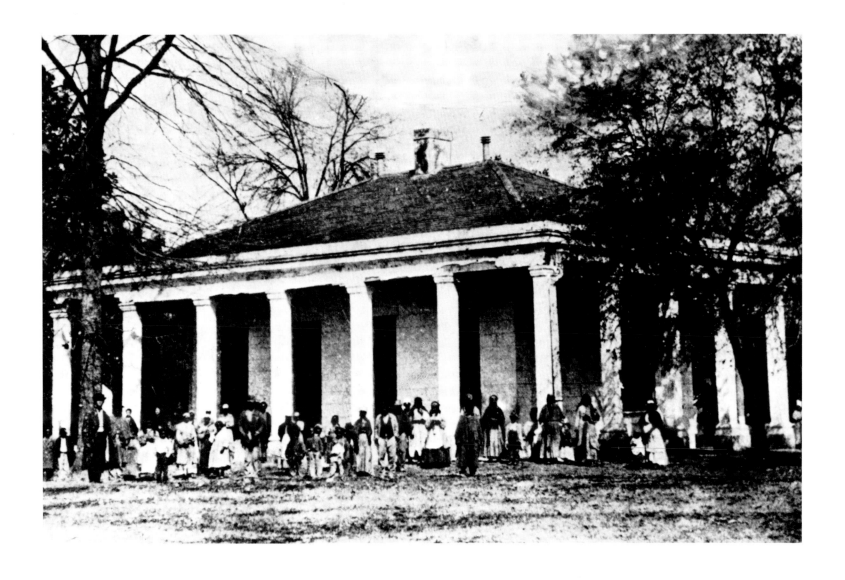

IN THE WAKE OF GRANT'S ARMY

Former slaves of Joseph Davis, brother of the Confederate president, assemble for a photograph with a Federal soldier on Davis's plantation near Vicksburg. The U.S. Army hired freed slaves for such tasks as digging trenches and working abandoned plantations.

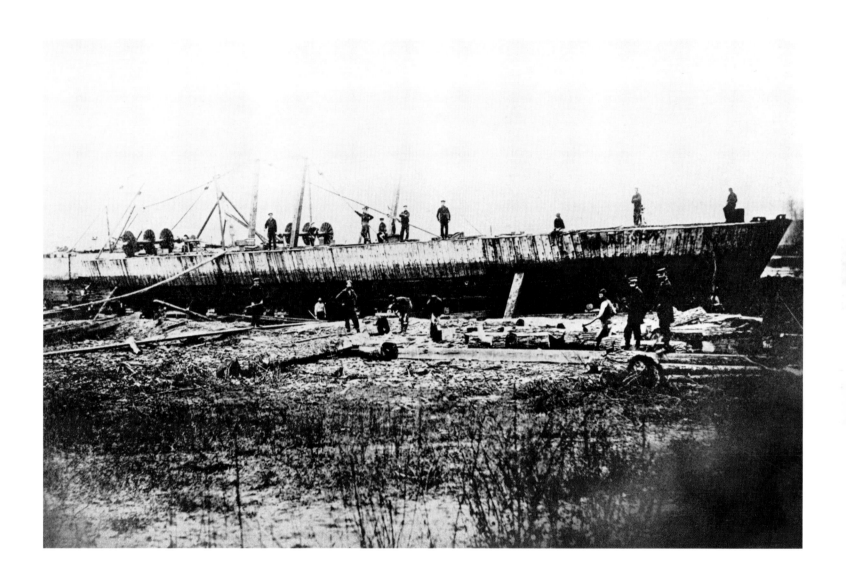

BATTERED IRONCLAD

The Union ironclad *Indianola*, shown being salvaged at the end of the war, spent much of the conflict beached near Vicksburg. Badly damaged by Confederate rams, she was abandoned in February 1863. The Confederates set fire to the vessel to keep the foe from reclaiming her.

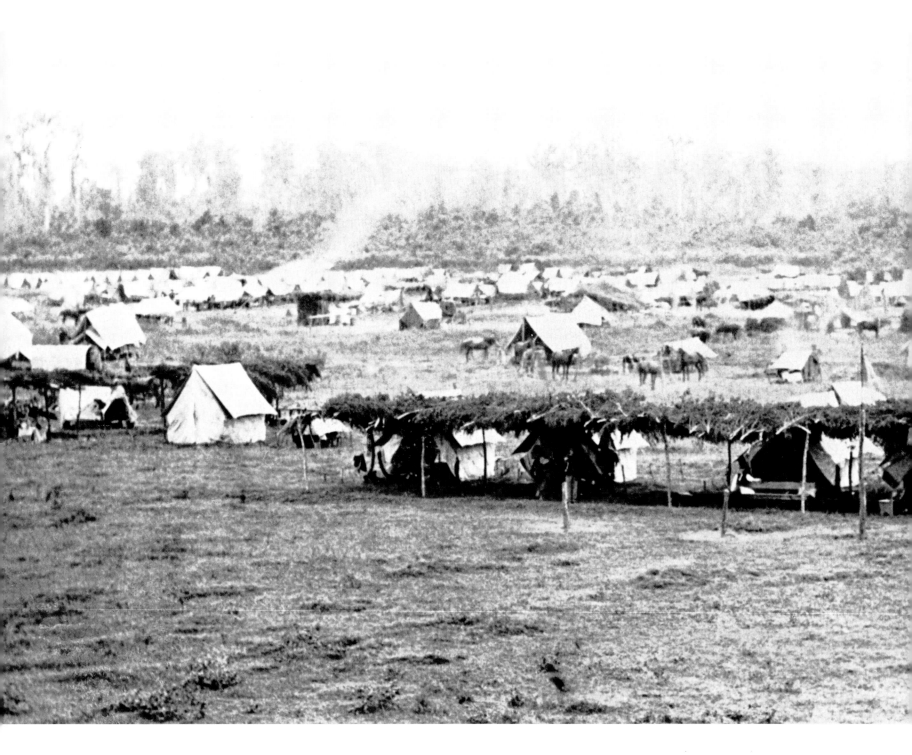

GRIERSON'S RAIDERS

A regiment of Illinois cavalry, possibly part of General Benjamin Grierson's newly arrived command, camps outside Baton Rouge in May 1863. Grierson had just led his cavalry division on a successful 600-mile raid into Tennessee, Mississippi, and Alabama.

CONFEDERATE TROOPER

Confederate cavalryman from Kentucky

UNION TROOPER

Private Friedrich Holdmann, 2nd Wisconsin Cavalry

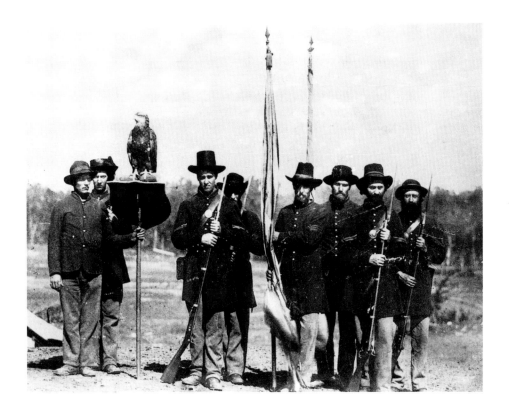

FIGHTING MASCOT

One of the more famous regimental mascots of the Civil War was the 8th Wisconsin Infantry's "Old Abe," an eagle that accompanied the regiment into battle while tethered to a special perch. Although Old Abe was wounded in several battles, he was able to "muster out" in September 1864, finding a home in a specially made cage in Wisconsin's statehouse. Here Old Abe lived an honored existence as a patriotic symbol until 1881, when he died in a fire.

BRIDGE BUILT ON RUBBER BOATS

In a single night, federal engineers laid four floating bridges across the Big Black River to speed the passage of Grant's army to Vicksburg. They first inflated a string of India rubber pontoons with hand bellows and roped them securely in place to span the stream. Finally, wooden planking was lashed atop the pontoons, and the bridge was ready to carry troops, wagons, and artillery safely across the river.

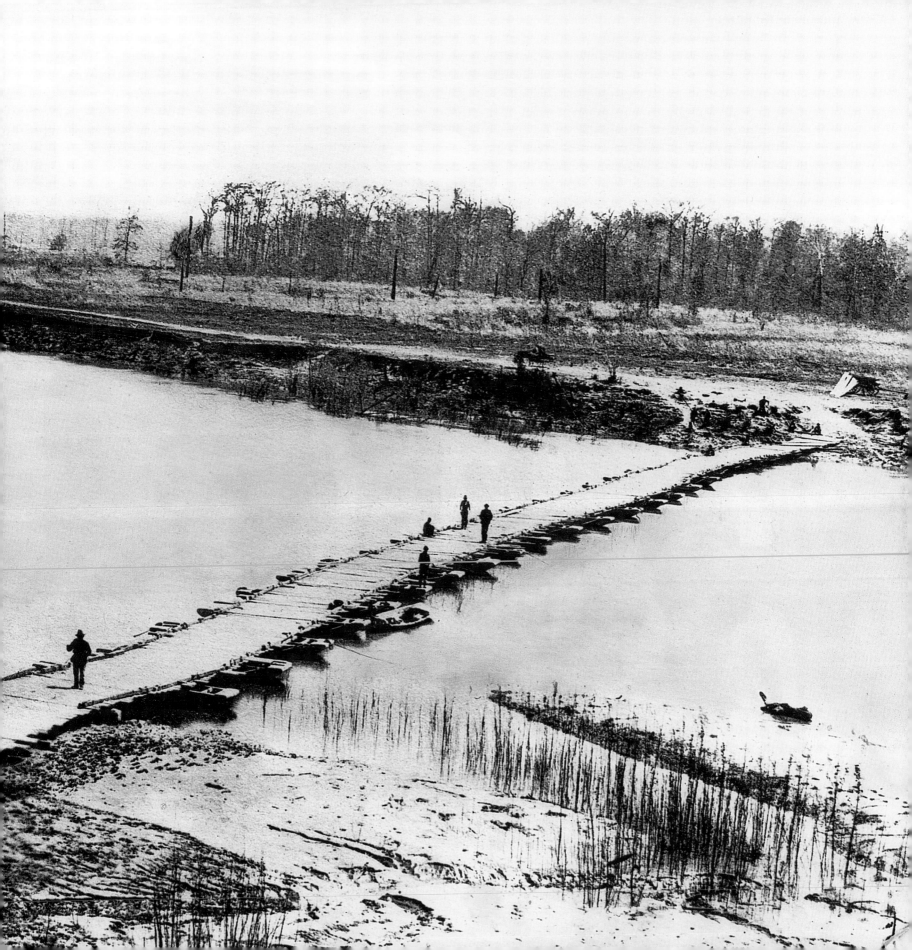

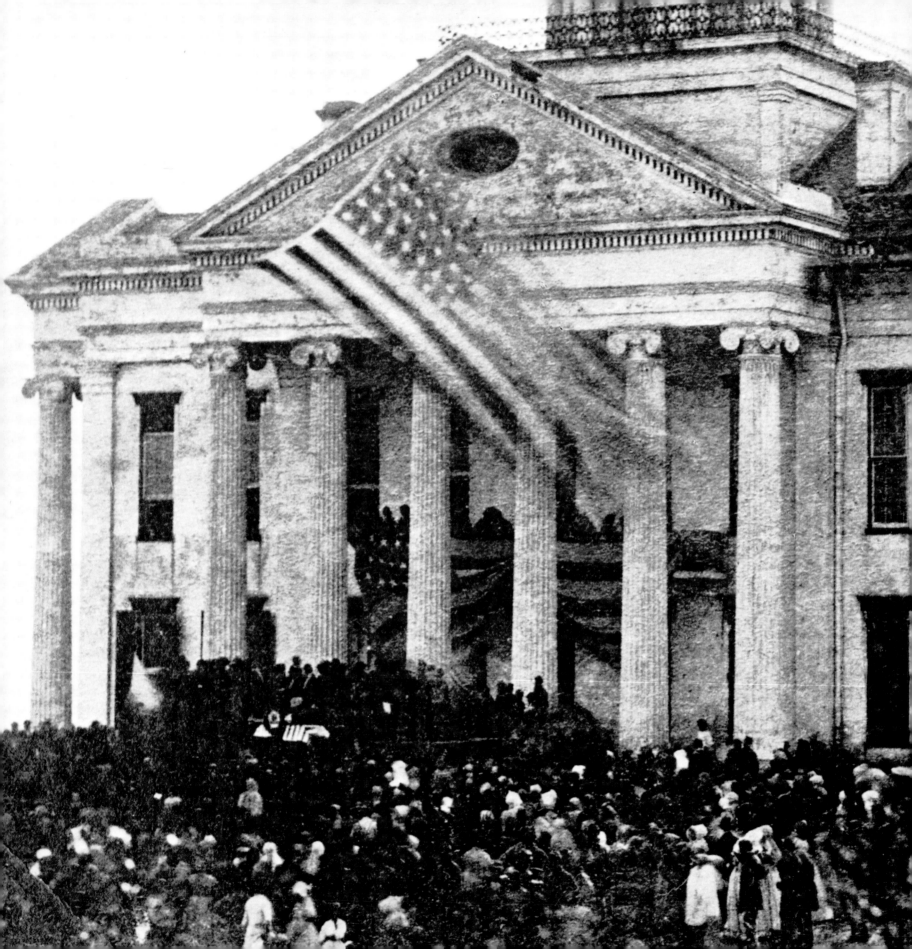

"All this 47 days, we were looking and hoping for relief by Joseph E. Johnston, but alas, on the morning of July 4th, we were surrendered."

LIEUTENANT JOSEPH W. WESTERBROOK
4th Mississippi Infantry

FLAG RAISING AT THE COURTHOUSE
Amid the crowd of Yankee celebrators, Vicksburg residents lament the raising of the Stars and Stripes at the courthouse on July 4, symbolizing Federal control of the town. One of Grant's first moves after the surrender was to send food to the starved residents.

Gettysburg

SOON AFTER THE CONFEDERATE TRIUMPH AT CHANCELLORSVILLE, Robert E. Lee decided to lead his victorious army into the rich farmlands of Pennsylvania. He hoped that carrying the fight to the North would relieve war-ravaged Virginia, and possibly force a decisive battle with the Union's Army of the Potomac. Lee also hoped that a major Confederate victory on northern soil might encourage France or Great Britain to recognize southern independence.

In June 1863, Lee's army—three corps under Richard Ewell, James Longstreet, and A. P. Hill—marched down the Shenandoah Valley while Jeb Stuart's horsemen clashed with Union cavalry

east of the Blue Ridge. After routing Federal forces at Winchester, Lee's soldiers forded the Potomac, with Longstreet and A. P. Hill advancing on Chambersburg while Ewell moved on York and Carlisle.

Back in Virginia, Lincoln named II Corps commander General George G. Meade to command the Army of the Potomac. On June 29, after learning that Meade was advancing in the vicinity of Frederick, Maryland, Lee ordered his corps to concentrate around Cashtown and Gettysburg. At dawn on July 1, the battle began by accident when Confederates, seeking shoes from a warehouse, unexpectedly ran into John Buford's Federal cavalry. Bitter fighting ensued for control of the ridges west of Gettysburg as both armies converged on the town. By day's end the Federals had been driven back but managed to hold a line of ridges south of town.

On July 2, Lee launched the first of two days of ferocious attempts to shatter Meade's army, culminating on July 3 with a brave but disastrous assault led by George Pickett and Johnson Pettigrew, whose troops crashed like a wave against a solid Federal wall. On July 4, Lee began to withdraw his battered forces toward Virginia, and Confederate hopes went with him. Of the more than 160,000 men who fought at Gettysburg, the Confederates lost 28,000 and the Federals 23,000.

DEFIANT PRISONERS

Three Confederate prisoners stand beside a rail-and-timber breastwork on Seminary Ridge as they await transport to a prison camp. They were among the 5,150 captured; another 6,802 wounded fell into Federal hands.

LAST POST IN THE DEVIL'S DEN

The body of a young Confederate soldier lies in a sharpshooter's nest in the Devil's Den. Another photograph of the site has revealed that the soldier actually died elsewhere and suggests that the photographer, probably Timothy O'Sullivan, had the body moved about 40 yards for dramatic effect.

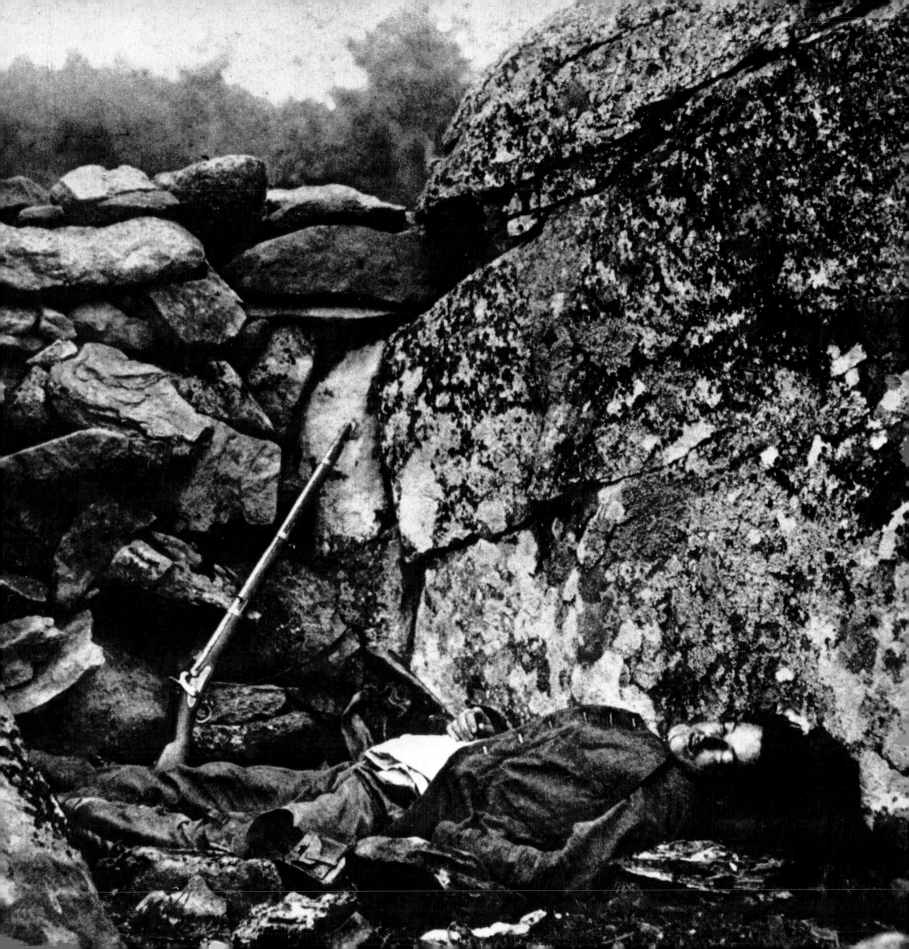

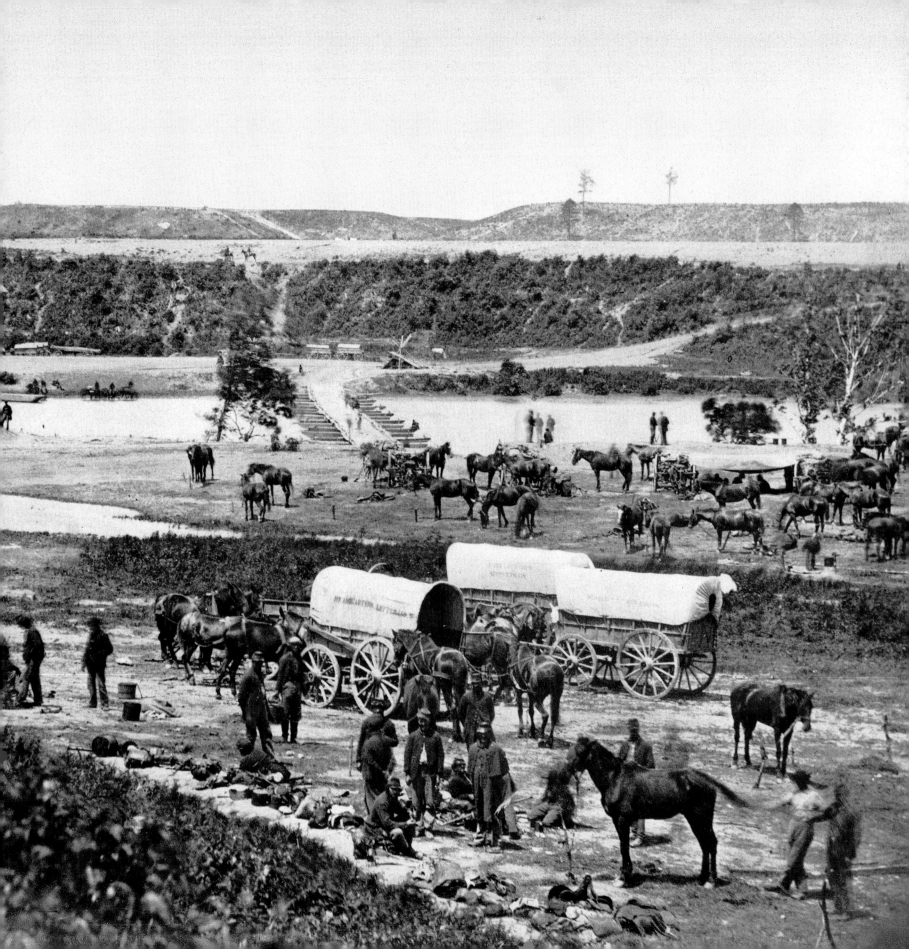

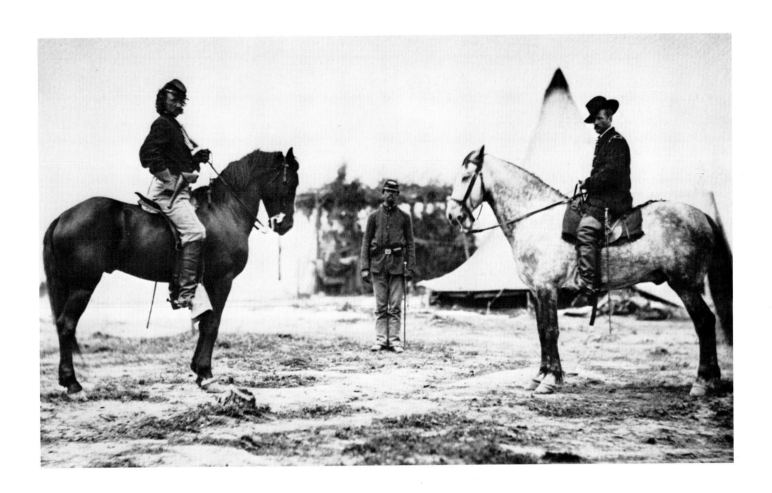

ACROSS THE RAPPAHANNOCK

Artillerymen of the VI Corps pause near a pontoon bridge over the Rappahannock River south of Fredericksburg, Virginia, during the federal reconnaissance to locate Lee's army in early June 1863.

HORSE SOLDIERS

Brigadier General Alfred Pleasonton (*above, right*), chief of the revitalized Federal cavalry of the Army of the Potomac, poses with a dapper George Custer. Pleasonton was so impressed with Custer's ability and dash that he jumped him in rank from captain to brigadier general.

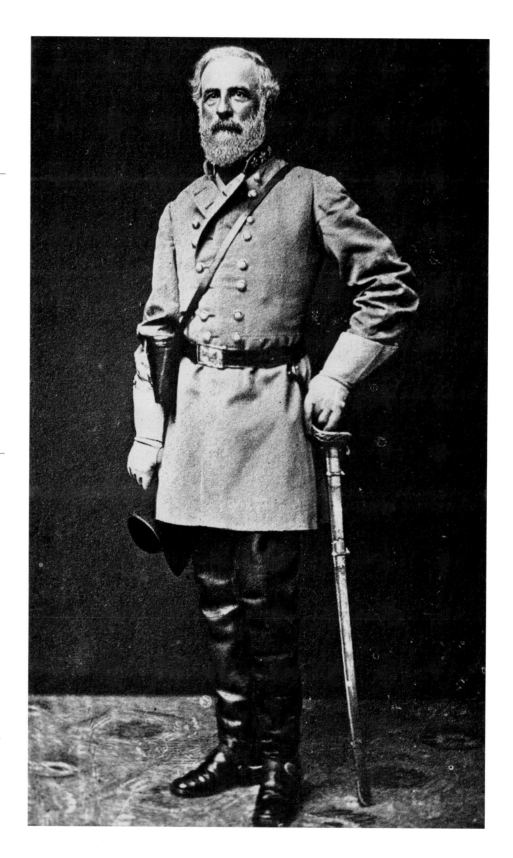

"The troops of Lee were now at the zenith of their perfection and glory. They looked upon themselves as invincible, and that no General the North could put in the field could match our Lee."

LIEUTENANT D. AUGUSTUS DICKERT,
3rd South Carolina

A PERFECT GENTLEMAN
Guards officer Arthur Fremantle, a British observer who was traveling with Major General James Longstreet, characterized General Robert E. Lee as "a perfect gentleman in every respect," noting that Southerners pronounced him "as near perfection as a man can be."

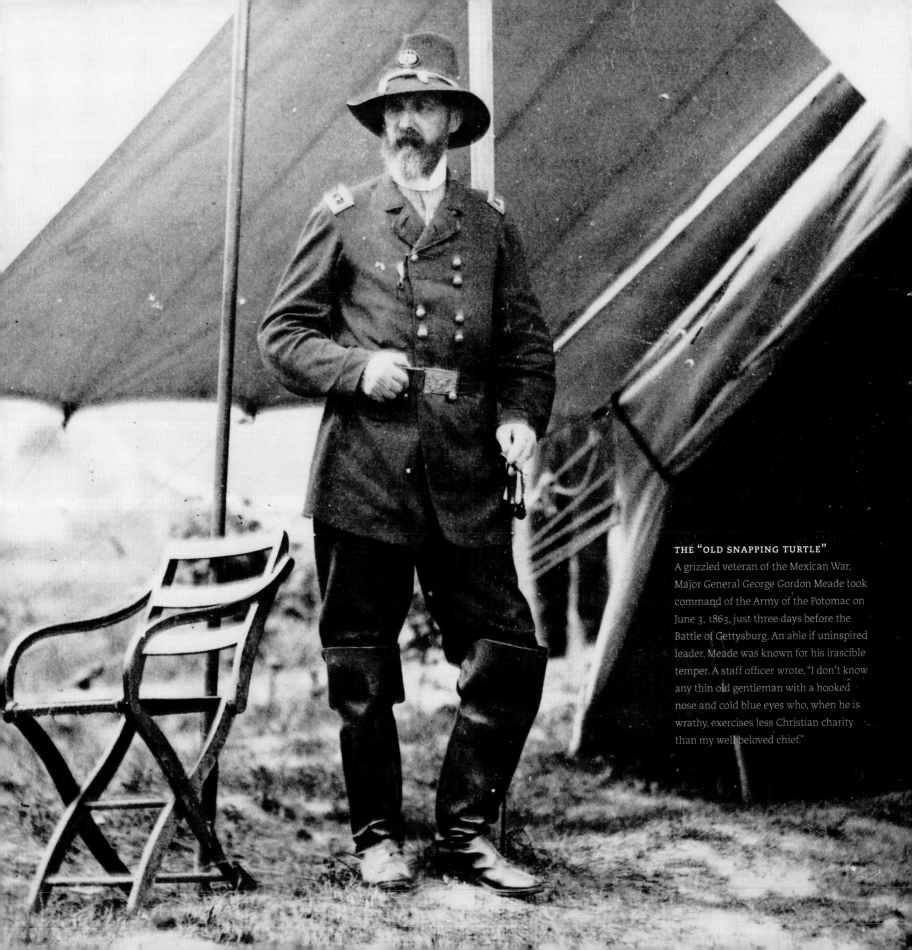

THE "OLD SNAPPING TURTLE"

A grizzled veteran of the Mexican War, Major General George Gordon Meade took command of the Army of the Potomac on June 3, 1863, just three days before the Battle of Gettysburg. An able if uninspired leader, Meade was known for his irascible temper. A staff officer wrote, "I don't know any thin old gentleman with a hooked nose and cold blue eyes who, when he is wrathy, exercises less Christian charity than my well beloved chief."

CROSSROADS VILLAGE

Neat houses line Carlisle Street where it passes through the center of Gettysburg. After heavy fighting west of the town on July 1, 1863, the shattered Federal XI Corps retreated south along this route to take up positions on Cemetery Ridge. Confederates under General Richard S. Ewell occupied the town and held it during the remaining two days of fighting.

ON SEMINARY RIDGE

The imposing main building of Gettysburg's Lutheran Theological Seminary was the scene of fighting during the withdrawal of the Federal I Corps on July 1. The structure would serve both sides as a field hospital and observation post.

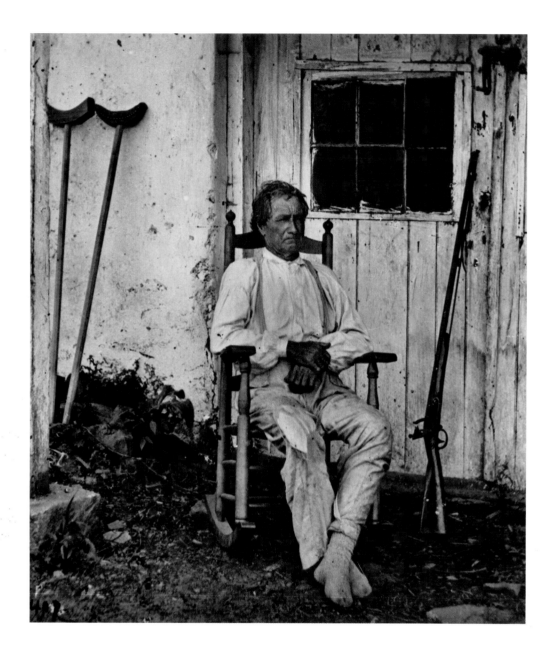

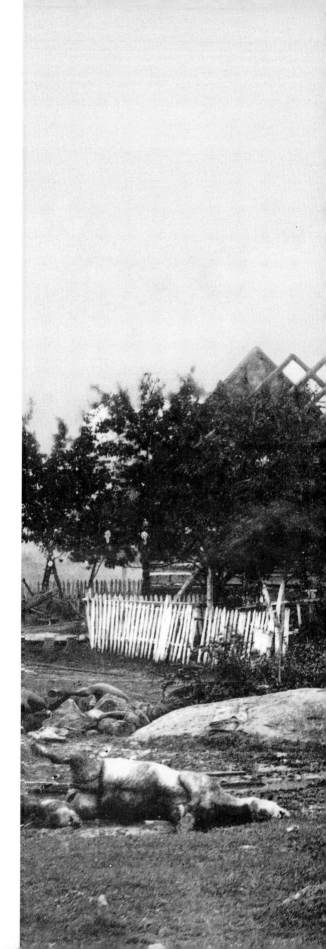

THE "OLD PATRIOT"

The sole civilian known to have fought at Gettysburg was 72-year-old cobbler John Burns, who offered his services to the 150th Pennsylvania Volunteers. Wounded, he became a national hero, sought out by Lincoln and eulogized in verse by Bret Harte: "John Burns, a practical man / Shouldered his rifle, unbent his brows / And then went back to his bees and his cows."

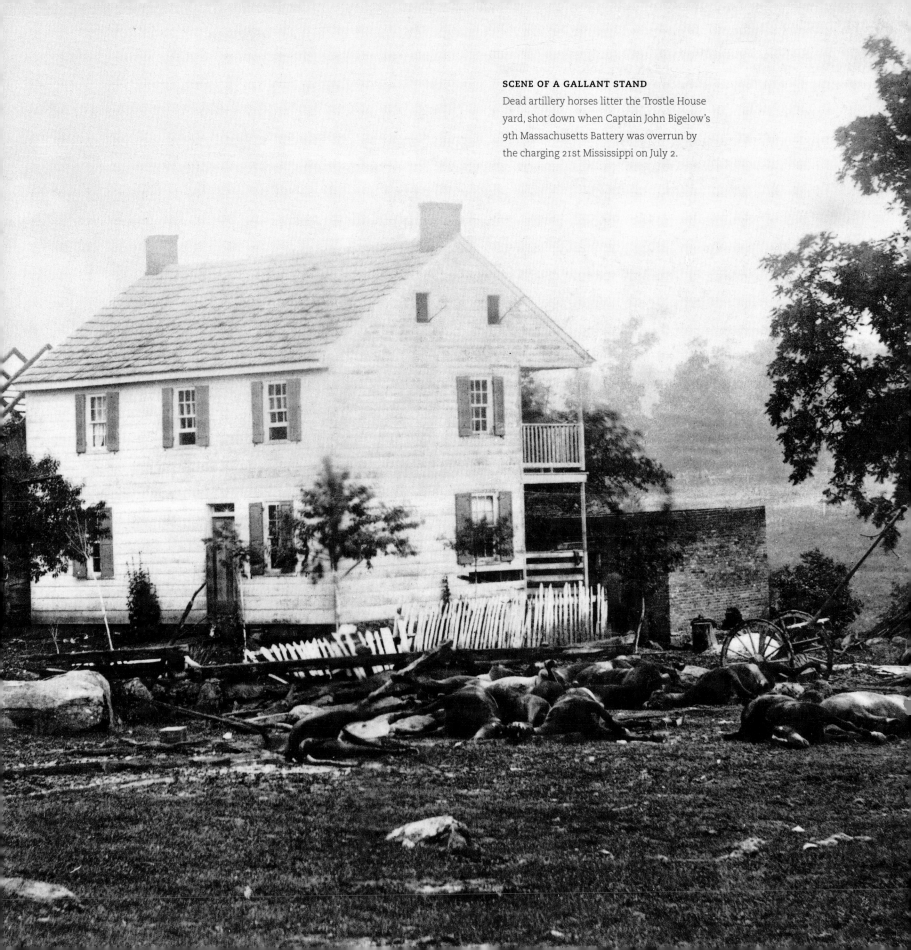

SCENE OF A GALLANT STAND
Dead artillery horses litter the Trostle House yard, shot down when Captain John Bigelow's 9th Massachusetts Battery was overrun by the charging 21st Mississippi on July 2.

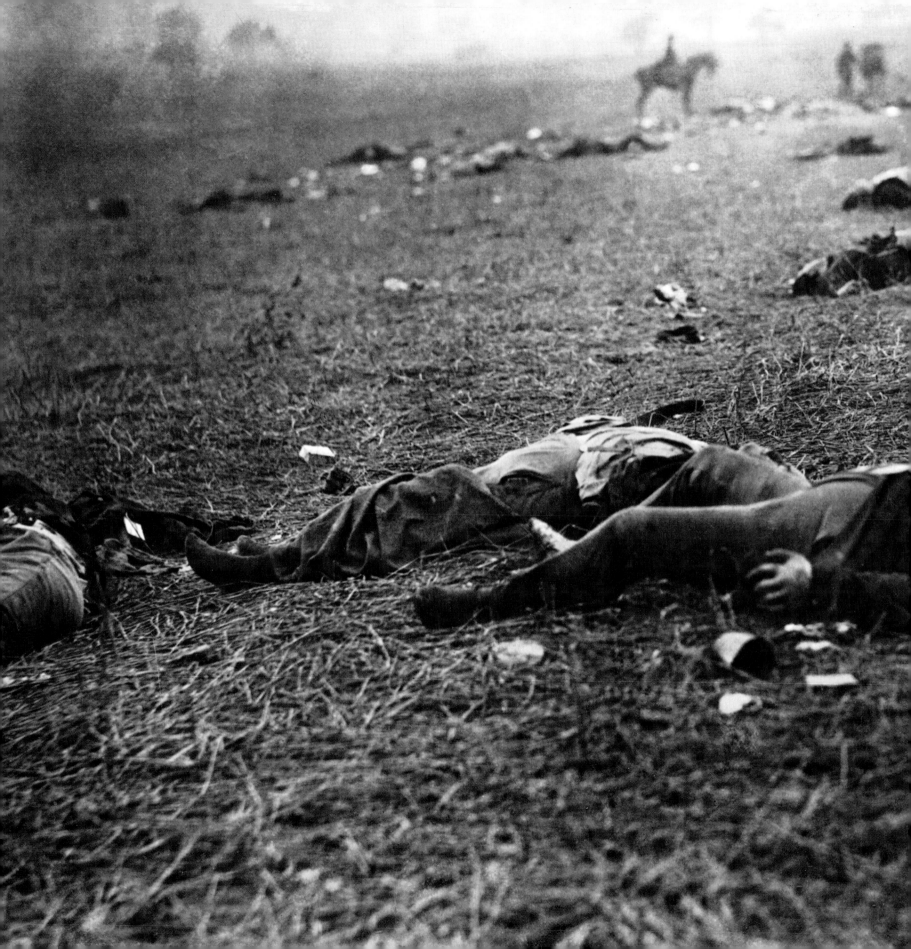

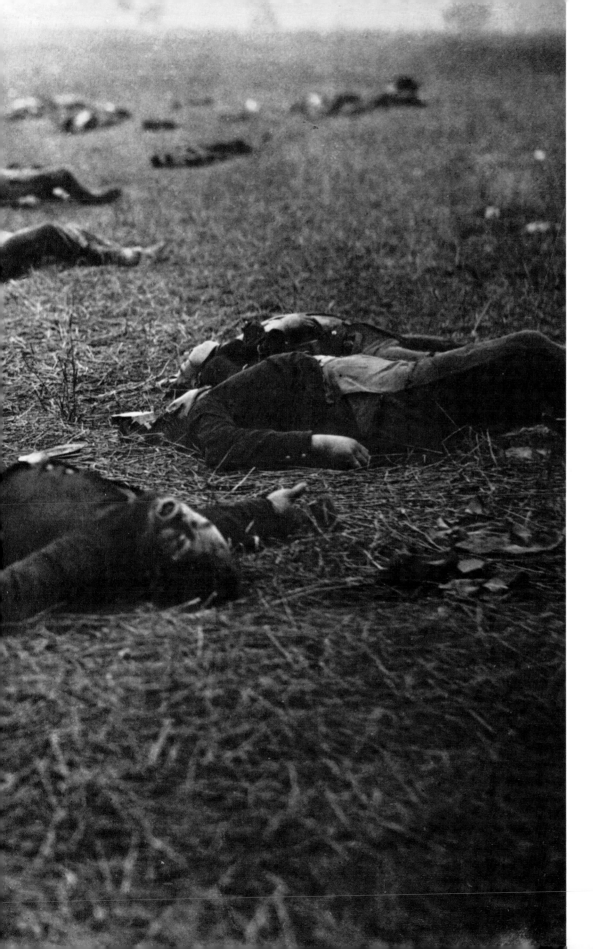

"The sights and sounds that assailed us were simply indescribable, corpses swollen to twice their original size, some of them actually burst asunder with the pressure of foul gases and vapors."

LIEUTENANT ROBERT STILES,
Virginia artillery

HARVEST OF DEATH
Bodies swollen by the hot July sun, Federal dead of the III Corps lie in a trampled field near the Peach Orchard. Many of the bodies lack shoes, which had been scavenged by Confederate soldiers who had occupied the ground on July 2.

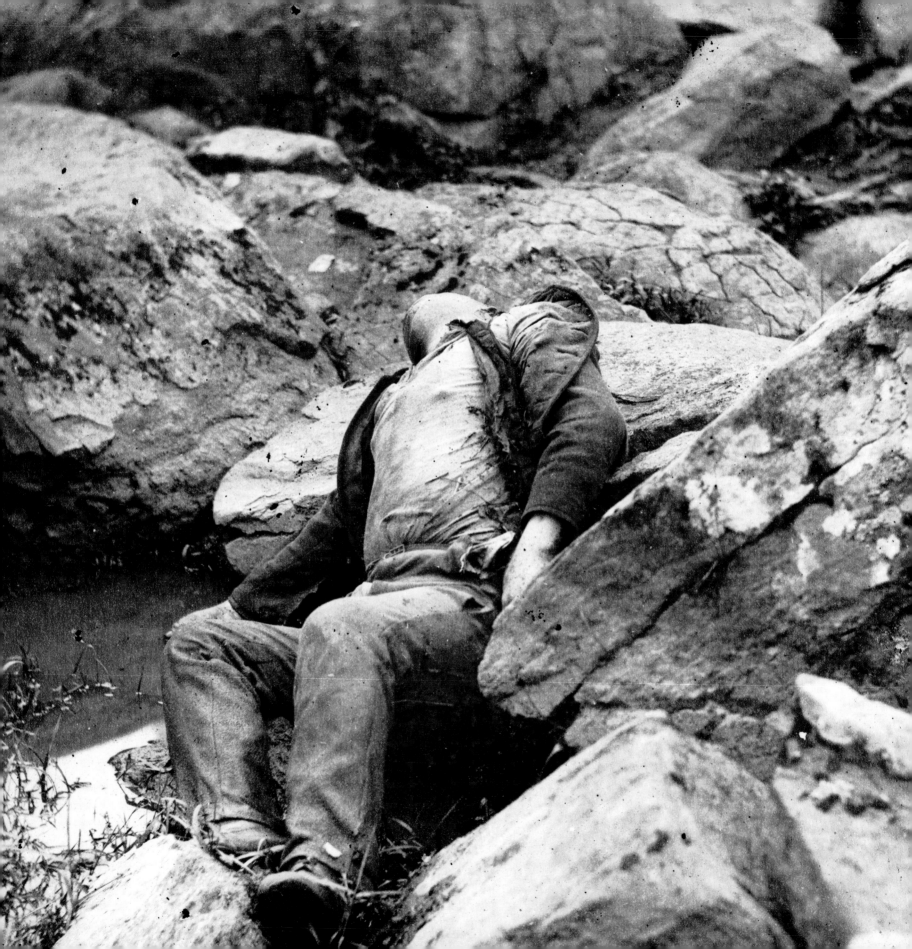

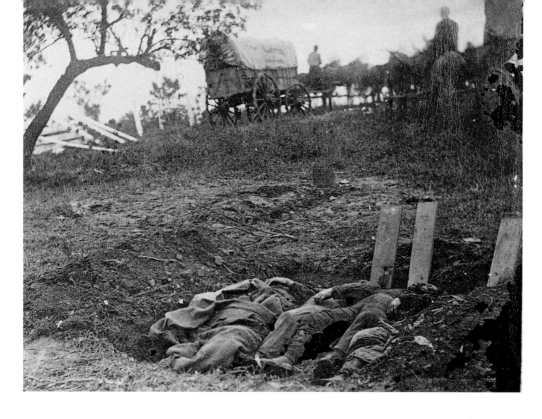

A SHALLOW GRAVE
Confederate dead lie in a shallow grave near the Rose farm as a burial detail labors in the background in this Timothy O'Sullivan photograph.

IN FEDERAL HANDS
In a rare hospital photograph, 1st Lieutenant Sanford Branch of the 8th Georgia Infantry (*on cot at right*) recuperates after being left for dead on the field by his own men. Captured and treated by the Federals, he was later exchanged in 1864.

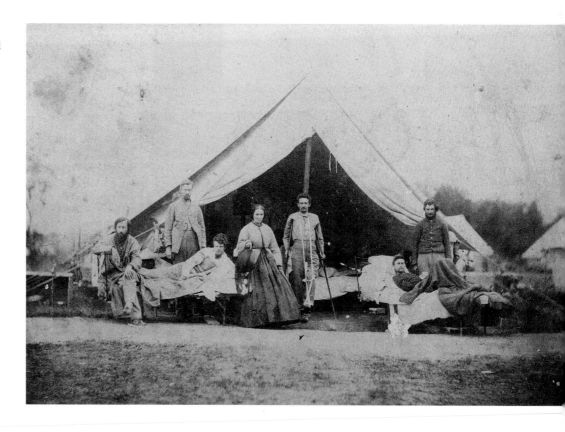

FALLEN IN THE "SLAUGHTER PEN"
To make this picture tragic instead of merely gruesome, photographer Alexander Gardner kept the face of this Rebel soldier, bloated by rains, out of view. The man fell at the foot of Little Round Top, one of the hundreds of Confederate soldiers who died there on July 2.

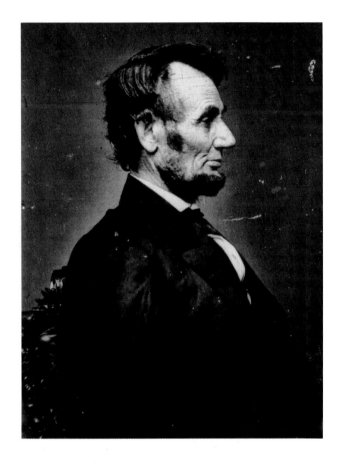

PORTRAIT OF A LEADER

In his address at the dedication of the National Cemetery at Gettysburg, President Abraham Lincoln used the opportunity to characterize the war as a crusade for human freedom rather than a struggle to preserve the union. Lincoln posed for this profile portrait in Mathew Brady's studio the following year.

GETTYSBURG ADDRESS

At the dedication of the Gettysburg National Cemetery on November 19, 1863, President Lincoln—bareheaded and to the right of center—delivered his unforgettable message.

Soldier Life

MOST OF THE THREE MILLION MEN who joined the armies to fight in the Civil War saw themselves not as professional soldiers but as civilians temporarily serving their country, and their deeply ingrained sense of independence challenged the discipline imposed by military life. Men quickly learned that the excitement of combat was only a brief part of a soldier's life and that regular rounds of drill and ceremony did little to break the monotony. Much of his time would be spent waiting for something to happen. "War," wrote infantry captain Oliver Wendell Holmes, "is an organized bore."

Soldiers passed the time by doing the tasks necessary for living in the field, ranging from laundry and camp sanitation to mending clothing and constructing their own shelter. They subsisted on an unfamiliar and unchanging diet of coffee, hard bread, and salted beef or pork. For the first time many young men had to cook for themselves.

Men in both armies devised creative ways to relieve the tedium with music, improvised theatricals, and baseball games. Others experienced the coarsening effect of military life, where drinking and gambling were widespread. As an antidote to the boredom and vice, waves of spiritual fervor sometimes swept the camps, particularly when events caused the men to have reason to sit and ponder their fate.

The uncertainty of a soldiers' existence was all too apparent. In addition to death on the battlefield, widespread sickness and crude surgical conditions threatened survival. In fact, disease cost more lives than combat did.

Throughout the war, Yankee and Rebel soldiers set an example of self-sacrifice and endurance that would rarely be surpassed, and they recorded their experiences in letters, diaries, and artwork, creating an extraordinary record of the common soldier's life.

A WELL-EARNED REPOSE

His tent flaps raised to let in the breeze, Lieutenant Colonel Samuel W. Owen of the 3rd Pennsylvania Cavalry dozes through a hot afternoon at Harrison's Landing on the James River in July 1862. The liquor bottle on his cot was probably placed there by a mischievous onlooker who wanted to make it look as if Owen had overindulged.

HOUSEKEEPING IN CAMP

As his messmates look on, a Federal soldier takes time out from chopping firewood beside a mud-daubed winter hut near Falls Church, Virginia, in February 1863. The company cook—or "dogrobber," as he was often called—stands beside a former slave, hired as cookhouse servant.

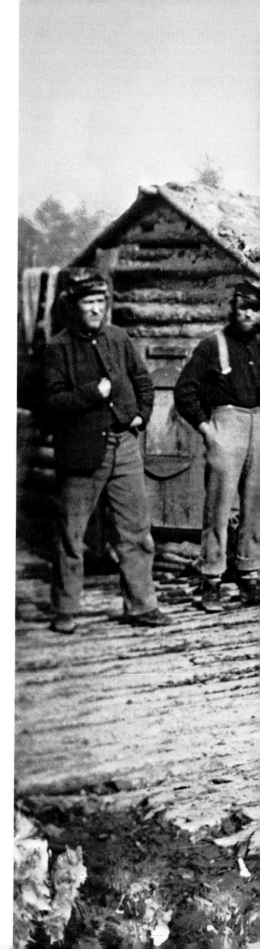

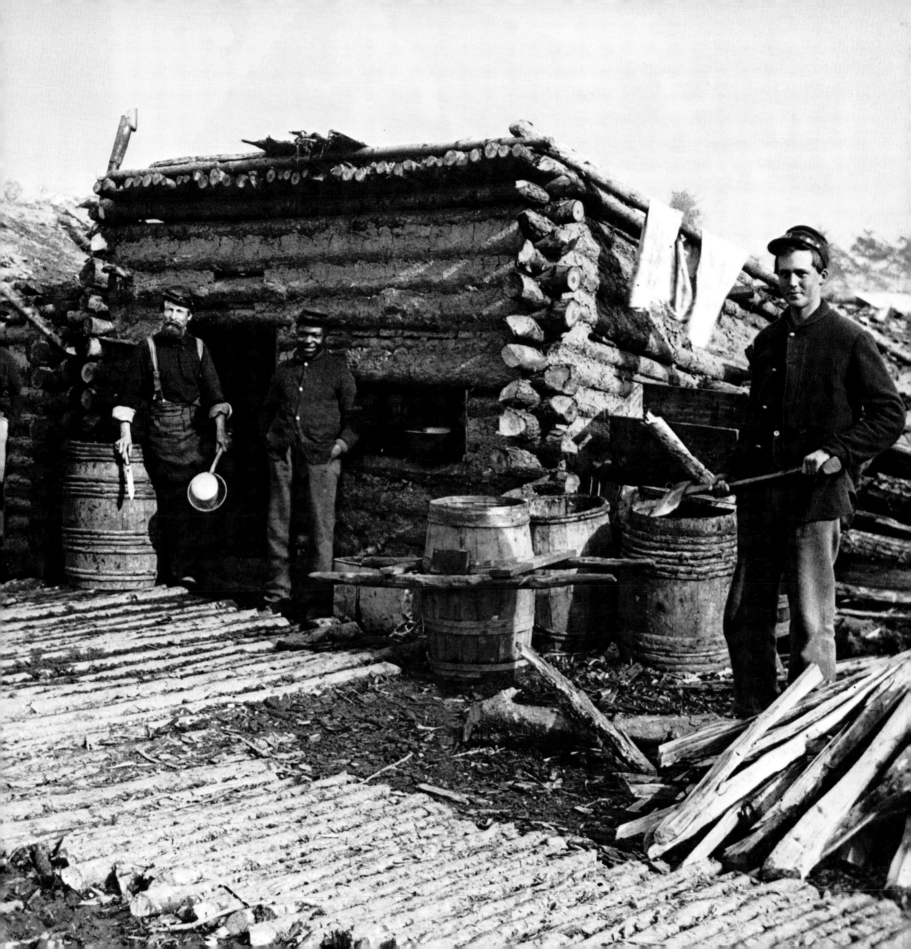

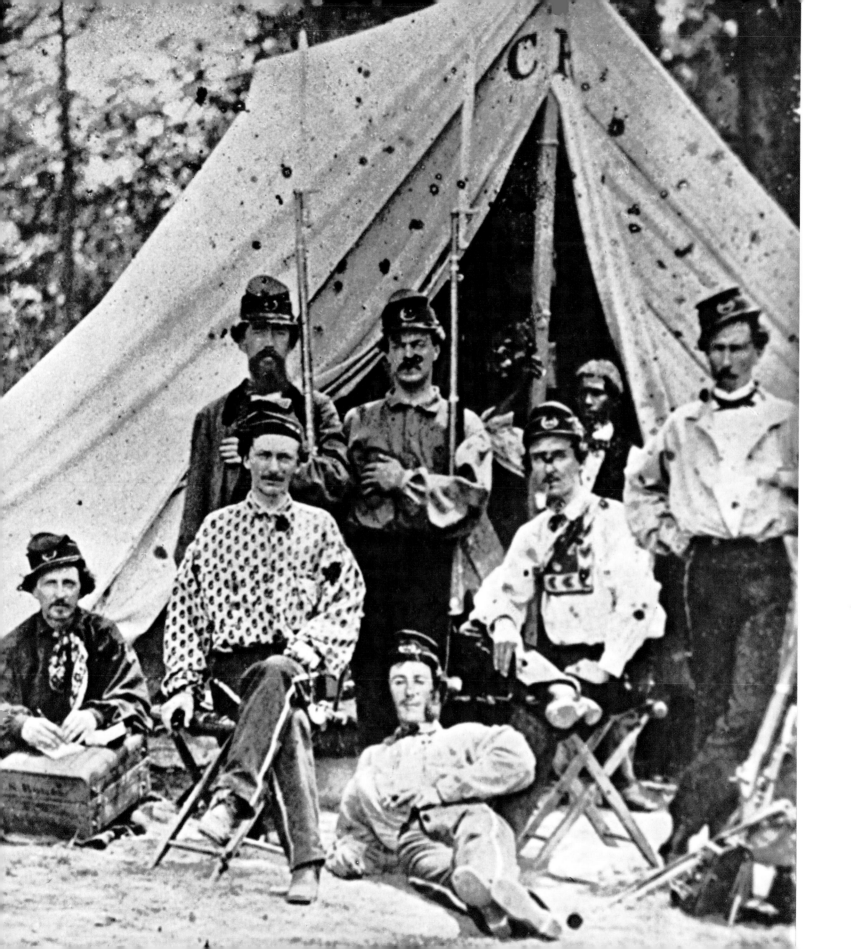

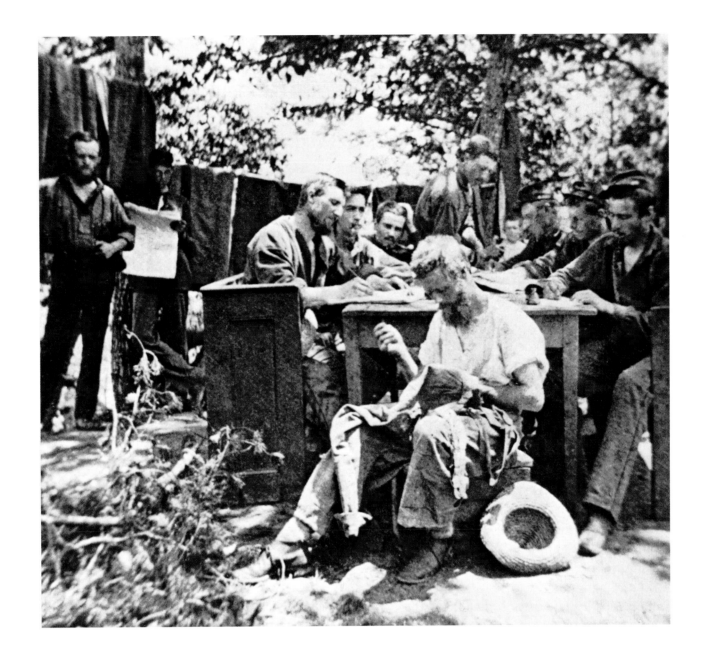

MEN OF COMPANY A

Company A of the 5th Georgia Volunteers and their black camp servant lounge before a wall tent in this damaged photograph, taken at Augusta, Georgia, in 1861. The letters CR on the front of the tent stand for Clinch Rifles, the company's informal name.

HOMELY DUTIES

Seated in the shade in church pews, Federal troops pass the time in camp writing letters, while a fellow soldier mends his clothes. Soldiers carried sewing kits called housewives and took pride in their skill; one boasted of patching his trousers "as good as a heap of women would do."

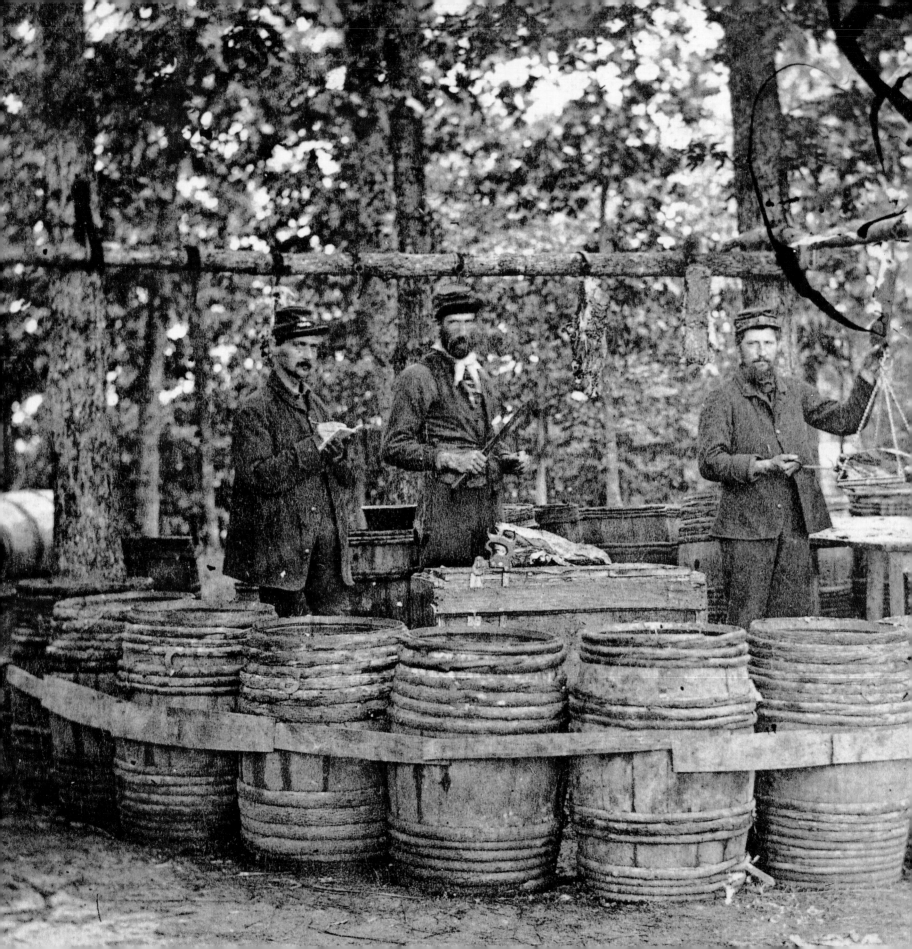

"SALT HORSE"

Federal army butchers weigh rations of meat under the watchful eyes of a commissary at Camp Essex in Northern Virginia. Regulations mandated a daily ration of 20 ounces of salt beef or 12 ounces of salt pork. The meat, dubbed "salt horse" by the soldiers, was packed in brine sufficient to preserve it for two years.

THE COLONEL'S FORAGER

His horse draped with chickens foraged from nearby farms, Private Billy Crump, an orderly on the staff of Colonel Rutherford B. Hayes of the 23rd Ohio Infantry, returns to his camp in western Virginia. In one memorable foraging expedition, Crump netted 50 chickens, two turkeys, one goose, 20 dozen eggs, and more than 30 pounds of butter.

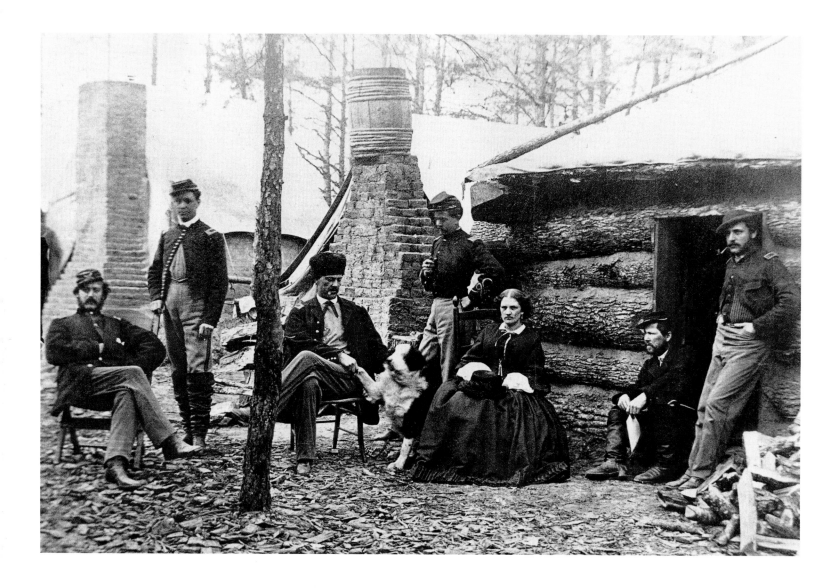

LADIES IN CAMP

A female visitor sits with staff officers of Captain James M. Robertson's 1st Brigade Horse Artillery in front of a headquarters hut at Brandy Station, Virginia, in February 1864. Opinions about spousal visits were mixed: One Federal officer remarked, "I think I should consider some time before I brought my wife to a mud-hill."

WASHDAY

At Camp Pendleton in northern Virginia, a laundress for the 31st Pennsylvania works beside her soldier husband and their children. Army regulations allowed each regiment four washerwomen in camp; in the field, the troops would wash their own clothes.

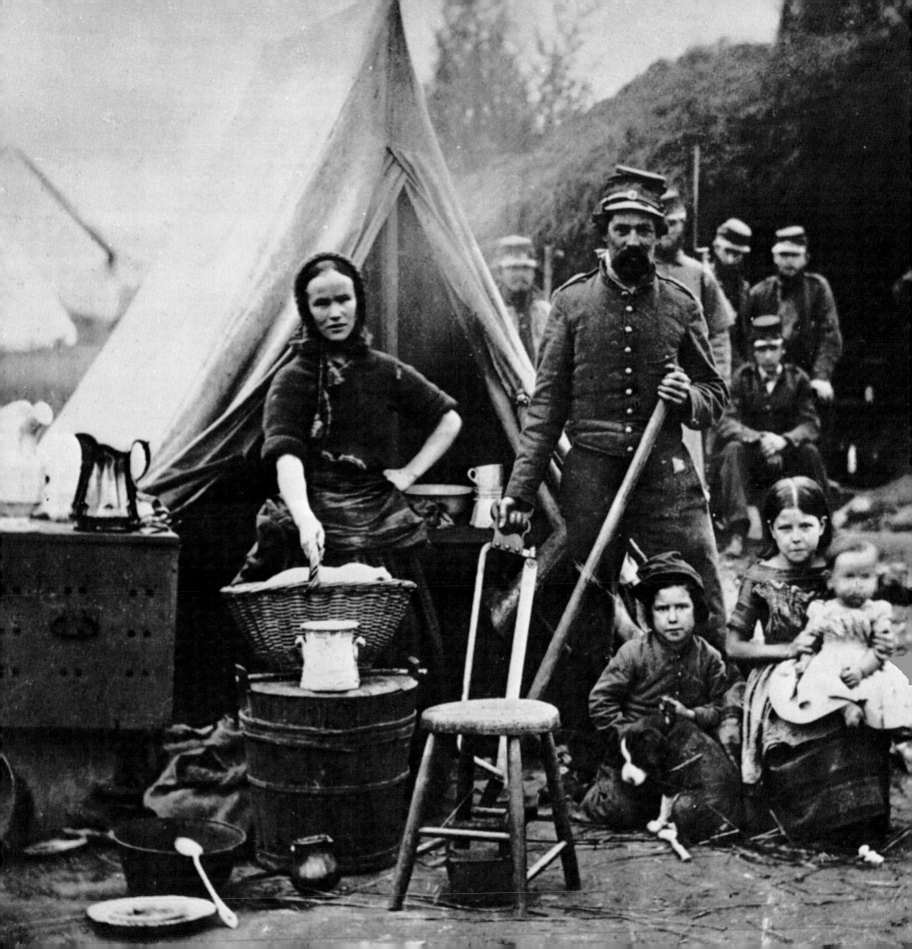

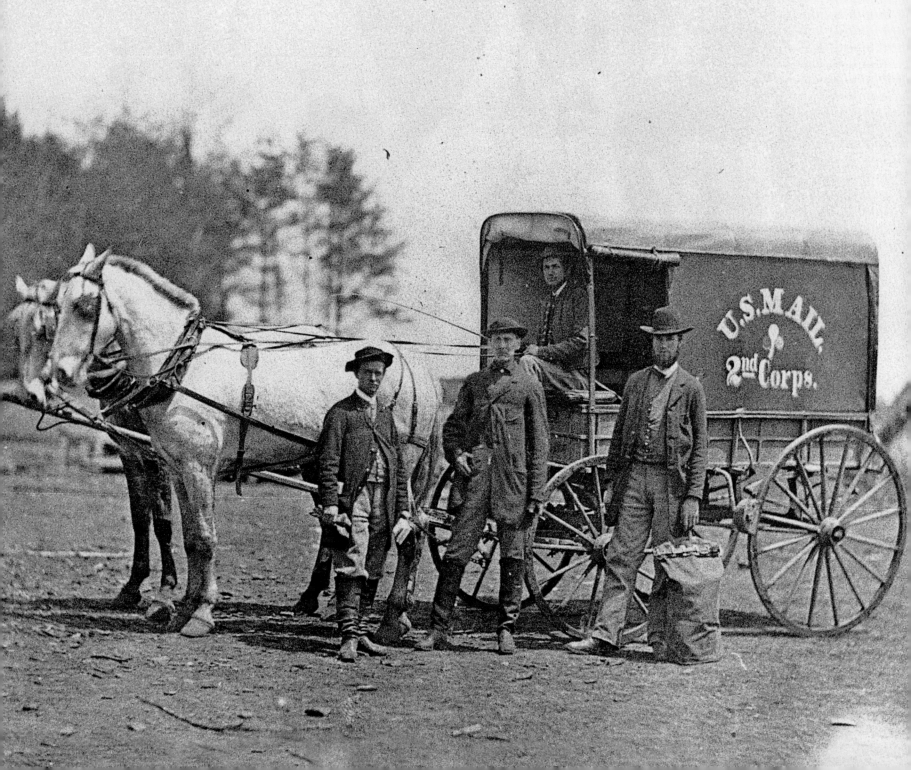

NEWS FROM HOME

Letter carriers pose with their mail wagon at Brandy Station in 1864. The previous year General Joseph Hooker instituted bureaucratic reforms that greatly increased the reliability of the mail, which was vital to the army's morale.

LICENSE TO STEAL

A group of sutlers pose with crates of their goods. Although these government-approved vendors occasionally advertised their wares, such promotion was largely unnecessary, for the army licensed only one sutler per post or regiment. To further ensure a captive clientele, many sutlers made change in scrip negotiable only in the sutler's tent.

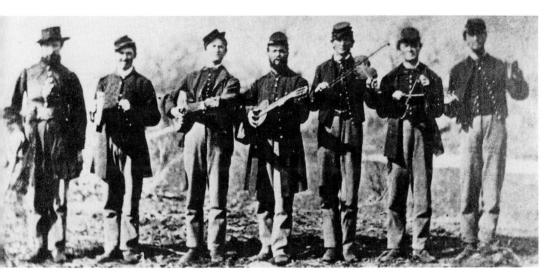

MILITARY MINSTRELS

A spirited musical ensemble of Federal soldiers displays their instruments—a tambourine, banjo, guitar, fiddle, triangle, and bones.

A SHAVE AND A HAIRCUT . . .

Beneath an arbor, a Federal soldier receives a haircut from an amateur barber. After long campaigns, the men looked forward to such amenities; one Confederate recalled that "the luxury of a shave completed the restoration of the man to decency."

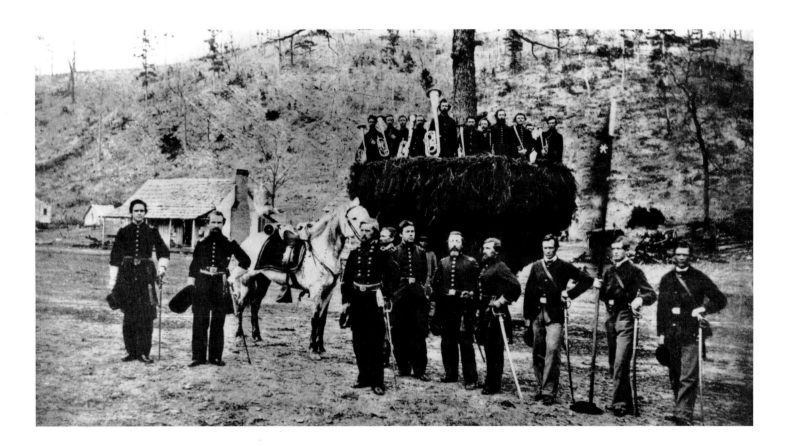

CONCERT UP A TREE

Perched inside an improvised bandstand that resembles a large bird's nest, the regimental band of the 38th Illinois prepares to serenade Brigadier General William P. Carlin (center) and his staff in their camp in Tennessee.

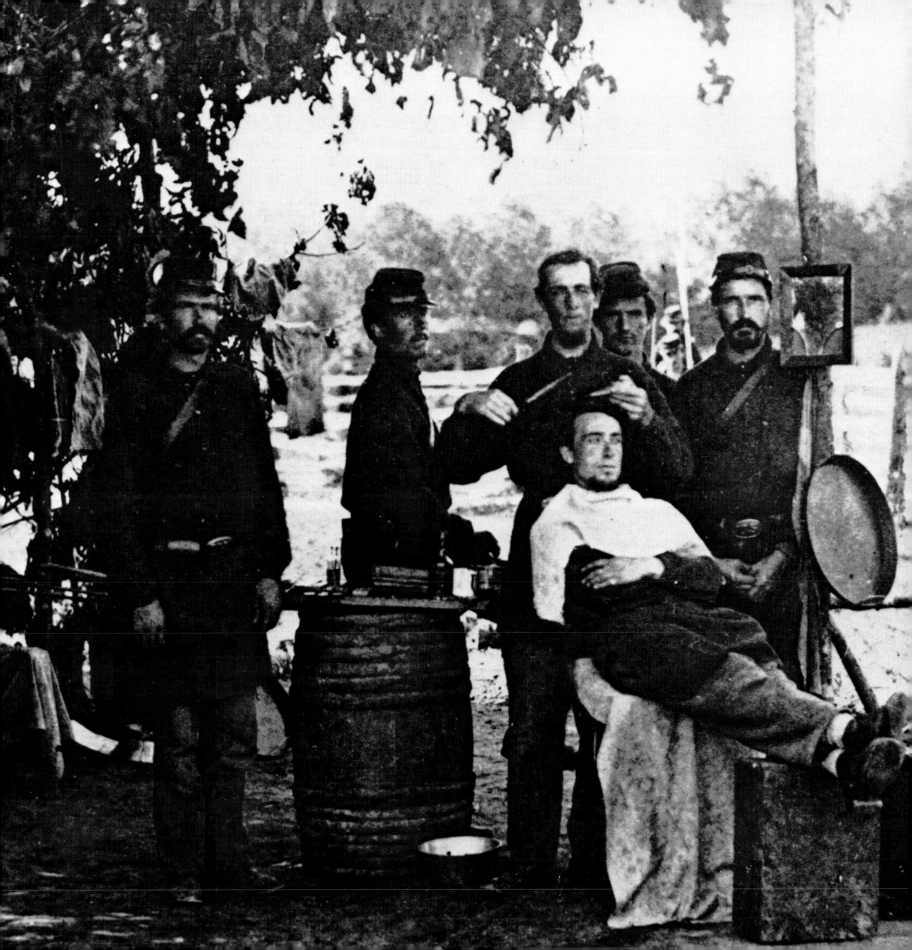

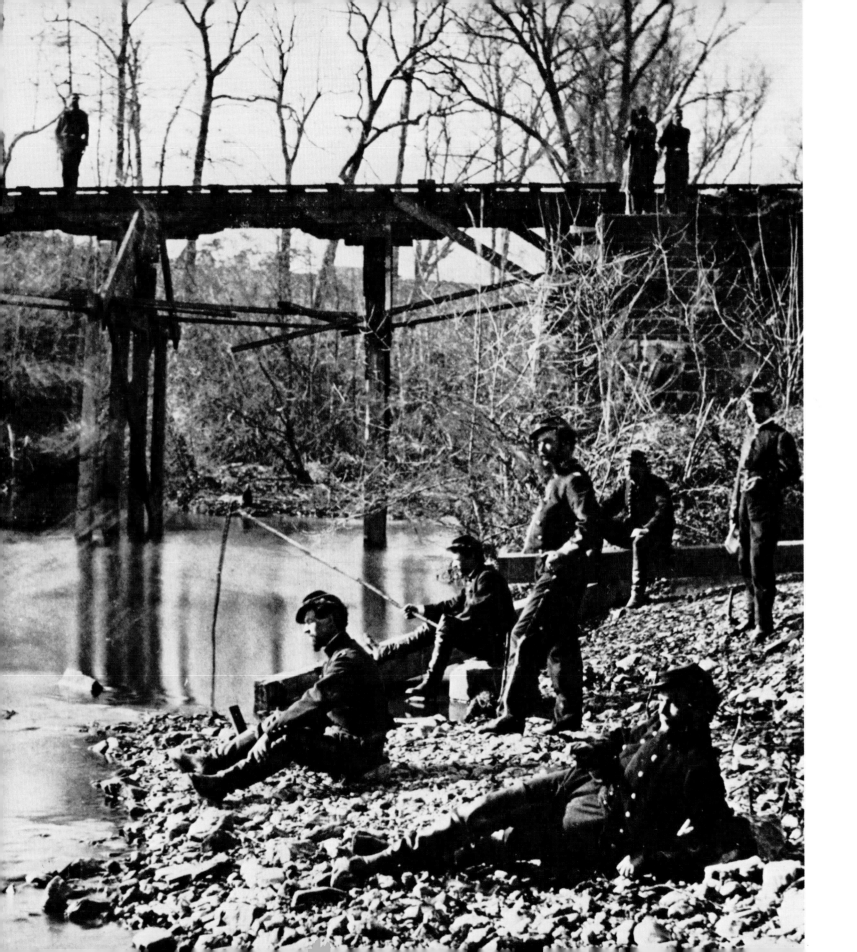

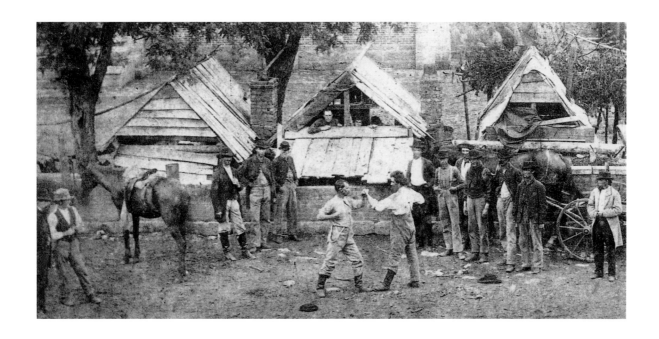

BAREKNUCKLE MATCH

Stripped to their shirtsleeves, with their hats tossed into the "ring," two Federal soldiers square off for an impromptu bareknuckle boxing match near their quarters in an occupied Southern city.

AN INFREQUENT OPPORTUNITY

Federal soldiers take advantage of a brief lull in the Wilderness Campaign to bathe in Virginia's North Anna River below the ruined bridge of the Richmond, Fredericksburg, and Potomac Railroad. Photographer Timothy O'Sullivan exposed this plate during the last week of May 1864.

TAKING TIME OFF

Officers of the 164th New York fish and loll along Pope's Run near Sangster's Station, Virginia, as three Federal sentries guard the railroad bridge above.

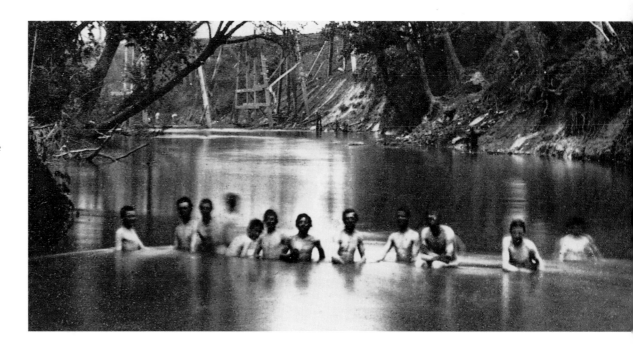

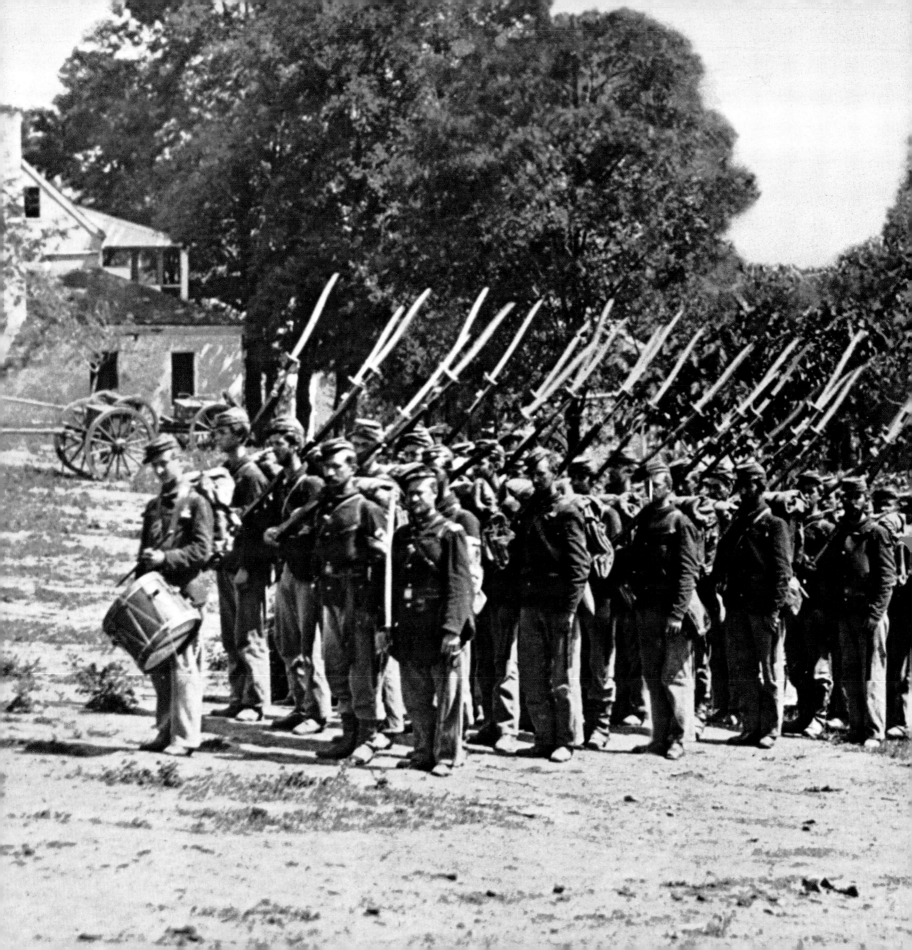

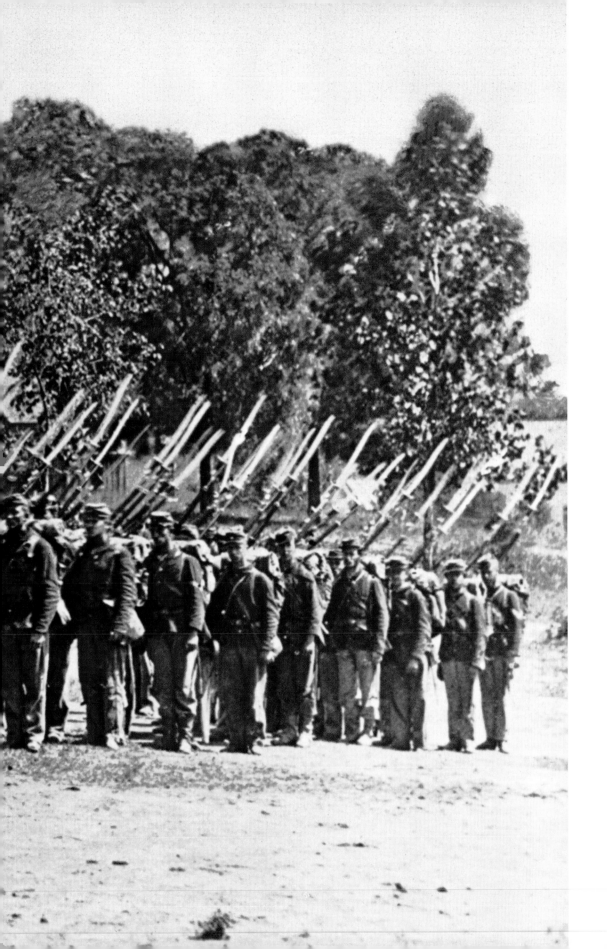

> "Let an honest pride be felt
> in possessing that high virtue
> of [a] soldier, obedience!"

MAJOR GENERAL GEORGE B. MCCLELLAN,
Commander, Army of the Potomac

DRILL AND MORE DRILL
Led by a drummer and their company commander,
soldiers of the 22nd New York State Militia drill in
a column of fours near Harpers Ferry, Virginia. Drill
was universally unpopular with the troops. "Between
drills," quipped a soldier from Pennsylvania, "we
drill, and sometimes stop to eat a little."

213

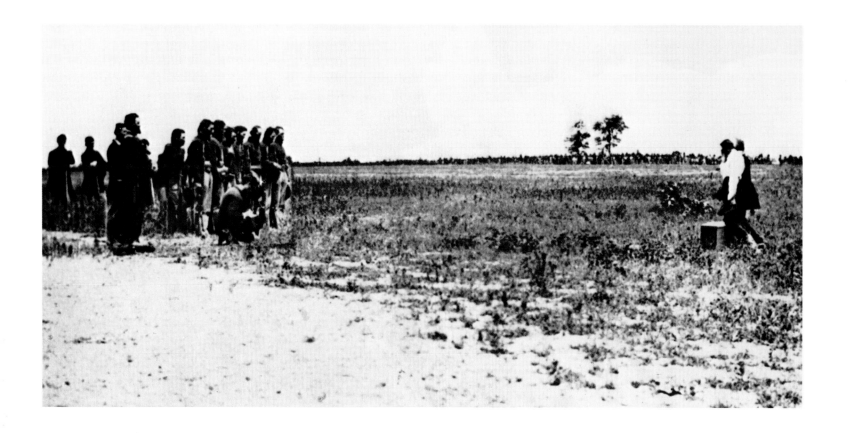

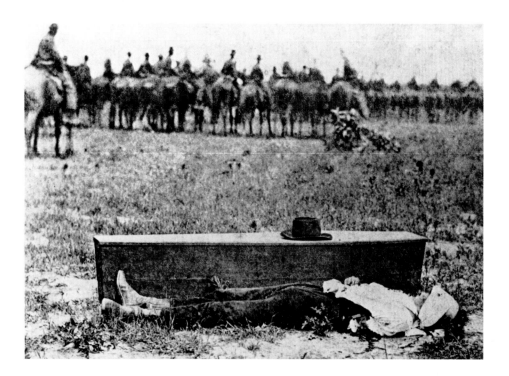

ULTIMATE PUNISHMENT

Standing behind his own coffin, a condemned Federal deserter listens to a chaplain intone a final prayer while the men of the firing squad bow their uncovered heads. In the distance, soldiers from the deserter's division line up to watch. After the execution, cavalrymen troop past the body *(below)*. As a final disgrace, deserters were often buried face down in unmarked graves.

CHAPLAIN OF THE 69TH

A tent serves as a chapel for Father Thomas Mooney *(right)*, who christened a cannon for the Irish 69th New York before the battle of Bull Run, much to the chagrin of his bishop.

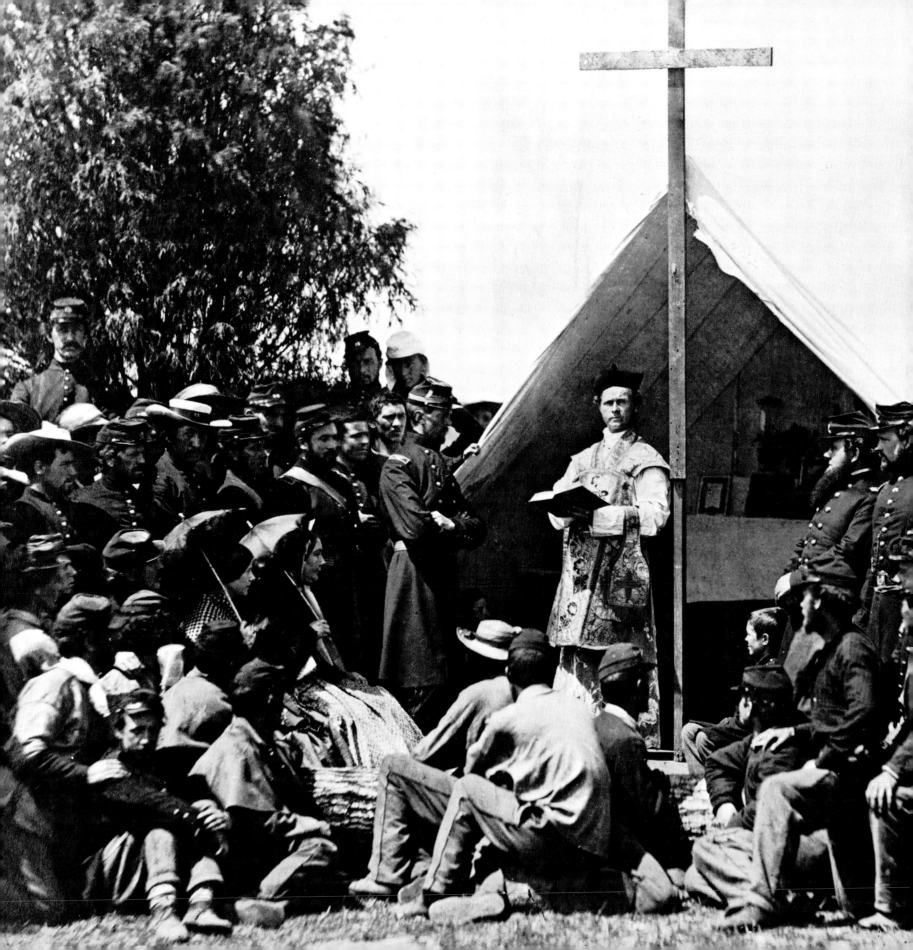

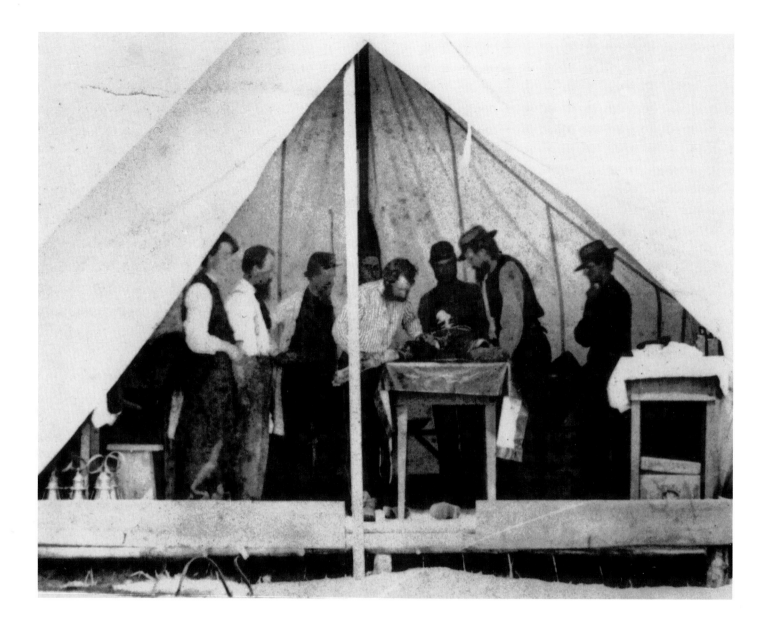

SURGEON AT WORK

Federal surgeon John J. Craven operates on a soldier with an injured leg during the siege of Charleston in 1863. The orderly at the rear of the tent is holding a chloroform-soaked rag over the patient's face to anesthetize him. Many battlefield surgeries were amputations, because when bones were splintered, "amputation was the only means of saving life."

TREATMENT IN THE FIELD

Wounded soldiers recover from surgery on the grounds of a Federal field hospital near the Marye House at Fredericksburg, Virginia, in May 1864. The men would eventually be evacuated by river to permanent hospitals located in Alexandria, Virginia, and Washington, D.C.

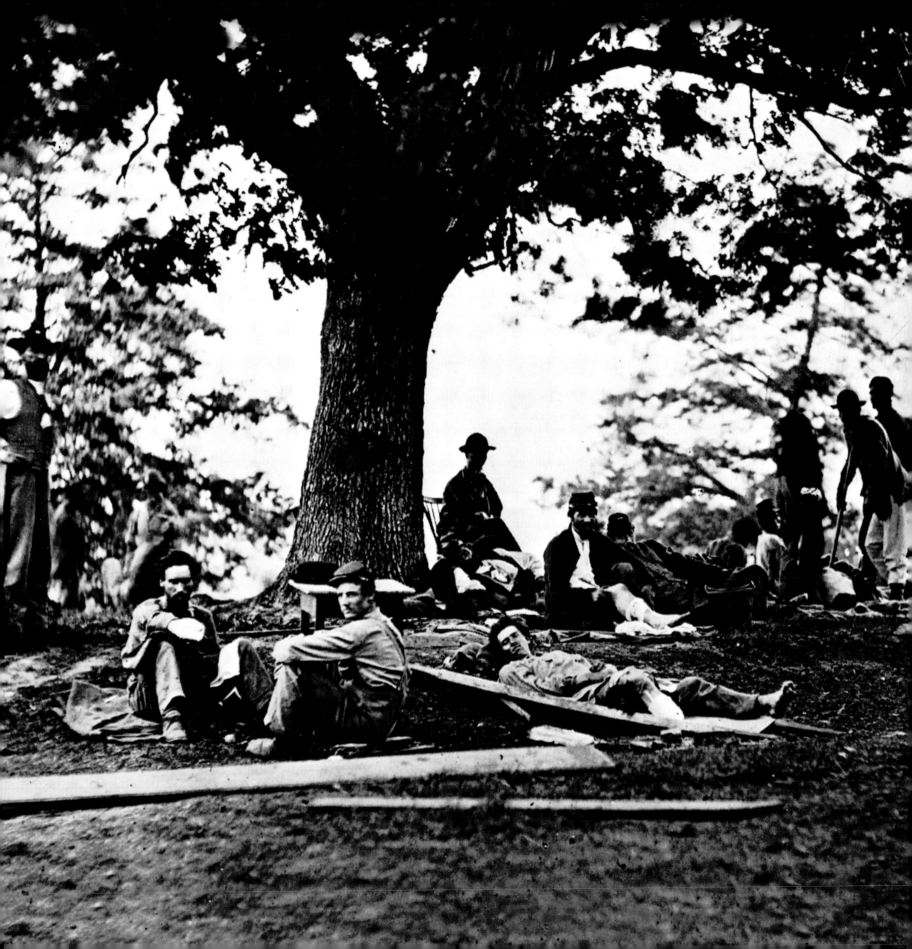

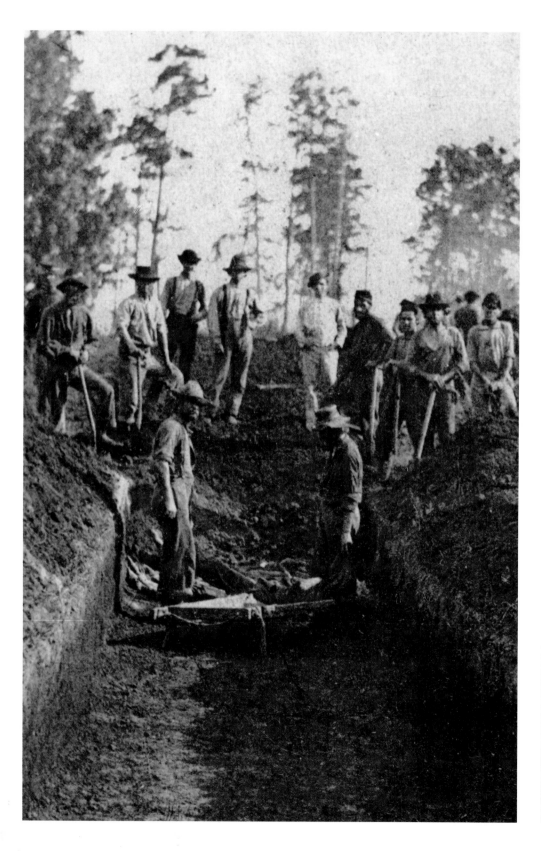

RUDE BURIAL

Granted extra rations so they might be strong enough to carry out their grim task, Federal prisoners at Andersonville inter the victims of hunger, disease, and exposure in a burial trench north of the stockade. In 1864 the death rate exceeded 100 captives per day.

SKELETAL FEDERAL SOLDIER

One of a series of horrifying images of former prisoners, the photograph below of a skeletal Federal soldier fueled the cry for vengeance against Confederate prison authorities. Exchanged from Belle Isle prison near Richmond late in the war, this soldier probably suffered from unchecked dysentery.

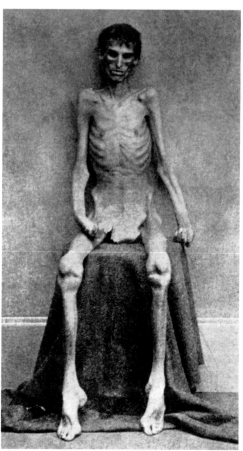

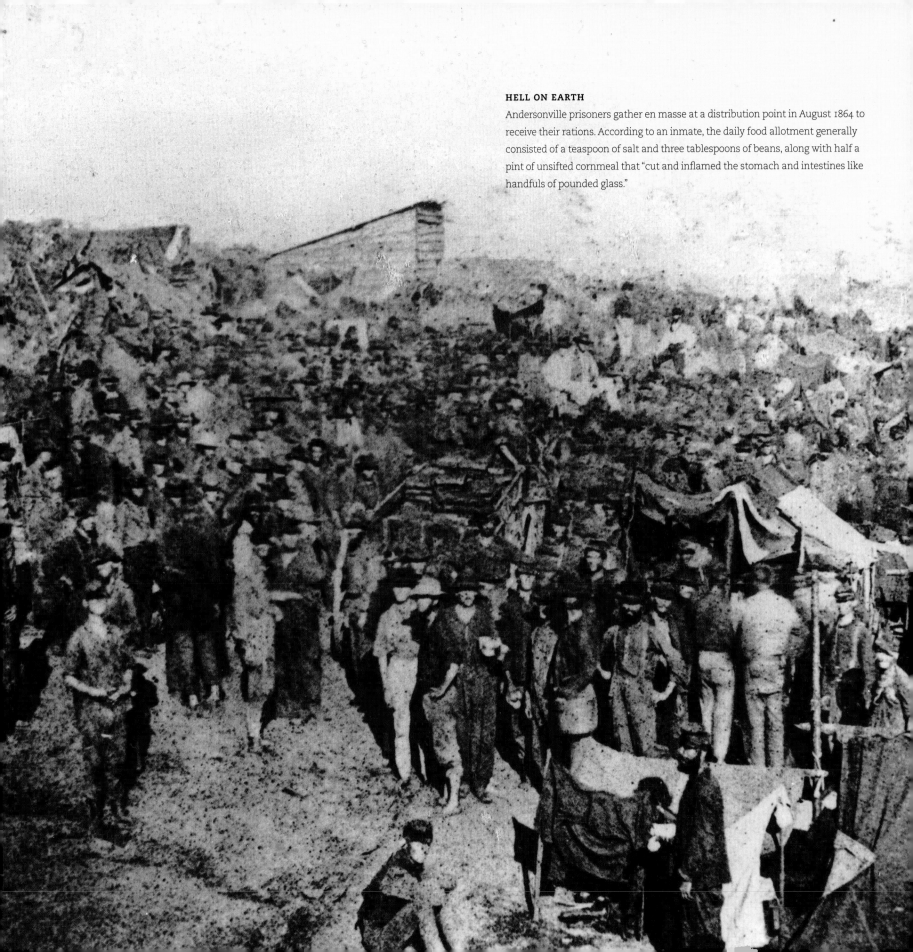

HELL ON EARTH
Andersonville prisoners gather en masse at a distribution point in August 1864 to receive their rations. According to an inmate, the daily food allotment generally consisted of a teaspoon of salt and three tablespoons of beans, along with half a pint of unsifted cornmeal that "cut and inflamed the stomach and intestines like handfuls of pounded glass."

Icons of Remembrance

FOR THE CITIZEN SOLDIERS OF THE CIVIL WAR AND THE FAMILIES THEY LEFT BEHIND, no memento was more precious than a photographic likeness, be it of a proudly uniformed volunteer or of loved ones at home. Like the painted portrait miniatures of earlier times, glass plate ambrotypes and enameled iron tintypes were one-of-a-kind images, mounted in decorative cases—or, if the tiny "gemtype" format, set in a locket—and treasured as sentimental icons. Photography enthusiast Oliver Wendell Holmes described them as "faithful memorials of those whom we love and would remember," and many preferred the unique cased images over the cheaper mass-produced cartes de visite. If tinted with color by a skilled photographer's assistant, their effect was particularly striking and lifelike.

As with daguerreotypes, which by the late 1850s they had supplanted in popularity, ambrotypes and tintypes recorded a mirror image of the subject, and it was not uncommon for soldiers to compensate by reversing their weapons and accoutrements when they posed for a portrait. Depending upon the available light, exposure times generally varied from 3 to 10 seconds, and required that sitters remain motionless lest the image be blurred. For that reason smiling was discouraged, even in informal vignettes, though the hint of a grin was sometimes hard to suppress. Infants and animals proved particularly difficult to photograph, unless physically restrained to prevent movement and blurring.

Despite the technical limitations of the art, photographs often provided a powerful reminder of cherished lives disrupted by war. Many veterans remarked on the poignant sight of family portraits lying amid the detritus of the battlefield, or beside the bodies of slain soldiers whose last thoughts were of the precious faces recorded on a piece of iron or glass.

After the battle of Gettysburg, a burial detail came upon a dead Union soldier whose only identification was an ambrotype of three young children clasped in his hand. Copies of the picture were circulated throughout the North in an effort to identify these "children of the battlefield" until a woman whose soldier husband was listed as missing recognized the picture as one she had sent him before the battle. He was Sergeant Amos Humiston of Company C, 154th New York Infantry.

CHILDREN OF THE BATTLEFIELD
Proceeds from the sale of carte de visite copies of slain sergeant Amos Humiston's ambrotype and of a sentimental ballad commemorating the "children of the battlefield" were used to establish the Soldier's Orphan Home in Gettysburg in 1866. The sergeant's widow, Philinda, became the first matron, and his children—Franklin, Frederick, and Alice—were educated there.

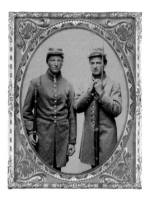

Confederate infantrymen

Private George F. Murray,
114th Pennsylvania Zouaves

Captain Houston B. Lowrie,
6th North Carolina Infantry

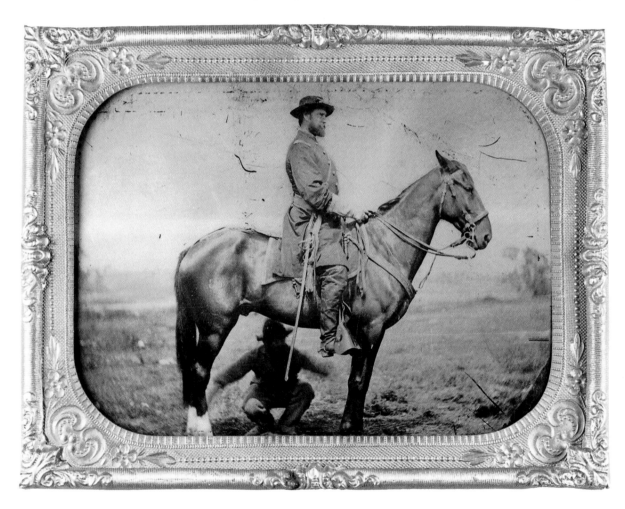

INTREPID HORSEMAN

Major Henry W. Granger of the 7th Michigan Cavalry strikes a martial pose astride his horse, while an enlisted man steadies the restive animal. Highly regarded for his bravery, Granger was killed leading a charge at the Battle of Yellow Tavern on May 11, 1864.

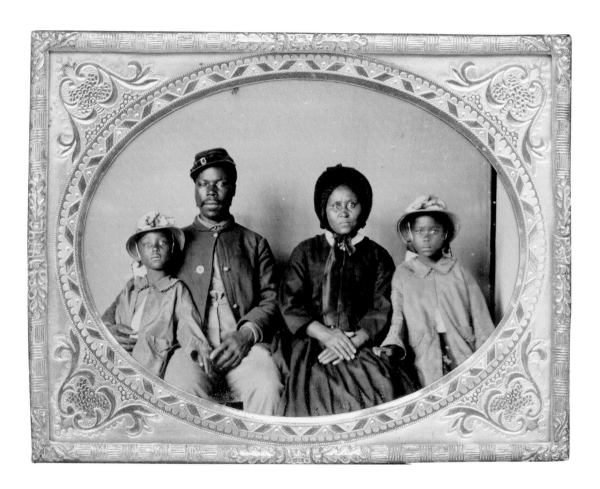

PROUD HUSBAND AND FATHER

Wearing a uniform of Federal blue, a proud soldier of the United States Colored Troops sits for a family portrait before leaving for the front. President Lincoln's Emancipation Proclamation paved the way for the enlistment of thousands of black volunteers, whose bravery and devotion were vital to the success of the Union war effort.

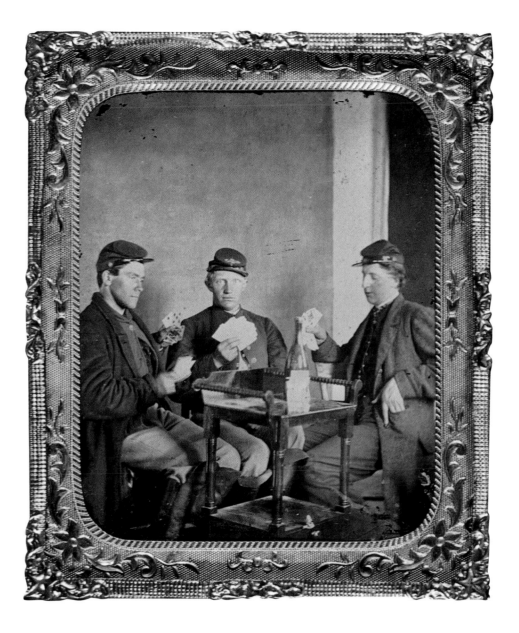

Gemtype portraits, 36th Illinois Infantry

Union soldiers with baseball gear

LEISURE TIME

Three Federal soldiers enjoy a game of cards, a favorite pastime in off-duty hours. Despite the casual nature of the scene, the sitters maintain stoic expressions, as smiles were hard to maintain during the long exposure.

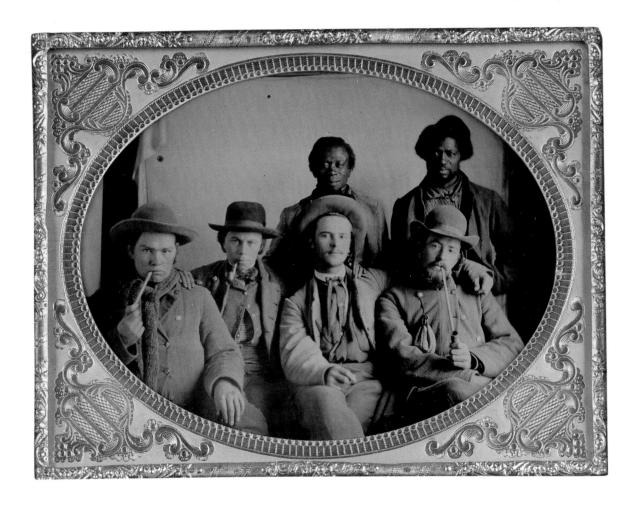

CONFEDERATE SOLDIERS AND SERVANTS

Troopers of the 7th Tennessee Cavalry, a unit serving in General Nathan Bedford Forrest's command, pose with their slaves or body servants. Most Confederate units were accompanied by black auxiliaries, including some "free men of color" who functioned as teamsters, cooks, and laborers for the Southern war effort.

Confederate General William B.
Taliaferro (*seated*) and officers

Soldier of the 14th Brooklyn Regiment in
French-styled chasseur uniform

Private Thomas Holman,
13th Tennessee Infantry

Captain George Hillyer,
9th Georgia Infantry

Private James Berry,
79th New York Infantry "Highlanders"

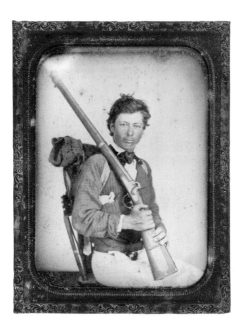

Confederate infantryman

Federal Zouave

Confederate artilleryman

Soldier of the Pennsylvania "Bucktails"

Private James M. Stedham,
25th Alabama Infantry

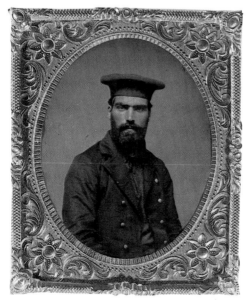

U.S. Navy sailor

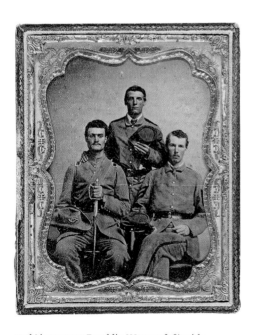

2nd Lieutenant Franklin Weaver *(left)* with
comrades from the 4th North Carolina Infantry

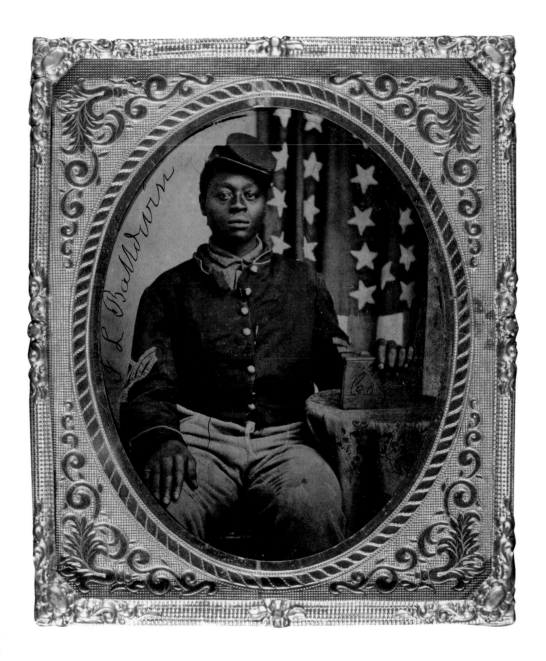

A WARRIOR FOR FREEDOM

With the chevrons and diamond of a first sergeant on his sleeves, James Baldwin of Company G, 56th U.S. Colored Infantry, poses before the stars and stripes. As senior noncommissioned officer in his company, Baldwin played a gallant part in the July 26, 1864, battle of Wallace's Ferry, Arkansas.

Struggle for Tennessee

FOR SIX MONTHS, FOLLOWING THE FEDERAL VICTORY AT STONES RIVER early in 1863, Federal Major General William S. Rosecrans's Army of the Cumberland and General Braxton Bragg's Confederate Army of Tennessee sat idle less than 30 miles apart in central Tennessee. Finally, under pressure from Washington, Rosecrans took the initiative in June, boldly flanking Bragg from his position around Tullahoma and forcing the Confederates to fall back on Chattanooga, a vital transportation hub and supply center on the Tennessee River. When Federal troops advanced on the town in September, Bragg evacuated the city without a fight.

Rosecrans pursued Bragg into northern Georgia, and the two armies collided on September 19 near Chickamauga Creek in a day of confused fighting that resulted in little gain for either side. On the morning of September 20, Bragg, reinforced by General James Longstreet's corps, which had arrived by rail from Virginia during the night, launched a stunning blow that sent the Federals reeling back to Chattanooga. Only the brave stand made by troops under General George Thomas—the "Rock of Chickamauga"—saved Rosecrans's army from destruction.

On reaching Chattanooga, the Confederates severed the Union supply lines, initiating a partial siege. Rosecrans's telegraph to his superiors from Chattanooga offered little hope. "We have met with a serious disaster," he wrote, "we have no certainty of holding our position here."

Abraham Lincoln, keenly aware of the importance of the city, gave Ulysses S. Grant command of all forces west of the Appalachians. Grant immediately began operations to concentrate his forces and open supply lines to Chattanooga. Finally, between November 23 and 25, Grant attacked at Orchard Knob, Lookout Mountain, and Missionary Ridge, in a series of fierce engagements that forced Bragg to abandon the siege and retreat into Georgia. The stage was set for the burning of Atlanta and Sherman's destructive march to the sea.

GALLANT CORPORAL

Corporal William C. Montgomery displays the tattered national colors of the 76th Ohio. He lost an arm carrying this flag in the futile attack on the Rebel rear guard at Ringold, Georgia, where the 76th suffered 25 percent casualties.

ON TO NASHVILLE

Federal troops in formation make their way across a bridge over the Big Barren River near Bowling Green, Kentucky. Recently repaired by the use of pontoons, the span served as a vital link in the Louisville-to-Nashville supply line.

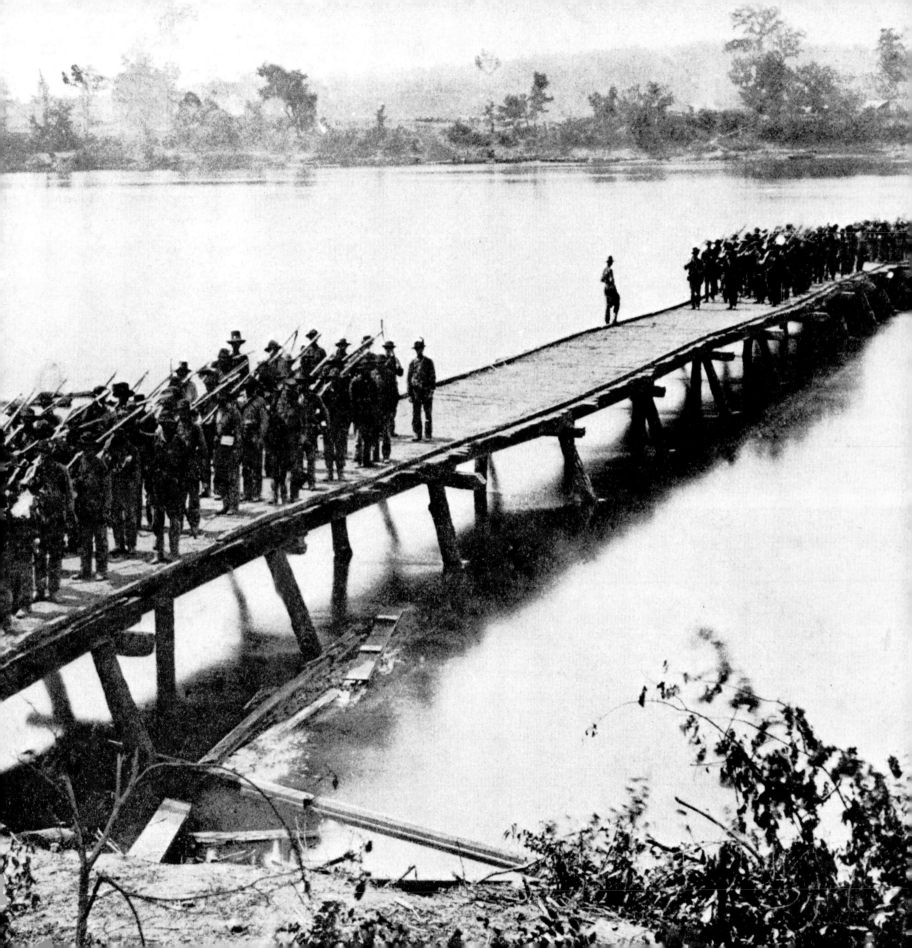

"Hurrah for the bully little steamboat! Rations once more—hurrah!"

ANONYMOUS FEDERAL
SOLDIERS IN CHATTANOOGA

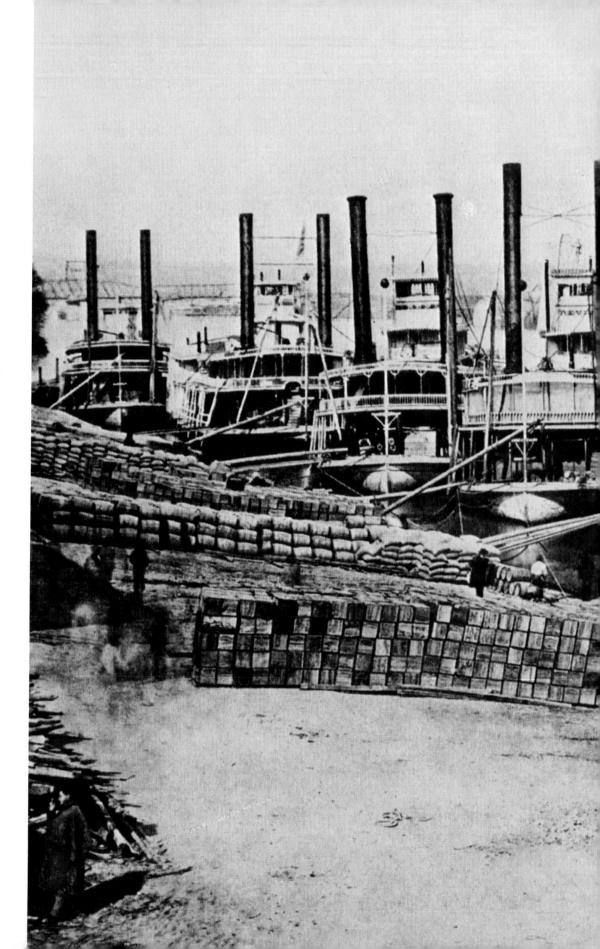

STEAM-DRIVEN LIFELINES

Steamboats lie moored to Nashville's wharf in
December 1862 as stevedores unload hardtack, flour,
sugar, molasses, and whiskey. Nashville afforded
ready access to the Mississippi, Ohio, and Tennessee
Rivers and became a strategic supply center for
Federal armies in the West.

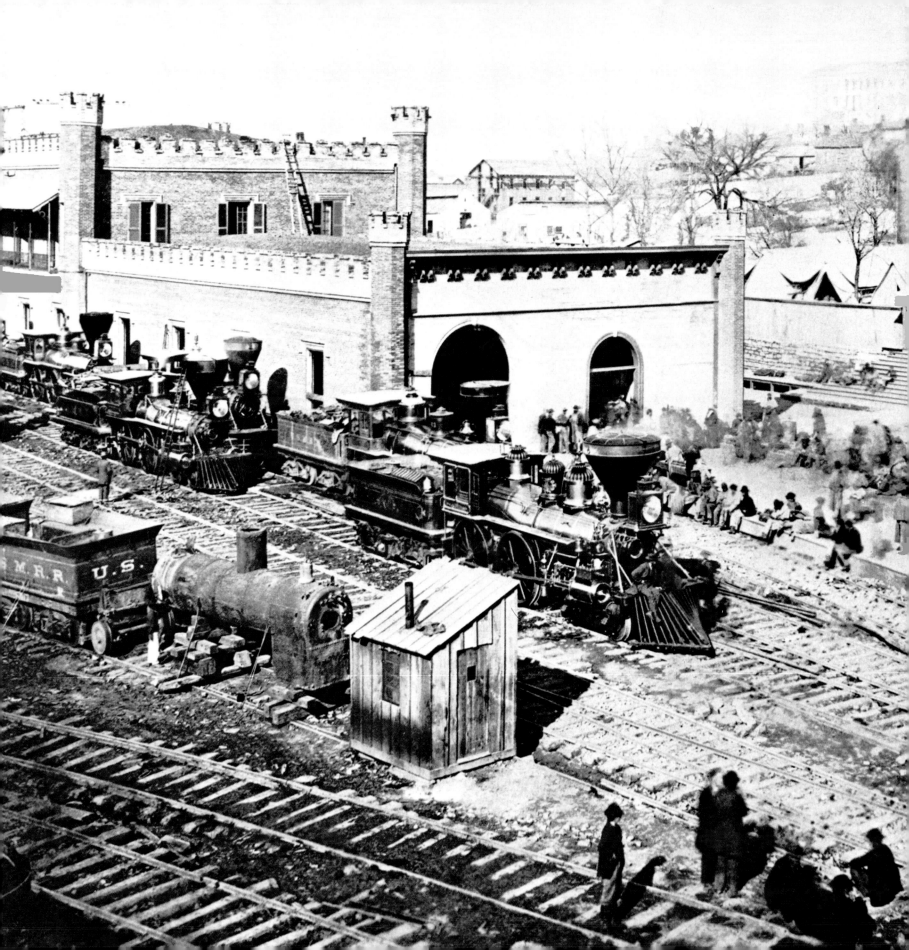

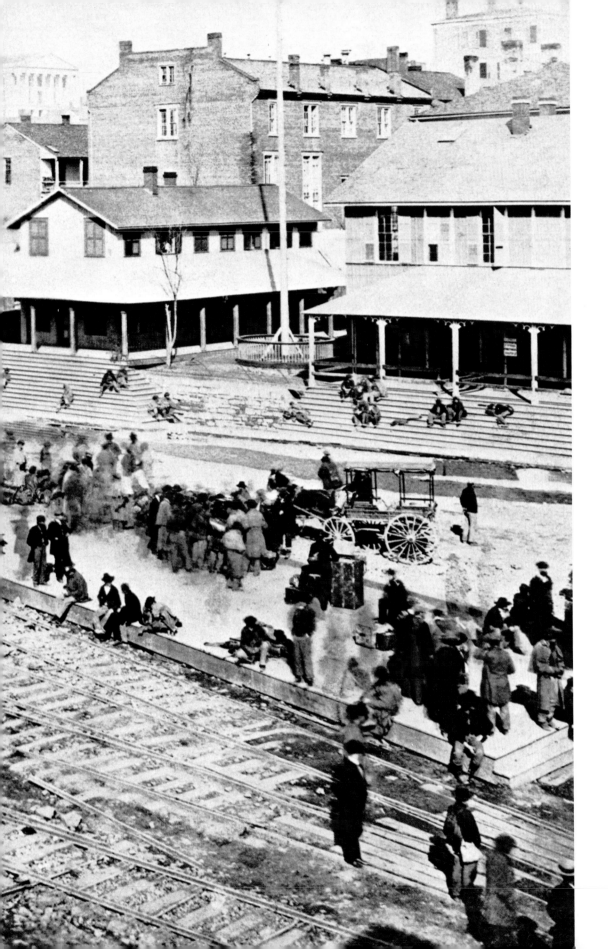

MILITARY RAIL DEPOT

Locomotives stand ready for service in Nashville's busy railroad depot. Under the control of Union logistics experts, with headquarters in the building at far right, Tennessee's railroads became models of military efficiency, carrying men and supplies to the front while shuttling prisoners and the sick and wounded to the rear.

"*The Yanks made their appearance very suddenly on the opposite side of the River and commenced shelling the town. The streets are crowded with soldiers & citizens, men, women & children. You never saw such a skidadling in all your life.*"

COLONEL NEWTON N. DAVIS,
24th Alabama Infantry in Chattanooga

VIEW FROM LOOKOUT MOUNTAIN
The view from Lookout Mountain, one of the Cumberlands' highest ramparts at 2,126 feet, includes the horseshoe bend made by the Tennessee River as it meanders just west of Chattanooga. The mountain, said a Confederate, was all "gorges, boulders and jutting cliffs."

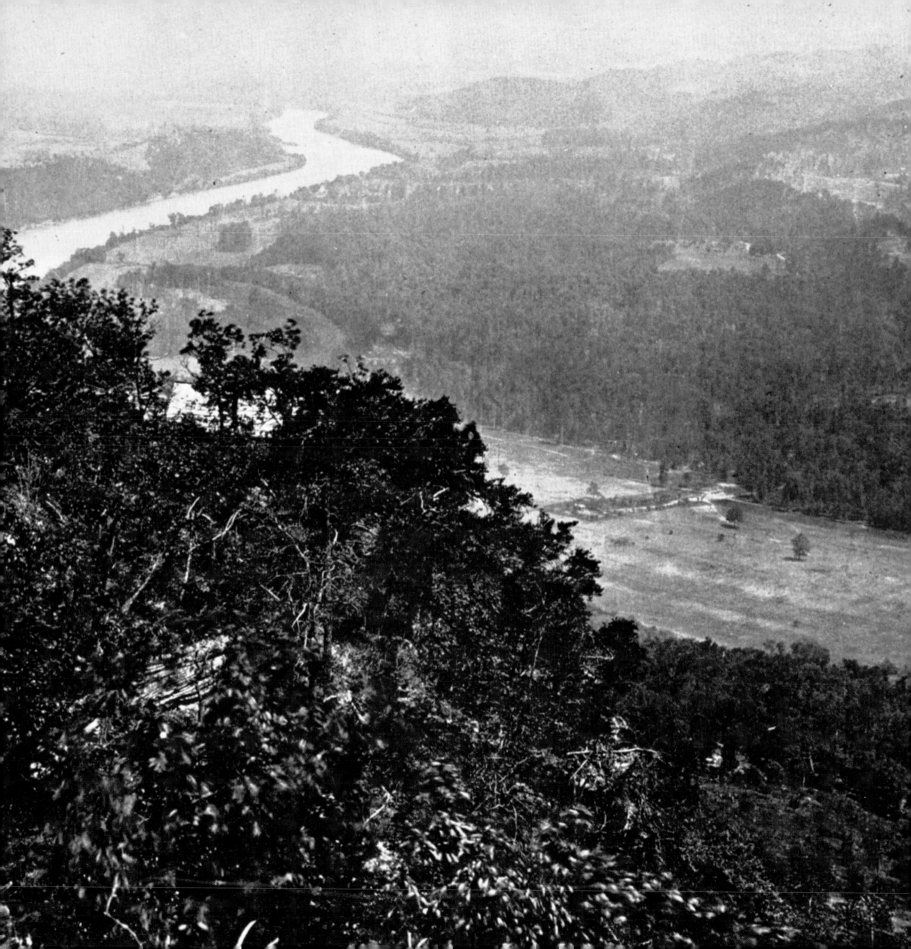

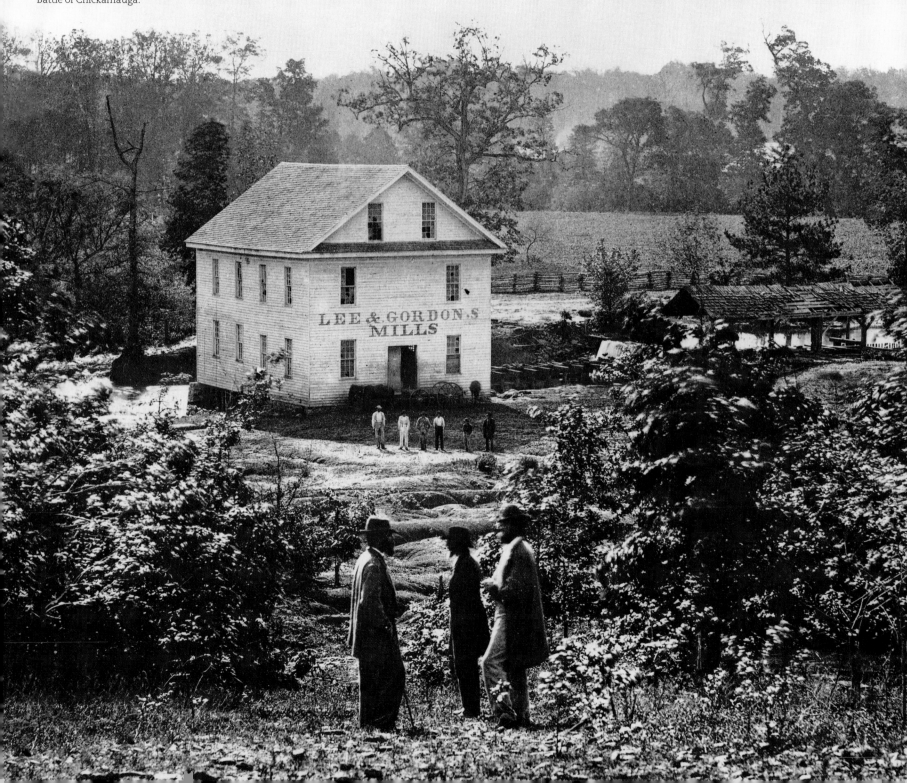

GORDON'S MILLS

The neat white frame structure that housed Lee & Gordon's Mills, about 12 miles south of Chattanooga, was the scene of some of the early skirmishes that marked the beginning of the two-day Battle of Chickamauga.

MOUNTED INFANTRY

Private John Munson, shown astride his mount, Col. John Mosby, and sporting a seven-shot Spencer rifle, served with the 72nd Indiana, a regiment of Colonel John T. Wilder's "Lightning Brigade," a brigade of mounted infantry that played a key role in the Tullahoma and Chickamauga campaigns.

EN GARDE

Members of the 8th Kansas Infantry strike a warlike pose in this 1862 photograph. The 8th Kansas saw heavy fighting at the Battle of Chickamauga.

DRUMMER BOY OF CHICKAMAUGA

At the age of 10, Ohioan Johnny Clem enlisted as a drummer in the 22nd Michigan Infantry. In 1863, Clem earned fame throughout the North as the "Drummer Boy of Chickamauga." During the battle, Clem grabbed a fallen rifle and killed a Confederate officer who demanded his surrender.

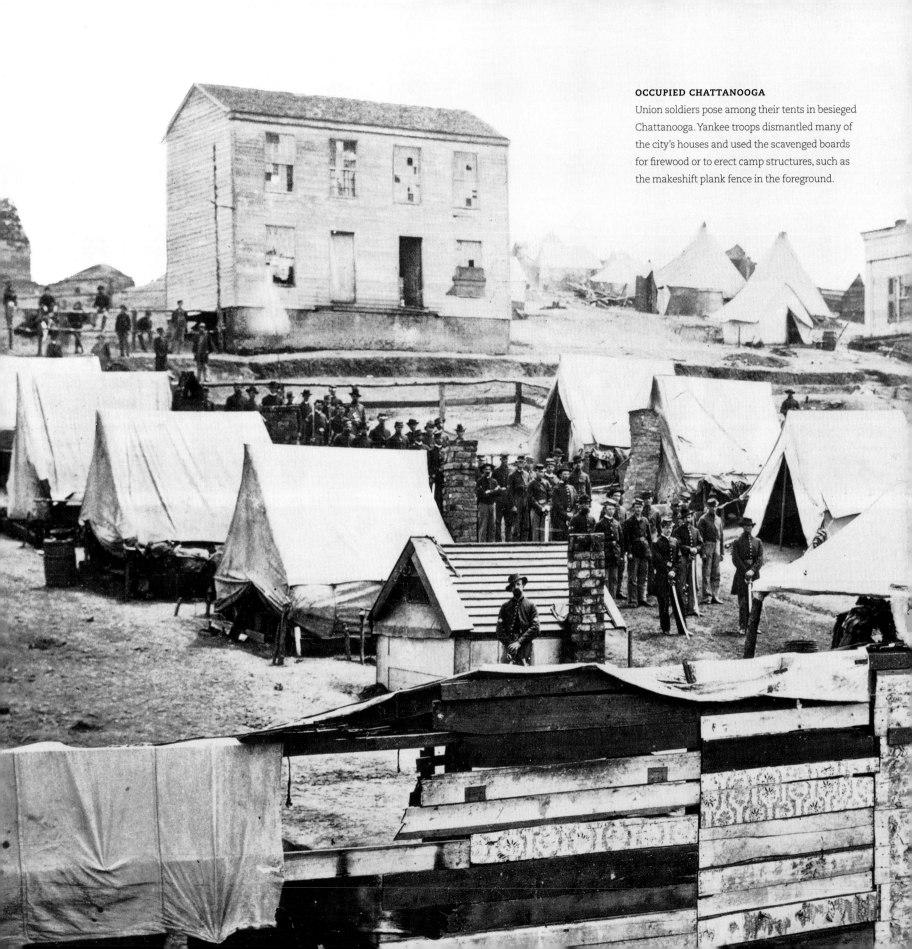

OCCUPIED CHATTANOOGA

Union soldiers pose among their tents in besieged Chattanooga. Yankee troops dismantled many of the city's houses and used the scavenged boards for firewood or to erect camp structures, such as the makeshift plank fence in the foreground.

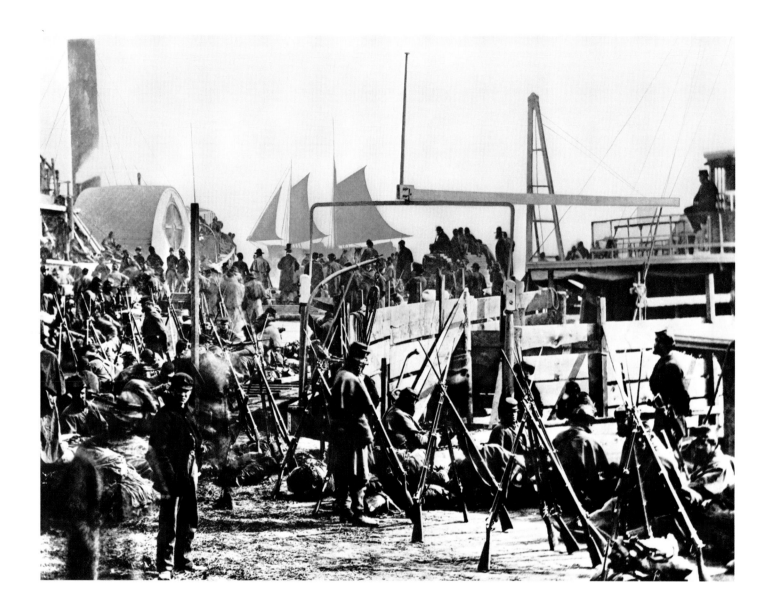

LEAVING FOR THE WEST

On their way west after the Fredericksburg campaign in February 1862, men of the Federal IX Corps wait to board transports at Aquia Creek Landing, Virginia. Eventually they joined Burnside's Army of the Ohio near Lexington, Kentucky.

FORT SANDERS'S BLOODY DITCH

A Federal sentry stands atop the ramparts of Fort Sanders in Knoxville. On November 29, 1863, the main Confederate attack on the fort came from the right, over the flats, through telegraph wire entanglements, and into the ditch ringing the bastion.

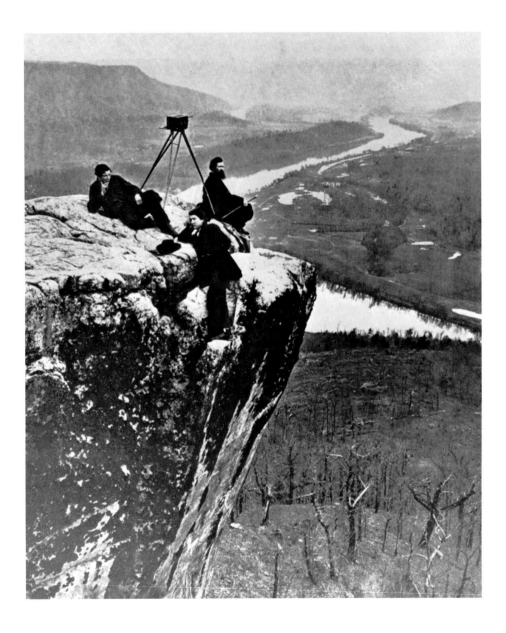

STUDIO ON THE CLOUDS

Royan M. Linn, cane in hand, sits with two of his assistants beside a stereo camera, looking out over the magnificent view he helped to popularize. Even after Linn's death in 1872, his family continued to maintain the studio on the rock.

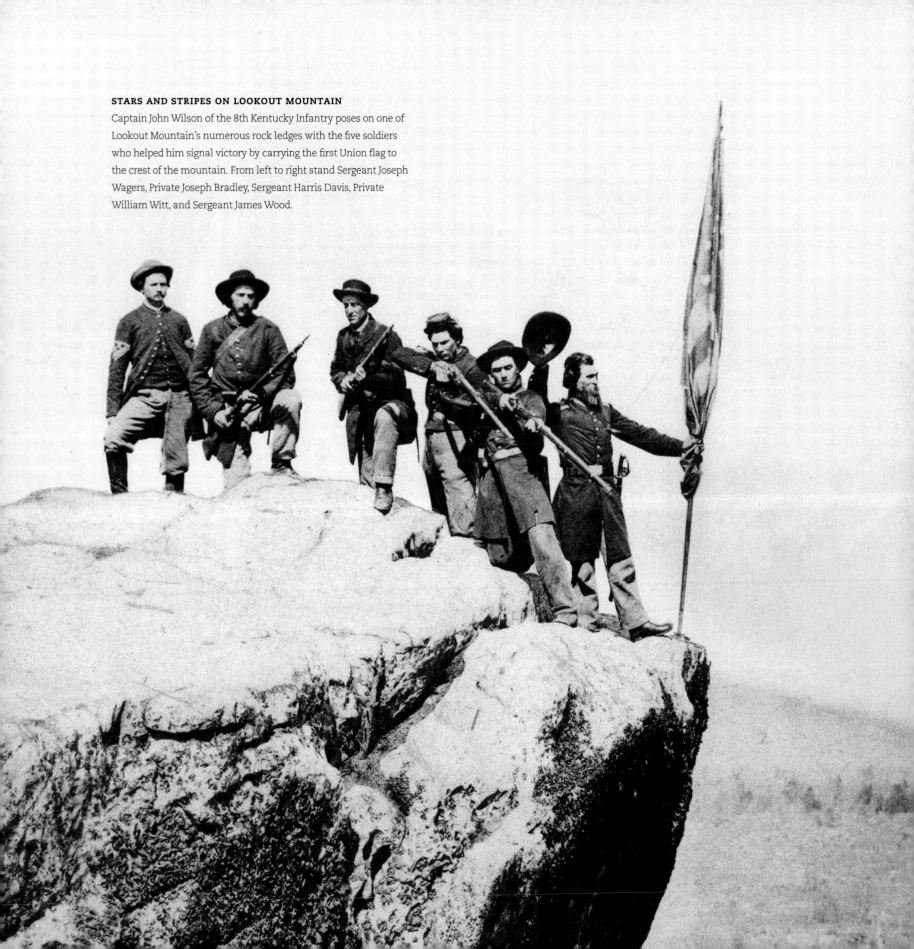

STARS AND STRIPES ON LOOKOUT MOUNTAIN

Captain John Wilson of the 8th Kentucky Infantry poses on one of Lookout Mountain's numerous rock ledges with the five soldiers who helped him signal victory by carrying the first Union flag to the crest of the mountain. From left to right stand Sergeant Joseph Wagers, Private Joseph Bradley, Sergeant Harris Davis, Private William Witt, and Sergeant James Wood.

The Killing Ground

IN EARLY MARCH 1864, LINCOLN SUMMONED ULYSSES S. GRANT to Washington. Determined to find a general who could ensure a final Union victory, the president promoted Grant to lieutenant general and gave him command of all of the Federal armies. Grant, convinced that there could be no peace until "the military power of the rebellion was entirely broken," ordered Sherman to advance on Atlanta, while he joined Meade's Army of the Potomac in a campaign to crush Lee's forces in Virginia. Grant planned to "hammer continuously against the armed force of the enemy and his resources, until by mere attrition, if in no other way, there should be nothing left to him but . . . submission."

On May 1, 1863, Federal forces crossed the Rapidan River into the tangled thickets of Virginia's Wilderness. Lee moved rapidly to counter Grant's advance, colliding with the Federals in two days of brutal fighting. By the second day, the Federals had suffered more than 15,000 casualties, causing Grant to cease his attacks and earning Lee a tactical victory. But the next day, instead of withdrawing, Grant forged ahead toward Spotsylvania Court House.

Lee responded quickly and again blocked the Federals, triggering a week of horrific fighting as Federal columns smashed repeatedly against the entrenched Confederates. Battered, the Rebel line held. Once more Grant sent his forces marching to get around Lee, fighting at the North and South Anna Rivers before concluding in a bloody three-day assault on Lee's trenches at a vital crossroads near Cold Harbor. The month of nearly constant battle brought staggering losses on both sides: 50,000 Federals and 30,000 Confederates. Still determined to crush Lee, Grant marched quickly to catch Lee off guard by crossing the James River to seize the railroad hub at Petersburg, 23 miles south of Richmond.

FORBIDDING DISCOVERY
Skeletons of soldiers lie in the Wilderness near the Orange Plank road. Such stark remains, left after the Battle of Chancellorsville in 1863, greeted the troops as they arrived to do battle in 1864. "We wandered to and fro," one Federal recalled, "looking at the gleaming skulls and whitish bones, and examining the exposed clothing of the dead to see if they had been Union or Confederate soldiers."

BRANDY STATION
During the long winter break from active campaigning, Federal staff officers of Major General John Sedgwick's VI Corps relax beside their comfortable log hut constructed in the yard of a mansion near Brandy Station, Virginia.

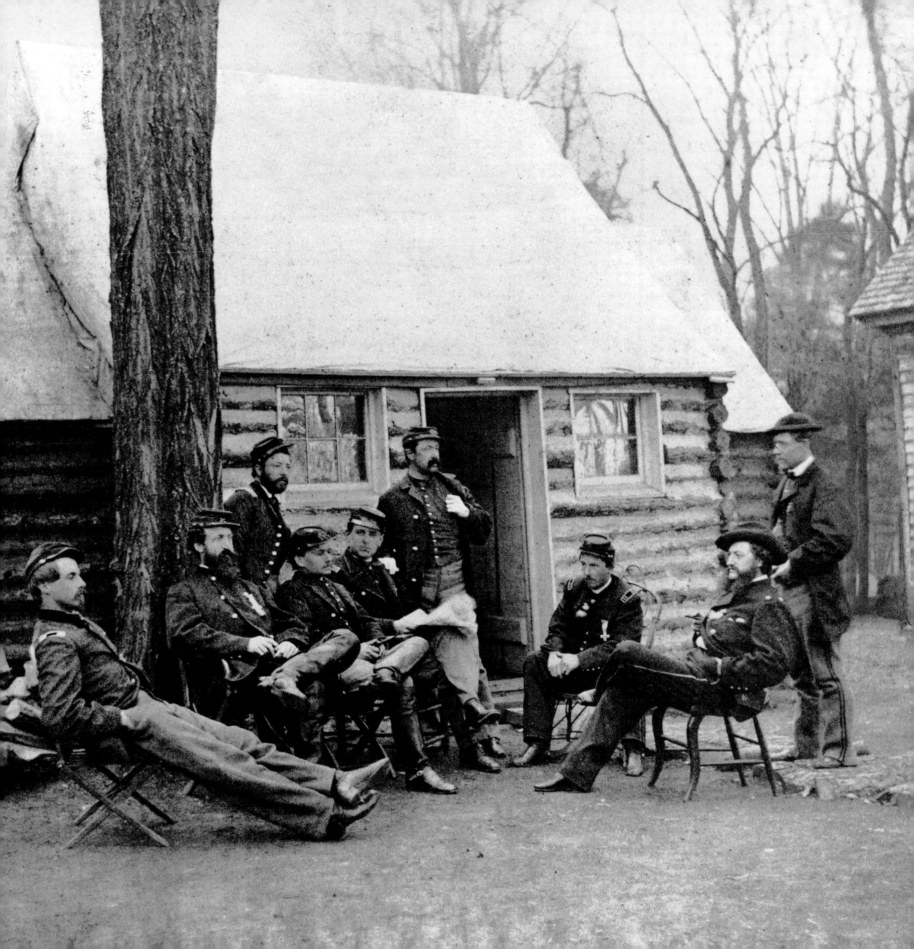

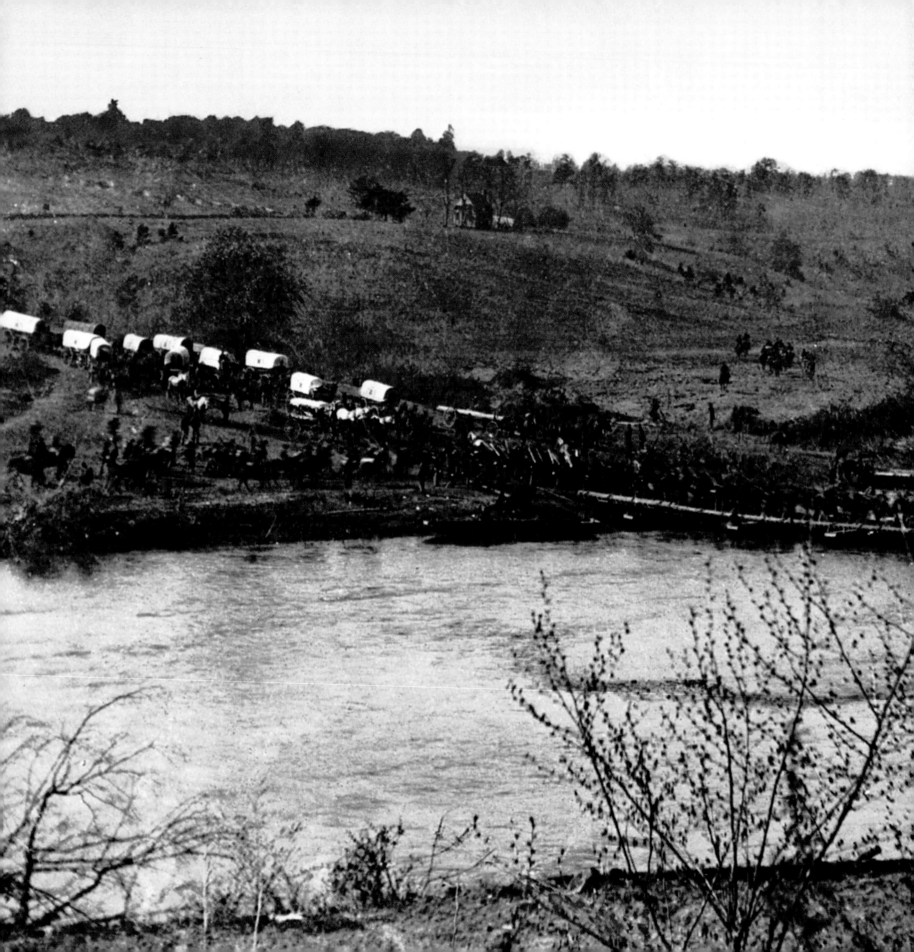

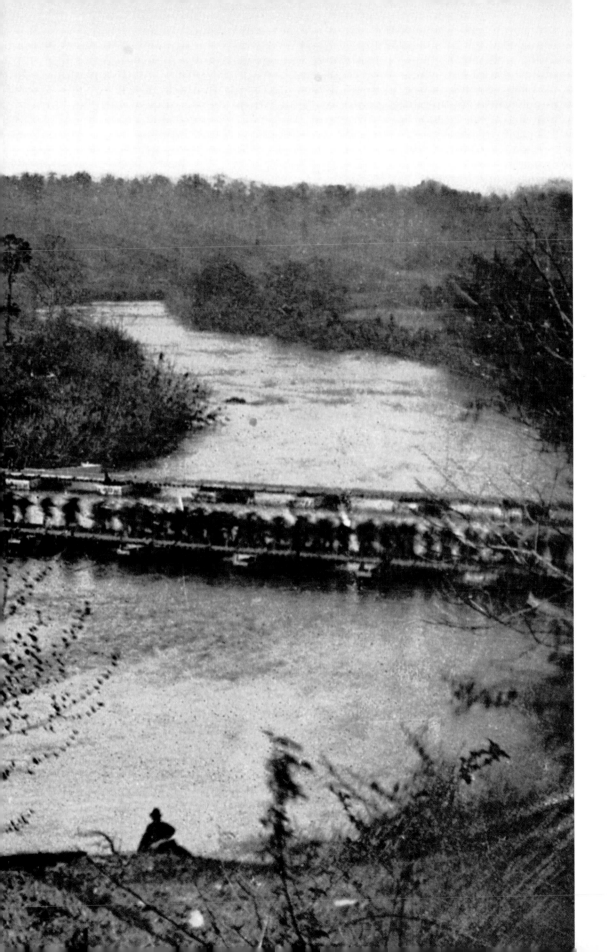

"*All day long we watched the ominous cloud of dust hanging in the air and stream of wagons and glittering gun metal and knew that a few hours would find the two armies contending once more on a Wilderness battle ground.*"

LIEUTENANT MCHENRY HOWARD,
Confederate staff officer

INTO THE WILDERNESS

Trailed by a long train of supply wagons, troops of John Sedgwick's VI Corps cross a pontoon bridge over the Rapidan River at Germanna Ford on the afternoon of May 4. Before them, wrote a Federal soldier, lay the Wilderness, "reaching back in mysterious silence."

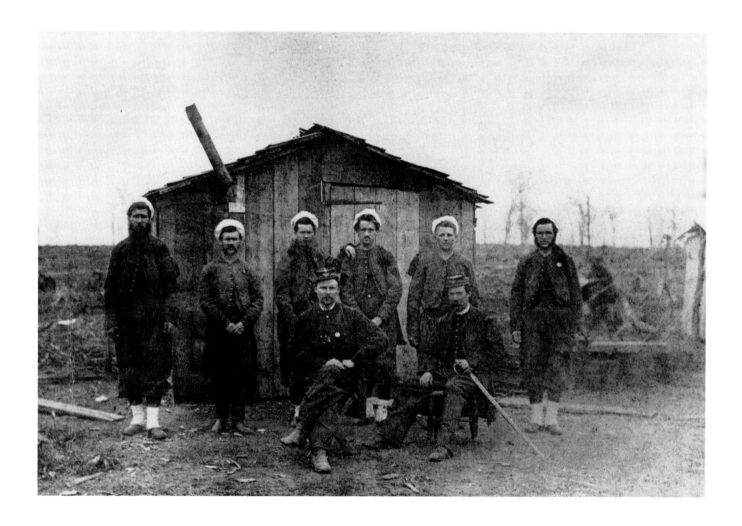

ZOUAVE BRIGADE

With a shout that its adjutant said "drowned out all other sounds," the 140th New York, some of whom are pictured here at Warrenton Junction, Virginia, led the charge at the Battle of the Wilderness in May 1864. The 140th were part of Brigadier General Romyn B. Ayres's Zouave brigade, made up of regular army battalions and Zouave units from New York and Pennsylvania.

RESOLUTE COMMANDER

Lieutenant General Ulysses S. Grant poses for a Brady & Company photographer in front of his tent during the Wilderness Campaign of 1864. An observer recalled that the new general in chief has a "look of resolution, as if he could not be trifled with."

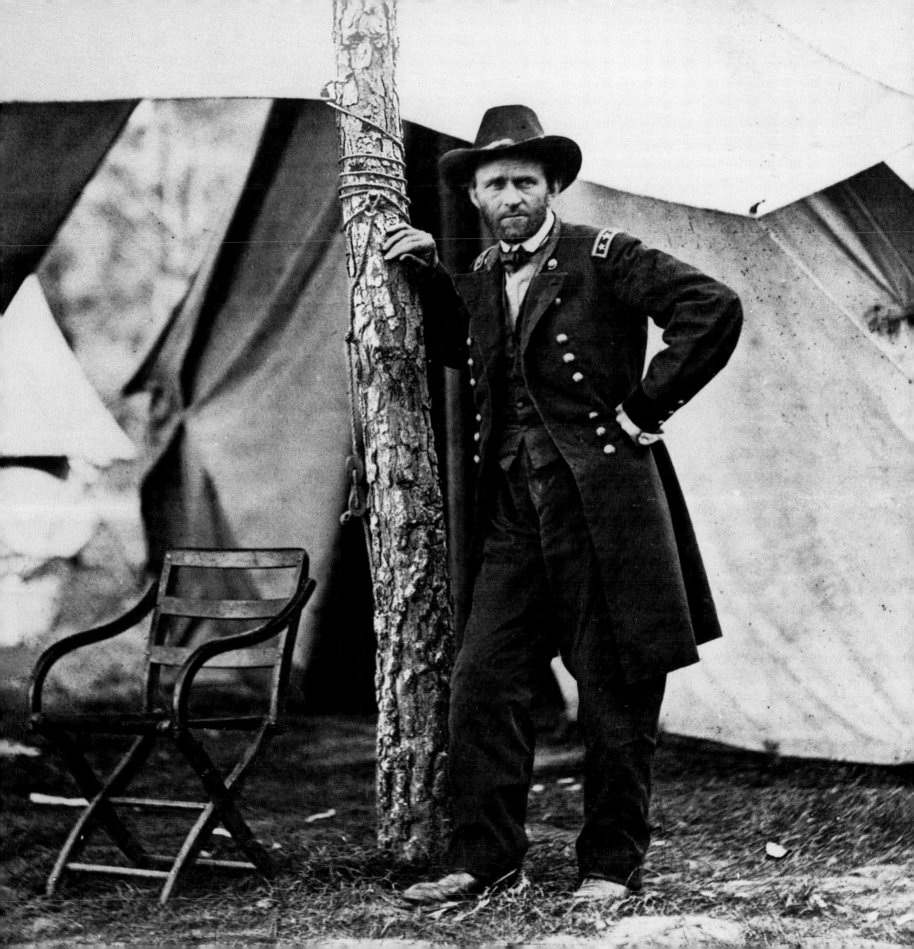

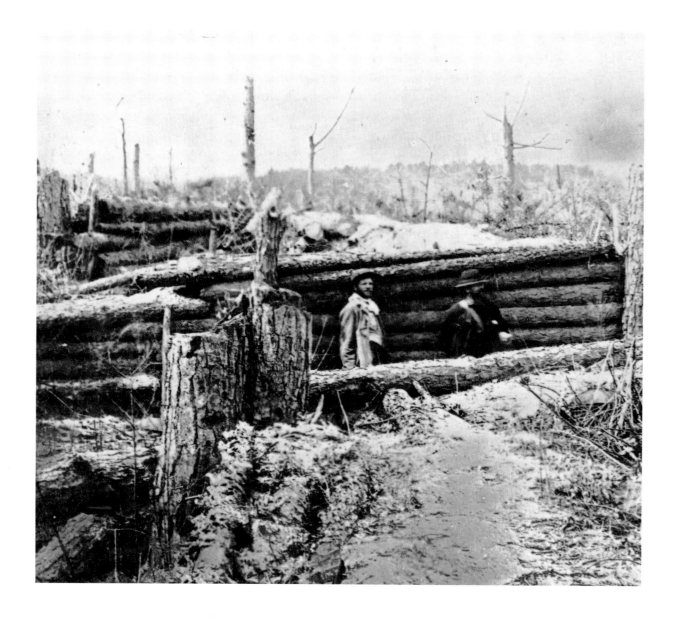

TRIUMPH OF THE SPADE

Log-and-earth breastworks constructed by Southerners defending the "Mule Shoe" salient at Spotsylvania for a time halted the Yankees in the fighting on May 10 and 12, 1864. By the final campaigns of the war, both sides had discovered the value of field fortifications, and the shovel and axe became as important as the rifle and bayonet.

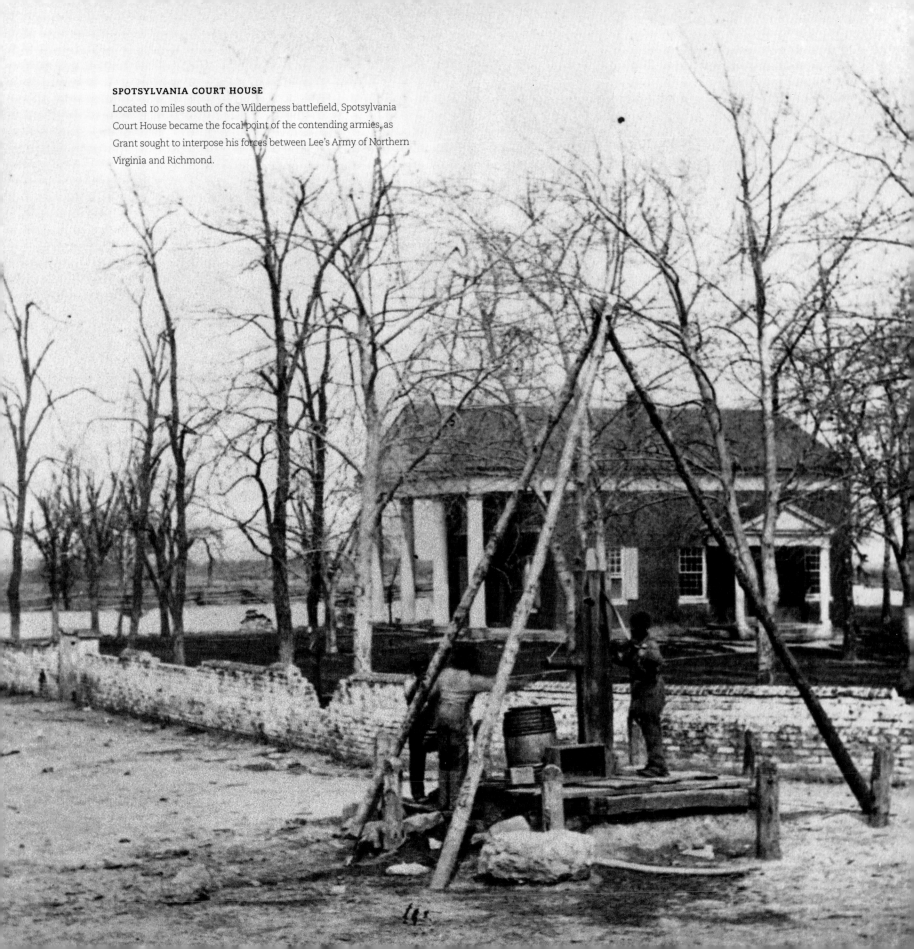

SPOTSYLVANIA COURT HOUSE
Located 10 miles south of the Wilderness battlefield, Spotsylvania Court House became the focal point of the contending armies, as Grant sought to interpose his forces between Lee's Army of Northern Virginia and Richmond.

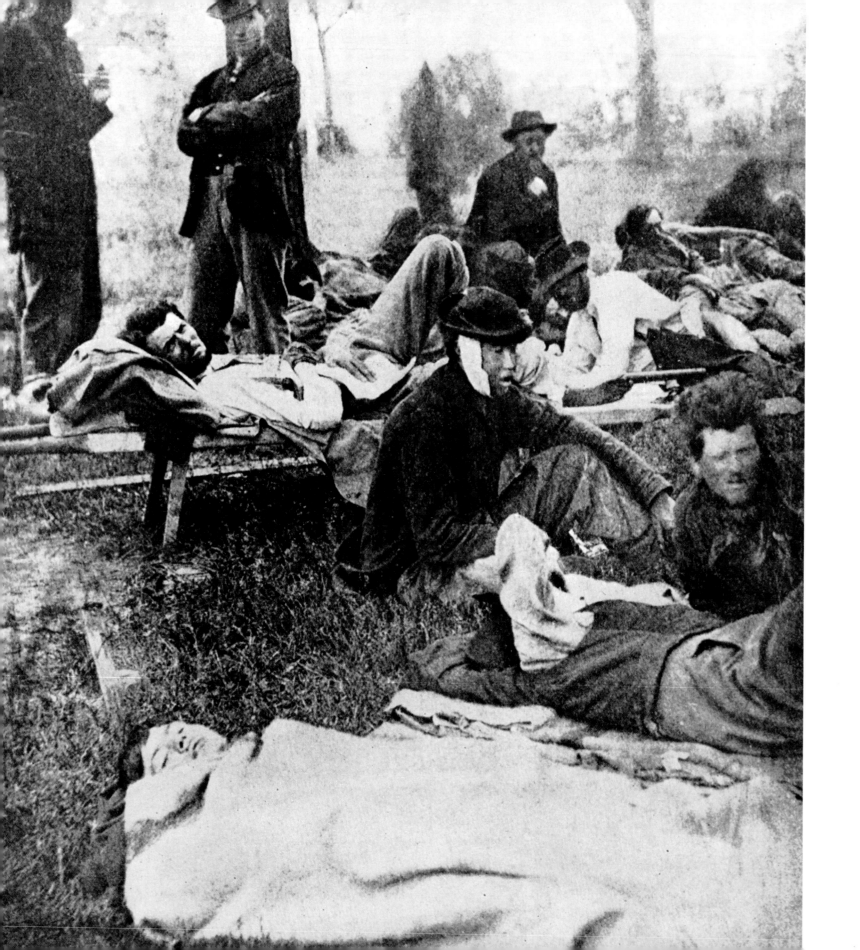

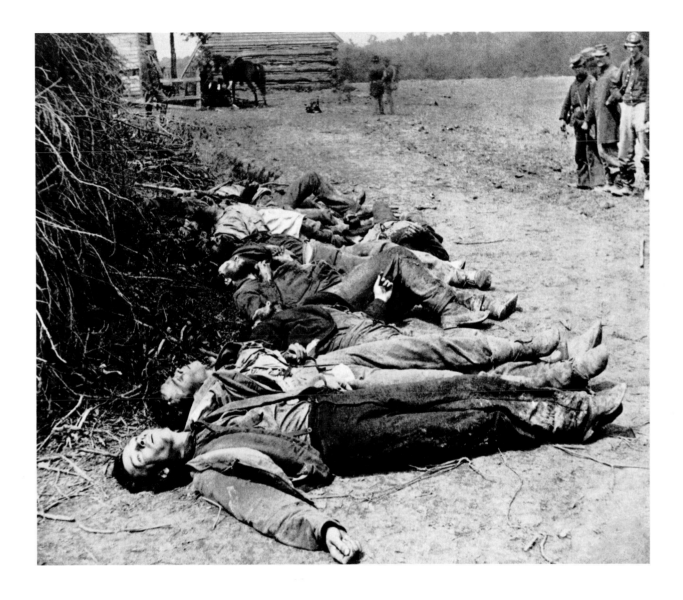

THE WOUNDED

Wounded soldiers, evacuated from the Wilderness and
Spotsylvania battlefields, rest on Marye's Heights, outside the city
of Fredericksburg. Nearly every store, warehouse, and church
was used for shelter, and the hills surrounding the town were,
according to one observer, "white with tents and wagons."

LAID OUT FOR BURIAL

Confederate dead are laid out for burial near the Alsop Farm,
where the final clash at Spotsylvania took place. Standing
by are the men of the 1st Massachusetts Heavy Artillery, who
were assigned to help in the grim duty of burying the dead
of both sides.

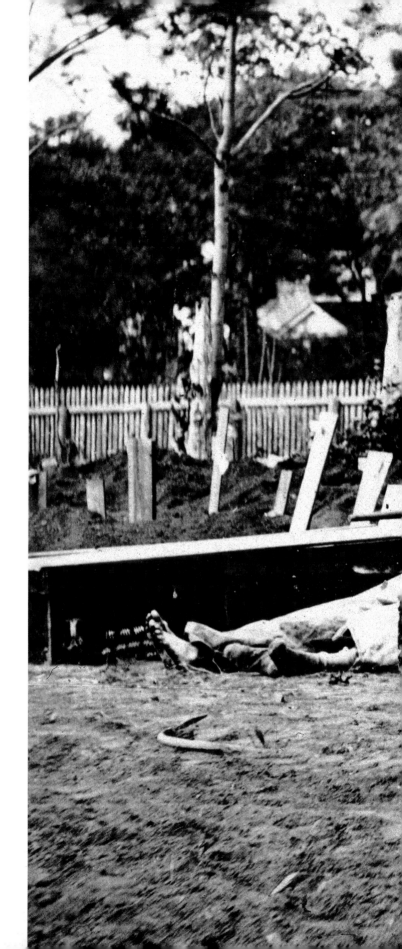

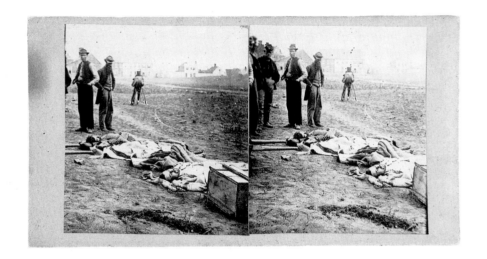

RECORDING A GRIM SCENE

Federal soldiers who succumbed to their wounds in a Fredericksburg hospital await burial in a military cemetery as a photographer *(background)* prepares to record the grim toll of the fighting at Spotsylvania. This stereograph, one of the few images of a Civil War photographer at work, was one of eight images of the scene made by employees of Mathew Brady's gallery, most likely on May 19, 1864.

IMPERMANENT BURIAL PLACE

A burial detail prepares temporary graves for soldiers who have died of their wounds. The bodies were later reinterred in permanent plots.

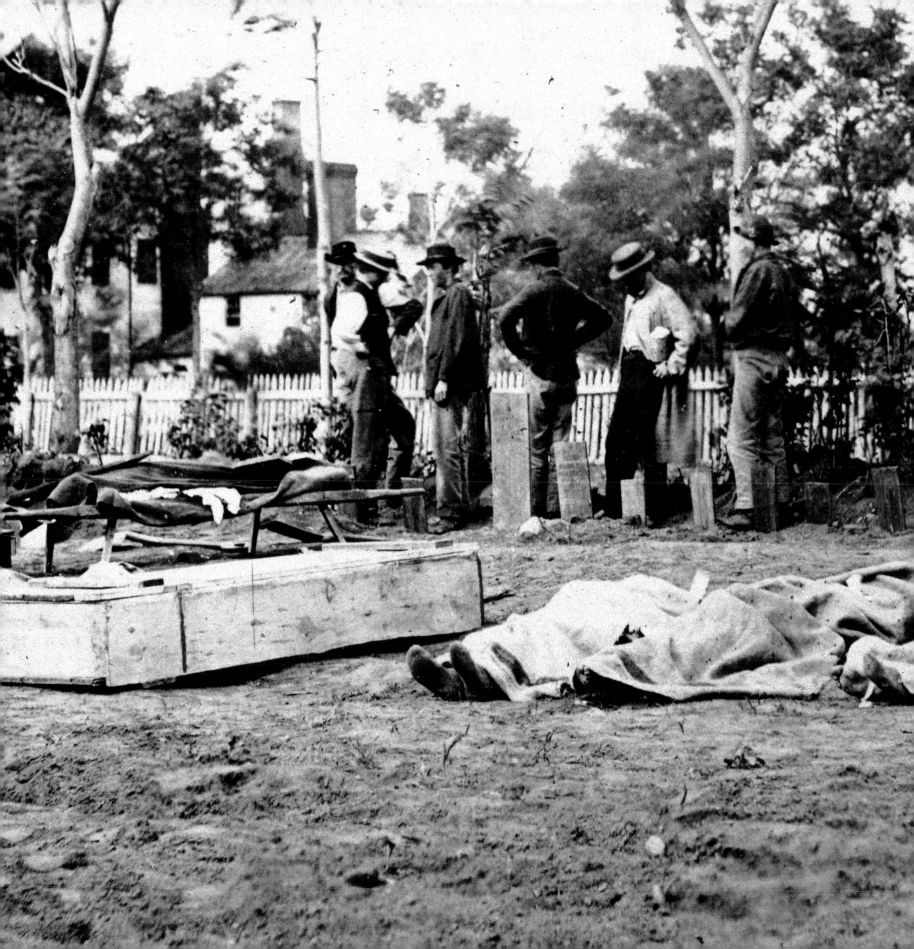

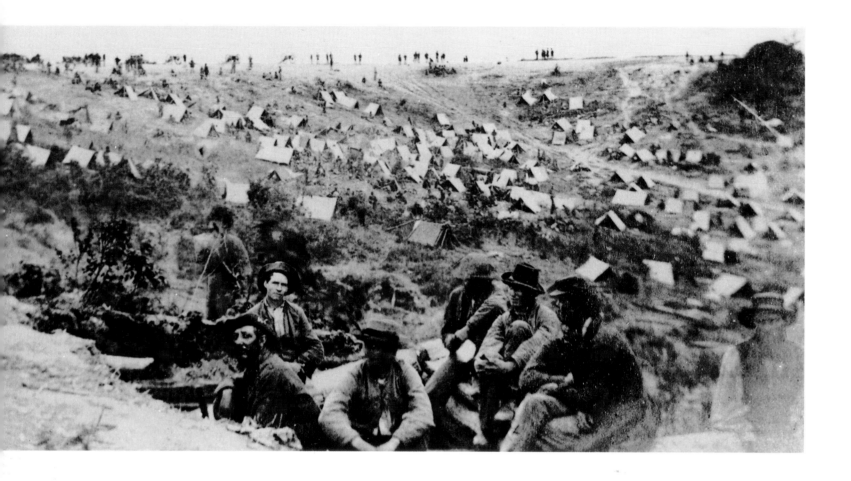

REBELS IN THE "PUNCH BOWL"

Confederate prisoners crowd the slopes of a ravine dubbed the Punch Bowl, an improvised holding area near the Army of the Potomac's supply base at Belle Plain, on the Potomac River. Between May 13 and May 18 some 7,500 rebels passed through Belle Plain en route to the Federal prison compound at Point Lookout, Maryland. Nearly half of them had been captured during the Union assaults on the Mule Shoe at Spotsylvania.

MEMENTO MORI

A grisly collection of Union soldiers' skeletal remains sits atop a stretcher on the Cold Harbor battlefield, awaiting shipment to the North for reburial after the war. About 2,500 Union and Confederate soldiers were killed at Cold Harbor; half of them fell in the first few minutes of the battle.

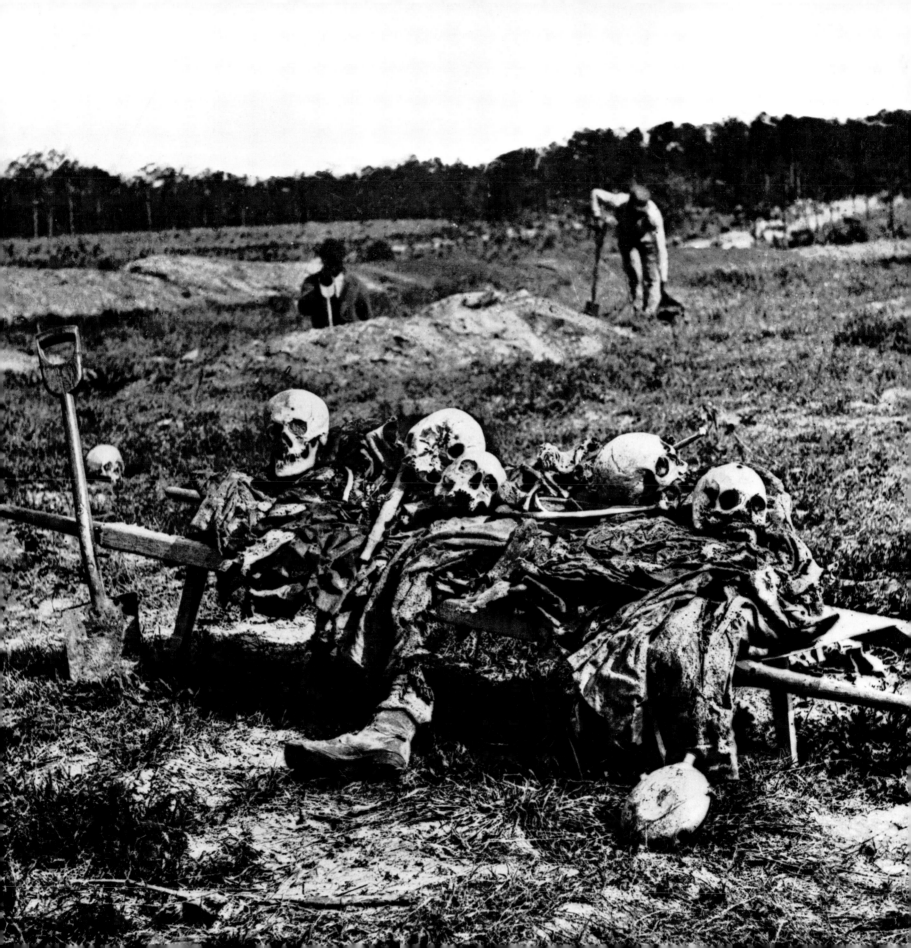

Battles for Atlanta

IN MAY OF 1864, GENERAL WILLIAM TECUMSEH SHERMAN led his armies into Georgia on a crucial mission—to bring the Confederate Army of Tennessee to battle and seize Atlanta, the strategic back door to the central Confederacy. Atlanta was a key supply center and, with four railroads radiating from the city, a critical transportation hub for the South's armies.

Although his three armies totaled nearly 100,000 men, Sherman faced 120 miles of some of the roughest country in the South, defended by General Johnston's army, fighting on its home ground. For nearly two months the armies fought a campaign of continuous maneuver during

which Johnston repeatedly avoided Sherman's attempts to force a climactic battle, each time slipping away to occupy yet another strong position. On June 27th a frustrated Sherman ordered an all out assault at Kennesaw Mountain, but was defeated with heavy losses.

By early July, the Federals stood just 15 miles from Atlanta. Johnston was replaced with the aggressive general John Bell Hood, who suffered severe losses in a series of furious counterattacks at Peachtree Creek, Atlanta, and Ezra Church. When the Federals cut Hood's only remaining supply line, he realized that his weakened army could not successfully defend Atlanta and evacuated the city on the night of September 1, 1864.

On November 12, 1864, Sherman marched out of Atlanta toward the Atlantic coast, leaving the city in flames. With little opposition, his columns cut a 60-mile-wide swath of destruction through the Confederacy's heartland, reaching Savannah and the coast on December 10. Sherman then turned north, flanking Charleston and burning Columbia, South Carolina, on February 17, 1865. "We are not only fighting hostile armies," Sherman wrote, "but a hostile people, and must make old and young, rich and poor, feel the hard hand of war."

REBEL RAIDERS

The rough-and-ready Confederate cavalrymen above served as scouts under Captain Alexander Shannon. As Sherman's forces forged a path of destruction through Georgia and the Carolinas, Shannon's 30 scouts hung on the flanks of the Federal columns, waylaying isolated Yankee patrols, supply wagons, and foragers.

FALLEN STRONGHOLD

While his comrades lounge atop the ramparts of a captured Confederate fort, a Federal soldier quietly reads in the entrance to a bombproof dugout. Contemplating the formidable cordon of defenses that ringed Atlanta, one Union soldier wrote, "It is astonishing to see what fortifications they had on every side of the city. All in vain for them, but quite convenient now for us."

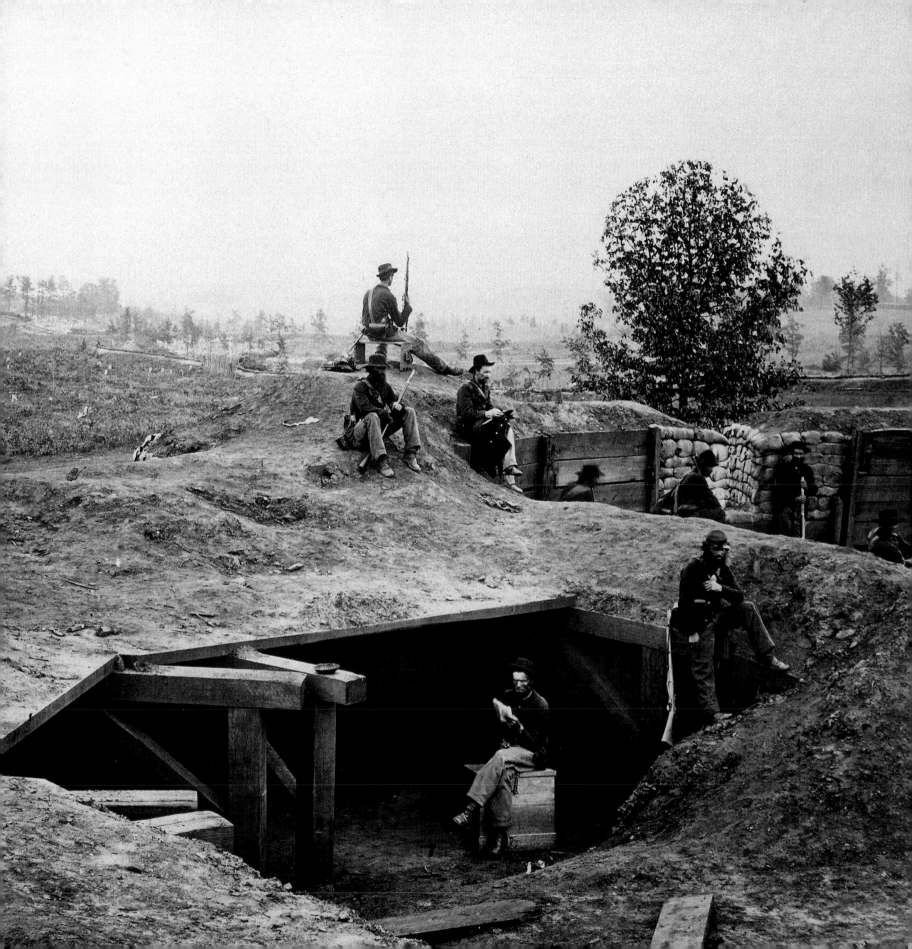

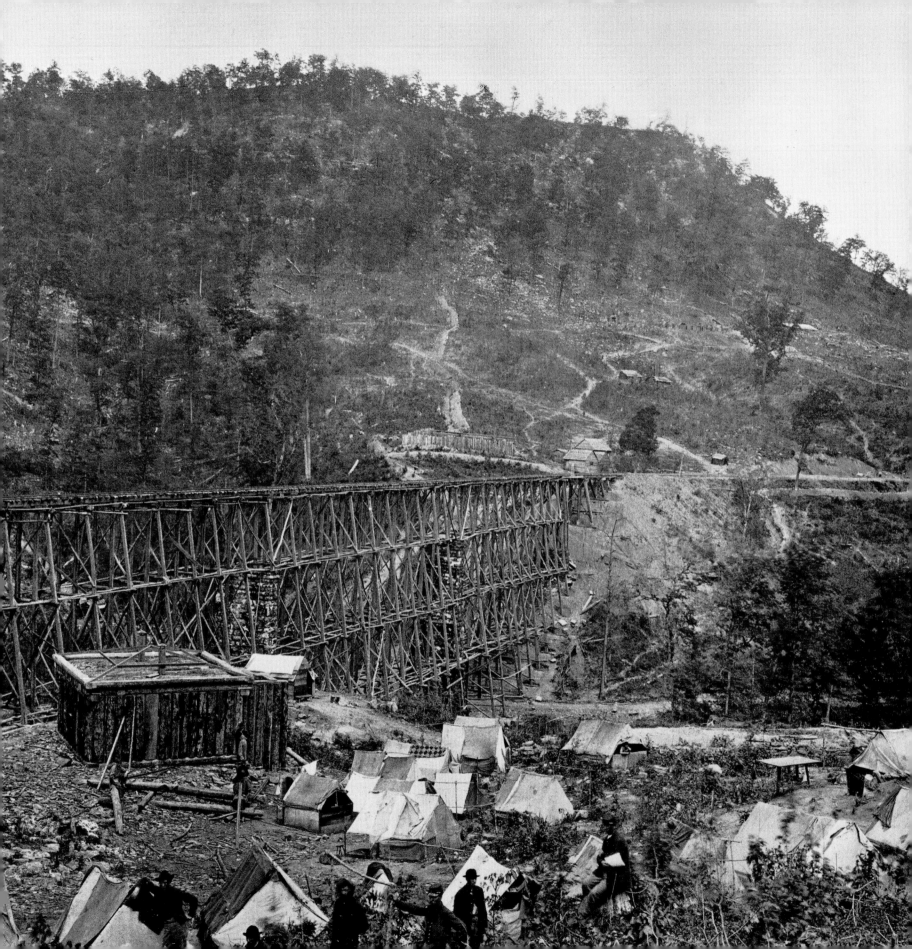

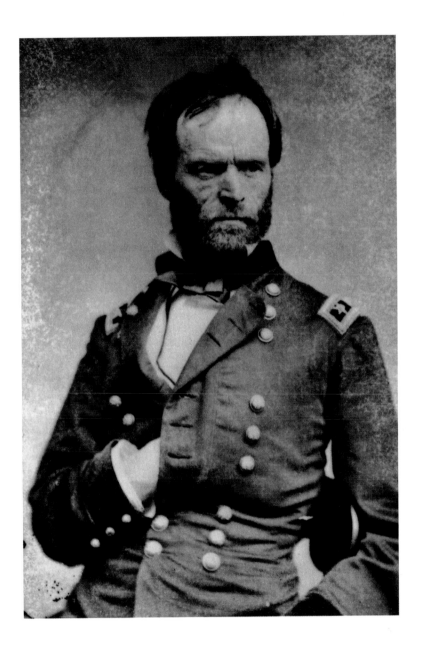

WELL-DEFENDED RAILROAD BRIDGE

One of the vital links along Sherman's supply line during his drive on Atlanta, this railroad bridge boasts blockhouses and a permanent garrison to defend the span against the constant threat posed by Confederate cavalry.

WAR IS HELL

William Tecumseh Sherman, whose personality was reflected in his reddish beard and wild eyes, flowered under Grant's command. Of the Union campaigns, his were considered the most brilliant.

"I can make this march and make Georgia howl!"

MAJOR GENERAL
WILLIAM TECUMSEH SHERMAN

ENTRENCHED FIELD GUNS
Behind an earthen rampart, 12-pounder Napoleons stand at embrasures—gaps cut through the wall—in a Confederate bastion now occupied by Federals. Engineers had bolstered the interior of the works with a revetment, or facing, made of planks and beams and had cleaned the land beyond to create an open field of fire.

263

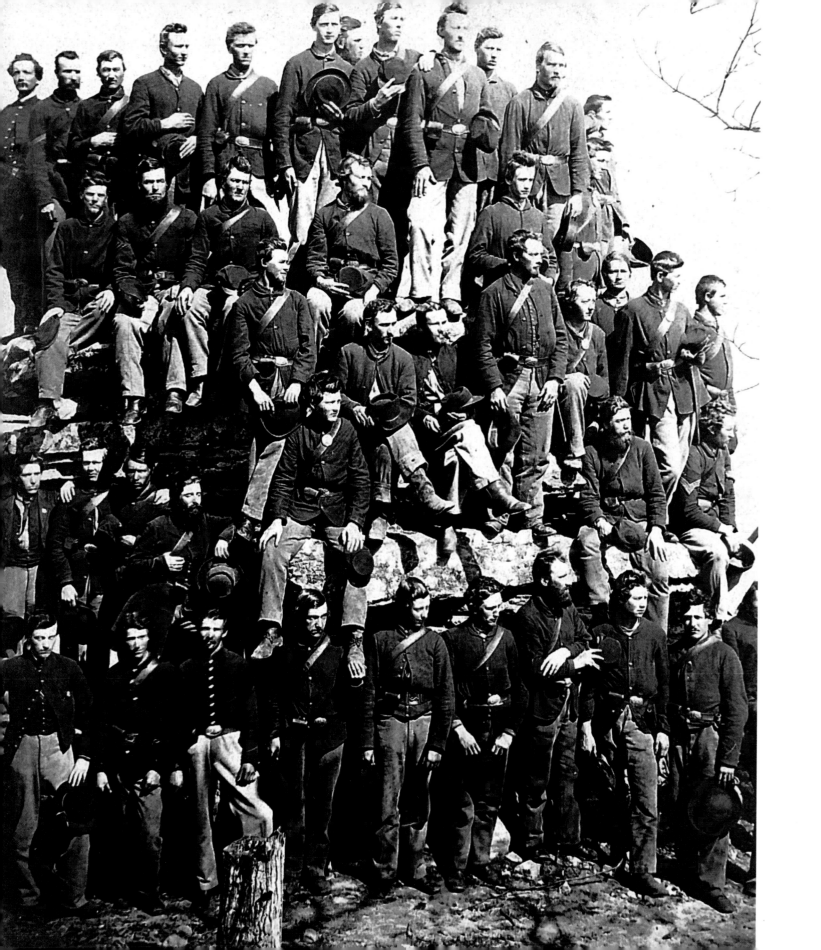

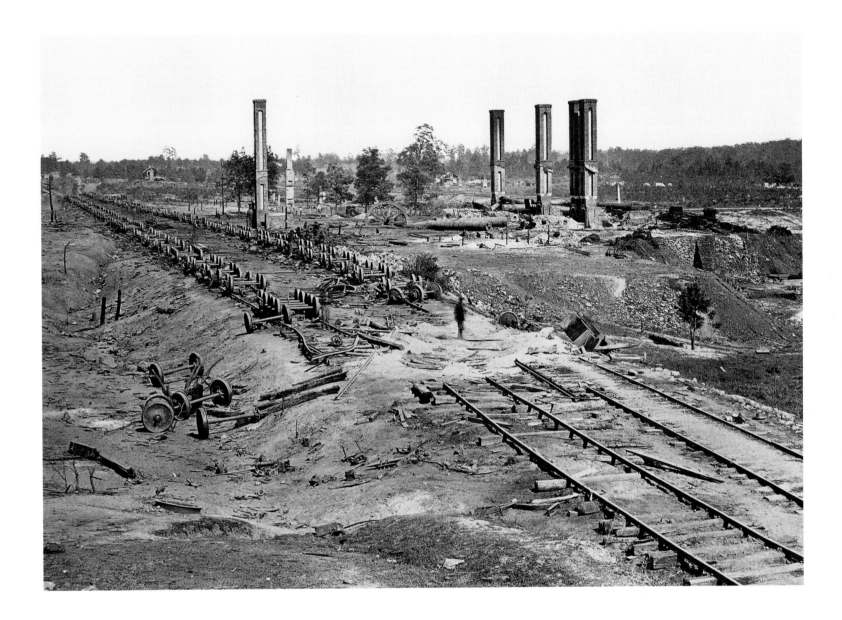

A QUIET MOMENT

Men of the 78th Pennsylvania doffed their hats for this group portrait atop Lookout Mountain before marching into Georgia. During the campaign against Atlanta the regiment fought as part of the XIV Corps, Army of the Cumberland, at Rocky Faced Ridge, Dallas, New Hope Church, and Kennesaw Mountain.

A SHATTERING BLAST

Severed tracks and scattered axles testify to the force of the explosion that ripped through a train carrying Confederate ordnance on the night of September 1, 1864, leveling the walls of the rolling mill in the background. Hood's troops touched off the blast as they prepared to abandon Atlanta to the Federals.

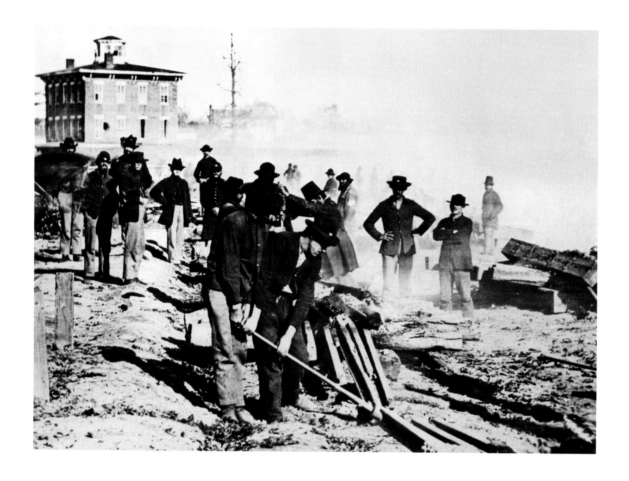

"SHERMAN'S HAIRPINS"

A demolition squad pries loose a section of track in Atlanta's rail yard. Adhering to Sherman's order that "the destruction be so thorough that not a rail or tie can be used again," the Federals heated the rails over burning ties, and then twisted them out of shape. The twisted rails became known as Sherman's Hairpins.

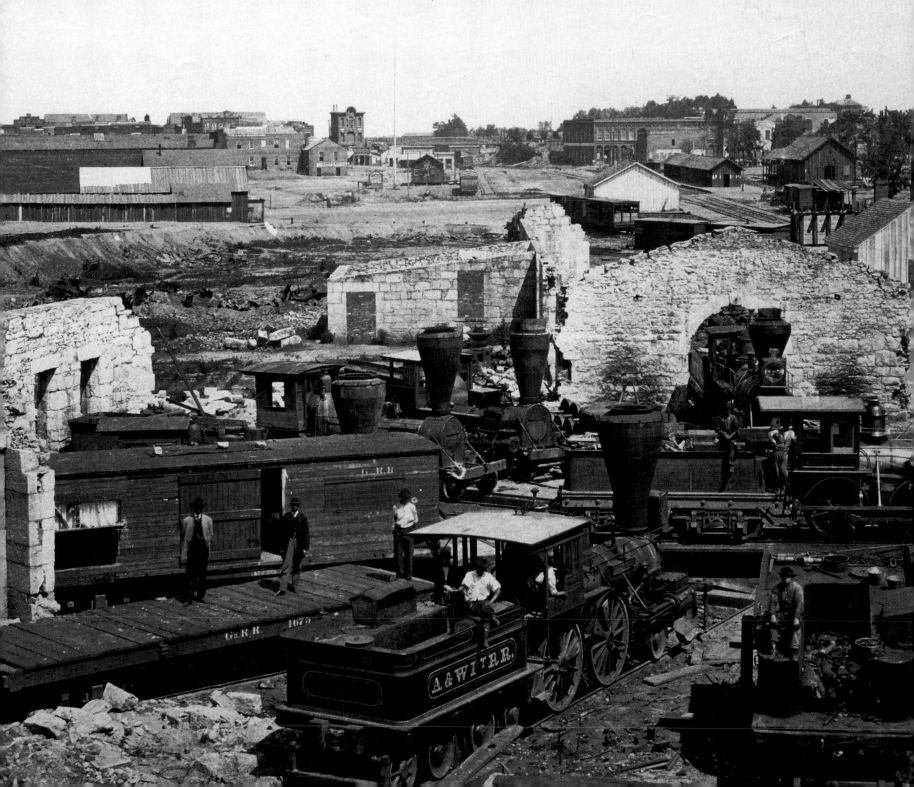

ATLANTA IN RUINS

Locomotives and freight cars stand isolated in the ruins of Atlanta's roundhouse. The devastation of the city was so widespread, a Union private wrote, "that I don't think any people will want to try and live there now."

Death in the Trenches

"THIS IS LIKELY TO PROVE A VERY TEDIOUS JOB," Ulysses S. Grant wrote to his wife in the late summer of 1864, "but I feel very confident of ultimate success." After Cold Harbor, Grant was determined to pin down Lee's forces and sever the supply lines that fed his Army. On June 12, Grant began to shift his forces south of the James River, hoping to seize Petersburg, the terminus of four vital rail lines that linked Richmond with the South.

On June 15, Federal forces attacked Petersburg, but forces under Beauregard blocked the assault. When Lee's forces slipped into Petersburg, Grant had little option but to begin formal siege operations, a grueling process that would last until the closing days of the war.

While the Federals began ringing the city with earthworks, Grant sent forces to cut the railroads south and west of Petersburg, fighting at the Weldon Railroad and Jerusalem Plank Road. On July 30 Federal engineers exploded a mine, obliterating a Rebel strongpoint, but attacking Federal troops became disorganized in and around the rubble-filled Crater and were driven out by determined Confederate counterattacks. Black soldiers fought courageously at the Crater, proving their bravery to the world.

In the fall, Grant struck north of the James at Fort Harrison and again to the west of Petersburg. Finally, on April 2, 1865, a Federal assault seized Fort Mahone, in what proved to be one of the war's final battles. Lee was forced to evacuate Richmond and Petersburg. As the remnant of his army staggered westward, Lee's columns were pursued by hard-marching Federal infantry and cavalry. At Appomattox, his way blocked by Federal forces, Lee opened negotiations with Grant. "There is nothing left to do," he told his aides, "but to go and see General Grant and I had rather die a thousand deaths." The two generals signed the surrender document at Appomattox Court House on April 9, 1864.

FALLEN IN THE LAST DITCH
A dead Confederate soldier lies crumpled in the bottom of the ditch at Fort Mahone outside Petersburg, Virginia. On April 2, 1865, after a massive bombardment, Federal infantry overran the fort, manned by men of the 53rd North Carolina Infantry.

INGENIOUS DEFENSES
Wattle cylinders filled with stone and earth line the traverses and parapets of Fort Sedgwick, a Federal fortification on the Jerusalem Plank Road southeast of Petersburg. The traverses were earthwork barriers constructed at right angles to a trench line to protect soldiers from enfilading fire. Other obstacles are visible beyond the outer walls.

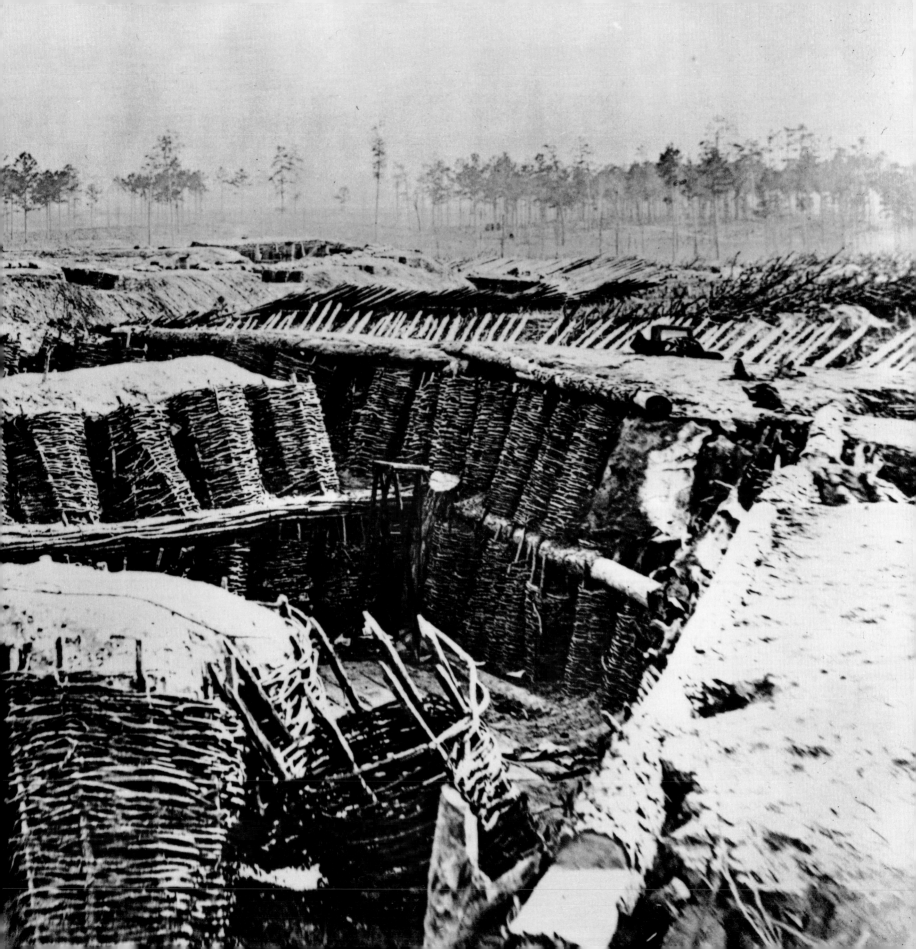

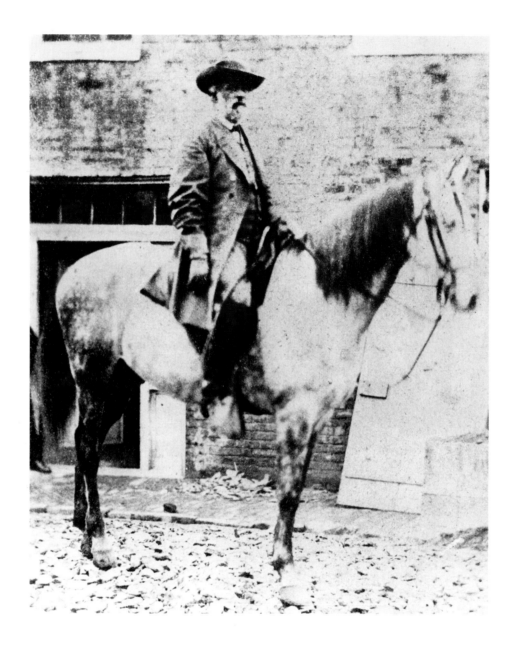

LEE AND TRAVELLER

Robert E. Lee sits astride his horse, Traveller, in the only wartime photograph of the Confederate commander in the saddle; the picture is believed to have been taken in rubble-strewn Petersburg in 1864. As the siege wore on, the rigors of the campaign began to tell on both Lee and his mount. "My horse is dreadfully rough," he wrote to his wife from Petersburg, "& I am very stiff and heavy."

GRANT

General Grant studies a map at field headquarters in June 1864. With him are Colonel Theodore Bowers (*standing*) and General John Rawlins of his staff.

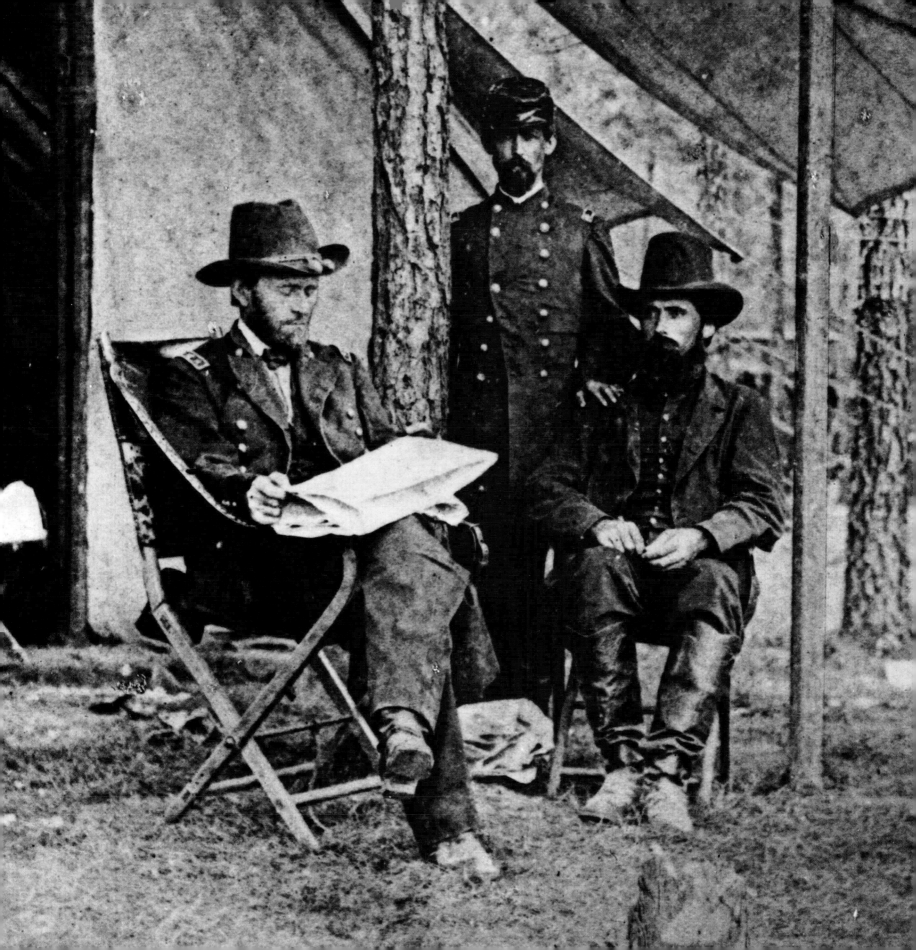

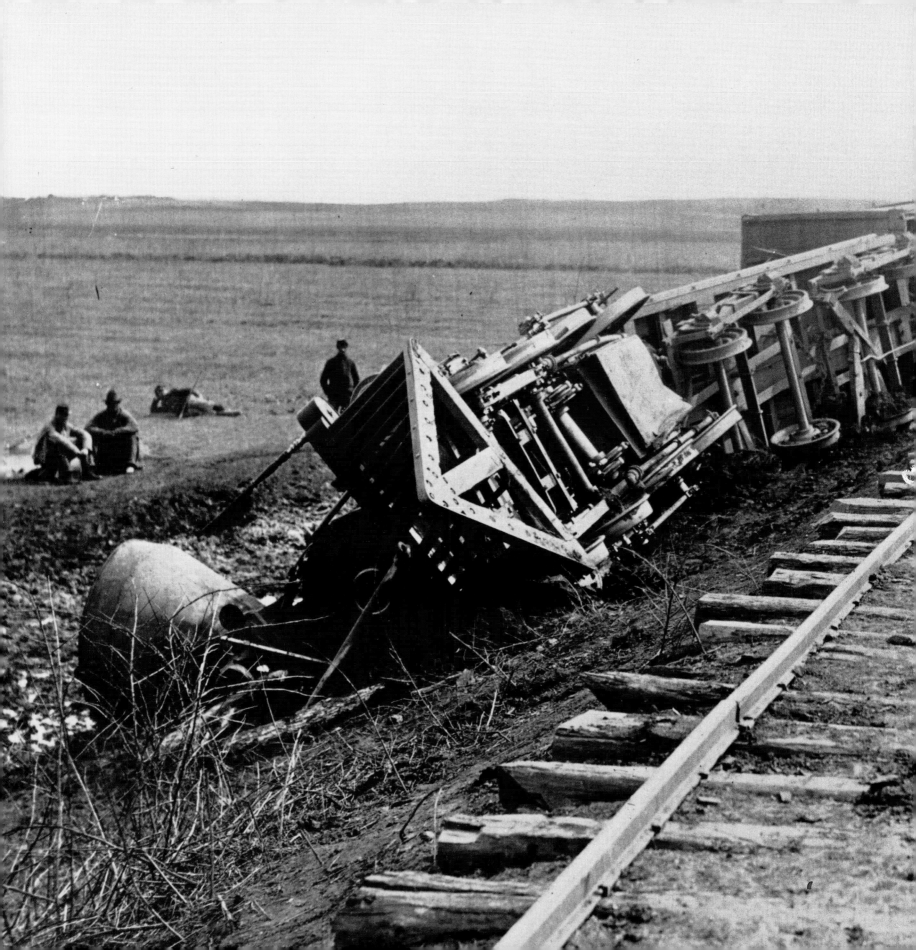

"*If you are going to fight, then be the attacker.*"

COLONEL JOHN SINGLETON MOSBY,
43rd Virginia Cavalry "Partisan Rangers"

DOWN THE BANK
A Federal locomotive derailed by Confederate
raiders lies on its side by the Orange & Alexandria
tracks near Brandy Station, Virginia, in 1864.
Derailed engines could be righted and repaired.
A more effective method of rendering them "unfit
for service," related one soldier, was "to fire a
cannon ball through the boiler."

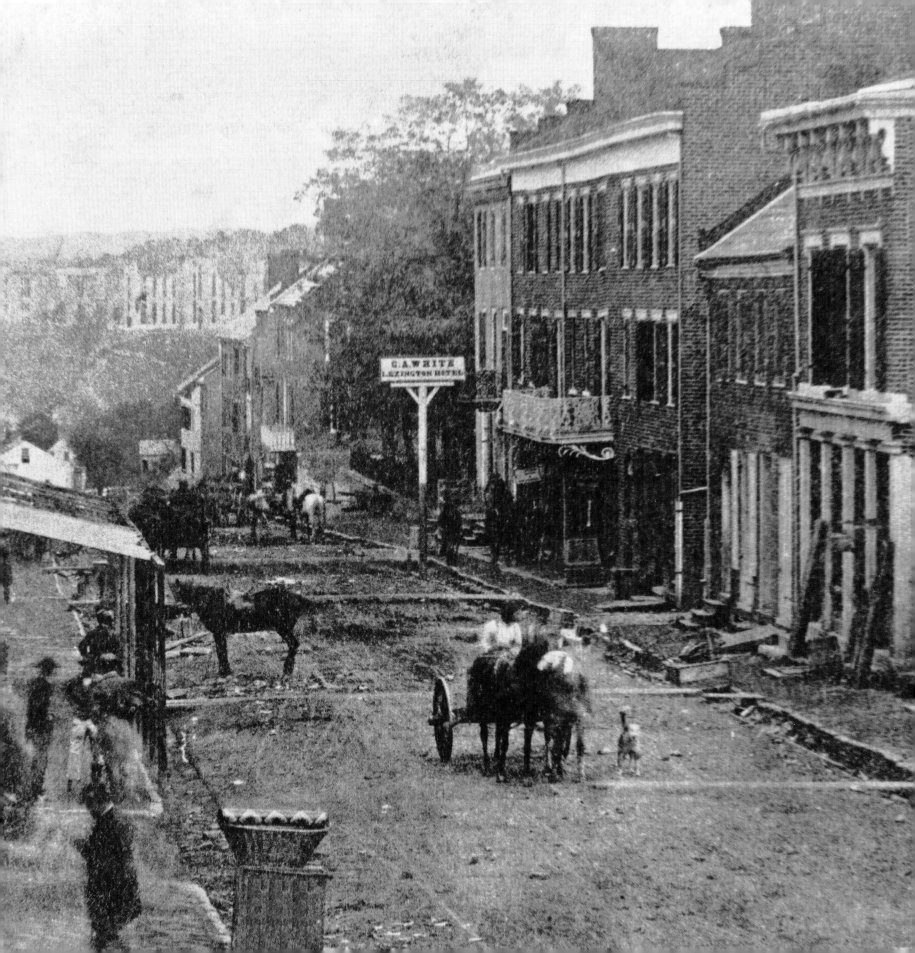

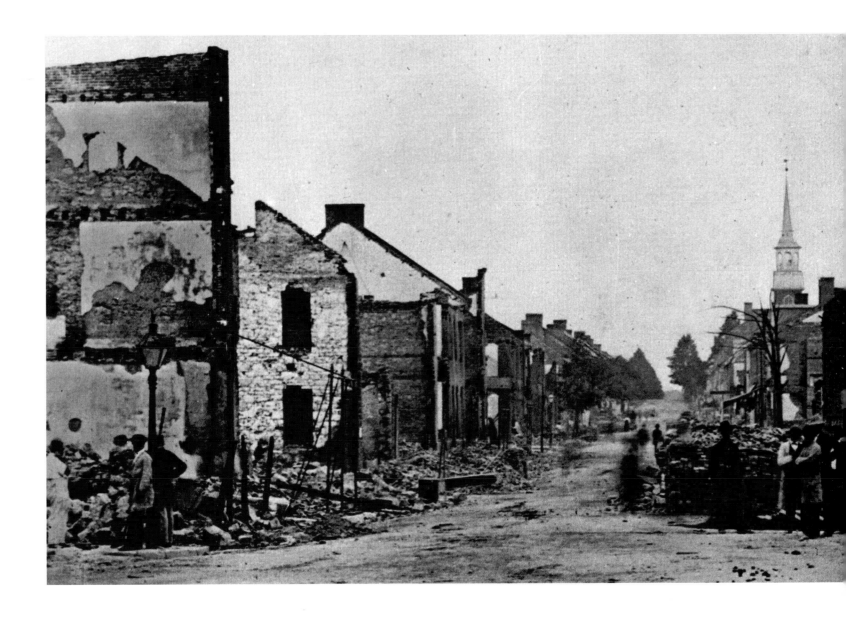

HUNTER'S RAID

Residents go about their business on Lexington's main street after the departure of General David Hunter's Federals. In the distance stand the burned-out ruins of the Virginia Military Institute, target of a destructive three-day Yankee visit in June 1864.

RETRIBUTION

Chambersburg residents examine the burned-out ruins along South Main Street, seen from the Diamond, the town's unusual 12-sided central square. Confederate troops under General Jubal A. Early burned the town in retribution for Federal depredations throughout the South. In the distance rises the spire of Zion's Reformed Church, which was spared by the Confederates.

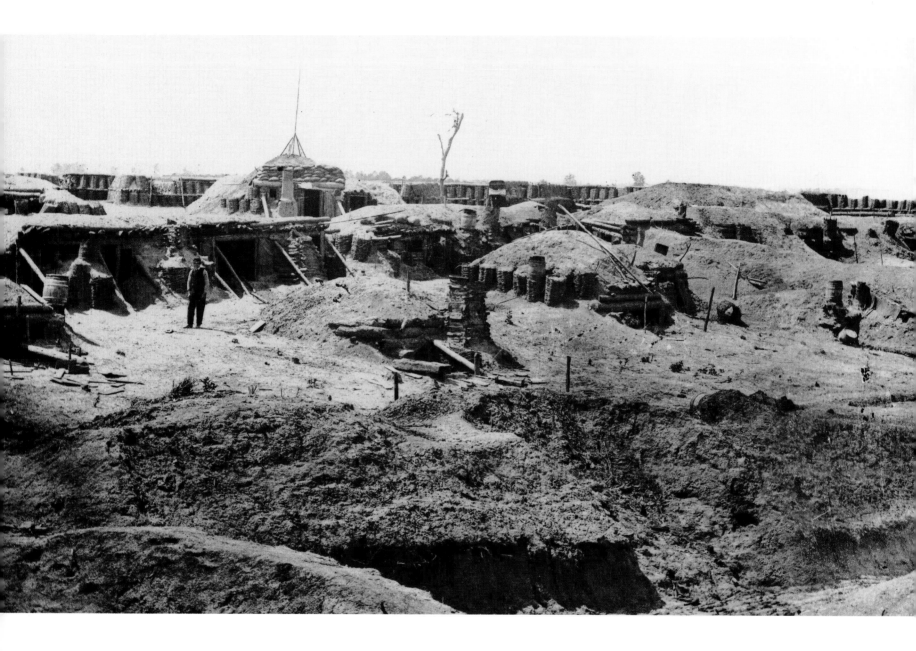

FORT HELL

The panoramic view of the interior of Fort Sedgwick reveals an intricate maze of bombproofs, traverses, and trenches. Subject to intense bombardment from nearby Confederate batteries, Federal soldiers dubbed their strongpoint Fort Hell. The Rebel battery received the appellation Fort Damnation.

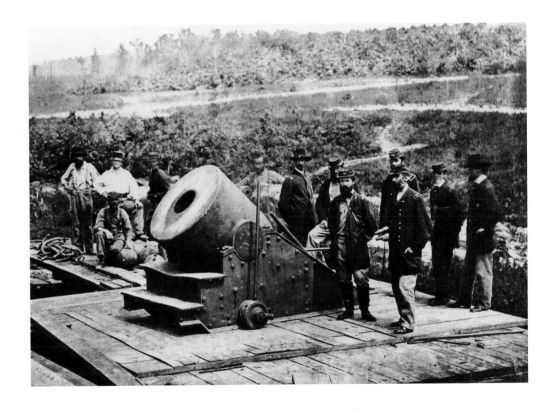

THE DICTATOR

Colonel Henry L. Abbott *(in high boots at left)*, commander of the 1st Connecticut Heavy Artillery, stands in front of the "Dictator," the largest of the Federal artillery pieces deployed against Petersburg. The 13-inch seacoast mortar went into action on July 19, 1864, lobbing 200-pound shells a distance of more than two and a half miles.

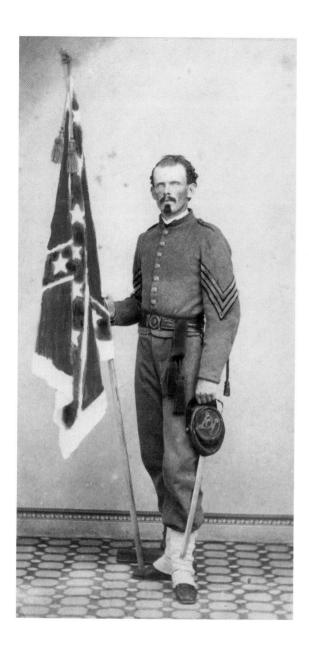

GALLANT COLOR-BEARER

Sergeant William Smith, color-bearer of the 12th Virginia, holds the new regimental flag that his unit was issued after the fighting at the Crater. Smith participated in the climactic conterattack by Brigadier General William Mahone's brigade, carrying the remnants of his regiment's flag and flagpole, which had been shattered by a Federal shell.

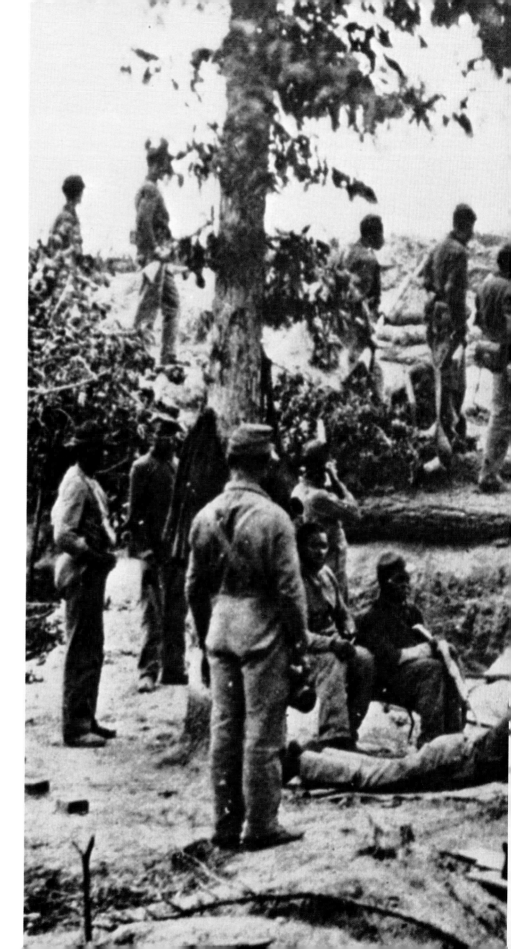

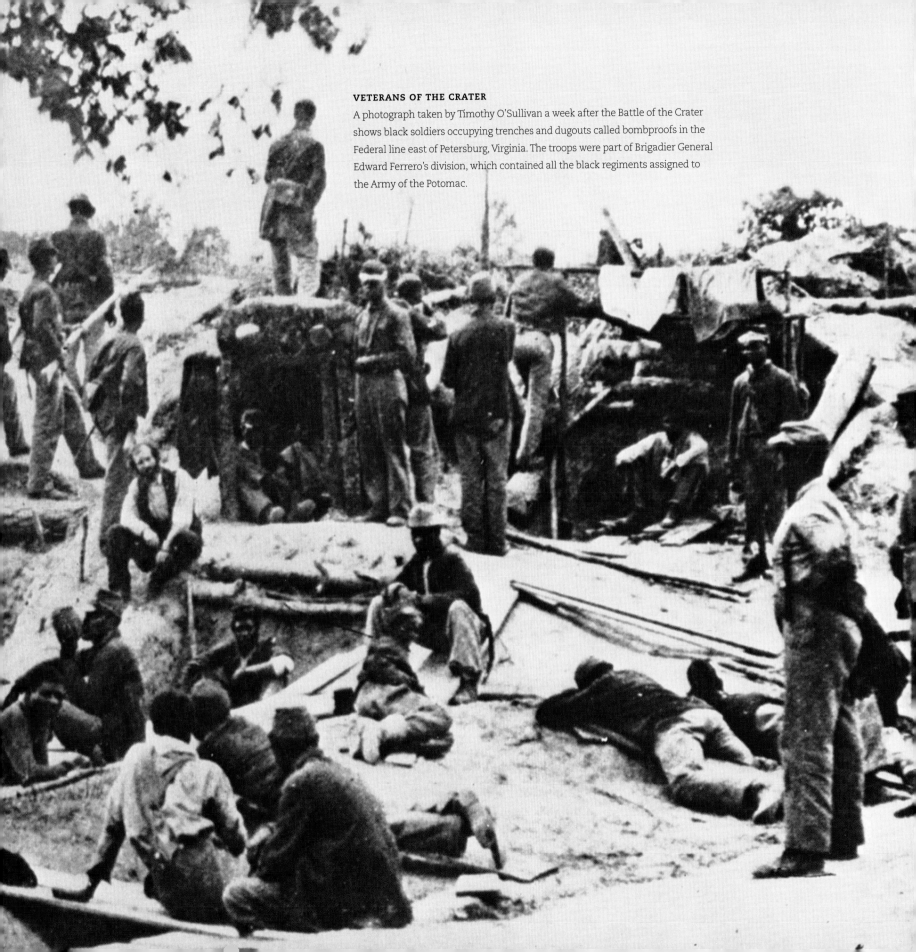

VETERANS OF THE CRATER

A photograph taken by Timothy O'Sullivan a week after the Battle of the Crater shows black soldiers occupying trenches and dugouts called bombproofs in the Federal line east of Petersburg, Virginia. The troops were part of Brigadier General Edward Ferrero's division, which contained all the black regiments assigned to the Army of the Potomac.

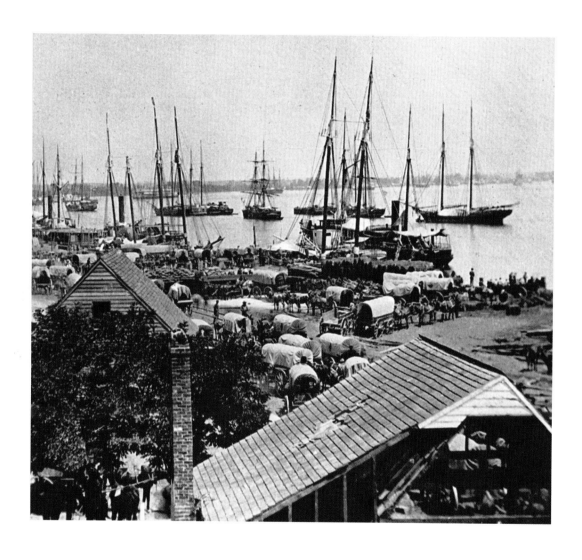

CITY POINT WHARF

In a photograph of the City Point wharf, quartermaster wagons gather to receive supplies from newly arrived ships. City Point, located near the confluence of the Appomattox and James Rivers, served as the primary supply depot for the Army of the Potomac during the siege of Petersburg.

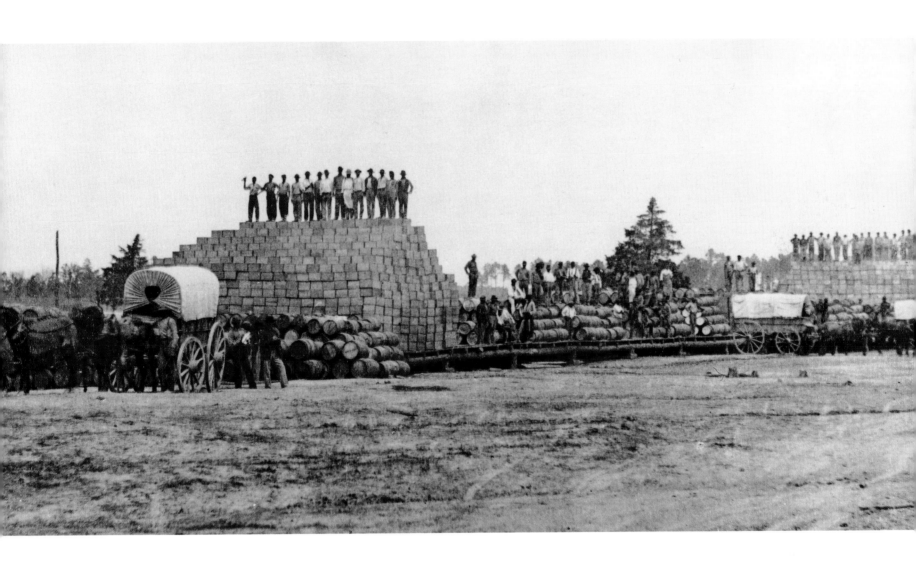

FIELD RATIONS

Men of the U.S. Army Quartermaster Corps stand atop two giant stacks of hardtack boxes at a depot near City Point, Virginia. Hardtack, a flour-and-water cracker, was one of the main field rations of the Federal army. The large, wood-hooped barrels piled in the foreground contain either salt pork or beef, the other primary ration.

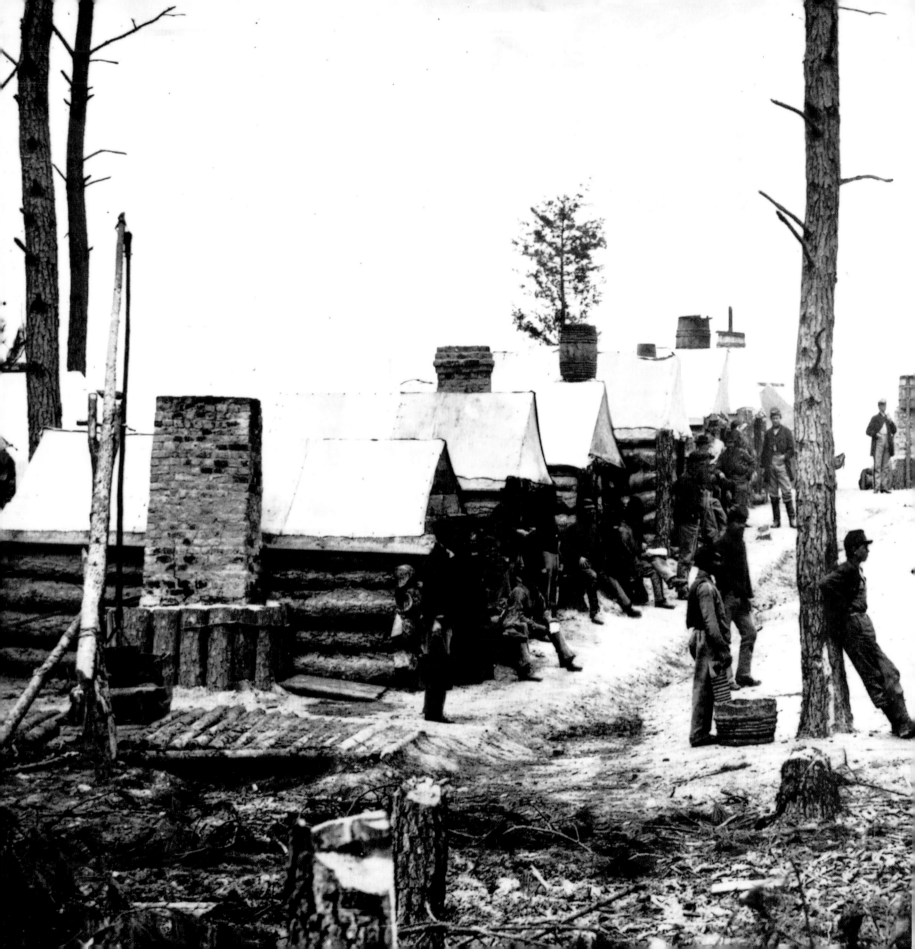

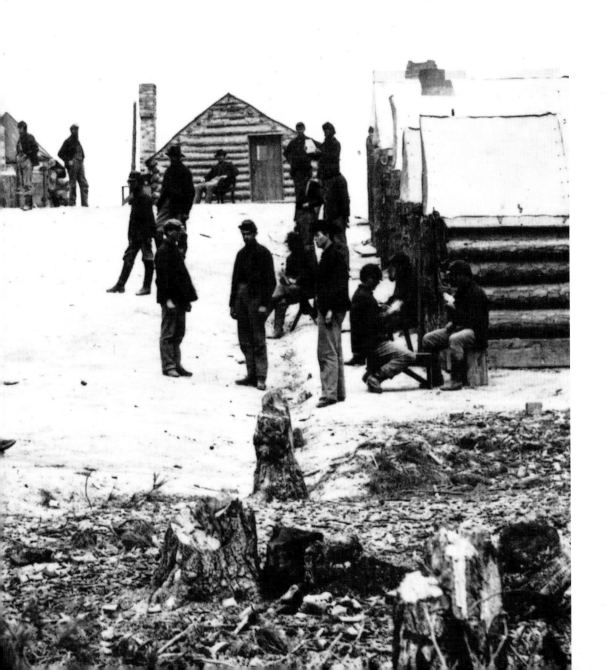

> "Everyone knew that with the advent of spring the final struggle must occur, and few if any doubted what the result would be."
>
> FEDERAL CAVALRY CAPTAIN,
> Army of the Potomac

LOG HUTS NEAR PETERSBURG

Troopers of the Independent Company Oneida (New York) Cavalry, the headquarters escort of the Army of the Potomac, relax outside their comfortable log huts near Petersburg in March 1865. During four years of war, the New Yorkers served all four men who at one time or another commanded the army: Generals George B. McClellan, Ambrose E. Burnside, Joseph Hooker—and now George G. Meade.

283

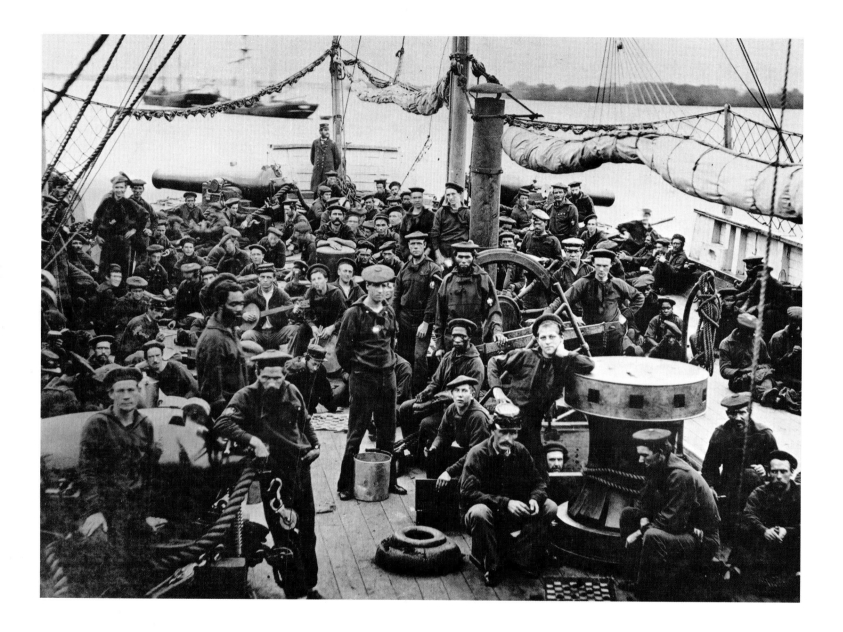

RIVER PATROL

Sailors and marines crowding the deck of the U.S. gunboat *Mendota* use checkers and a banjo to pass their idle time in March 1865. The *Mendota* was on picket duty at the mouth of the James River when an unnamed photographer working for Mathew Brady photographed her racially mixed crew.

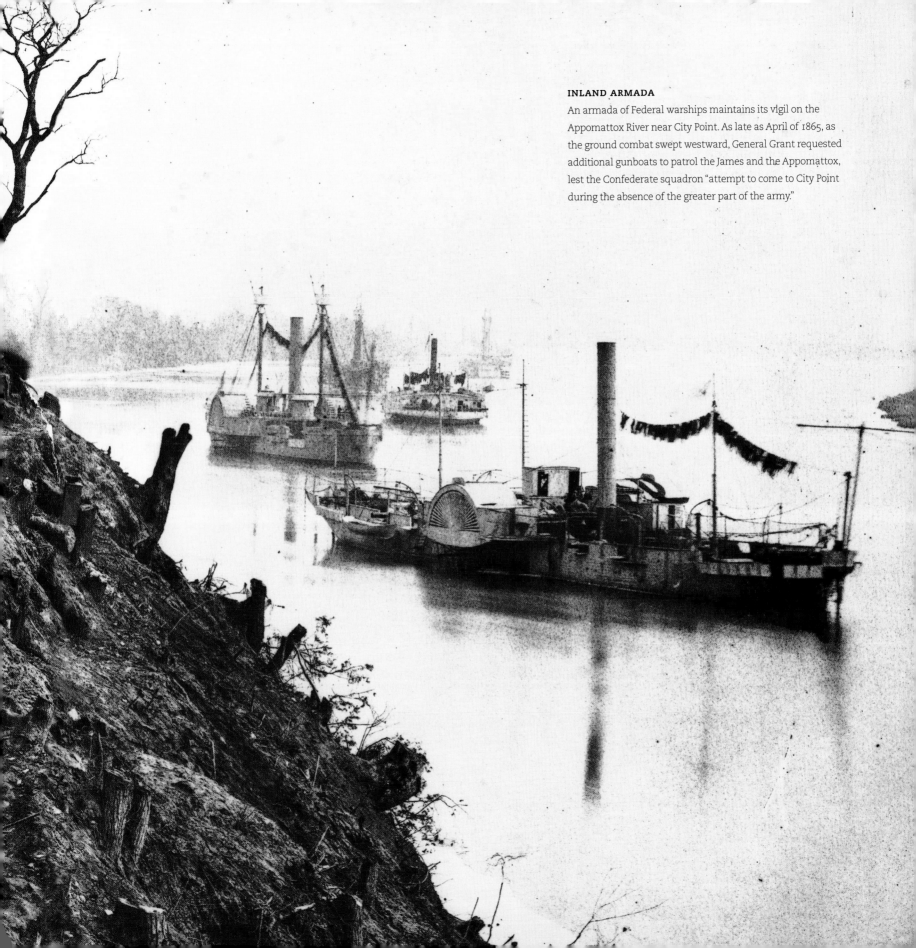

INLAND ARMADA

An armada of Federal warships maintains its vigil on the Appomattox River near City Point. As late as April of 1865, as the ground combat swept westward, General Grant requested additional gunboats to patrol the James and the Appomattox, lest the Confederate squadron "attempt to come to City Point during the absence of the greater part of the army."

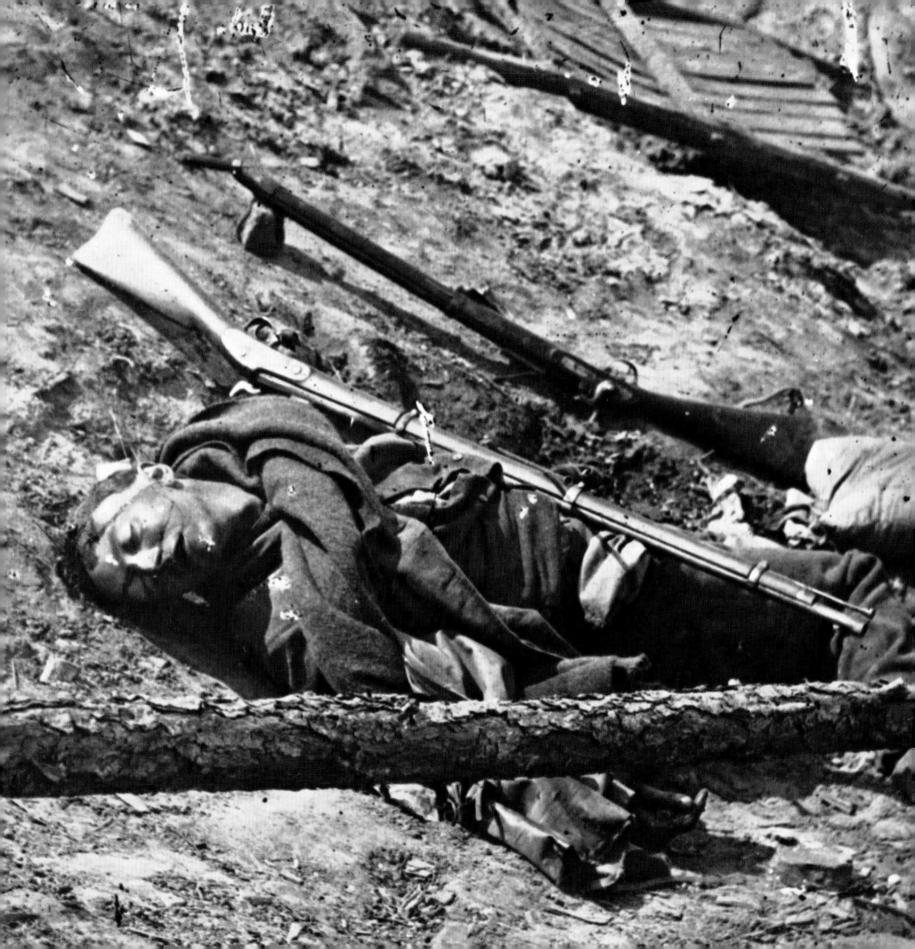

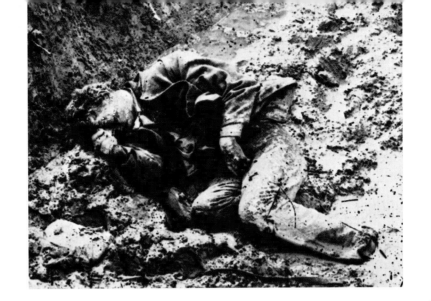

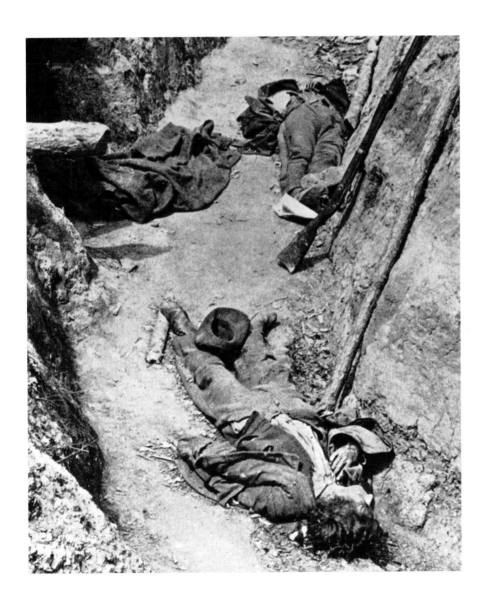

THE DEAD AT FORT MAHONE
On the morning following the capture of Confederate Fort Mahone on April 2, 1865, photographer Thomas Roche carried his bulky equipment into the fort and photographed the Confederate dead where they had fallen in the fort's mud-choked labyrinth of trenches.

The Final Act

ON MARCH 4, 1865, ABRAHAM LINCOLN WAS SWORN INTO OFFICE for a second term as president of the United States. In his inaugural address Lincoln declared that he favored a hard war and a merciful peace, with "malice towards none; with charity for all." Within a month the Union was victorious. The Confederate government had fled Richmond, leaving the heart of the city in flaming ruins, and on April 9, 1865, Lee surrendered his army at Appomattox. With the surrender of General Johnston's army in North Carolina, the war was effectively over. The Lincoln administration began to focus on the massive problems of reconstruction.

Amid the festivities, Lincoln was troubled by a haunting dream that he shared with his wife just prior to his death, "Before me was a catafalque, on which rested a corpse in funeral vestments . . ." And when he asked who had died, he was told, "The president, he was killed by an assassin!"

This premonition was soon to become a reality on April 14, when actor and rabid Confederate sympathizer John Wilkes Booth entered Ford's Theater and fired a bullet into Lincoln's brain. The president died the next morning. After a daring escape, Booth was killed 12 days later, and his coconspirators were captured, tried, and hanged.

One hundred forty years later, we still grapple with the repercussions of the bitter Civil War that claimed the lives of more than 620,000 Americans. Nearly half a million more were wounded, many permanently maimed, while others were afflicted with chronic illness. The epic conflict, forged in fire and blood, redefined our nation forever. One Union general put it best when he reflected, "The muster rolls on which the name and oath were written were pledges of honor, redeemable at the gates of death. And they who went up to them, knowing this, are on the list of heroes."

ASHES OF DEFEAT
Two women, dressed in black as a sign of mourning, walk in a rubble-strewn street past some of the 900 buildings destroyed in the fires set by Richmond's defenders when they evacuated the city on April 2, 1865.

WITH MALICE TOWARDS NONE
Standing beside a small iron table and surrounded by notables on the Capitol steps, Lincoln reads his second inaugural address on March 4, 1865. Many in the throng at the ceremony were moved to tears by the speech's most memorable line: "With malice towards none; with charity for all."

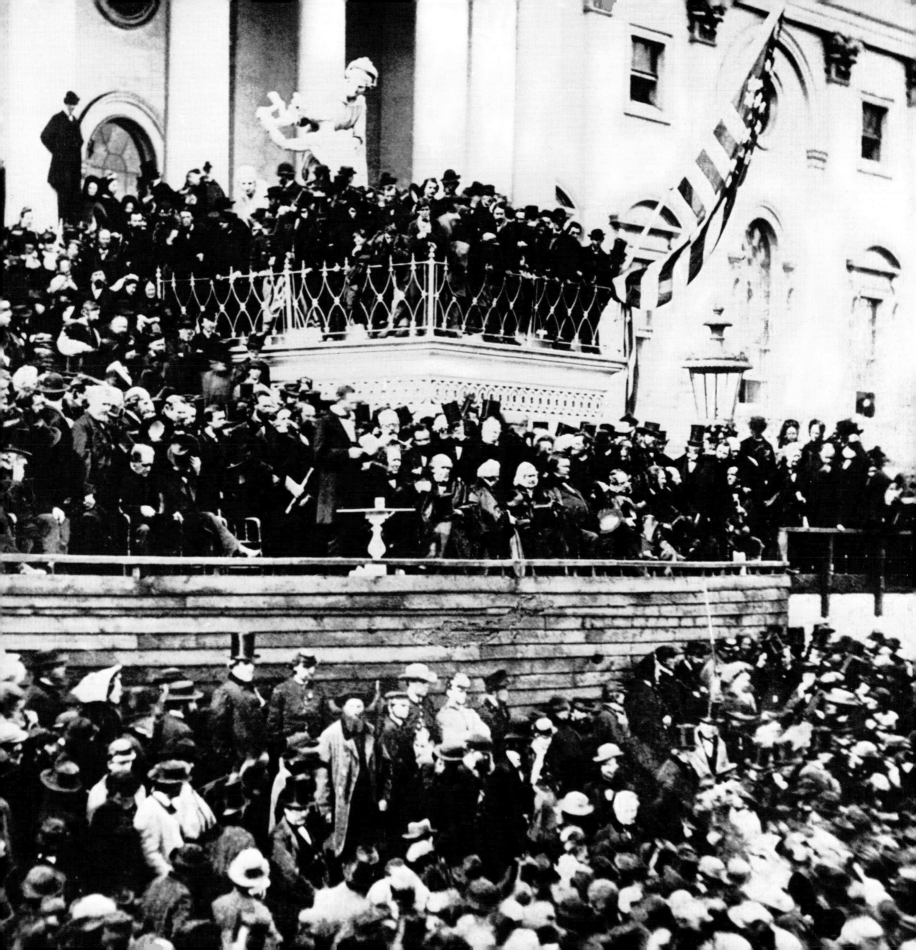

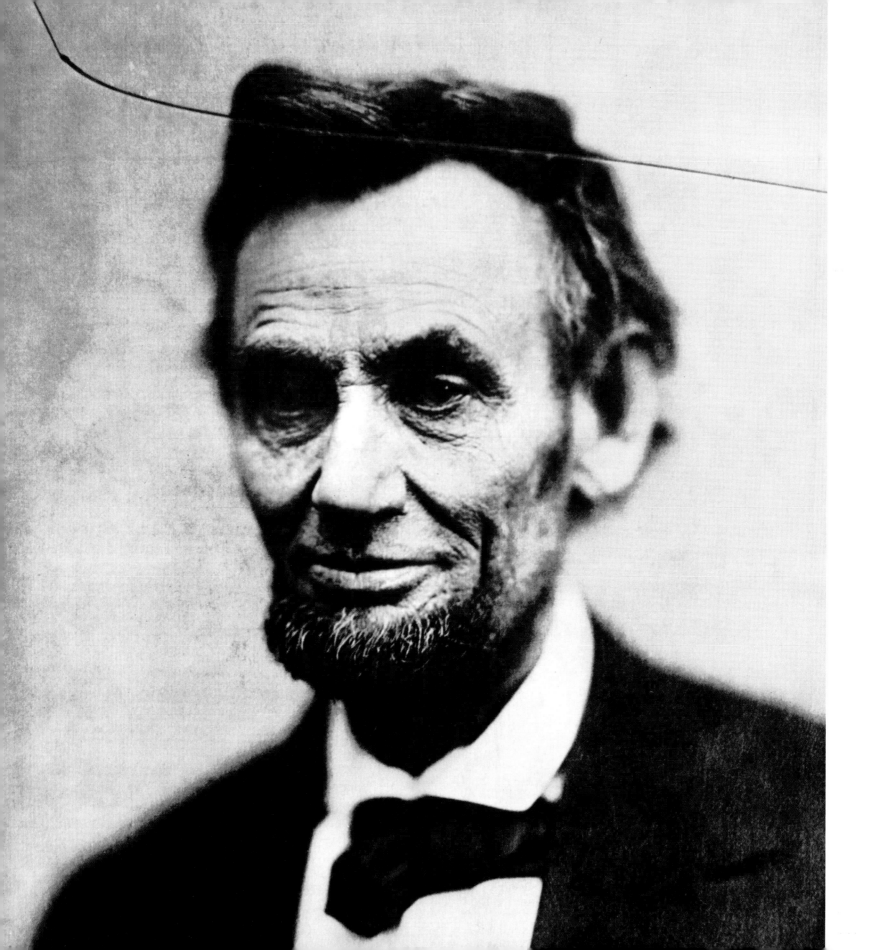

LAST PORTRAIT

Abraham Lincoln sat for the photograph at left in February 1865. Only one print was made from the glass negative, which broke during the development process.

PORTRAIT OF AN ASSASSIN

Handsome and charismatic, actor John Wilkes Booth was also an ardent secessionist. His hatred for Abraham Lincoln was so great that it caused him, in the words of his sister, to break into "wild tirades, which were the very fever of his distracted brain and tortured heart."

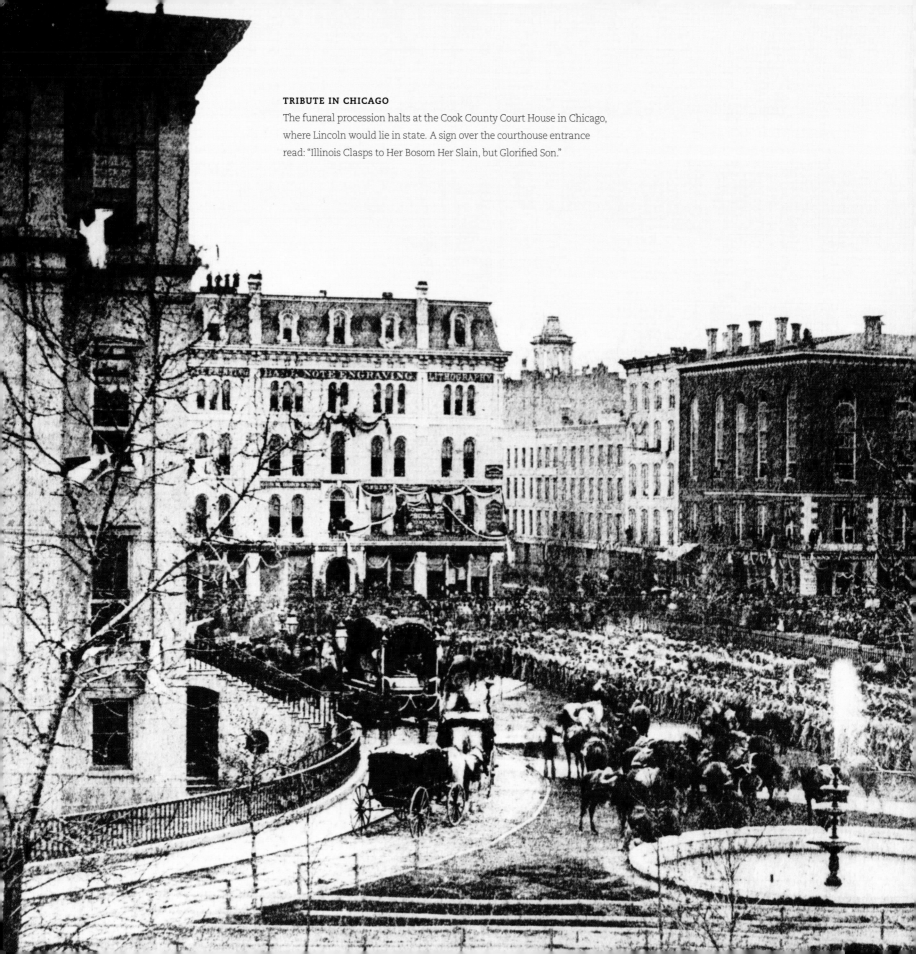

TRIBUTE IN CHICAGO

The funeral procession halts at the Cook County Court House in Chicago,
where Lincoln would lie in state. A sign over the courthouse entrance
read: "Illinois Clasps to Her Bosom Her Slain, but Glorified Son."

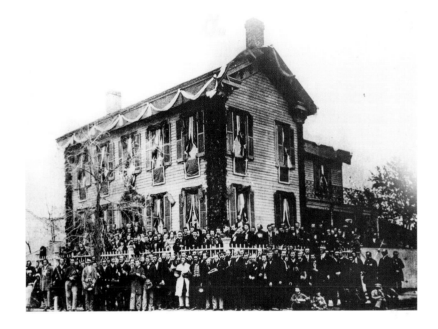

HOMETOWN IN MOURNING

A delegation of Illinoisans gathers in front of the Lincoln home on the corner of 8th and Jackson Streets in Springfield. Lincoln had hoped to return here after his second term as president.

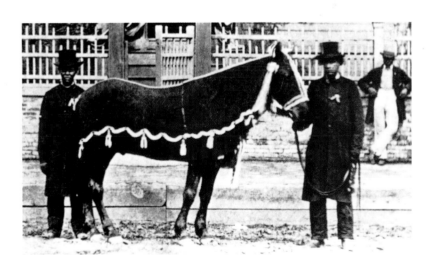

A PLACE OF HONOR

The Reverend Henry Brown, a black minister who had known the Lincolns for years, stands to the left of Old Bob, Lincoln's horse, on the day of Lincoln's interment. Brown led Old Bob in the place of honor behind the hearse on the final walk to the cemetery.

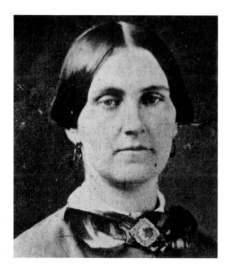

MARY SURRATT

Mary Surratt, an affable 42-year-old widow, managed the boardinghouse in Washington where Booth and his accomplices—including Mary's son John—met to plot the attack on President Lincoln and other Federal officials.

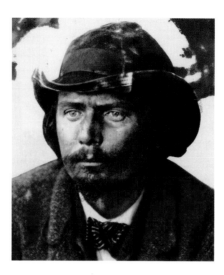

GEORGE ATZERODT

Marylander George Atzerodt smuggled supplies, escaped prisoners, and Confederate sympathizers into Virginia. He failed in his part of the conspiracy—the murder of Vice President Johnson—but his knowledge of the assassination plot led to his conviction.

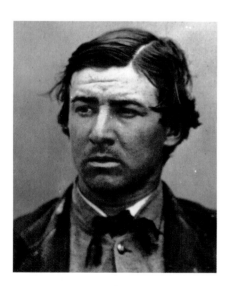

DAVID HEROLD

An associate of John Wilkes Booth and part of a failed plot to kidnap Lincoln, David Herold served as liaison among the other conspirators, and accompanied Booth during the 12 days that the assassin eluded the authorities.

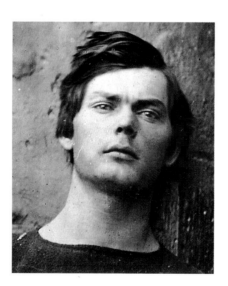

LEWIS POWELL

A former Confederate soldier, and at 21 the youngest of the conspirators sentenced to die, Lewis Powell was over six-feet-tall, powerfully built, and good looking. He wounded Secretary of State William Seward and four others in a brutal rampage through Seward's home.

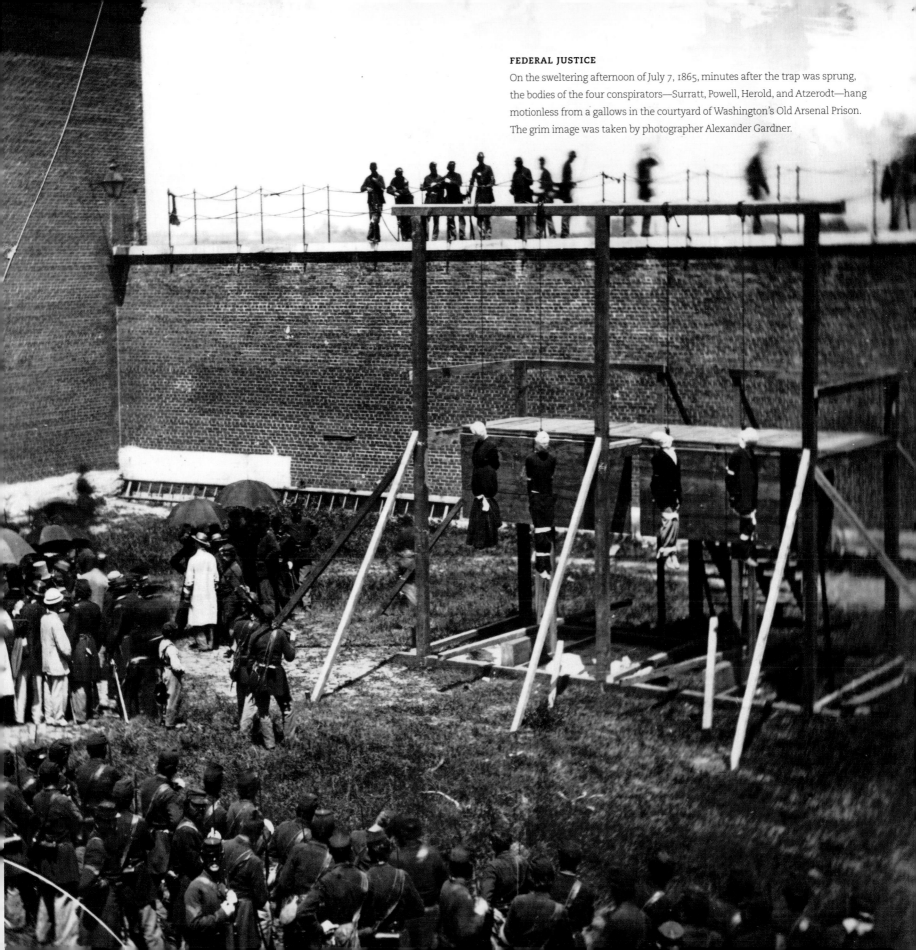

FEDERAL JUSTICE

On the sweltering afternoon of July 7, 1865, minutes after the trap was sprung, the bodies of the four conspirators—Surratt, Powell, Herold, and Atzerodt—hang motionless from a gallows in the courtyard of Washington's Old Arsenal Prison. The grim image was taken by photographer Alexander Gardner.

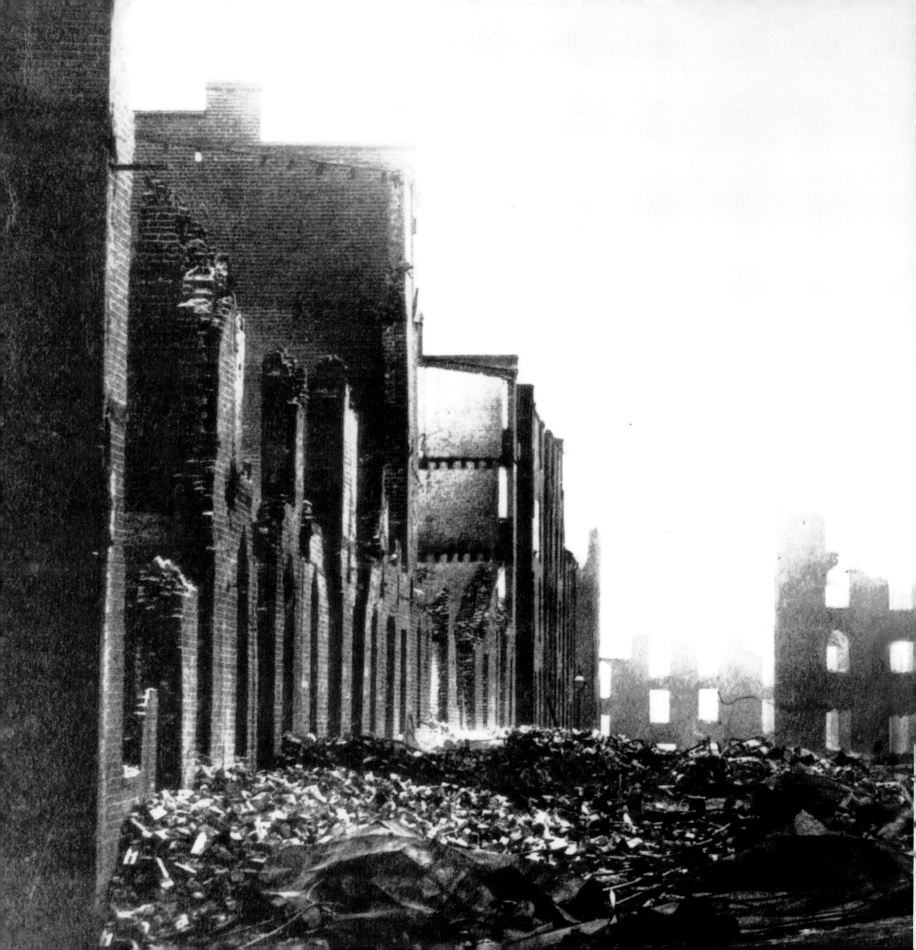

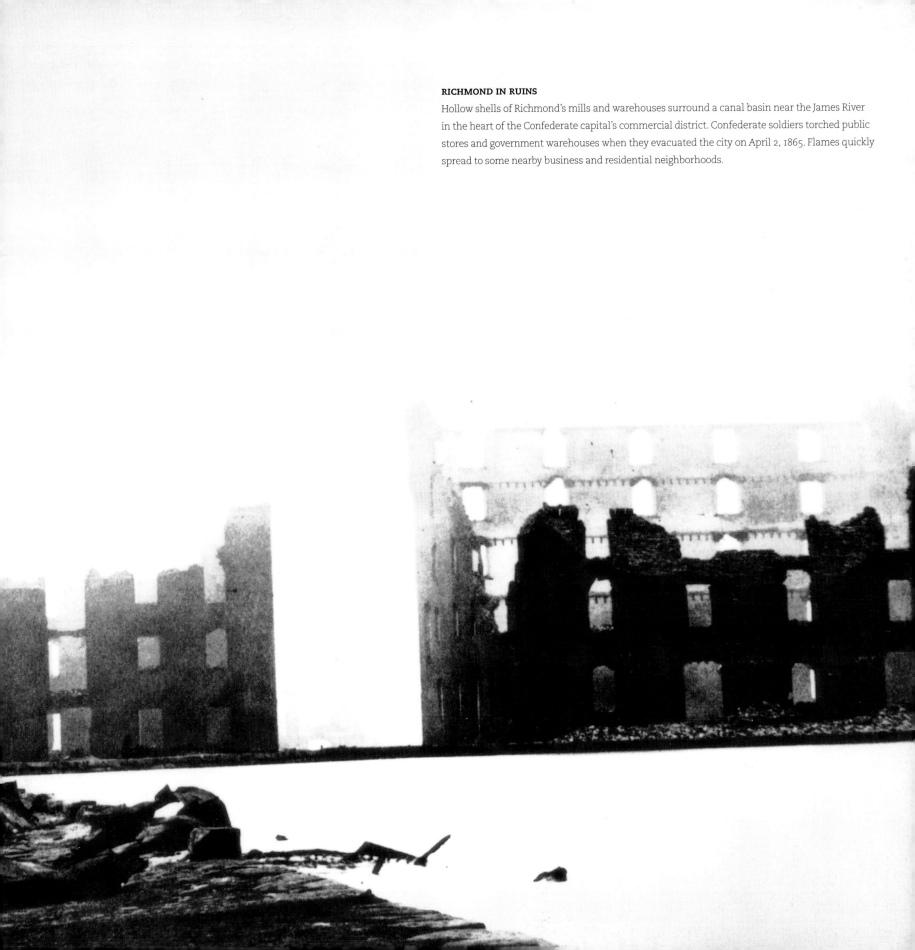

RICHMOND IN RUINS

Hollow shells of Richmond's mills and warehouses surround a canal basin near the James River in the heart of the Confederate capital's commercial district. Confederate soldiers torched public stores and government warehouses when they evacuated the city on April 2, 1865. Flames quickly spread to some nearby business and residential neighborhoods.

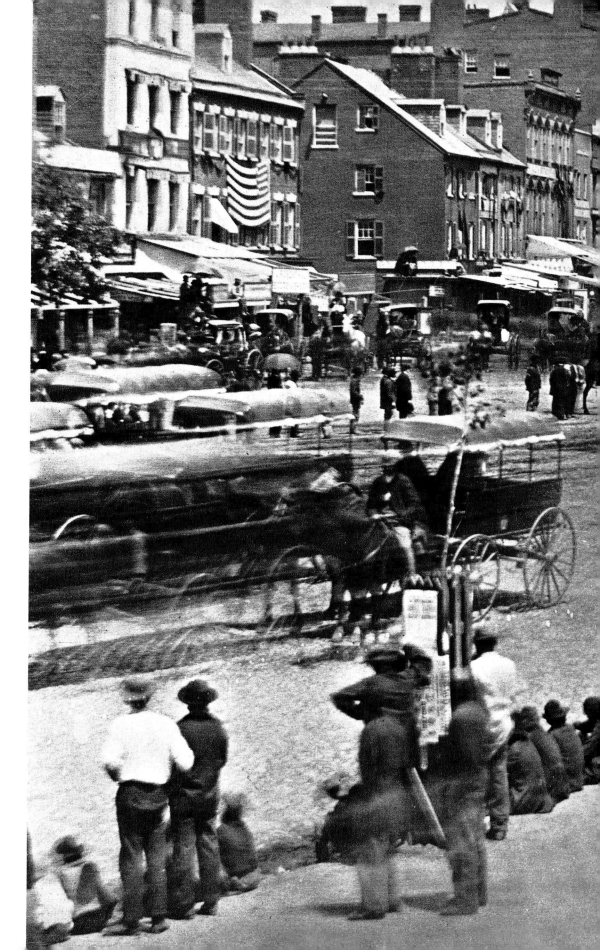

"The generation that carried on the war has been set apart by its experience. Through our great good fortune, in our youth our hearts were touched with fire. It was given to us to learn at the outset that life is a profound and passionate thing."

OLIVER WENDELL HOLMES,
20th Massachusetts Infantry

GRAND REVIEW

Five weeks after Lincoln's assassination, the streets of Washington were thronged with citizens paying final honor to the Army of the Potomac under Meade and to Sherman's Army of the West. This motion-blurred picture by Gardner recorded the Grand Parade, held in celebration of the men who had kept the nation intact.

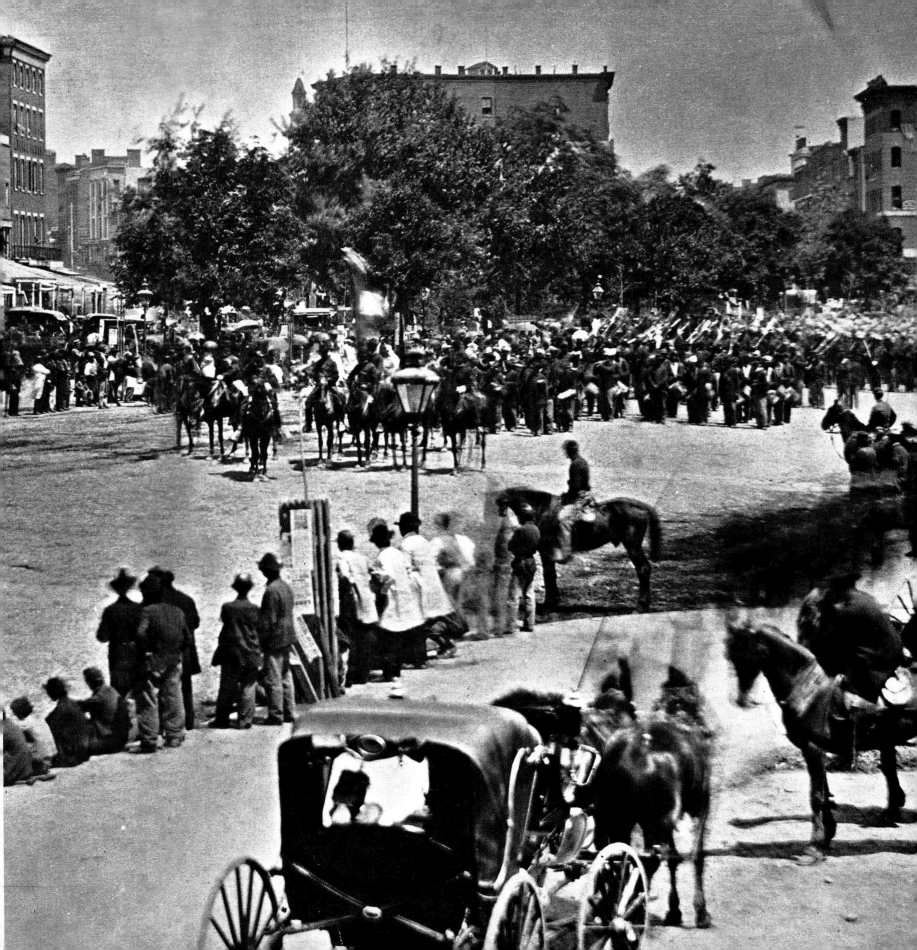

PICTURE CREDITS

Credits from left to right are separated by semicolons, from top to bottom by dashes.

Abbreviations Key:

LC	Library of Congress
MOLLUS-MASS	Military Order of the Loyal Legion of the United States-Massachusetts
NA	National Archives
USAMHI	U.S. Army Military History Institute, Carlisle, PA
USMAL	Orlando Poe Collection, Special Collections, U.S. Military Academy Library, West Point
WRHS	The Western Reserve Historical Society, Cleveland, OH

COVER: LC, Courtesy James R. Mellon. **2:** NA. **5:** Collection of C. Paul Loane, copied by Arthur Soll.

IMAGES OF WAR: 6, 7: Meserve-Kunhardt Collection, picturehistory.com. **8, 9:** Medford Historical Society. **10, 11:** LC, Neg. No. LC-B8184-4547A. **12, 13:** Archives of the University of Notre Dame. **14, 15:** USAMHI. **16, 17:** LC, Neg. No. LC-DIG-cwpb-03415. **18, 19:** LC, Neg. No. LC01098V.JPG. **20, 21:** NA, Neg. No. 165-A-441. **22, 23:** USAMHI. **24, 25:** Meserve-Kunhardt Collection, picturehistory.com.

AMERICA'S FIRST PHOTOJOURNALISTS: 26, 27: LC; LC, Neg. No. 28279-B881-710732. **28, 29:** Museum of the Confederacy, Richmond, VA, copy photography by Katherine Wetzel; Courtesy William J. Schultz. **30:** Courtesy Jim Stamatelos–William Gladstone Collection. **31:** George Eastman House, Rochester, NY. **32:** USAMHI –George Eastman House, Rochester, NY. **33:** LC, Neg. No. LC-B8184-651 DLC. **34, 35:** NA, ARC identifier #524463. **36:** USAMHI, copied by Robert Walch–USAMHI.

THE TWO AMERICAS: 38, 39: WRHS; USAMHI (Neg: Vol 118, p. 6081). **40, 41:** Meserve-Kunhardt Collection, picturehistory.com (2). **42, 43:** PHMC, Drake Well Museum, Titusville, PA. Neg. No. DW497; Michigan Dept. of State Archives. **44, 45:** New-York Historical Society; WRHS; NA, Neg. No. 111-BA-4687. **46, 47:** Peabody Museum, Harvard University (photo numbers N33717; N35552; N35484; N33712), Daguerreotypes by J. T. Zealy. **48, 49:** LC; Collection of the Louisiana State Musuem; New-York Historical Society. **50:** Unknown artist, American School, Frederick Douglass, ca. 1855, Daguerreotype, 7 x 5.6 cm (2 x 2 3/16 in.), The Metropolitan Museum of Art, New York, the Rubel Collection, Partial and Promised Gift of William Rubel, 2001 (2001.756). **51:** LC; Schlesinger Library, Radcliffe Institute, Harvard University–Sophia Smith Collection (Women's History Archive), Smith College, Northampton, MA; Department of Special Collections, Wichita State University Library. **52, 53:** From the Archives of Chessie Systems, B & O Railroad Museum; Ohio Historical Society. **54, 55:** Chicago Historical Society, Neg. No. ICHi-17161; Chicago Historical Society, photographed by Alexander Hesler; Lloyd Ostendorf Collection, Dayton, OH. **56, 57:** LC; Boston Athenaeum; Chicago Historical Society. **58, 59:** NA; Clements Library, University of Michigan.

FIRST BLOOD: 60, 61: Courtesy Gil Barrett; Meserve-Kunhardt Collection, picturehistory.com. **62, 63:** Valentine Richmond History Center, VA; General Sweeney's Museum, Republic, Mo; LC. **64, 65:** Courtesy of the Burton Historical Collection, Detroit Public Library; Lloyd Ostendorf Collection, Dayton, OH. **66:** LC—Medford Historical Society. **67:** LC, Neg. No. B8171-313.

THE BLOCKADE: 68, 69: USAMHI (2). **70, 71:** WRHS; LC. **72, 73:** LC; Chicago Historical Society. **74, 75:** WRHS. **76, 77:** LC; Courtesy The Mariners' Museum, Newport News, VA. **78, 79:** USAMHI, copied by Robert Walch. **80, 81:** LC, Neg. No. B817-824; LC.

ROAD TO SHILOH: 82, 83: Courtesy Ronn Palm; Herb Peck Jr., Nashville. **84, 85:** WRHS. **86, 87:** Cairo Public Library, Cairo, IL; LC. **88, 89:** NA, Neg. No. 165-C-702. **90, 91:** New-York Historical Society. **92, 93:** The State Historical Society of Missouri; Albert Shaw Collection, the Review of Reviews, *The Photographic History of the Civil War*, photographed by Larry Sherer.

FORWARD TO RICHMOND: 94, 95: Collection of Brian Pohanka; Medford Historical Society. **96, 97:** NA, Neg. No. 16-AD-2; LC. **98, 99:** LC; Courtesy The Vermont Historical Society. **100, 101:** LC; LC, Neg. No. LC-B8171-0377. **102, 103:** LC, Neg. No. LC-B8171-7383; LC, Neg. No. LC-B8171-431. **104, 105:** LC.

LEE TAKES COMMAND: 106, 107: D. Mark Katz; Minnesota Historical Society. **108, 109:** NA, Neg. No. CN-11090; Courtesy Ronn Palm. **110–115:** LC.

THE BLOODIEST DAY: 116, 117: Michael McAfee; LC, Neg. No. 21371-B811-560. **118, 119:** The Guilder Lehrman Institute; Courtesy Mr. Benjamin Rosenstock. **120, 121:** NA; USMAL, photographed by Henry Groskinsky. **122, 123:** LC. **124, 125:** LC, Neg. No. 21365-B8151-179; LC. **126, 127:** LC. **128, 129:** LC, Courtesy James R. Mellon; **130, 131:** LC; LC, Neg. No. B8171-570. **132, 133:** LC (2). **134, 135:** LC; MOLLUS-MASS/USAMHI, Courtesy William A. Frassanito.

LIBERATION: 136, 137: USAMHI, copied by Robert Walch; LC. **138, 139:** WRHS. **140, 141:** The Stowe-Day Foundation, Hartford, CT; USAMHI, copied by Robert Walch. **142, 143:** LC, Neg. No. LC-B8171-2594; NA, Neg. No. 111-B-400. **144, 145:** LC; USAMHI.

REBELS RESURGENT: 146, 147: George E. Gorman IV; LC. **148, 149:** LC (2). **150, 151:** MOLLUS-MASS/USAMHI, copied by A. Pierce Bounds; LC. **152, 153:** LC; WRHS. **154, 155:** Courtesy Georgia Division of Archives and History, Office of Secretary of State; LC. **156, 157:** LC, Neg. No. B8184-10365; Courtesy Stonewall Jackson Foundation, Lexington, VA; MOLLUS-MASS/USAMHI, copied by A. Pierce Bounds. **158-161:**

WRHS. **162, 163:** William Gladstone Collection, USAMHI, copied by A. Pierce Bounds. **164, 165:** NA, Neg. No. 96; USAMHI.

WAR ON THE MISSISSIPPI: 166, 167: Courtesy Charlie T. Salter; Chicago Historical Society. **168, 169:** LC, Neg. No. LC-DIG-cwp6-01011-DLC. **170, 171:** NA. **172, 173:** Courtesy Illinois State Historical Library. **174, 175:** Old Courthouse Museum, Vicksburg, MS, copied by Bill van Calsem; LC. **176, 177:** Andrew D. Lytle Collection, Mss. 893, 1254, Louisiana and Lower Mississippi Valley Collections, LSU Libraries, Baton Rouge, LA; Courtesy Herb Peck, Jr.–Wisconsin Historical Society, Neg. No. WHi(X3)15263. **178, 179:** Old Courthouse Museum, Vicksburg, MS; LC, Neg. No. B8184-10195. **180, 181:** Albert Shaw Collection, The Review of Reviews, *The Photographic History of the Civil War,* copied by Larry Sherer.

GETTYSBURG: 182, 183: NA, Neg. No. 200(S)-CC2288; NA, Neg. No. 1655-B41. **184, 185:** D. Mark Katz; LC. **186, 187:** Courtesy Robert E. Lee Memorial Assoc., Stratford Hall, photographed by Larry Sherer; LC, Neg. No. B818-4B29. **188, 189:** Chicago Historical Society; LC, Neg. No. B811-2393. **190, 191:** LC, Neg. No. B8171-2402; LC, Neg. No. 3538 Plate 42. **192, 193:** LC. **194, 195:** LC; USAMHI, copied by A. Pierce Bounds–Atlanta History Center/DuBose Collection, photographed by Larry Sherer. **196, 197:** National Portrait Gallery, Smithsonian Institute/Art Resource, NY; NA.

SOLDIER LIFE: 198, 199: LC, Neg. No. 26543; NA, Neg. No. 111-B-252. **200, 201:** Joseph Canole; Collection of the Rochester Museum and Science Center, Rochester, NY. **202, 203:** Minnesota Historical Society, Neg. No. E425.11118; Hayes Presidential Center, Freemont, OH. **204, 205:** Courtesy of the Civil War Library and Museum, Philadelphia, PA, 19103, copied by Blake A. Magner; LC. **206, 207:** USAMHI; MOLLUS-MASS/USAMHI, copied by Robert Walch. **208:** From *"Dear Friends" The Civil War Letters and Diary of Charles Edwin Cort,* compiled and edited with commentaries by Helyn W. Tomlinson, 1962–From *The Photographic History of the Civil War,* Vol.2, edited by Francis Trevelyan Miller, published by The Review of Reviews Co., NY, 1912. **209:** The Lightfoot Collection. **210, 211:** WRHS; Courtesy T. Scott Sanders–LC. **212, 213:** NA, Neg. No. B-189. **214:** Chicago Historical Society, Neg. No. ICHi08247–Courtesy Illinois State Historical Library. **215:** LC. **216, 217:** USAMHI; LC. **218, 219:** NA, Neg. No. 165-A-446; Bettmann/Corbis; NA.

ICONS OF REMEMBRANCE: 220: The J. Howard Wert Gettysburg Collection and Civil War Antiquities, photographed by Larry Sherer. **221:** Tom Farish, photographed by Michael Latil; Fredericksburg and Spotsylvania National Military Park, photographed by Larry Sherer; George E. Gorman IV–Richard F. Carlile. **222, 223:** Courtesy Dean E. Nelson; Courtesy Kean E. Wilcox; Courtesy Herb Peck Jr., Nashville–Stamatelos Brothers Collection, Cambridge, MA, photographed by Andrew K. Howard. **224:** Courtesy Tom Farish, photographed by Michael Latil. **225:** Jerry Wright Collection, photographed by Henry Mintz; Kean Wilcox; David Wynn Vaughan–Courtesy Georgia Division of Archives and History, Office of Secretary of State, photographed by George S. Whiteley IV; Courtesy Barbara and Robert Brezek; George Barnard Erath Papers, CN08739, Center for American History, University of Texas, Austin. **226:** Courtesy Kean Wilcox; Tom Farish, photographed by Michael Latil; Courtesy Kean Wilcox–David Wynn Vaughan; Courtesy Kean Wilcox; John F. Weaver, McLean, VA. **227:** Chicago Historical Society.

STRUGGLE FOR TENNESSEE: 228, 229: Courtesy Richard F. Carlile; WRHS. **230, 231:** From *The Photographic History of the Civil War,* Vol. 2, by Henry W. Elson, published by The Review of Reviews Co., NY, 1911. **232, 233:** WRHS. **234, 235:** USMAL, photographed by Henry Groskinsky. **236, 237:** LC, Neg. No. B818-410260; Collection of C. Paul Loane, copied by Arthur Soll. **238, 239:** Kansas State Historical Society; LC; WRHS. **240, 241:** LC (2). **242, 243:** NA, Neg. No. 77-F-147-2-11; T. Scott Sanders.

THE KILLING GROUND: 244, 245: USAMHI; USMAL, photographed by Henry Groskinsky. **246, 247:** LC. **248, 249:** From the Photographic Collection of the Rochester Historical Society; USAMHI. **250, 251:** LC, Neg. No. 863B-8184537; USAMHI. **252, 253:** From *Prisons and Hospitals,* Vol. 7 of *The Photographic History of the Civil War,* edited by Francis Trevelyan Miller, published by The Review of Reviews Co., NY, 1911; Meserve-Kunhardt Collection, picturehistory.com. **254, 255:** WRHS; Medford Historical Society. **256, 257:** WRHS; LC.

BATTLES FOR ATLANTA: 258, 259: Panhandle-Plains Historical Museum, Canyon, Texas; Medford Historical Society. **260, 261:** USMAL, photographed by Henry Groskinsky; National Portrait Gallery, Smithsonian Institution/Art Resource, NY. **262, 263:** USMAL, photographed by Henry Groskinsky. **264, 265:** L. M. Strayer Collection; USMAL, photographed by Henry Groskinsky. **266, 267:** Medford Historical Society (2).

DEATH IN THE TRENCHES: 268, 269: LC, Neg. No. B818-3180; LC. **270, 271:** Dementi Studios, Richmond; LC. **272, 273:** USAMHI. **274, 275:** Virginia Military Institute Archives, Lexington; Historical Society of Pennsylvania. **276, 277:** LC; LC, Neg. No. 818-44794. **278, 279:** Courtesy Bill Turner; Valentine Richmond History Center, VA. **280, 281:** NA, Neg. No. 111-B-152; WRHS. **282, 283:** LC. **284, 285:** Photri; LC. **286:** LC, Neg. No. B817-13175. **287:** LC, Neg. No. B811-3190 –USMAL, photographed by Henry Groskinsky.

THE FINAL ACT: 288, 289: LC; NA, Neg. No. 66-G-22J-11. **290, 291:** National Portrait Gallery, Smithsonian Institution/Art Resource, NY; Harvard Theatre Collection, The Houghton Library. **292, 293:** Chicago Historical Society, Neg. No. ICHi-11252; Courtesy Illinois State Historical Library(2). **294, 295:** The Huntington, Art Collections and Botanical Gardens, San Marino, CA/SuperStock; LC, Neg. No. LC-B8178-7781–LC, Neg. No. LC-B8171-7784; LC, Neg. No. LC-B8171-7773; LC, Neg. No. LC-B8171-7798. **296, 297:** LC. **298, 299:** Meserve-Kunhardt Collection, picturehistory.com.

INDEX

Numerals in bold indicate an illustration
of the subject mentioned.